Visions
from the
Forests

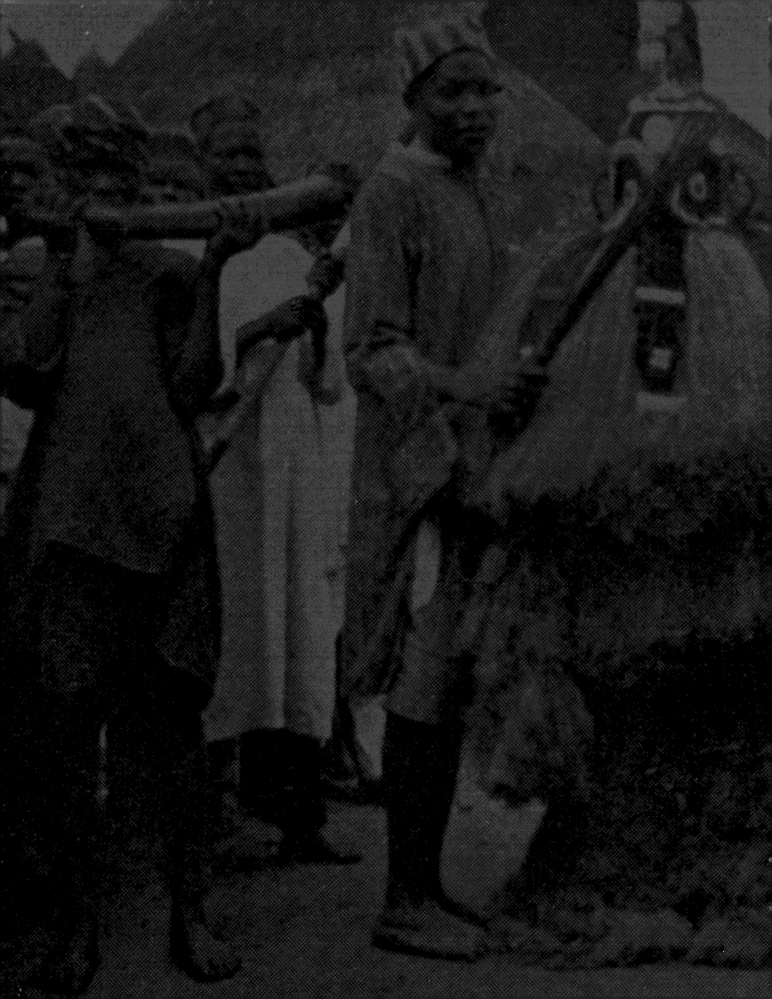

Visions
from the
Forests

The Art of Liberia and Sierra Leone

JAN-LODEWIJK GROOTAERS
AND **ALEXANDER BORTOLOT**,
GENERAL EDITORS

ESSAYS BY
MARIANE C. FERME AND **PAUL RICHARDS**
JAN-LODEWIJK GROOTAERS
NANINA GUYER
BARBARA C. JOHNSON
CHRISTINE MULLEN KREAMER
FREDERICK JOHN LAMP
DANIEL B. REED

CATALOGUE BY
ALEXANDER BORTOLOT
JAN-LODEWIJK GROOTAERS
NATASHA THORESON

MINNEAPOLIS
MIA INSTITUTE
OF ARTS

DISTRIBUTED BY
THE UNIVERSITY OF WASHINGTON PRESS
SEATTLE AND LONDON

Contents

KAYWIN FELDMAN, DIRECTOR AND PRESIDENT, MINNEAPOLIS INSTITUTE OF ARTS

Director's Foreword

I HAVE LONG BEEN FASCINATED by a type of wooden "helmet mask" made in Sierra Leone and Liberia whose hallmarks are beautifully burnished black surfaces and compact female facial features. In fact, this is the only kind of helmet mask in all of Africa reserved exclusively for women dancers. Used during initiation ceremonies for pubescent girls, these masks highlight the key position women hold in the Upper Guinea Forest region of West Africa. After spending a year in seclusion in the forest, the girls emerge attired in their finest clothes and are led back to their communities by mask-wearing women of high social standing. Each girl has been given a new name, marking her status as a marriageable young woman.

For more than forty years, this vital West African tradition was represented at the Minneapolis Institute of Arts (MIA) by a single helmet mask. In late 2011, however, we received an astonishing bequest from William (Bill) Siegmann, a native of Minneapolis who had done years of museum work and field research in West Africa before becoming the curator of African and Oceanic art at the Brooklyn Museum in 1987. Among the sixty objects comprising the gift, four are striking female helmet masks. Distinct differences between the masks reveal a surprising and delightful degree of artistic freedom within the theme.

In fact, Bill's generous gift to the MIA represented only a fraction of his overall collection of art from Liberia and Sierra Leone, amassed over several decades. Also included were other types of masks, objects of personal adornment in silver, prestige objects in ivory, figurative works in stone and brass, and textiles. By the time of his death in November 2011, Bill had also given away or bequeathed works to the Smithsonian's National Museum of African Art in Washington, D.C., the Indiana University Art Museum in Bloomington, the High Museum in Atlanta, the Saint Louis Art Museum, and the Brooklyn Museum.

An exhibition featuring the works in his collection was the topic of many happy conversations between Bill and Dr. Jan-Lodewijk Grootaers, curator of African art at the Minneapolis Institute of Arts. Bill was thrilled and comforted to know that *Visions from the Forests: The Art of Liberia and Sierra Leone* would be organized by the MIA and that it would travel to several of the museums that had received gifts from him. I am extremely grateful to Jan-Lodewijk for his dedication to this important project. Under his passionate leadership, the museum's commitment to collecting and displaying African art has greatly expanded.

This exhibition and accompanying catalogue provide further evidence of the MIA's dedication to enhancing public understanding and appreciation of art from Africa. The museum's African art galleries reopened in the fall of 2013, having been closed for renovation for almost a year. Their exciting new design was shaped in part by focus groups and regular consultation with representatives from immigrant African communities in the Twin Cities who take great pride in seeing the artistic accomplishments of their cultures so prominently and respectfully exhibited. It is my sincere hope that this exhibition and book will also find resonance among peoples of West African descent in the Twin Cities—and beyond—as well as members of the general public for whom Africa remains, by and large, mysterious and little-known.

Between the late 1980s and early 2000s, Liberia and Sierra Leone suffered through protracted civil wars, hugely destructive to both human life and cultural heritage. Thanks to the collecting efforts of Bill Siegmann, we can now study and enjoy a wide range of artworks, the likes of which may in some cases no longer exist in their countries of origin. The objects displayed in *Visions from the Forests* and discussed in this catalogue remind us all of the long history of artistic production and inventiveness that characterizes this region of West Africa.

JAN-LODEWIJK GROOTAERS AND ALEXANDER BORTOLOT

Introduction

THE AREA THAT ENVELOPS modern-day Liberia and Sierra Leone has long held a prominent place in global history. An early point of contact between Europeans and Africans in the mid-fifteenth century, it was later a haven for freed African slaves in the 1800s. In recent decades, it was the site of brutal civil wars that attracted worldwide attention. And, as illustrated in this publication, the two countries are also the source of some of Africa's most beloved and recognizable art forms. The late William (Bill) Siegmann was a master of understanding how the history and art of the region fit together. His abiding commitment to Africa—especially West Africa—found expression professionally in a long and storied museum career in both Liberia and the United States and personally in his enduring friendships with Liberians, including his adoptive Liberian family.

As a recurrent resident of Liberia over several decades, Siegmann was in a unique position to witness the immediate impact of unfolding events and to situate them within the broader context of history, culture, and tradition. His collection reflects this vantage point. With his encyclopedic knowledge of the art of Liberia and Sierra Leone, Siegmann identified and acquired fifteenth-century stone carvings and exemplary wooden masks from the late nineteenth century. But he also gravitated toward overlooked art as well as toward works that reflect social change and artistic development. These objects expand our understanding of the art of the region and, in some cases, demonstrate the impact of local politics, artistic personalities, and other factors on the making of art. In this regard, an exhibition of Siegmann's collection introduces the major aesthetic traditions of the area and sheds light on the historical settings in which the objects were created.

VISIONS FROM THE FORESTS

The countries of Liberia and Sierra Leone belong to the Upper Guinea Forest region, a zone of dense tropical rainforest that runs from Guinea in the west to Nigeria in the east. The forest and its associated riches have long influenced the movement and prosperity of this region's inhabitants as well as its cultural and aesthetic heritage. Whether cleared to accommodate new farm settlements or embraced as the spiritual and intellectual wellspring of the region's numerous initiation associations, the forest has provided a vital framework for human life in Liberia and Sierra Leone.

In numerous and ever-changing ways, the forest provides the physical and conceptual terrain where actions and ideas are developed and pursued. For initiation associations such as the Sande, Poro, and

Thoma, the forest is the place where individuals experience life-shaping events. It is also the source of specialized knowledge gleaned from the tutelary spirits believed to reside there. In Dan society, for example, forest-dwelling spirits visit individuals in dreams and request physical manifestation in the form of masks. Among the Loma and Mende peoples, masks whose forms and materials explicitly or implicitly refer to the animal world are among the most treasured of artworks.

LIBERIA AND SIERRA LEONE: A BRIEF HISTORY

Sierra Leone and Liberia were among the first sub-Saharan places Europeans visited. In the 1460s, Portuguese merchants made initial contact with the coastal inhabitants of these areas, establishing trading posts in what they named, respectively, the "Lioness Mountains" (*Serra Leoa*) and the "Pepper Coast," after the melegueta pepper that grew abundantly along the Liberian coast. There, they interacted with the no-longer-extant Sapi peoples, a loose confederation of the forebears of some of today's area residents. The Sapi are thought to have made the region's oldest surviving figurative art form—striking stone sculptures; some surviving examples are today used in new ways. With the arrival of the Dutch and the British during the sixteenth and seventeenth centuries, more trade developed, including the transatlantic slave trade.

Both countries also figure prominently in the history of abolition and emancipation. Freetown, Sierra Leone's capital, was founded by freed slaves from the United States in 1792. Following Britain's abolition of the international slave trade in 1807, Freetown served as a repatriation point for enslaved Africans the British Navy seized from vessels bound for South America. Liberia became a homeland for freed U.S. slaves from the 1820s on, and in 1847 it was officially declared the Republic of Liberia.

Protracted civil wars raged intermittently between 1989 and 2003 in Liberia and Sierra Leone. Large-scale looting and destruction accompanied these conflicts, which cost the lives of an estimated three hundred thousand people, severely ruptured civil society, and seriously damaged both countries' cultural heritages. Consequently, countless Sierra Leonean and Liberian artworks were lost forever—including most of those acquired, documented, and installed by Siegmann in the two Liberian museums where he worked between 1965 and 1987: the Africana Museum at Cuttington University College in Suakoko and the National Museum of Liberia in Monrovia.

PRESERVING THE PAST, CREATING THE FUTURE

Individuals and organizations in West Africa and beyond have worked collaboratively to preserve the history and material culture of Sierra Leone and Liberia for the benefit of coming generations. Collectively, these efforts have advanced the pursuit of scholarship on the arts of the region, and are reflected in several of the essays included in the pages that follow.

A large body of photographs documenting art and social practices—both historical and contemporary—is being utilized through several initiatives whose aim is to foster better understanding of the region's cultural legacy. One such initiative, SierraLeoneHeritage.com, is an online digital archive of Sierra Leonean artworks in museum collections in both that country and the United Kingdom. It is the outcome of the project "Reanimating Cultural Heritage: Digital Repatriation, Knowledge Networks and Civil Society Strengthening in Post-Conflict Sierra Leone," directed by the anthropologist Paul Basu.

The Indiana University Liberian Collections project has attempted to re-create, in part, the Liberian National Archives, which were largely destroyed during that country's civil wars. The collections were started informally in the early 1990s at the university's Archives of Traditional Music by the ethnomusicologist Ruth Stone and have grown with the donations of archives assembled by Liberian specialists, including the anthropologists Svend Holsoe and Warren d'Azevedo and, most recently, Bill Siegmann. Initiatives such as these help preserve the aesthetic heritage of Liberia and Sierra Leone.

History has shown that culture is always in flux, and that the past and "tradition" are in a perpetual state of redefinition. Some changes are for the better. Take, for example, the traditional practice of clitoridectomy, in which part of the clitoris is surgically excised; it is performed on pubescent girls during the seclusion phase of their initiation into the Sande Society. In recent years, both Liberia and Sierra Leone have officially restricted clitoridectomy—Liberia by banning it altogether and Sierra Leone by outlawing it for females under age eighteen.

The initiation practices of Liberia and Sierra Leone will continue to change, and the accompanying masks will continue to take on new forms and roles. The objects Bill Siegmann collected thus present a singular opportunity to reflect upon the balance achieved between honoring the past and adapting to the future.

Acknowledgments

Many individuals contributed to the development of this exhibition and catalogue. We must first thank Bill Siegmann himself for his generous gift of art and collection notes to the Minneapolis Institute of Arts (MIA) and for his early support of the exhibition. Ed DeCarbo—Siegmann's longtime friend and the executor of his estate—made innumerable contributions. We also thank the following individuals and museums for their generous loans to the exhibition: Kevin Dumouchelle, Arnold Lehman, and the Brooklyn Museum; Carol Thompson, Michael Shapiro, and the High Museum, Atlanta; Diane Pelrine, Adelheid Gealt, and the Indiana University Art Museum, Bloomington; Christine Kreamer, Johnetta Cole, and the National Museum of African Art, Washington, D.C.; Brent Benjamin and the Saint Louis Art Museum; Ed DeCarbo, and two anonymous collectors.

In addition, we are grateful to Mariane Ferme, Nanina Guyer, Barbara Johnson, Christine Kreamer, Frederick Lamp, Daniel Reed, and Paul Richards, whose essays constitute the core of this publication. The personal recollections of Joseph Ngafua Bolay, Diane Chehab, Ed DeCarbo, Kevin Dumouchelle, James Gibbs, Barbara Johnson, Pat Reilly, and Henrique Tokpa, assembled on pages 16–29, enable us to know Siegmann better. Amyas Naegele shared highly informative audio recordings of his 2011 interviews with Siegmann about his life and collection. Sarah Muenster-Blakley transcribed the interviews for the authors' use, and Lou Wells read and annotated an early version of them. Verlon Stone of the Indiana University Liberian Collections provided vital research support and guidance. William Hart, Frederick Lamp, Ruth Phillips, and Gary Schulze all offered important insights into the Siegmann collection.

The editor of this book, Phil Freshman (assisted by Susan C. Jones); its designer, Deb Miner; and its printing-and-distribution manager, Jim Bindas, all deserve our special thanks for their patience and enthusiasm. Finally, we are immensely grateful to our colleagues at the MIA for their support of the project: Laura DeBiaso, Rayna Olson, and Natasha Thoreson of the Curatorial Division; Dan Dennehy, Josh Lynn, and Charles Walbridge of the Department of Visual Resources; Kaywin Feldman, Director and President; and Matthew Welch, Deputy Director and Chief Curator.

—JLG AND AB

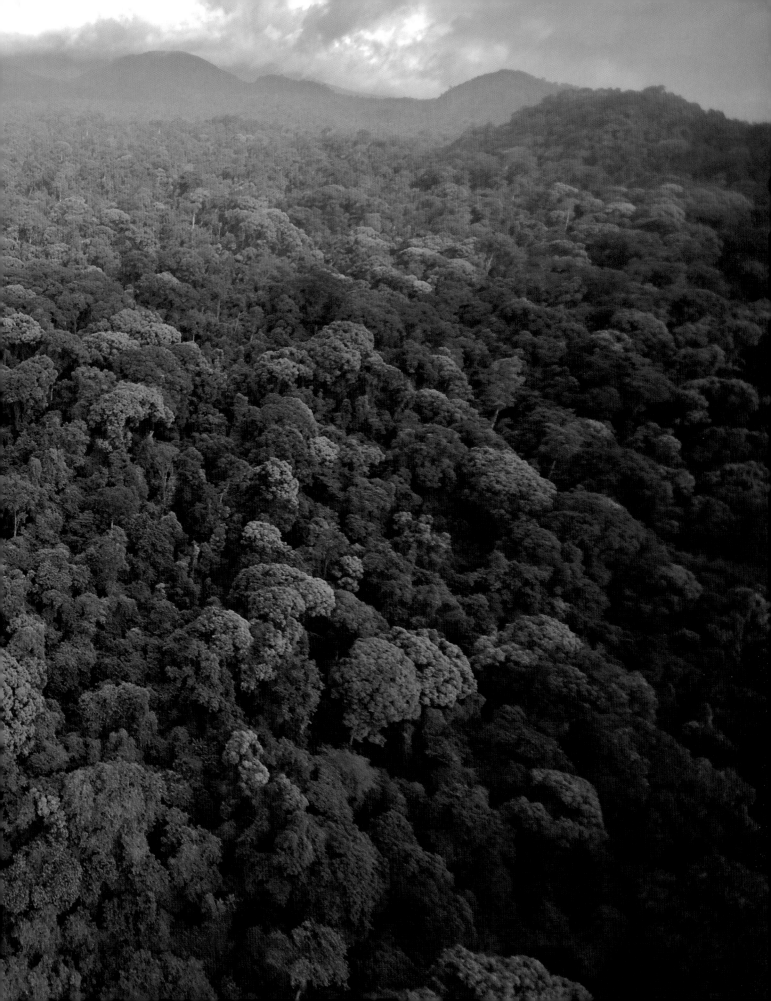

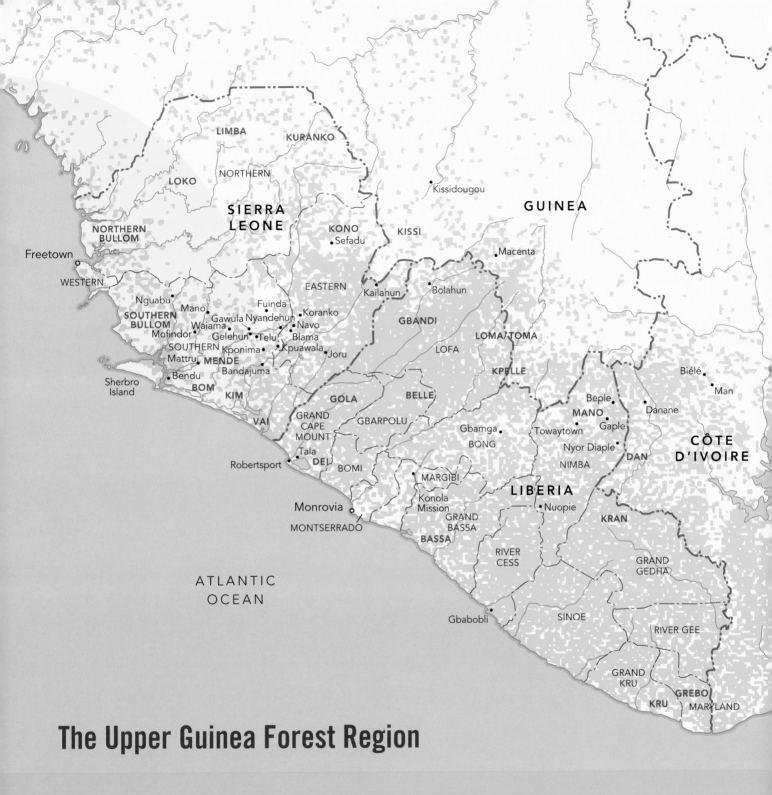

LIMBA

KURANKO

• Kissidougou

LOKO

NORTHERN

GUINEA

SIERRA
LEONE

KONO
• Sefadu

KISSI

• Macenta

Freetown ✪

WESTERN

EASTERN

Kailahun

• Bolahun

NORTHERN
BULLOM

Nguabu •
Mano • Fuinda
SOUTHERN Gawula Nyandehun • Koranko
BULLOM Waiama • Navo
Mofindor Gelehun • Telu Blama
SOUTHERN Kponima • Kpuawala
Mattru MENDE Joru •
• Bendu Bandajuma
BOM KIM

GBANDI

LOMA/TOMA

LOFA

KPELLE

Biélé •
• Man

VAI

GOLA

BELLE

MANO
Beple •
• Danane
Gaple •

Sherbro
Island

GRAND
CAPE
MOUNT

GBARPOLU

Gbarnga •
BONG

Towaytown •

Nyor Diaple •

DAN

CÔTE
D'IVOIRE

Tala
Robertsport • DEI

BOMI

MARGIBI

Konola
Mission

NIMBA

LIBERIA

• Nuopie

KRAN

Monrovia ✪

MONTSERRADO

GRAND
BASSA
BASSA

RIVER
CESS

GRAND
GEDHA

ATLANTIC
OCEAN

Gbabobli •

SINOE

RIVER GEE

GRAND
KRU

GREBO
KRU MARYLAND

The Upper Guinea Forest Region

KEY

▢ Green designates forest areas.

▢ Brighter yellow designates the approximate location of the historic Sapi peoples.

Names in **BROWN BOLDFACE CAPITAL LETTERS** indicate ethnic groups (**LOKO**, **LIMBA**).

Names in PLAIN CAPITAL LETTERS indicate provinces and counties (NORTHERN, SOUTHERN).

Other names indicate cities, towns, and islands (Freetown, Nguabu).

Remembering

Bill Siegmann

JAN-LODEWIJK GROOTAERS

Remembering Bill Siegmann

BILL SIEGMANN (1943–2011) unabashedly loved objects. He was surrounded by them in all the rooms of his Brooklyn apartment, and he acquired them assiduously for the museums where he worked, both in Liberia and the United States. He was, in many respects, a true art person. According to everyone who knew him, however, Bill was primarily a people person, a man who put a premium on his personal and professional relationships. When several of his friends and colleagues were asked to recall and describe the man they knew, they enthusiastically agreed. Interspersed here with the captivating facts and recollections these individuals provided—often no more than fond but fleeting personal memories—are a group of largely informal photographs and excerpts from two interviews conducted on August 21 and September 24, 2011, a few months before Bill passed away.[1]

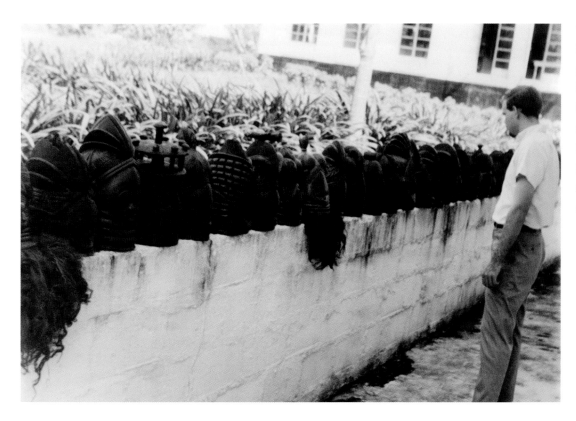

In this undated photograph, Siegmann inspects Sande masks at the National Museum of Liberia, Monrovia. *Photographer unknown.*

"WITH MORE THAN A DECADE of residence and multiple sojourns in Africa and across the diaspora, Bill served and built institutions that preserve and present African arts as well as serve the social needs of Africans. In the U.S., he advised the federal government and trained a generation of scholars and museum professionals. In Liberia, he directed the Africana Museum at Cuttington University College (now Cuttington University) from 1965 to 1969 and from 1974 to 1976. And from 1984 to 1987, he directed the National Museum of Liberia in Monrovia."

—ED DECARBO, PROFESSOR OF NON-WESTERN ARTS, SCHOOL OF ART AND DESIGN, PRATT INSTITUTE, NEW YORK

"And there were an awful lot of [Sande masks]. Not initially. It was 1966, 1967 probably, when the kind of flood of Sande masks started coming out."

—BILL SIEGMANN, 8.21.11

1.2

Founded in 1889 as Cuttington College by the Protestant Episcopal Church in America, Cuttington University is the oldest private, coeducational, four-year, degree-granting institution in sub-Saharan Africa.

Rock of the Ancestors:

ŋamôa kɔni

text
WILLIAM C. SIEGMANN
with CYNTHIA E. SCHMIDT

photography
MICHAEL H. LEE

Liberian Art and Material Culture
from the Collections of the Africana Museum

Cuttington University College
Suakoko, Liberia

1.3

Title page, *Rock of the Ancestors*.

"WITH THE PASSING OF WILLIAM SIEGMANN ON NOVEMBER 29, 2011, Cuttington University lost one of its most illustrious former professors. What I admired about Bill Siegmann was his ability to appreciate and understand the richness of the culture and traditions of our people. In fact, he loved wearing some of the art forms—a bracelet or necklace or traditional hat. His love for the people of Liberia and their culture is manifested in the fact that he willed that part of his ashes be buried in Liberia." —HENRIQUE TOKPA, PRESIDENT, CUTTINGTON UNIVERSITY

"My Loma name is Coolaboi, which means 'red iron,' the iron that you draw from the forge. They thought that since I was sunburned a lot, that is what I looked like." —BILL SIEGMANN, 8.21.11

"WHEN I ENROLLED AT CUTTINGTON IN 1974, Bill was teaching African history there and helping to develop the Africana Museum. Realizing my desperate need for financial assistance, he gave me a work-study scholarship, which enabled me to be assigned to him at the museum as assistant curator. My tasks then included the identification of the various artifacts (such as bracelets, passport masks, and amulets) that were brought in by villagers or collected from the surrounding towns and villages, and cataloging them. Our work led to the publication of the museum's 1977 exhibition catalogue, *ŋamôa koni*, which means, in Kpelle, rock of the ancestors. I suggested that phrase, the Kpelle being a large ethnic group in Liberia to which I belong. I worked at the museum until I graduated from Cuttington, in June 1976." —HENRIQUE TOKPA

"Bill Siegmann took full advantage of the fact that Cuttington had students from all over Liberia, from adjoining (then) colonies, and from other parts of Africa. He utilized these students as informants about art objects. Bill was also known for his wide acquaintanceship among the itinerant traders from Mali, Senegal, and Nigeria, often known as 'Charlies.' They valued his growing knowledge of art objects and contributed to it. They sold authentic masks to discerning customers like Siegmann. But most of their sales were of reproductions, made to customers who were not concerned with authenticity—or could not detect it." —JAMES GIBBS, PROFESSOR OF ANTHROPOLOGY EMERITUS, STANFORD UNIVERSITY

"This term 'Charlie' is an interesting one, because it seems to date from the time of the Second World War, when the GIs in Liberia called traders 'Charlie.' And then they would distinguish them by number—Charlie Number One, Charlie Number Two, and so on." —BILL SIEGMANN, 9.24.11

"Bill Siegmann was generous of spirit and of resource. It is not surprising that the first piece of African art he collected in Liberia was sold to him by a Cuttington student's father who was trying to pay for his son's tuition. That first piece bespeaks the compassion and human connectedness that was African art in his life. In his last years, he returned almost all of his country cloth to weavers and to the families of weavers in Liberia, knowing that contemporary weavers are few and that their art is less and less available." —ED DECARBO

"The very first piece that I bought, probably on my third day at Cuttington, was a textile, from the father of one of my students who had a beautiful blanket he was selling in order to help pay for tuition. I became fascinated by the textiles and the really wonderful handwork. Very quickly, I went on from these to sculpture." —BILL SIEGMANN, 8.21.11

❝BILL SIEGMANN ALSO WORKED ON the ethnography of the Bassa, a southeastern Liberia people about whom he published a monograph in 1969. His fieldwork was not traditional, in that he did not work for long periods of time in a single place. Rather, he collected information from elders and informants in a wide variety of villages.**❞**—JAMES GIBBS

❝In 1966, I did an ethnographic survey of the Bassa . . . with a research assistant. The District Commissioner said, 'Well, how many gun bearers do you have?' I said, 'We don't have any.' He asked, 'How are you going to hunt elephants if you don't have gun bearers?' And I said, 'We're not hunting elephants,' and explained the whole issue of history and ethnography and such. As it turns out, I was the first white man to have gone through that area since Graham Greene in 1936.**❞**—BILL SIEGMANN, 8.21.11

❝BILL SIEGMANN AND I WORKED ON A RESEARCH PROJECT in Nimba County of Liberia, in both 1983 and 1986, to identify certain Dan sculptors who had been suggested or written about by several earlier researchers. We first had to obtain permission from the Liberian government to travel 'upcountry' and ask questions. Next, we arranged to talk about our coming and goals in the Dan language on the radio station broadcast to the Dan villages. We traveled to a number of Dan villages and interviewed many carvers, brass casters, chiefs, and old people who remembered the sculptors. Always we were treated with warm hospitality and great curiosity.**❞**—BARBARA C. JOHNSON, AUTHOR, *FOUR DAN SCULPTORS: CONTINUITY AND CHANGE*

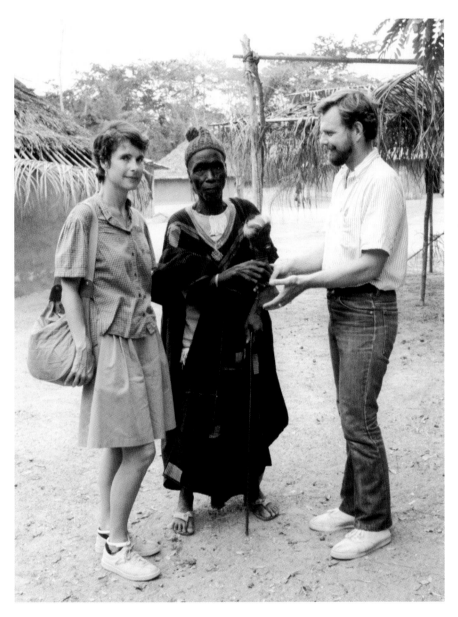

1.4
Siegmann and
Barbara Johnson
during fieldwork
among the Dan
people in Liberia,
accompanied
by the wood-
carver Si, April
1983. *Photographer*
unknown.

"In 1967, BILL SIEGMANN WENT UP to the Holy Cross Mission in Bolahun, a community established by Anglican Benedictine monks among the Gbandi people in northwestern Liberia, to celebrate Christmas. There he met my father, Chief Joseph Massange Bolay Sr., who died in 1985; my mother, Eunice K. Bolay; and their six children, of whom I am the youngest. Bill became our adopted brother. He considered our mother as his mother. Bill helped with my high school and college education at Cuttington University. I moved to the U.S. in 2002, and he later served as godfather to my children." —JOSEPH NGAFUA BOLAY, THE YOUNGEST BROTHER IN SIEGMANN'S ADOPTIVE LIBERIAN FAMILY

"[The Bolay family] adopted me, and they take it seriously. For instance, when my father in this family died, they waited until I could come to Liberia to have the funeral feast, and . . . participate in it. . . . We have a very, very close relationship, and, in fact, part of my ashes will be buried in Bolahun." —BILL SIEGMANN, 9.24.11

1.5
Siegmann with Joseph Ngafua Bolay at Bolay's graduation from Konola Academy, Margibi County, Liberia, 1985. *Photographer unknown.*

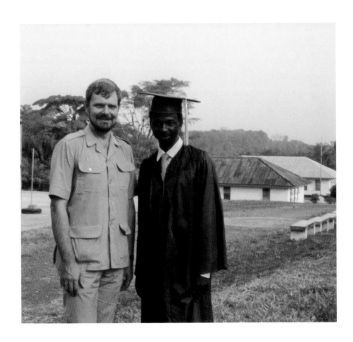

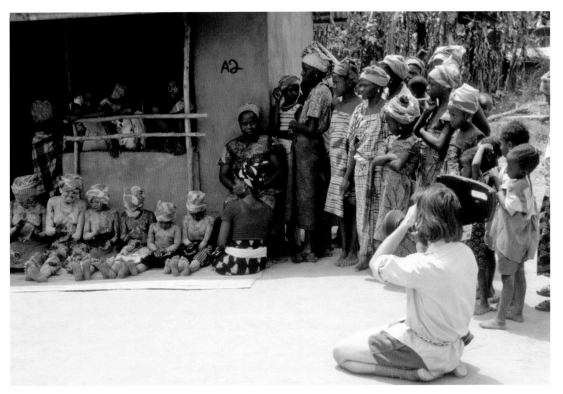

1.6
Robb Moss filming
Sande initiates in
Bolahun, March
1981. *Photograph by
William Siegmann.*

"IN 1981, BILL LED A GROUP OF FILMMAKERS to Bolahun in order to make an ethnographic film about the Gbandi people. It so happened that my older brother's daughter, Simo Bolay, was undergoing initiation into the Bondo Bush (i.e., Sande Society). It was here that young women were trained to take care of their households as wives and learned to survive in the forest setting. Thanks to his close ties to the Bolay family, Bill was able to undertake this filming, even as some members of the community felt that the white man had come to steal away their secret." —JOSEPH NGAFUA BOLAY

"In 1984 . . . Siegmann was tasked with . . . relocating the National Museum of Liberia to . . . the mid-nineteenth-century Old Supreme Court building. He met with President Samuel Doe—in person—to secure funding to renovate the building, which was in serious disrepair. Rather than money, he was awarded a line of credit for up to $60,000 with a building-supplies company. A workforce was provided by the Ministry for Public Works. It took three years and a mountain of obstacles to renovate the building. No architect was provided; Siegmann worked with the site workers to figure out solutions. They had to remove and replace the roof and floors. . . . The West African Museums Programme provided additional funds to acquire a collection. Siegmann traveled to villages all over Liberia to buy objects. The museum, when it opened in 1987, featured three floors: first floor, historical pieces; second floor, ethnographic material; and third floor, contemporary art exhibitions."—DIANE CHEHAB, PROJECT MANAGER AND BLOGGER, AWAY FROM AFRICA WEBSITE. FROM HER JANUARY 2010 INTERVIEW WITH SIEGMANN, POSTED ON THE SITE, AWAYFROMAFRICA.COM

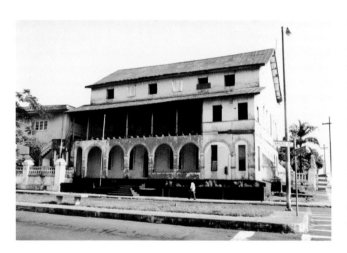

1.7

Mid-19th-century Old Supreme Court building, Monrovia, before it was converted into the National Museum of Liberia, 1984. *Photograph by William Siegmann.*

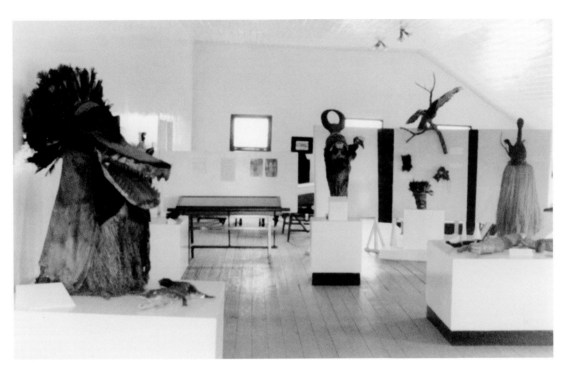

1.8

Second-floor installation view, National Museum of Liberia, Monrovia, 1987.

Photograph by William Siegmann.

"DURING THE FIRST LIBERIAN CIVIL WAR, 1989–96, both the National Museum and the museum of Cuttington University were ruined, their collections looted. Bill took the opportunity to return to Liberia, in 1997, as an election observer with the Friends of Liberia to survey the damage. Friends in that delegation recollected him scouring the art shops in Monrovia for the pieces that had belonged to the collections he had built at the two museums. Bill returned to Liberia a few years ago after the second Liberian civil war, 1999–2003, to consult with the Liberian government about the National Museum." —PAT REILLY, VICE PRESIDENT, FRIENDS OF LIBERIA. FROM HER SIEGMANN OBITUARY, POSTED ON THE FRIENDS OF LIBERIA WEBSITE, FOL.ORG, NOVEMBER 2011

"In the Gbandi area . . . there is a huge mask that is very old. . . . When the war broke out in 1989, and again in 1999, they took the mask and wrapped it in burlap and other things, probably plastic . . . covered it in tar or something like that, and put it in the river. After the war ended, in 2003, they took it back out, and it's dancing again." —BILL SIEGMANN, 9.24.11

1.9
Siegmann with
New York City
Mayor David
Dinkins (right)
and Brooklyn
Museum Director
Robert Buck in the
museum's African
art galleries, 1992.
Photograph by
Joan Vitale Strong,
photographer to the
Mayor.

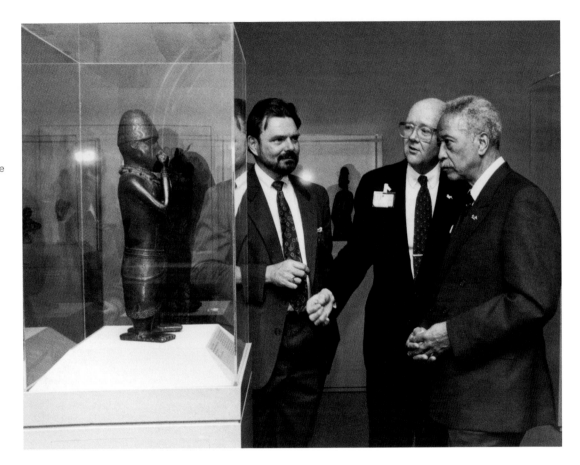

"IT IS THROUGH HIS ROLE AS CURATOR at the Brooklyn Museum, for twenty very productive years, that Bill's public legacy lives on most prominently. Bill worked assiduously to promote the inherent strengths and marvels of Brooklyn's African collection (among the, if not the, largest and oldest in an American art museum), all while continuing to develop the museum's holdings in areas such as Liberia and Sierra Leone, which previously had been underrepresented. During his tenure at Brooklyn, from 1987 to 2007, Bill acquired more than sixteen hundred objects, a prolific record of applied connoisseurship that is effectively unmatched in the history of the museum's African and Pacific collections. Among these are more than two hundred objects from Liberia and Sierra Leone, which, when added to the museum's existing stores, transformed Brooklyn into a major center for the art from this region." —KEVIN DUMOUCHELLE, ASSOCIATE CURATOR, ARTS OF AFRICA AND THE PACIFIC ISLANDS, BROOKLYN MUSEUM

"SHARING A DEEP AND ABIDING PASSION for Liberia and Sierra Leone, Bill Siegmann acquired a significant number of works from Blake Robinson. Robinson was a diplomat and polymath who worked as executive director of the United States Educational and Cultural Foundation in Liberia from 1969 to 1975. He and Bill met in-country. Over the course of this period, and in the years following, Robinson also developed an important personal collection of artworks from the region—a great many of which were later given to the Brooklyn Museum at Bill's request." (See cat. nos. **10**, **29**, **68**, and **73**.)—KEVIN DUMOUCHELLE

"IN 1976, BILL SIEGMANN AND JUDITH PERANI published an article in the journal *African Arts* on men's masquerades from Liberia. It features the *gbetu* masquerade costume from the Gola people, an example of which Bill gave to the Brooklyn Museum in the final months of his life. This marks a fitting conclusion to his development of its collection. Acquired in the early 1980s, the work is remarkable for having an extremely rare, preserved full-body raffia costume. A men's masquerade, it nevertheless appears to 'give birth' to smaller masquerade performers, typically dressed only in raffia, who emerge from its folds briefly before returning to underneath the full costume. It is an image of celebration, creativity, and nourishment—a fitting monument to Bill's remarkable curatorial and teaching career."

—KEVIN DUMOUCHELLE

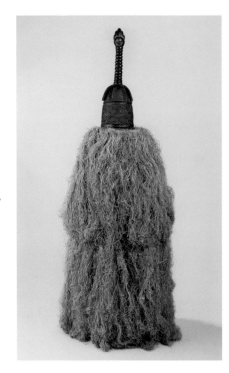

1.10

Gola

Grand Cape Mount or Lofa County, Liberia

HELMET MASK (*GBETU*) WITH RAFFIA COSTUME, early–mid-20th century

Wood, pigment, metal, raffia

H. 93 in. (236.2 cm)

Brooklyn Museum, Gift of William C. Siegmann, 2011.53.1a-b

Siegmann with
students, National
Museum of Liberia,
Monrovia, mid-
1980s. *Photographer
unknown.*

"THE ANCESTOR KNOWS NO PAUSE. His hand continues to guide and his spirit to lead. He is a presence in a cycle that is renewed and is renewing. Bill Siegmann knew this. He lived this in the accomplishments of those he mentored, in the donors he engaged, in the institutions he served, in the collections he built, and in the life he lived. He was a very special man, dedicated to the world as an artful place that offers its gifts of highest quality to those as adventurous, as courageous, and certainly as curious as he." —ED DECARBO

"I got deeply involved with Africa professionally, not just in terms of the art but in terms of really understanding the culture. I loved living in Africa and the relationships I developed with people there." —BILL SIEGMANN, 9.24.11

"IN 1987, BILL WAS GOWNED AS AN HONORARY ELDER of the Wawoma Clan in Kolahun District, home of the Gbandi people. Bill had gone up to Bolahun to see my family when suddenly a messenger from Clan Chief James Lombeh came to announce the decision to honor Bill for sharing with the people of Wawoma Clan their values and some aspects of their culture. The title of honorary elder is a very rare honor, bestowed on people whose service to humankind goes above and beyond the call of duty. Bill later decided that he wanted part of his ashes to be buried in Liberia, selecting the banks of the Wawo River in Bolahun as one of his final resting places." —JOSEPH NGAFUA BOLAY

1.12
Siegmann in ceremonial Gbandi dress, Bolahun, 1987. *Photographer unknown.*

1.13
Siegmann's funeral service, held in Bolahun before a portion of his ashes was buried there, December 23, 2011. *Photographer unknown.*

Visions from

the Forests

MARIANE C. FERME AND PAUL RICHARDS

Forests in the Imagination of the Upper Guinea Coast

The masks and other objects included in this book form part of the costume of dancers who embody the spirit forces associated with male and female secret societies—notably the Poro and Sande, respectively—of the forests of West Africa's Upper Guinea Coast. The performers of those masquerades display the skills, aptitudes, and disciplines necessary for the advance of social life in a hazardous and uncharted environment. These performances also celebrate compromises between, for example, hunters, who know and value the forest and its resources, and newer arrivals, who introduce into the forest useful but potentially disruptive farming techniques, mining, and trade connections.

The materials of the masquerade costumes reflect how increased human habitation has changed the forest environment. The helmet masks of the women's Sande Society are carved from the lighter wood of the quick-growing secondary trees that replaced the forest giants felled with modern metal tools. The raffia comes from two species of palm that spread when swamps are cleared of trees. These palm groves, the result of human occupation of the forest, supply villagers with a range of covering, bagging, and netting materials that historically were essential in an agrarian economy without access to zinc sheeting, barbed wire, or plastic bags. Thus these groves and the materials they yield reveal the impact of human intervention in shaping the kind of forest prevalent in modern Sierra Leone and Liberia. In a somewhat similar way, the animal symbolism evident in the decoration of the masquerade costumes and the ivory side-blown horns (cat. no. 66) of chiefs evokes the qualities of courage, force, and strength required by leaders—gleaned by observing animal behavior (fig. 2.1). These observations are possible because of close and frequent interactions between animals and people. Indeed, instead of living deep in the forest, far from human habitation, elephants and leopards are drawn to the rice fields that provide sustenance for animals and people alike.

Primary rain forests once covered a large portion of this region and are currently the object of conservation efforts by international organizations, with varying degrees of cooperation by national governments. Research into the culture and history of this region, however, suggests that deforestation has not been a straightforward process. On the one hand, farmers have cut down and burned trees in order to plant their crops, using ashes from the burns to fertilize relatively poor soils in the absence of animal manure. (Sleeping sickness has decimated cattle in the area.) On the other hand, trees planted for defense (for example, *Ceiba pentandra*, the giant kapok tree), rituals, medicine, and food have also served to stimulate forest re-growth. Indeed, the kapok tree bears such historic significance and utility that it has become a symbol of Sierra Leone in tourist and cultural-heritage literature. These iconic trees are abundant in secondary-growth forests, but they are rare in the primary rain forest.[1]

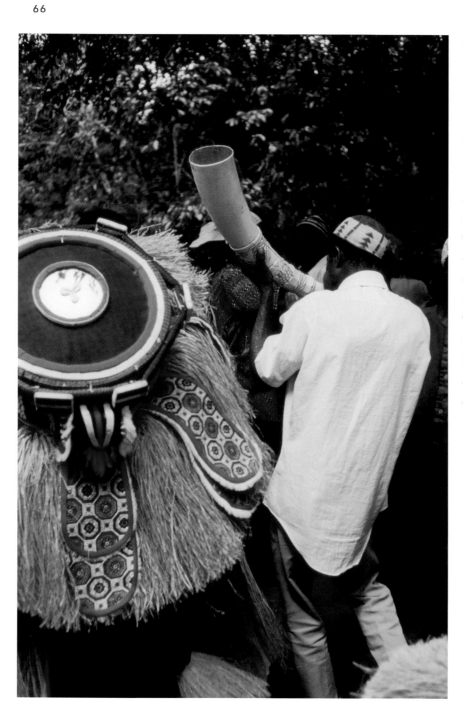

2.1

Goboi masquerade performance— announced by the blowing of an elephant-tusk horn—at the celebration of the election of Aruna Vandi-Jimmy to Parliament. Compound of the Paramount Chief, Wunde Chiefdom, Bo District, Sierra Leone, 1986.

Photograph by Mariane C. Ferme.

2.2

Paramount Chief B. A. Foday-Kai (left) and visitor emerging from the Poro initiation enclosure. Note the mature forest grove. Telu, Jaiama-Bongor Chiefdom, Bo District, Sierra Leone, 1986. *Photograph by Mariane C. Ferme.*

The configuration of plant species in the forest reveals more about the human presence in the area than its absence. For instance, kapok trees were planted in rows as town fortification during the nineteenth century, and the placement of several in close proximity today often indicates the location of a former settlement. Other trees growing closely together in the midst of the bush or forest, such as fruit or kola-nut trees, similarly suggest previous habitation. Additional corroborating evidence of prior human occupation would be sunken terrain and mounds that mark the presence of graves, collapsed houses, or fortifications.

Over the course of this region's history, especially in times of war, agricultural activities have temporarily ceased

as farmers abandoned the countryside to find shelter in deep-forest refuges or well-secured urban settlements. As a result, tree growth resumed and wildlife recovered—or at least their destruction was limited.[2] This occurred in the nineteenth century, when slave raiding and the advancing colonial presence heightened tensions among warlords of the region. It has again happened as a result of the conflicts that erupted since then, most recently in Liberia in 1989, when a regional conflict spilled across neighboring borders. Even the pattern of warfare underscores the regional unity of this area, as war zones that have crisscrossed Liberia, Sierra Leone, Guinea, and Côte d'Ivoire since 1989 (and continue to pit north and south against each other in the latter country) have fed off one another.

60

Historically, people and goods have moved across porous and thickly forested national boundaries. During the days of the trans-Saharan caravans, trade for a prized stimulant, kola nuts, linked this forested region with the Sahel and desert regions to the north. Much more recently, the Liberian warlord Charles Taylor colluded with rebel fighters in marketing Sierra Leonean diamonds in order to buy arms for the civil war of 1991–2002. Diamonds and other precious metals are among the commodities that have long attracted outsiders to the forest. Today, gold and diamond miners—many of them rootless ex-combatants from the region's recent wars—have set up camps deep in the remaining primary forest of Liberia and Sierra Leone; negotiations with them, as well as with the descendants of established settlers who have rights to the land, are critical to forest-preservation efforts.

Even where the forest has been cleared for farming, as it has over much of southeastern Sierra Leone, small islands of mature tree growth dot the landscape. These reveal how the men's Poro Society, in particular, has husbanded forest resources and regulated access to them through mystical sanctions. The stands mark the presence of Poro initiation groves, where bundles of medicinal leaves hanging from tree branches or near waterways signal to passersby that fishing, logging, and other culling of forest resources are temporarily prohibited; the penalty for defying these markers could be serious illness or death (fig. 2.2).[3]

Other spirits haunt the forests as well and contribute to the perception of them as sites infused with power and potential danger. Forest villagers frequently tell stories about a race of dwarfs (*temuisia*, in the Mende language) that supposedly preceded the present human occupants. The spirits of these beings still inhabit the environment, and more recent arrivals must placate them. Descendants of the earlier settlers claim expertise in dealing with supernatural forces, and this enables them to hold at bay the sometimes-violent invasions of their habitat by miners searching for quick wealth. Some apparently contend that the forest *temuisia* made the *nomoli* stone cult figures (cat. no. 60), which have been found in modern times—often unearthed when farmers dig up the soil—and about which present-day inhabitants of the region know little, other than that they once were religious objects.[4] They are, in fact, among the oldest surviving artifacts in the region.

One of the most essential foraged crops for forest dwellers is the so-called bush yam. Because people replant the vine when they harvest the tuber, this vegetable is often found in the protective forests and tree-crop plantations that ring many settlements. In some communities, failure to replant a bush yam is an offense against local by-laws and can result in punishment. This yam-based forest proto-agriculture probably has a long history in the Upper Guinea Coast forest and is associated with fewer malaria-transmitting mosquitoes than farming rice, which is the staple food across the region; communities in the midst of forests tend to have lower levels of the (malaria-selected) sickle-cell gene as well.[5] The longer-established forest groups, such as the Gola and the Kran, still eat large quantities of gathered

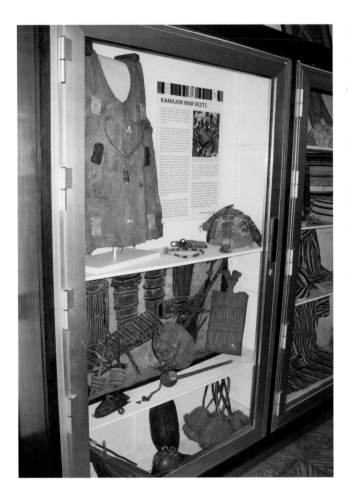

2.3

A display of clothing worn by hunters during Sierra Leone's civil war. National Museum, Freetown, Sierra Leone, 2012. *Photograph by Mariane C. Ferme.*

yams as a regular part of their diet, now supplemented by modern root crops, such as cassava and sweet potato.

The predominant subsistence activity associated with the forest in the area's cultural imagination is hunting. The figure of the forest hunter was closely linked with armed groups fighting recent insurgencies in the region. After the 1991–2002 civil war, hunter shirts, caps, guns, and other paraphernalia were displayed in Sierra Leone's national museum; the exhibit was dedicated to the *kamajors* (hunters, in the Mende language), and the accompanying text described their magical powers during that conflict (fig. 2.3).

Historically, hunters were pioneers of the forest and founders of early settlements. The Gola people, who are among the region's earliest occupants, tell of a time when the area was first settled. A hunter followed an elephant into a remote and empty part of the forest. After he outwitted and killed the animal, he sent for his people to dispose of the carcass. While men removed the tusks and smoked the meat, women delved among the animal's entrails, discovering large amounts of undigested rice seed, which they carefully cleaned and dried. The women then asked the men to clear a portion of forest on which to plant the seed. A successful harvest encouraged the group to establish a village. Even today, the names of some varieties of rice that mean "found in elephant dung" exist in the various languages of the forest-edge region.[6]

This story suggests that hunting contributed to the origins of settlements and agriculture in the forest. It also reveals

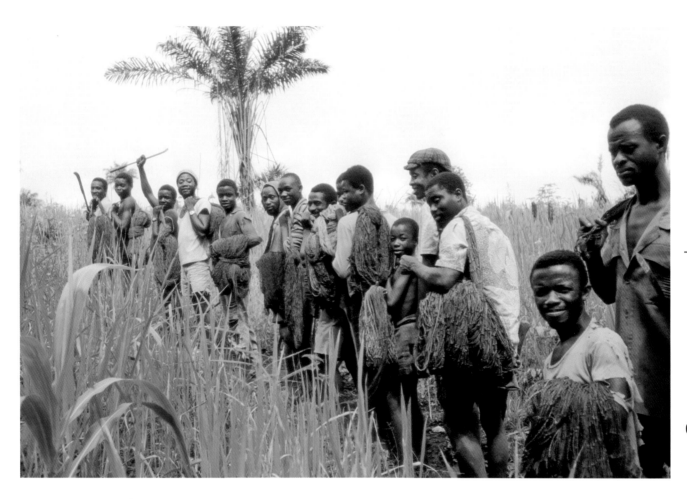

2.4

A hunting party equipped with nets walking through a rice field. Wunde Chiefdom, Bo District, Sierra Leone, 1986.

Photograph by Mariane C. Ferme.

how a different kind of forest was crucial to subsistence and sociability in this region. In local languages, the secondary-growth forest is distinguished from the primary rain forest, and it is generally what people refer to whenever they leave their rural settlements to hunt, set or check traps, or gather food and medicinal plants (fig. **2.4**). Even though the cultural associations with secondary-forest growth, which is often referred to as "the bush," are contrasted with the attributes of farms and of village settlements, this place also has a significant agricultural function. After a rice-farming season, the bush grows where the land is left fallow. Farms are carved out of secondary-growth forest, which is cut, left to dry, and burned; and once the harvest is in, trees begin growing back (figs. **2.5** and **2.6**). Subsistence farming, as

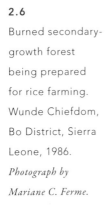

2.5
Cutting down
mature trees for a
rice farm. Wunde
Chiefdom, Bo
District, Sierra
Leone, 1990.
*Photograph by
Mariane C. Ferme.*

2.6
Burned secondary-
growth forest
being prepared
for rice farming.
Wunde Chiefdom,
Bo District, Sierra
Leone, 1986.
*Photograph by
Mariane C. Ferme.*

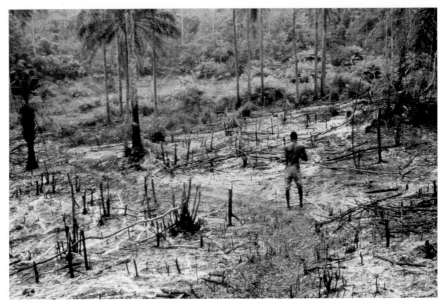

it has been practiced for centuries in this region, is a brief interlude between longer stretches of time during which forest growth perpetually reclaims the landscape. Here, too, is where wild animals such as leopards and elephants, now rare except in the high forests, come to find food. It bears repeating that secondary-growth forest—a space partly domesticated by human habitation—is the source of most of the materials used in making the various masks and artistic objects featured in this book.

GENDERED MATERIALS AND TECHNOLOGIES

The role of gender is critical in the symbolic and social organization of this region. Throughout the Upper Guinea Coast, this principle is expressed in the form of male and female initiation societies, the Poro for men and the Sande for women.[7] The Poro Society is mobilized in warfare, in politics, and in regulating access to economically valuable

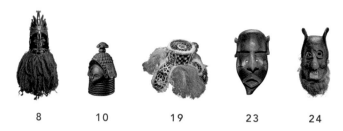

8 10 19 23 24

natural resources. By contrast, the Sande Society is focused on preparing pubescent girls to be marriageable women and then mothers as well as on dealing with the medical aspects of midwifery and childbirth. Many of the art objects from this region that are now in Western museums and private collections are associated with Poro and Sande ceremonial and entertainment activities; these range from initiations to the installation of chiefs, from the election of new members of parliament to agricultural fairs. A shared feature of this region is a strong emphasis on gender distinctions. The existence of the Poro and Sande societies in any particular locale becomes a key element in determining a distinct cultural area and artistic production.[8]

When collecting and studying the region's artistic production, emphasis is often placed on wooden carvings and masks. These represent the labor of male carver-blacksmiths, who work metal with fire (a potentially dangerous craft when performed near combustible vegetation and thatched buildings) and work wood with metal tools. One of the best-known types of mask, the helmet mask associated with the Sande Society, is made by these highly skilled craftsmen for women's use, while the signature masks of the men's Poro Society, the *goboi* and *gbini*, consist entirely of raffia, fabrics, and more ephemeral materials normally associated with women's productive activities. The Sande helmet mask and other carvings of female human figures convey in hard, durable wood the ideals of feminine beauty, such as fat rings around the neck, elaborate hairdos, and scarification patterns (cat. nos. **8** and **10**). By contrast, the Poro masks

are mélanges of raffia, animal skins, woven cotton, and the cowrie shells that once were valued currency in the region (cat. no. **19**).

Materials associated with forest hunting and included in the appendages attached to masks—notably ivory and leopard skin—serve as badges of high office. Because those embellishments symbolize the strength and power of chiefs, scholars have pointed out a structural distinction in the relationship between masks and political power among societies at the western end of this region and those in Liberian-Ivoirian, or Dan, territory. For Dan chiefs it is apparently sufficient simply to demonstrate ownership of certain masks, which often are displayed next to them while they sit in state or in court judgments.[9] Among most peoples of Sierra Leone, however, the relationship between the politically powerful and the societies embodied in masquerades is more complex and actually can be antagonistic. Not only do chiefs here not have such an unambiguous control over masks, but also it would be unthinkable to uncover any part of the body of a Sande or Poro mask, let alone reveal the distinction between mask and wearer. The exception is the *gongoli*, an outsized comical mask that the wearer ostentatiously lifts several times throughout performances; this exceptional gesture of public unmasking seems designed to confirm that full concealment is the norm (cat. nos. **23** and **24**).

The materials that constitute masks reflect a complex social world dependent on a range of skills and activities. For example, teams of young performers make Poro

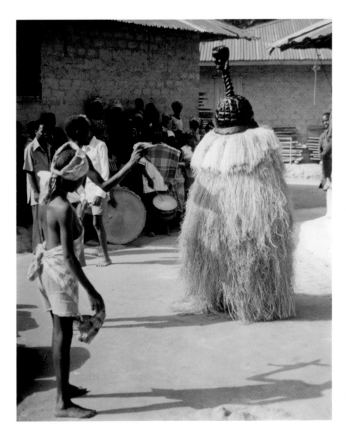

2.7

Performance of a *gbetu* masquerade. Bolahun, Liberia, 1981. *Photograph by William Siegmann.*

masquerade costumes for public display. Sande elders pick raffia-palm leaves, strip them from their ribs, and painstakingly attach them to strings to form rows, which are then dyed in successive baths of indigo to achieve the desired black hue. As many as seven layers of raffia skirting cover the body of the *ndoli jowei*, the "dancing *sowei*" of the Sande Society, before the wearer dons the helmet mask, with a ring of raffia around the base of its neck.[10] Black-fabric stockings and sleeves entirely cover the extremities that might protrude from the raffia during the dance.

The wooden elements of masks are exceptionally durable, indicating not only the dexterity of those who carved a given mask and animated its performance but also the

essential skills of the woodcutter who felled the tree and the blacksmith who forged the axe and knife. Often less well-preserved are those essential elements of costumes designed to impress through musical movement. Made from raffia and cotton cloth, these components impart additional dynamism to the surface of the twirling, lunging masquerade (fig. 2.7). The raffia comes from palms that grow abundantly in partially cleared swamp forests, and women and men produce different kinds of twine and thread that are incorporated in the costumes.

Cotton is planted alongside rain-fed rice, the main staple, but its yield comes in the second year, after the rice that feeds extended families has been harvested. Following that harvest, the field (known at this stage as *jopoi*, in Mende) has already begun returning to forest. Mostly, it is the women, who own the remaining crops—including the cotton—who visit this site. Thus gender differences are expressed through the ownership of particular crops and materials as well as by the division of labor. A farm dominated by the male-controlled crop that is the household's staple gives way to women's control over the *jopoi*. Women pluck, card, and spin cotton into thread, and these spools constitute a sort of stored savings, to be sold in case of emergencies or spun into cloth for a family burial or a rite of passage. On such occasions, male weavers, working on portable tripod looms in the dry season, convert the thread into the long strips of cloth from which large "country cloths" or ceremonial items of clothing, including hammocks and hunting shirts, are stitched (fig. 2.8).[11]

18

In addition to products harvested from the forest or gleaned from farming activities are many other elements incorporated in the masks that are acquired through trade or are reworked from trade items. Among these are the yellow beads that Sande Society initiates wear (cat. no. **18**). Blacksmiths in this region are particularly skilled at melting down and reworking scavenged metal. Using leaf springs from abandoned or wrecked trucks or lengths of old railway line, they craft everything from farm tools and buckets to jewelry to adornments for the carved ivory tusks that announce the arrival of chiefs.

The innovative creativity that is so evident in the artifacts of the Upper Guinea Coast is one consequence of this region being a crossroads of contacts among disparate peoples and modes of livelihood. This applies to the masks themselves,

which result from innovations emerging from a confluence of peoples and goods. An example of this dynamic is the way metalworking skills spread from farther north in the savanna, a process generally presumed to postdate settlement by the earliest hunting and yam-farming groups in the forest. William Siegmann firmly believed that masquerades reflect both change and historical rootedness. In his publications written with Judith Perani, he underscored the relative novelty of some masking traditions in this region and argued for the established age of others.[12]

• • • • •

The objects featured in *Visions from the Forests* comprise a material expression of how the represented West African cultures are integrated within regional flows of goods, beliefs, and practices. These cultures have long been connected with the wider world—for instance, through slavery and the antislavery movements. Present-day Sierra Leone and Liberia were both founded by abolitionists as settlements for freed slaves, from Britain and its colonies and from the United States, respectively. More recently, the region has become a major source of precious minerals and valued wood products for international trade. Each of the objects in this book combines faithfulness to established genres with innovation achieved by integrating natural elements such as wood and raffia with imported items acquired through trade.

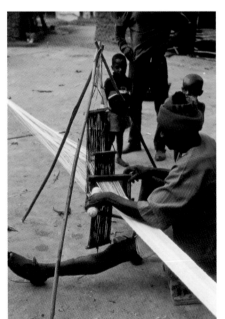

2.8
Weaver at work on a tripod loom. Komboya Chiefdom, Bo District, Sierra Leone, 1985. *Photograph by Mariane C. Ferme.*

Visions from the Forests | Forests in the Imagination of the Upper Guinea Coast

NANINA GUYER

Extending the Stage: Photography and Sande Initiates in the Early Twentieth Century

The Sande Society, a women's initiation association found among the Mende peoples of the Sierra Leone hinterland, is responsible for the physical and mental transformation of Mende girls into marriageable young women.[1] The Sande Society has attracted the attention of foreign visitors since the seventeenth century. Many documented encounters between this exclusively female association and the predominantly male foreigners revealed an underlying paradox. On the one hand, Westerners described the Sande as an association surrounded by mystery, emphasizing the difficulty of obtaining any reliable information about its secret activities. On the other hand, however, Western visitors were able not only to acquire helmet masks of the Sande *sowei* masquerade but also to take photographs relating to the Sande initiation, even though stages of this rite of passage normally proceed behind a cloak of visual secrecy.

Photographs have shaped the way we have looked at and thought about the African continent and its peoples since the second half of the nineteenth century.[2] Africans played an active part in producing these images as both professional photographers and photographic subjects. From the 1860s on, professional African photographers set up studios in prosperous West African coastal centers that served both African and Western clienteles.[3] Some of these photographers turned their most popular images into iconic picture postcards and thus facilitated the worldwide dissemination of African imagery.[4] As subjects, Africans purposely shaped the photographic outcome by presenting themselves in ways they wanted to be seen. Recent studies have focused on how West African coastal elites adopted photography as a new means of self-fashioning. Chiefs, who were among the first to discover the power of the image, commissioned portraits depicting themselves as imposing leaders with a cosmopolitan flair.[5] Wealthy women in commercial centers such as Accra, Conakry, and Freetown also enjoyed being photographed. Many had their likenesses taken at the public coming-of-age ceremony marking the end of the initiation process. Such portraits, which became fashionable in the late nineteenth and early twentieth centuries, served both as announcements of marriageability and as a means of enlarging the spectacle accorded a young woman's debut (fig. 3.1).[6]

Although little is known about how Africans in rural areas used photography to represent themselves, pictures often reveal how those who *were* photographed did much to shape the results. An examination of pictures of Sande women shows that they, much like women from coastal areas, used photography to present themselves in the context of initiation. In this essay, I explore the histories of some photographs of Sande Society initiates that were produced in the early twentieth century. Focusing on this visual theme, I trace the circumstances in which these images were made as well as how they were transformed for use in other media, such as postcards.

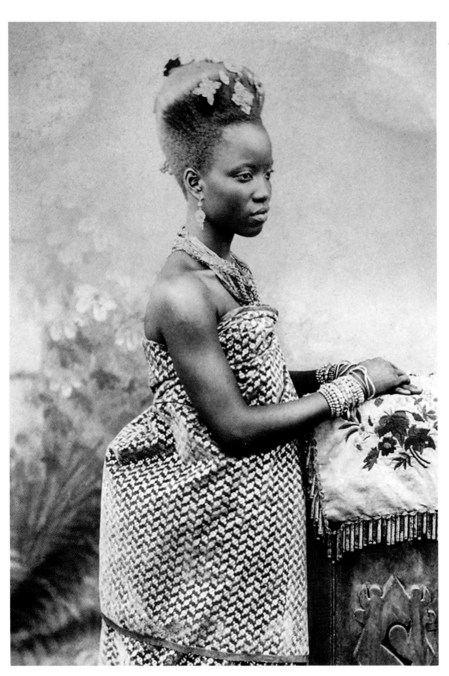

3.1

"Cape Coast
native girl,
decked with
gold ornaments,
and desiring
marriage,"
c. 1885–1910.
*Photographer
unknown. Ghana
Photographic
Album, EEPA no.
1995-0018-0002.
Eliot Elisofon
Photographic
Archives, National
Museum of African
Art, Smithsonian
Institution.*

11 12 13 14 15 16 17 18

3.2
Thomas Alldridge,
"After leaving the
Bundu," c. 1902–9.

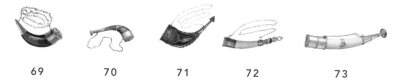

69 70 71 72 73

Initiation into the Sande Society was a several-months-long process that, traditionally, was crucial in women's lives in much of rural Sierra Leone. Mende girls were initiated around the time of puberty. In the first phase, they were taken to a forest enclosure outside the village. Men, children, and foreigners were rigorously excluded from the rites taking place in the forest, and initiates were instructed to avoid any men they inadvertently encountered.[7] The physical transformation, which brought young women as close as possible to the Mende ideal of beauty, began with a clitoridectomy and continued with a program of nourishment and training in grooming and deportment.[8] Following the initial period of seclusion, girls returned to their village during the day to perform chores. At this stage, the girls' bodies and faces were covered with white clay (*wojei*), a visible reminder of their status as initiates and a warning to men to keep their distance (figs. 3.3–3.7). Nevertheless, the initiates also performed, for a select group of men, special dances they had been taught.

A public festivity marked the end of the initiation. The protective white clay was washed away, and oil was rubbed onto their faces and bodies. Admiring the newly emerged women was a crucial part of this festivity. "The girls," one missionary reported in the late nineteenth century, "clad chiefly in trinkets and beads, parade the town, receiving the admiration of their friends, and evidently enjoying to the full the novelty of being on show."[9] A photograph taken by the British colonial commissioner Thomas Alldridge during the first decade of the twentieth century depicts newly released Sande initiates wearing their finest cloth, silver amulets, and pendants (fig. 3.2; see also cat. nos. 11–18 and 69–73).

FORBIDDEN IMAGES?

A review of existing photographs shows that few of them depict Sande-initiation graduates at their public coming-of-age ceremony. Instead, most images capture the young women amid the initiation process (figs. 3.3–3.7). The ambivalence between seclusion and public display permeating that process provides an interesting starting point from which to explore the visual record. Some of these images were made despite Sande rules that, theoretically, prevented outsiders from looking at initiates; this is especially true of photographs taken in the forest shortly after the first period of initiation (figs. 3.3 and 3.4). As Alldridge reported: "Bundu [Sande] girls when passing though the bush must not speak to any men. If men are within sight of any of them the girls must cover their heads, and if unable to avoid meeting them on the road they must turn their backs upon them."[10]

A picture by the Freetown-born professional photographer Alphonso Lisk-Carew (1887–1969) depicts seven initiates and an attendant posing on a forest path (fig. 3.3).[11] They wear short skirts with rattle beads as well as beads around their waists and necks. Initiates usually wore this attire when emerging for the first time from their secret enclosure after their first period of seclusion.[12] In this formative state, they were dressed androgynously and were expected to behave awkwardly.[13] The predominant feature of this photograph is the white clay worn by the initiates; it invested them with an otherworldly appearance that intrigues the viewer even today. Although this image presents tangible evidence of a violation of Sande rules, none of the girls here exhibits any discomfort; indeed, all seem at ease in the photographer's presence. Their body language conveys openness, and their facial expressions evince candid curiosity. Alldridge, who also photographed initiates in the forest, described the negotiations that preceded one such encounter:

> While I was staying at the town of Juru in the Gaura country there was a Bundu [Sande] in session in the bush outside the town, when the head woman at the request of the chief very kindly brought the initiates out of their sacred retreat to an open space on the road, in order that I might take a photograph of them. . . . The girls were brought out by some of the *duennas* [attendants], and being still in the Bundu bush were unable to enter the town, which would have been contrary to the stringent laws of the society.[14]

In the picture he subsequently took, eleven initiates are seen bent over on the ground for the camera, which was not something Alldridge had requested (fig. 3.4). He goes on in his account to suggest that the initiates determined their pose:

> This long row of young girls then prostrated themselves upon the ground in a supplicating attitude with arms up-stretched and hands clasped, and in that position they sang their morning and evening hymns in the Mendi language. It was an extraordinary sight. . . . I can only say that to me it was a most impressive service, and was certainly regarded by the initiates as a serious ceremony. . . . At the conclusion my thanks and offerings followed, and I witnessed the departure of the girls with their custodians into the dense forest to return to their isolated encampment, which is as secure and sacred from the outside world as it is possible to be.[15]

Alldridge's account confirms that the Sande Society was willing to relax, somewhat, its rules of visual secrecy when a camera was involved. Indeed, apparently, the society did not always closely follow its own regulations. According to the social anthropologist M. C. Jedrej, writing in 1980, the Mende "do things they admit ought not to occur e.g. initiates are seen out of seclusion before a ceremony at which they are supposed to emerge from seclusion for the first time."[16] Nevertheless, the Sande Society did determine the limits of exposure. Neither Lisk-Carew nor Alldridge was

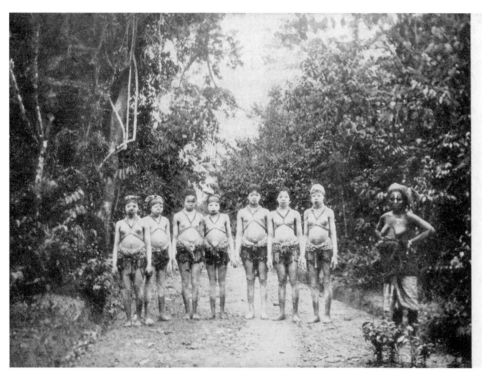

Bondu Girls.

Lisk-Carew Brothers, Photo,, Freetown, Sierra Leone. Registered.

3.3
Alphonso
Lisk-Carew,
"Bondu Girls,"
c. 1914. Postcard.
Courtesy of
Christraud M. Geary.

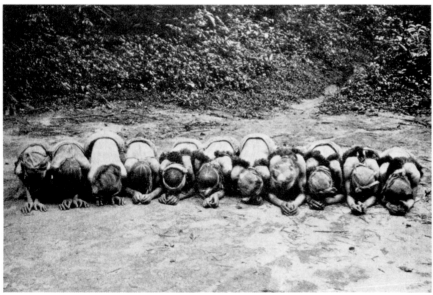

3.4
Thomas Alldridge,
"Bundu Initiates,,"
c. 1902–9.

3.5 AND **3.6**
Alphonso
Lisk-Carew,
"Bundu girls in
dancing costume.
Mendi Country,
Sierra Leone,"
c. 1907.

3.5 *(top)*
James Carmichael
Smith Sierra Leone
Collection IV, plate 6,
Y30446D.

3.6 *(bottom left)*
James Carmichael
Smith Sierra Leone
Collection IV, plate 5,
Y30446D.

3.7 *(bottom right)*
Alphonso
Lisk-Carew,
"Bundu girl in
dancing costume.
Mendi Country,
Sierra Leone,"
c. 1907.
James Carmichael
Smith Sierra Leone
Collection IV, plate 4,
Y30446D.

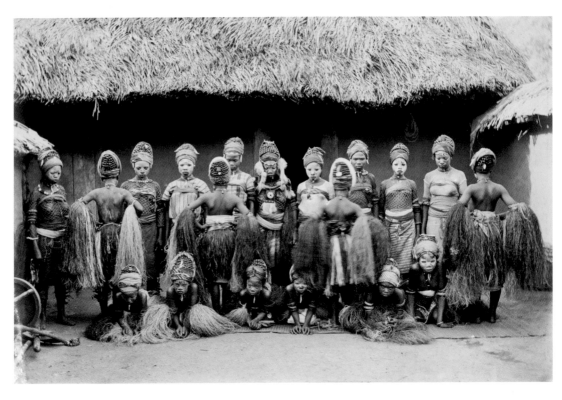

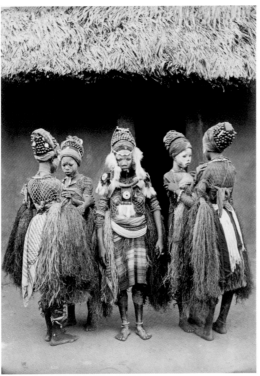

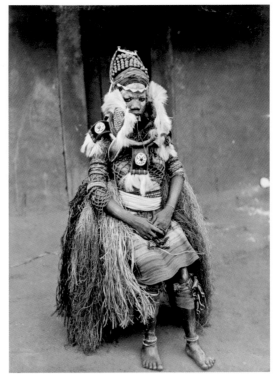

48

8 10

able to photograph initiates in the Sande forest enclosure, a place no outsider was allowed to enter. (Indeed, I am not aware of any photographs depicting initiates within that secret enclosure.)

Alldridge's report provides insight into the young women's response to having their pictures taken. Rather than being passive subjects, they actively shaped the images by offering the photographer different views. In this way, they did much to create the appealing qualities that characterize many such photographs.

These actions show that by the early twentieth century there was an acquaintance with photography and Western imagery in West Africa, even in the more remote areas—including familiarity with the status of the medium as a means of presenting the self. As early as the 1870s, missionaries had used stereoscopic images in their efforts to attract Mende peoples.[17] And by the 1890s, they had ventured far into the Mendeland interior, where they presented magic-lantern slide shows that "gathered practically the entire population."[18] British colonial administrators such as Alldridge traveled extensively in the country, preparing for the establishment of the British Protectorate of Sierra Leone in 1896 and taking numerous photographs. When he encountered reluctant subjects, Alldridge showed them images of their relatives that he had made on earlier trips.[19] Foreign traders who had settled along the area's rivers displayed photographs in their homes. By 1905, the medium

was further popularized in Mendeland through the circulation of commercial catalogs with picture advertisements.[20]

IMAGES OF DANCE AND GRACE

While the forest was presumably where initiates were shielded from the public, the village served as a stage for the dances they performed following the initial phase of their seclusion.[21] For these occasions, the solemn-appearing initiates—their faces still covered in white clay—emerged from the forest dressed in ornate dancing costumes (figs. 3.5–3.7). Alldridge described this attire in detail:

> [T]he dancing costume consists of a netting of country cotton worn over the body. Long bushy bunches of palm-leaf fibre are suspended from the thickly plaited bangles of the same fibre round the arms and wrists; various sebbehs or gree-gree charms hang from the neck, and short knicker-bockers of country cloth tied above the knees with country string complete the toilet. To these knicker-bockers are fastened small pieces of hollow iron with little rings loosely hanging from them, which, as the dancing goes on, jingle not unpleasantly, for country iron gives out a somewhat rich sound.[22]

The dancers wore headdresses made of silk handkerchiefs, clusters of collard seeds, and beads; the tops were embellished with silver amulets that bore Arabic inscriptions (see especially fig. 3.6).[23] Depictions of silver amulets or clusters of collard seeds can also be observed in the headdresses of Sande *sowei* helmet masks (see cat. nos. 8 and 10).

3

The Mende and foreigners alike admired the initiates' graceful dancing; it was one of the finest entertainments a chief could provide for important visitors. One English district commissioner even compared the Sande performances to those mounted by London's renowned ballet companies:

> Personally, I have been privileged to witness very many of these Bundu [Sande] dances, and after making due allowance for difference of nationality and taste, I can only say that for grace and rhythmic movement the performance of these dusky maidens is perhaps not far short of that of the coryphees of an Empire or Alhambra ballet.[24]

Instruction in singing and dancing was an integral part of Sande training; for photographic sessions, initiates used the repertoire they had learned. A series of carefully staged photographs taken by Alphonso Lisk-Carew around 1907 captures the solemn character of the young women's dances. The initiates appear to be performing, despite the fact that they were posing motionless (figs. 3.5 and 3.6).[25] When presenting themselves for the camera, they drew upon representational conventions of feminine beauty found in Sande *ndoli jowei* helmet masks—with downcast eyes, closed mouths, and expressions of concentration and composure (cat. no. 3).[26]

Lisk-Carew, for his part, excelled in image composition. In figure 3.5, for example, nineteen initiates are arranged in three rows, creating the impression of horizontal lines. The girls in the back row present themselves frontally, while those in the middle row turn their backs toward the camera, and the six girls in the front row kneel on the ground. In figure 3.6, striking for its symmetry, four initiates bracket the most lavishly dressed girl; the resulting pose captures the elaborately costumed initiates from every angle, creating the illusion that the same girl is turning around.

Lisk-Carew used a standard 8 x 10- or 11 x 14-inch camera. Exposures were made on glass-plate negatives and contact-printed by sunlight onto light-sensitive albumen paper.[27] In 1906 the Royal Geographical Society published *Hints to Travellers*, a manual that outlined the steps necessary for taking pictures with such cameras. A passage from the guide describes the lengthy preparations that preceded photographing each of these staged images:

> Having selected the position from which the view is to be taken . . . the tripod stand is first set up. . . . The camera is next screwed on to the stand, and the lens selected which on trial is found to include the required amount of subject. . . . Focus the picture accurately on the ground-glass screen of the camera. The focussing-cloth is thrown over the head and the camera, so as to exclude the light as

much as possible, and while looking at the inverted image on the ground glass, the milled head of the rack adjustment is turned till the image appears as sharp as possible. The camera is now turned about on its vertical axis till it exactly includes the view intended to be taken. . . . The full aperture of the lens should always be used for focusing. . . . Having then put the cap on the lens, the hinged frame carrying the focussing-glass is turned over, and one of the slides carrying the sensitive plates is inserted in its place. . . . The shutter of the slide is then withdrawn, and the exposure made. . . . The time of exposure must be estimated according to circumstances, and it requires considerable experience to judge of it accurately."[28]

Alldridge, for example, used up to four seconds of exposure time for his Mendeland images, indicating that such pictures were the result of collaboration between the photographer and his subjects.[29]

Figure 3.7, Lisk-Carew's portrait of the most lavishly dressed Sande dancing girl—who also appears at the center of figures 3.5 and 3.6—recalls studio portraits of young women's coming-of-age ceremonies in affluent commercial cities along the West African coast (see fig. 3.1). Wearing a pensive expression, the girl places her hands one over the other. Her identity is unknown, but given her elaborate costume and her focal position in all three images, it is possible that she was the daughter of a chief. Leather flaps, a

feature associated with entertainment and one that originally belonged to the male dancing costume, complement her attire.[30]

As in many photographic portraits from the West African coast, the girl sits in a chair. To the Mende, the seated pose carried an important meaning: sitting associated women with acts of belonging, becoming, arriving, and being.[31] Consequently, when Sande females were presented as graduates, following their transformation from girls into women, they sat or were carried in hammocks at some point during the festivity.[32] In that sense, the camera offered the female still transitioning from girlhood to womanhood an opportunity to stage her pending debut as a woman.

Photographs made of Sande initiates in the early twentieth century eventually appeared in a variety of forms and contexts. They were, for example, assembled in private albums and published in personal travel accounts or popular magazines. Transformed into picture postcards, they reached a worldwide audience. In the opening years of the century, the postcard became a popular and inexpensive form of communication that served to facilitate the wide distribution of images from Africa. Lisk-Carew soon recognized the commercial potential of photographs depicting Sande initiates and offered them as postcards in his store

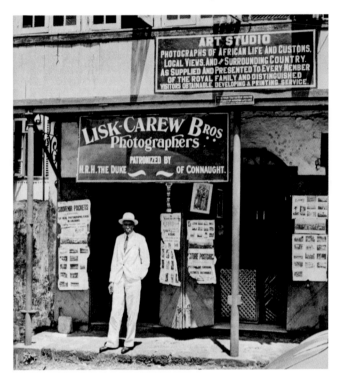

3.8

Postcards on
display in front
of Alphonso
Lisk-Carew's shop,
Freetown, Sierra
Leone, n.d. The
man pictured is
probably Lisk-
Carew.

in Freetown, an establishment heavily frequented by steamship passengers.[33] This helps explain why his picture postcards of Sande initiates can be found in many European and American private collections and archives. An undated photograph shows the front of Lisk-Carew's shop, postcards prominently on display (fig. 3.8).

Lisk-Carew's images of Sande initiates were repeatedly reissued as picture postcards with various captions, each of which conveys a particular meaning of an image and influences how the viewer interprets it.[34] For instance, an extensive caption added to a postcard version of the seven Sande initiates pictured in the forest provides as much contextual information as possible (fig. 3.9). It reads: "Well Adorned Nymphs of the Bundoo Society Making Their Debut in Their Newly Donned Finery, with Dignity and Grace. Sierra Leone." The use of the words "dignity and grace" can be viewed as an attempt to counteract prevailing views about traditional Mende associations at a time when many Westerners, and cosmopolitan Africans, decried these associations as "heathen" or uncivilized.

In some cases, a caption can change an image's original meaning entirely.[35] When the portrait of the seated Sande initiate (fig. 3.7) was repurposed as a picture postcard, the words "Fitish Dancing Girl" in the caption relegated the lovely image to the vast body of "fetish" pictures that existed

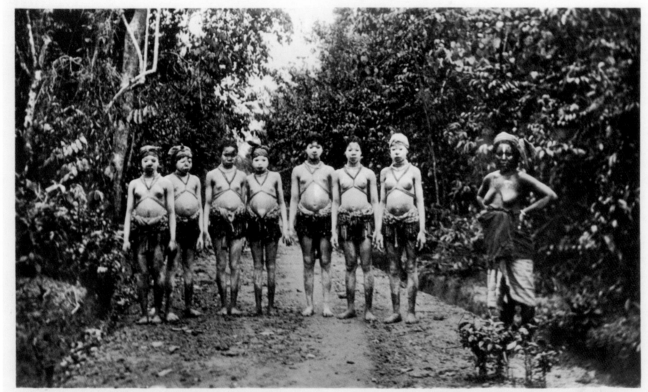

WELL ADORNED NYMPHS OF THE BUNDOO SOCIETY MAKING THEIR DEBUT IN THEIR NEWLY DONNED FINERY, WITH DIGNITY AND GRACE. SIERRA LEONE

3.9

Alphonso Lisk-Carew, "Well Adorned
Nymphs of the Bundoo Society Making
Their Debut in Their Newly Donned
Finery, with Dignity and Grace. Sierra
Leone," c. 1915. Postcard. *The Gary
Schulze Collection.*

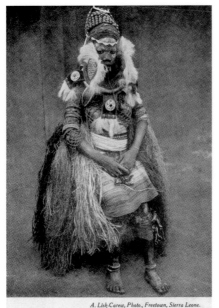

A. Lisk-Carew, Photo., Freetown, Sierra Leone.
A TYPICAL FITISH DANCING GIRL, UPPER MENDI, SIERRA LEONE.

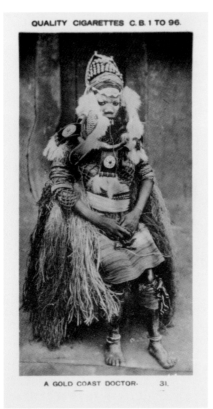

QUALITY CIGARETTES C.B. 1 TO 96.

A GOLD COAST DOCTOR. 31.

at the time and that reinforced prevailing stereotypes about Africans (fig. 3.10). Around 1930, the Manchester-based Quality Cigarettes company issued the same portrait as a photographic collectible card; its caption labeled the Sande initiate "A Gold Coast Doctor" (fig. 3.11). To European viewers unfamiliar with the Sande, the real context would remain a mystery.

Even more alienating was the way Lisk-Carew misrepresented the physical context of the two Sande initiates on the right in figure 3.6. When he began producing colored Christmas cards around 1920, he pasted the pair onto a different background, thus removing them from their original setting entirely (fig. 3.12). Ironically, Lisk-Carew chose for the background of the card an image of a place Sande initiates would assiduously avoid—the entrance to the initiation grove of the men's Poro Society.

■ ■ ■ ■ ■

Photographs of Sande initiates provide insights into the ways that an exclusively female association worked cooperatively with male foreign photographers to produce singular images. On the one hand, Sande elders were willing to suspend rules of visual secrecy for the camera, an indication of the high status accorded to photography in the early twentieth century, even in remote areas of West Africa. Sande initiates, on the other hand, shaped the resulting images

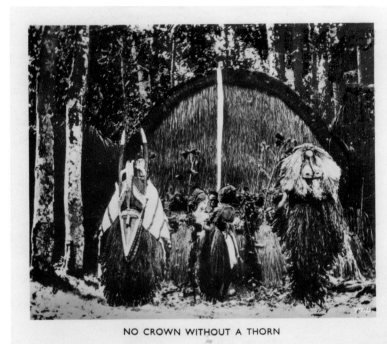

With all kinds thoughts for CHRISTMAS, and to wish you A Bright and Happy New Year

NO CROWN WITHOUT A THORN

3.12
Alphonso
Lisk-Carew,
"No Crown without
a Thorn," c. 1920.
Christmas card.
*The Gary Schulze
Collection.*

Visions from the Forests | Photography and Sande Initiates

by turning the photographic setting into a performance space. Photography offered the opportunity to extend their performances both in time and space by preserving them for posterity and making them visible to a global audience. Once these pictures were developed on paper, they assumed a life entirely independent of their photographic subjects. Unfortunately, when images of them were exploited for commercial purposes—for instance, altered by means of image blending or labeled with alienating captions—Sande initiates remained a puzzle to all but the Mende peoples of Sierra Leone.

FREDERICK JOHN LAMP

"By Their Fruits You Will Know Them": Sande Mask Carvers Identified

The helmet mask of the women's Sande association in Sierra Leone and Liberia is one of the best-known types of African mask.* In my experience, it also is one of the most beloved among the peoples of this region for the beauty of the carving and for the elegant movements of the dancers who wear them. The genre is unique, as it is the only mask in sub-Saharan Africa carved in wood to represent a female character and worn by women.[1] The sheer volume of these masks in museum and private collections as well as those still in use in Africa, the broad geographical range of the masks in indigenous ritual, the great diversity of artists' styles, and the technical excellence of many examples rank these sculptural works among the most significant in the history of African art.

No other single form of African sculpture has had as many books devoted to it—five major monographs, plus at least four PhD dissertations.[2] Because of their volume and variety, Sande masks serve as a fascinating index to artistic style across the wide spectrum of carving genres in Sierra Leone and northwestern Liberia. There have been hundreds of Sande mask carvers over the past century-and-a-half, resulting in distinct styles and interpretations of the image of the female spirit that the masks represent. Of course, quality varies: it ranges from artists who consistently produce masterful works to some who are fair to good to others who are inadequate.

The region covered by the distinct female initiatory association that is the context for this masking tradition is vast and extends through most of Sierra Leone into northwestern Liberia and perhaps into the fringes of the forest region of Guinea. Northern groups—Temne, Limba, Kuranko, Loko, Bullom (northern and southern dialect groups), Bom, and Kissi—tend to use the term *Bondo* (pronounced "bone-doe," rapidly with equal syllabic stress; sometimes spelled "Bundu") for the women's association.[3] Southeastern groups—Mende, Kono, Kim, Vai, Dei, Bassa, Gola, Kpelle, Belle, Gbandi, and Loma—apparently all use the term *Sande* (pronounced "sahn-day," rapidly with equal syllabic stress), although they are said also to recognize the term *Bondo*. The existence of Sande/Bondo does not necessarily mean that the black helmet mask appears; it is not essential to Sande/Bondo, and in fact does not represent the highest spirit, who is never seen materially.[4] It is most commonly documented among the Mende and Vai (both Mande speakers) who straddle the Sierra Leone-Liberia border. To my knowledge, it has never been documented among the Northern Bullom, Kuranko, Gbandi, Kpelle, Kono, or Belle. The origins of both Sande/Bondo and the helmet mask are uncertain, but the Temne, Southern Bullom (Sherbro), Vai, and Gola testify to a Mende origin for the mask.[5]

In this essay, I will not only describe the Sande/Bondo helmet mask but also discuss my own research techniques over the past several decades—and the recording and examination of minutiae, the search for patterns, and a concern for history and sequence. Much of what we as

* *Editors' note*: Although the term *Sande Society* appears in all other parts of this book, Frederick Lamp prefers to use *Sande association*. That preference is also reflected in his references to other initiation societies in this essay.

researchers do involves our subjective and non-scientific empiricism, in which the self-reflexive is absolutely important. Nonetheless, there are still facts to be recorded, such as the shapes of objects, events in the lives of artists, the geographical distribution of masks, the ranking of ritual officials, the structure of grammar, the meaning of names, and the words. I begin with the words, the grammar, and the meaning of names. I believe it is imperative to get the words in the language of the people.

In recent years, scholars studying the Sande among the Mende, Gola, and Vai have reported that the women's helmet mask itself has no name but is identified simply by the term designating the association official who wears it, *sowei/sowo*, or *ndoli jowei* (the *sowei* who dances); this appears to be the term most often used by the Mende today. In my research among the Temne, however, I found a specific term commonly in use, seemingly known by everyone, and that is *nòwo* (pronounced "naw-woh," rapidly with equal syllabic stress).[6] The Temne have certainly had Bondo for centuries, but it was probably only in the early twentieth century that they started using the helmet mask, especially along their borders with the Mende. My colleagues Sylvia Boone, Ruth Phillips, Loretta Reinhardt, and William Siegmann told me that, in their years of field research, they had never heard the term. But the documentation since the nineteenth century makes clear that this term was known as well among the Mende, Bullom, Bom, Kim, Vai, Kissi, and Loma peoples.[7] *Nòwo* also means "butterfly chrysalis" in Temne, although no one could tell me,

during my research from 1976 to 1980, which designation came first, or whether it is a borrowed word. (I provide a historiography of the use of the term in this book's Appendix, pages 204–5.)

Because the corpus of these masks is so huge and varies so widely in style and iconography throughout Sierra Leone and northern Liberia, there is good reason for an art museum to collect multiple examples that are of superior quality. Each mask is an individual interpretation of a spiritual concept embodied in the image of a primordial ancestral woman. The mask in performance represents this female ancestral spirit, who is said to be discovered in a sacred journey under the water by the high official of the Sande/Bondo association; the official returns from the journey with an example of the head of the spirit. One might make a comparison to European representations of the Madonna: the point of reference is always the same and the form is relatively consistent, but the style varies geographically and historically. For art-historical reasons, it is important that collectors and museums acquire a range of the most interesting and best-executed examples, particularly ones that represent highly regarded and prolific workshops.

The identities of artists in African art history have become of pressing interest to today's scholars, the objective being to counter notions about the anonymity of African artists. Even when the artists' names are not known, their individuality can be traced throughout their works, especially if the work is figurative, and workshops can be identified through

stylistic analysis. There is keen competition among African art curators throughout the country to acquire objects by known artists or recognized workshops—for example, the Master of Buli, among the Luba of the Democratic Republic of the Congo, who can be identified only by the name of his village.

For the past forty years, I have been collecting images of art objects from Sierra Leone and Guinea.[8] I have been able to identify ninety-four separate workshops—or styles—of the Sande helmet masks alone, with many cross-references to other forms of sculpture, such as human figures, figurative staffs, and other figurative utilitarian objects.[9]

It must be kept in mind, however, that the attribution of a given body of work based upon stylistic and formal similarities is fraught with complications. Style itself can be attributable to regional ethnicities, groups or lineages of sculptors, or to certain individuals. Style is also variable; one artist or a group of artists may change style over time due to artistic growth or shifts in creative outlook. A number of carvers and their apprentices may work together, and they may stick to the same style, or they may expand to a number of different styles, changing from time to time. An enormous number of individual masks are stylistically unique and cannot be matched to any other example. Does this suggest a vast population of artists working independently and sporadically, or perhaps a smaller number of artists experimenting in a wide range of styles?

A client may request work in another artist's style: Loretta Reinhardt learned from her carver-consultants that any one carver can receive a commission from a Sande woman with instructions to carve it in the style of a mask she has seen elsewhere.[10] Carvers frequently travel to see the work of other carvers, sometimes especially to see old masks that they can imitate. Reinhardt found that the carvers she met saw new commissions "as an opportunity to demonstrate their virtuosity." She was often asked, "What kind of the mask would you like me to make for you?" As the young Mende carver Paul Lahai told her:

> We, the beginners, work on the old masks, the ones we're seeing. . . . Every part of the country, wheresoever we may go. We travel to see an old mask. We have to look at it carefully. And so when we come to our home, we have to make it, to carve it, as the one we have seen. That's why I always look. Even at the pictures. . . . If I look carefully at each, and choose one, or two. . . . And I thought, I will carve it, and when I go back home, I have to keep the same style.[11]

Finally, Mende carvers have a habit of claiming as their own work masks that have been produced by others.

Most of the ninety-four workshops I have recognized cannot be identified by a given artist's name or even by a location. (Ruth Phillips and Loretta Reinhardt, however, documented several living artists in the 1970s.[12]) Even if we do not have a biography of the respective artist, we can begin building a picture of his preferences for form, iconography, decorative detail, and aesthetic characteristics. Or, to employ a biblical expression, "by their fruits you will know them" (Matthew 7:16).

1

WORKSHOP NÒWO-42:

MASTER OF THE BOWL-SHAPED EYES

Let us consider first the mask that William Siegmann argued was produced by the Vai of Liberia, one that other scholars have attributed to Southern Bullom (Sherbro), or to the closely related Kim, or to the Mende or Temne (cat. no. 1).[13] Siegmann, who was very playful with his attributions, called this artist the "Master of the Raccoon Eyes."[14] This is my Workshop Nòwo-42, which I, being less playful, call the workshop, or style, of the "bowl-shaped eyes." Other formal characteristics of this style are the oval protruding mouth set below the highest neck ring, a high stack of thick neck rings, a large flange at the bottom, large round tufts of hair on the sides, and either a large single hair crest or a four-lobed crown of hair on top with a square amulet. The top-center crest here is closest to one in the British Museum (fig. 4.1), but the rest of the coiffure is closest to one formerly in the collection of the Africana Museum, Cuttington University, Suakoko, Liberia.[15]

This workshop dates to the late nineteenth century. The earliest illustration of a mask in this style was published in 1906.[16] That mask is almost certainly the one now in the collection of the National Museum of Natural History, Smithsonian Institution, Washington, D.C. It was collected by Warren d'Azevedo, an anthropologist who worked among the Gola; he noted only that the mask was from western Liberia.

4.1

Culture unknown

Sierra Leone or Liberia

SANDE / BONDO HELMET MASK, late 19th or early 20th century

Wood

H. 17 5/16 in. (44 cm)

British Museum, Af1954,+23.3484. Acquired 1926

A photograph published by the folklorist A. R. Wright in 1907 shows another example from this workshop. Curiously, he labeled it as a Poro mask, used by the male initiation association, while labeling another helmet mask, in the same illustration, as a Bondo mask—which it certainly is.[17] Wright indicated that the mask "was worn by a personater of the 'kriffi ka porro' [ò-kərfi ka am-pòrò, a Temne term for the spirit of the Poro association] or porro 'devil,' a spirit who may not be seen by women or non-members, and who is supposed to devour candidates for the society, and afterwards give them birth again, returning to the sky."[18] The fact that Wright used a Temne word (kərfi = "spirit") suggests that the mask was found among the Temne. There is no indication as to where he got his information, whether personally in the field or from the report of another writer. Another example in this style, now in the Museo Etnográfico, Buenos Aires, was published by the

2

4.2

Mende

Sierra Leone

SANDE HELMET MASK, late 19th or early 20th century

Wood

H. 16 ⅛ in. (41 cm)

Pitt Rivers Museum, University of Oxford, U.K., no. 1984.28.1

Captain Charles Claude Humphreys, who regularly sailed between England and Sierra Leone from 1900 to 1914, collected this mask in the early twentieth century. The mask was formerly owned by Humphreys's daughter Aylwin Patricia Chancellor, to whom he had given it. It is attributed to Sogande the father or an earlier member of Workshop Nòwo-9.

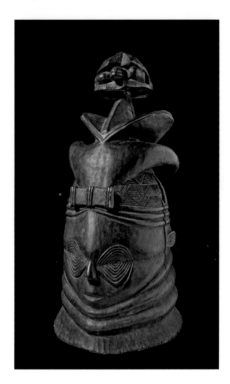

collector and dealer William Oldman in 1909; it is almost identical to the mask illustrated by Wright, with some distinguishing features.[19] Oldman equivocated, writing, "Used by the devils of the 'Bundu' or 'Porro' Societies"—probably simply borrowing from Wright. But a New York private collector purchased a mask in the same style from a Sande official in Gelehun, Bo District, in southeastern Sierra Leone. She told him she had inherited it when she was inaugurated, around 1930; this documents its female identity and Sande-official ownership.[20] In any case, this early workshop was quite prolific and seems to have distributed its products widely from northern Sierra Leone to Liberia.[21]

WORKSHOP NÒWO-9:

SOGANDE OF FUINDA

The second Siegmann mask (cat. no. **2**) is from the most prolific workshop, or style, in all of Sierra Leone or Liberia. It is no wonder that this style was so much in demand by Sande officials, considering the extremely pleasing aesthetic qualities in all of these masks that I have tentatively attributed to what I call Workshop Nòwo-9. There are more than one hundred twenty-five examples from this workshop in collections worldwide.[22] With their delicate features, huge outlined eyes, and elaborate coiffure, they are often described as the most beautiful Sande masks. Common features include an indication of eyebrows, eyes shaped like large lips (or sometimes an upper-lip-shaped eye with lower striations), a pug nose, a small pouting mouth, a C-shaped

ear with an indentation, blocked hair patterns, a flared lower base, and a prominent structure on top consisting of umbrellas, crowns, or animals.

This style has a long history. A Sande mask probably by the same workshop, now in the Pitt Rivers Museum, University of Oxford, was probably collected between 1900 and 1914 in Sierra Leone (fig. **4.2**). Another one entered the collection of the Nationalmuseet, Copenhagen, in 1922. These two are aberrant with respect to the form of the eye, and it is possible that they represent an earlier stage in the evolution of this style. An example in the Ethnographic Museum of the University of Zurich, acquired about 1900, was published in 1935 (fig. **4.3**), and a second example was acquired in 1941. Several masks from Workshop Nòwo-9 entered the collection of the British Museum between 1938 and 1942. One in the Museum Rietberg, Zurich, can be traced to a private collection in 1940. Ruth Phillips documented a mask in situ that had been carved in 1950. And Loretta Reinhardt interviewed a probable last-in-the-line carver in this style in 1968. So it seems that the workshop was in operation from at least the beginning of the twentieth century; it continued producing masks until late in the century, probably through several generations of sons and/or apprentices.

We know that this general style spread far and wide. The mask carved in 1950, photographed by Phillips, was found in Nguabu, Kaiyamba Chiefdom, Moyamba District, in southwestern Sierra Leone, where the Temne, Southern Bullom (Sherbro), and Mende meet. The ethnographer

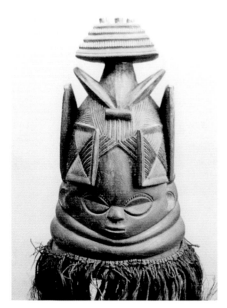

4.3

Mende

Sierra Leone

SANDE HELMET MASK, c. 1900

Wood

H. 15 in. (38.1 cm)

Ethnographic Museum of the University of Zurich, inv. no. 6911

Attributed to Sogande the father or an earlier member of Workshop Nòwo-9.

4.4
A Mende
Sande masker,
photographed
in performance
in Kailahun,
Luawa Chiefdom,
appeared as
figure 157 in the
ethnographer
Rudolf Eberl's
extensive 1936
report on his 1935
tour of Sierra
Leone. The carver
was probably
Sogande the
father or an
earlier member of
Workshop Nòwo-9.

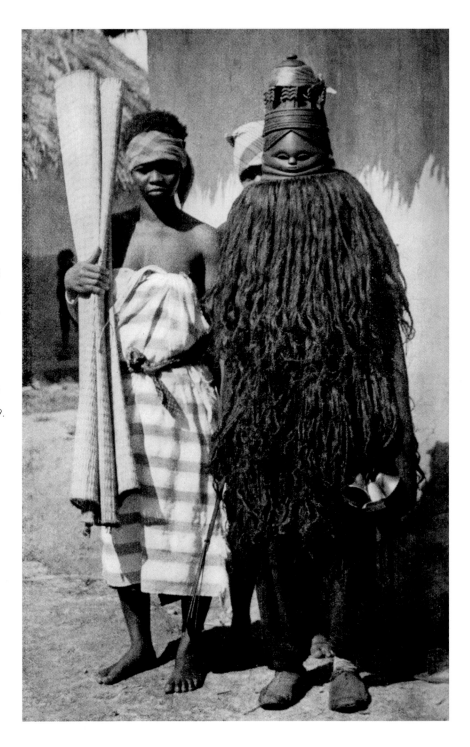

Rudolf Eberl included two photographs of this style of mask in use in Kanre Lahun (now Kailahun), Luawa Chiefdom, on Sierra Leone's eastern border with Guinea in his 1936 and 1943 publications (fig. 4.4).[23] He identified it as Kissi, although this is where the Kissi and Mende meet, and no other Sande helmet mask has ever been attributed to the Kissi. The art historian William Hommel also provided two photos of the same style of mask in use in Kenema District, in eastern Mende territory, in his 1974 book, *Art of the Mende*.[24]

Reinhardt photographed two similar masks with their carver, Bokarie Sogande, in Kenema District for her 1975 dissertation.[25] Born in the town of Fuinda, north of Kenema, Sogande was identified as one of the two best-known carvers in Sierra Leone.[26] Reinhardt wrote that his work "seemed ubiquitous"—a description that could only apply to Workshop Nòwo-9, with its enormous output. She was told, however, that there was more than one Sogande who carved Sande masks; and she learned that Sogande and his father, who was also called Sogande (possibly with the given name Braima), had worked together for some years.[27] Sogande the father was well known as a carver and had been employed by a government-sponsored woodcraft-production company, Forest Industries, in Kenema, for a year, after which he returned to Fuinda to serve as town chief for a year, until his death, in or shortly before 1968. Phillips wrote that he was active from the 1930s to the 1950s—though he may have begun carving earlier—and that he continued carving hair crests in the turn-of-the-century style, on the top of the masks. As Reinhardt noted:

[T]he difficulty in sorting out attributions to Sogande, or to his late father, also named Sogande, possibly implies a similarity in their styles at some period. In comparing the two masks I documented in Sogande's compound . . . with others attributed to simply "Sogande". . . it is clear that there is a considerable range in both proportion and detail within what might be called tentatively a "Sogande style."[28]

Sogande may be a contraction of *Sowo gande* (Sowo expert). Phillips wrote (probably about the late father):

Sowo Gande has a very great reputation in Kenema district and parts of Bo district. He is the best-known carver in the region and as a result many masks are attributed to him which bear very little stylistic relationship to each other. . . . It is probable that other carvers, possibly students, have made use of the same name.[29]

Bokarie Sogande, the son, "probably between forty and fifty years of age," Reinhardt estimated, had started carving only a couple of years before her interview, which was conducted in 1968; thus his work with his father, who had recently died, could not have lasted more than a year or so. Reinhardt wrote: "He carves, he says, because his father's blood is in him, he got it from his father, he was born with it. When he was little, he did observe his father carving, but [he claimed that] he never tried to copy or practice when he was young."[30] Like his father, he worked at Forest Industries, for about thirteen years. "It appeared, too," Reinhardt continued, that because "he had worked [as a carver] in conjunction with his father [it is possible] that

people may not have specified either carver when ordering a mask, and that probably both men may have worked on the same mask in some instances."[31] In any case, it seems evident that work in this stylistic range—the most numerous of any Sande mask styles I have documented—is that of the Sogandes, mostly by the father but perhaps some by the son, and perhaps even further back in the lineage, at least to the early twentieth century. The elder Sogande was certainly the most frequently commissioned carver for the Sande association and was arguably the greatest master of Mende carving; he is probably the carver of the Siegmann mask.

WORKSHOP NÒWO-47:
MASTER OF THE CRESCENT EYE LINE

A third mask (cat. no. 3) was attributed by Siegmann to the Sewa Mende of Bo District. He described its characteristics this way:

> Distinguishing features of this artist's work include a particularly bulbous forehead with a deep crease into which the eyes are set, a pointed chin, and the deep compression of the neck rings in front with their expansion in the back. This mask also has *a fandu* marks [scarification resembling a plus sign] and tear scarifications (*ngaya maki*) [three vertical marks] on the cheeks. The four small duiker horns on the sides of the mask symbolize protective medicine while the clusters of cowrie shells in the hair represent wealth. The hairstyle with three ridges ending in bulbous forms is an old style that this carver used on many of his masks.[32]

This mask is a product of the style I have identified as Workshop Nòwo-47, of the crescent eye line. Ruth Phillips included a photograph of this style of mask in use in Mofindor, Banta Chiefdom, Moyamba District, in a 1980 article and a photograph of another example, in Mattru, Tikonko Chiefdom, Bo District, in her 1995 book *Representing Woman: Sande Masquerades of the Mende of Sierra Leone* (fig. 4.5).[33] Both Mofindor and Mattru are in Mende territory. It is a magnificent, voluptuous style, and we wish we had more clues as to the identity of this artist—certainly one of the most accomplished of all. Two examples almost identical to the Siegmann mask have been published, but their current whereabouts are unknown.[34] Other very similar masks, certainly by the same hand, appear in numerous public and private collections.[35]

WORKSHOP NÒWO-72:
THE EARLIEST DOCUMENTED STYLE

A fourth Siegmann mask (cat. no. 4), collected in the field in 1965 by a well-known Maninka art dealer, Talibi Kaba (father of the dealer Jeremiah Cole), is known to be from the Vai. This is the style I have identified as Workshop Nòwo-72, ten examples of which are included in my image bank.[36] The characteristics of this style include a long, backward-slanted face, the lower half an indented triangle below the eyebrows; a ringless neck, except for short, projecting arcs around the back; a prominent flange around the base for holding the raffia costume, sometimes without holes; a tall, bell-curve-shaped crest in profile; closely spaced slit eyes; a semicircular ear with a dot in the center; a long,

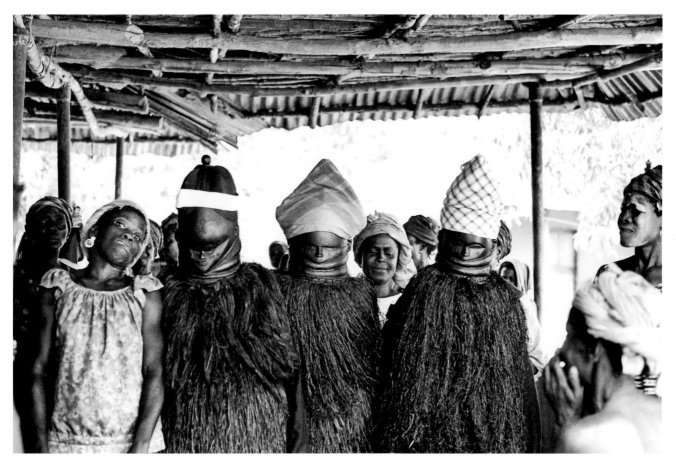

4.5

A Workshop Nòwo-47 Mende Sande mask (at left) was photographed by Henrietta Cosentino in Mattru, Tikonko Chiefdom, Bo District, Sierra Leone. The mask is now in an unknown collection. This photograph is figure 4.19a in Ruth Phillips's 1995 book *Representing Woman*.

4

4.6

The line drawing that appeared on page 309 of Johann Büttikofer's 1890 publication *Reisebilder aus Liberia* depicts a Vai Sande helmet mask (H: 15 15/16 in. [40.5 cm]) that Büttikofer donated to the Bernisches Historisches Museum (acc. no. 1924.322.0266).

rectangular nose; and a mouth represented by a small slit or open rectangle at the lower point of the triangular face. Certain examples have striated eyebrows. Some of the masks from this workshop have entered the market recently, without evidence of great age or use; so it is possible that the style has been widely copied, or that a succession of sons/apprentices continued the workshop into the mid-twentieth century.

The very first known illustration of a Sande mask—a small but detailed drawing (fig. **4.6**)—is found in the Swiss zoologist Johann Büttikofer's 1890 report on his journey in Liberia, although it is not the first mention of the mask. (The first mentions were by the missionaries and linguists Sigismund Koelle in 1854 and James Frederick Schön in 1884.[37]) Büttikofer had collected the mask shown in the illustration in Tala village, near Robertsport, in November 1881. He donated it to the Bernisches Historiches Museum, Bern, Switzerland, in 1924. It is certainly of the same style, if not by the same hand or workshop, as catalogue number **4**.

Büttikofer provided some interesting data indicating that the helmet masks are worn by the "soh" (So) and "soh-bah" (So-ba = the Big So), which today are the terms used by the Vai. He added that the "masks of the soh-bah depict men's faces, [and] those of the soh show women's faces which imitate their unique character as with much care." This would correspond to more recent ethnography in Liberia by Warren d'Azevedo, published in 1980, claiming that the Liberian Sande helmet masks depict males, not females, as is widely reported in Sierra Leone.[38] Büttikofer's testimony

5

suggests a male version and a female version, of higher and lower rank, respectively. He seems to indicate that the mask in his drawing is female. ("Schwarze Holzmaske [devil head] einer Frau aus dem Vey-Stamm"—"Black Wooden Mask [devil head] of a Woman from the Vai tribe.")

WORKSHOP NÒWO-27:
MASTER OF THE SCARRED EYE BAGS

A fifth mask (cat. no. **5**) was identified by Siegmann as Southern Bullom (Sherbro), which is plausible. This is the style I have identified as Workshop Nòwo-27, of which I have collected images of three other masks and one female figure.[39] The National Museum and Galleries on Merseyside, England, has a mask in a somewhat similar style that it acquired in 1910 and catalogued as Mende. It may be an earlier example in the evolution of this workshop. In 1936 the anthropologist Henry Usher Hall purchased a very similar mask from Chief Bahn of Bendu, Bendu-Cha Chiefdom, Bonthe District, on the mainland opposite Sherbro Island; he deposited it in the University of Pennsylvania Museum of Archaeology and Anthropology (fig. **4.7**). If these are all from the same workshop, the mask is of considerable antiquity.

The characteristics of this style are a tall, overall cylindrical form, scarred eye bags, a three-circle decoration in a triangle on the forehead and the temples, pursed lips, a beaded coiffure, a concave face, puffy cheeks, and a protruding chin. Sometimes there are two sets of eyeholes, one within the eye and one under it.

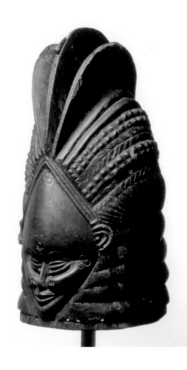

4.7

Southern Bullom (Sherbro)

Bendu-Cha Chiefdom, Bonthe District, Sierra Leone

BONDO HELMET MASK

Wood

H. 15 ¾ in. (40 cm)

Museum Expedition to Sierra Leone, 1936–37, Henry Usher Hall, University of Pennsylvania Museum of Archaeology and Anthropology 37-22-266

6 7

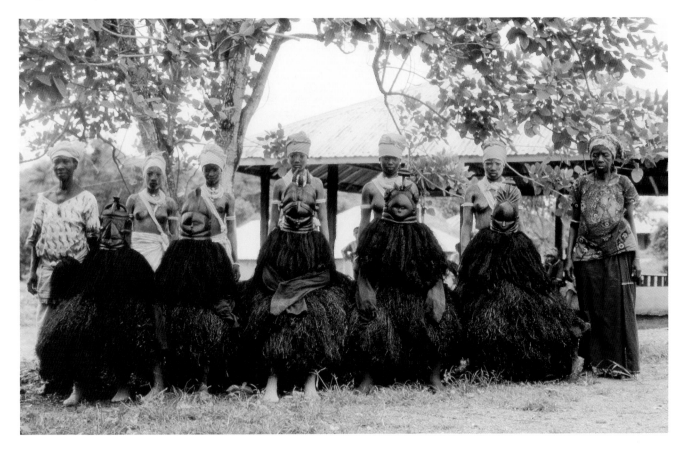

4.8

Five Mende Sande maskers are shown in Bandajuma Kovegbuami, Small Bo Chiefdom, Kenema District, Sierra Leone. Pa Jobo made the mask on the far left. The photograph is figure 4.7 in Ruth Phillips's book *Representing Woman*.

WORKSHOP NÒWO-39:
PA JOBO OF MANO-PENOBU

A sixth mask (cat. no. **6**), clearly Mende, fits into my Workshop Nòwo-39, which is identified with the carver Pa Jobo, who lived in Mano-Penobu, Bagbwe Chiefdom, Bo District. Reinhardt interviewed him.[40] The characteristics of this style are an overall rounded face, a simple dome-shaped coiffure with minimal projections, a striated lip-shaped eye, a small pointy nose, pointy lips, and C-shaped ears. The faces of these masks seem gentle and pleasant. Several of them include a band of rounded flaps, representing leather bands worn around the head by musicians and other entertainers. These masks tend to be very thin walled, showing great confidence and skill on the part of the carver.

A female figure in the Siegmann collection is also almost certainly by Pa Jobo (cat. no. 7). In his Collection Notes, Siegmann suggested that this figure and the mask were by the same hand, although he did not know the name of the carver.[41] This is quite interesting, as it is difficult to match full figures to the Sande masks because of the extreme difference in scale and in the detail permitted. The Sande mask gives the carver an opportunity to express his aesthetic of the human face in great detail, but in the figure, we see how he would approach the entire body. Several other female figures in European and American collections seem to be by the same hand.[42] In most cases, the heavy shoulders and breasts taper down through the arms to tiny hands held out to the sides, the torso is fully scarified, the legs are thick and short, the figure usually wears a small apron, and the neck rings are thick.

Pa Jobo ("Mr. Jobo"—Pa is an honorific) was a carver, Reinhardt wrote, who was "clearly held in much affection and respect for he had both charisma and substantial knowledge of some of the more arcane aspects of Mende culture."[43] His given name was probably Amara, but he also claimed the name Nyangaba, which seems to mean something like "The Great Egotist/Exhibitionist." It is a name he seems to have given himself, suggesting his narcissism. His surname is also ambiguous: he insisted it was Jobo, although others pronounced it Jobu or Jibao. Reinhardt regarded him as somewhat cagey and elusive, and they

had some tiffs in the course of her interviews with him.[44] When Reinhardt encountered him, he had been carving for approximately fifty years. He died shortly afterward, in 1970. Jobo bragged that his work could be found from Kono to Freetown, and it is obvious that he was extremely prolific. Reinhardt found examples of his work in the Bagbwe, Kori, Komboya, and Badjia chiefdoms, in Bo District in south-central Sierra Leone. Phillips illustrated two examples that were in use in the villages of Navo and Bandajuma Kovegbuami, Small Bo Chiefdom, Kenema District, in southeastern Sierra Leone, seated in a row with four other Sande maskers (fig. 4.8).[45] I have found nineteen examples of Jobo's work.[46] A master carver and technician, he was able to execute such thin-walled, delicate masks probably because, as he told Reinhardt, "I use the roots [of the tree, rather than the trunk], and they do not crack."[47]

WORKSHOP NÒWO-25 A AND B:
VANDI AND ANSUMANA SONA OF TELU

A seventh mask (cat. no. 8), fortunately still bearing its luxurious cape of raffia fiber, is by another well-known carver, Ansumana Sona.[48] This artist continued very much in the stylistic tradition he had learned from his father, Vandi Sona, whose output seems to have been much greater, even though it is not always easy to distinguish between the two men's work.[49] This is my Workshop Nòwo-25b, a style characterized by a naturalistically proportioned face; high, arched eyebrows; long, puffy eyes slit across the middle, outlined with eyelids; a long nose with full

8

4.9

Ansumana Sona
carved this
Mende Sande
mask around 1960
as a copy of a
damaged mask
made by his father,
Vandi Sona. Telu,
Jaiama-Bongor
Chiefdom, Bo
District, Southern
Province, Sierra
Leone. Its owner is
the Sande Sowei
Jenne Kai, who
has given it the
personal name
Ngolia. These
photographs
are figures 8.26
a and b in Ruth
Phillips's book
*Representing
Woman*.

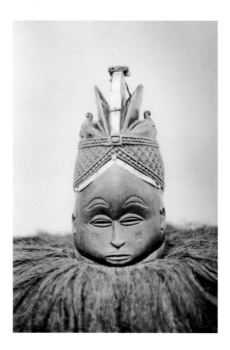

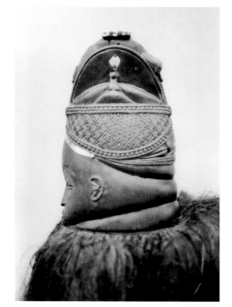

nostrils (but shorter than in masks his father made). In addition, the masks Ansumana Sona made have fuller lips, fuller cheeks, and a more indented ear than those carved by his father. They are also distinguished by vertical linear scarifications on the cheeks (*ngaya maki*, or tear marks), a checkerboard coiffure on the sides, and a square amulet at the peak of hairline above the forehead; this is set into a distinct headband around the crown, binding the coiffure—often with the flourish of a baroque scroll. Phillips photographed a mask very similar to the Siegmann mask in situ (fig. **4.9**). The work of Vandi Sona (Workshop Nòwo-25a) and his son Ansumana is separated by about forty years; so this workshop did not operate continuously. But it certainly was characterized by a renewal and rebirth of the elder Sona's style in Ansumana's work. Phillips analyzed the contrast between the two:

Ansumana seems to have adopted the more complex rather than the simpler representations contained within his father's work, quite possibly because these more evolved forms were those being used by Vandi during Ansumana's own youth. On early masks by Ansumana . . . the ear form, for example, resembles [the semicircular form of Vandi's], while on a mask he was carving in 1972 this form had become more naturalistic, standing away from the head and taking an irregular shape. . . . Ansumana, like other contemporary carvers, has been moving away from the solemnity and reserve of earlier masks, such as those carved by his father, toward an image which is more animated and more communicative.

This expressive quality conveys an impression of accessibility that is reinforced by the portraitlike quality lent to his masks by the more naturalistic depiction of the human visage.[50]

Siegmann reported that his mask was carved around 1960 and that he had collected it in a mixed Vai and Mende area of Sierra Leone, near the border with Liberia. The hairdressing is heavily embellished with silver amulets as protective devices. "But since these have not been fashionable for several generations," Siegmann noted, "it seems likely that this piece was carved as a replacement for an older mask."[51]

The father, Vandi Sona (c. 1885–1951), was active in the Bo District through the first half of the twentieth century. Vandi claimed that he was self-taught and that he was influenced by a style practiced among the Kim people, his maternal relatives, on the southern coast of Sierra Leone. In 1968 a Peace Corps Volunteer, Nancy Barr, photographed one of his masks in performance in Koranko, Kandu-Leppiama Chiefdom, Kenema District (fig. 4.10). Another of his masks is surely the one with the English royal crown that is in the Brooklyn Museum collection (fig. 4.11). It represents a rare departure by Vandi into the political realm, made during a time when the English crown was well known from photographs of Queen Victoria and her son King Edward VII. In my own experience some years later, just about everyone in Sierra Leone owned a photograph of the young Queen Elizabeth II, who was crowned two years after Vandi Sona died. Posters of the queen were

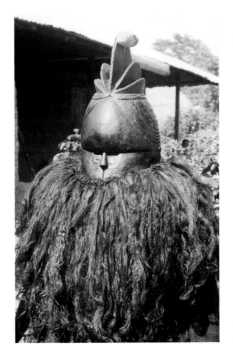

4.10

A Mende Sande mask by Vandi Sona is seen here in use in Koranko (near Blama), Kandu-Leppiama Chiefdom, Kenema District, Sierra Leone, 1968. The mask is now in the collection of Cesaré DeCredico, Providence, R.I. *Photograph by Nancy Barr.*

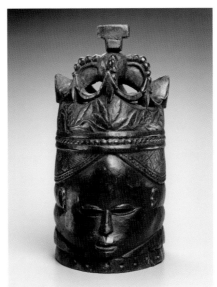

4.11

Vandi Sona (c. 1885–1951)

Mende

Sierra Leone

SANDE HELMET MASK, early–mid-20th century

Wood, pigment

H. 16 in. (40.6 cm)

Brooklyn Museum: Robert B. Woodward Memorial Fund and Gift of Arturo and Paul Peralta-Ramos, by exchange 69.39.2

distributed everywhere. The crown on Vandi Sona's mask is simply an extension of his signature headband.

The son, Ansumana (b. 1931), who was born in Gawula, Wunde Chiefdom, spent some of his childhood in Telu, Jaiama-Bongor Chiefdom. He worked as a blacksmith and, later, as a carpenter in Segbwema, Kailahun District, in far-eastern Sierra Leone. According to his testimony, it was only after his father's death that he began studying the masks the older man had carved and started carving himself in much the same style. He based himself back in Telu, where he received the patronage of the Paramount Chief B. A. Foday-Kai. In 1968 the government hired him to work in Kenema, where he became a prolific carver of decorative objects while still carving Sande masks on commission, working openly on the front veranda of his house. Reinhardt, conducting research from 1967 to 1969, found that he was one of the best-known carvers in Sierra Leone.[52]

WORKSHOP NÒWO-62:
MASTER OF THE GRILLED VIEWING PANEL

An eighth mask (cat. no. 9) is one clearly belonging to the style I have identified as Workshop Nòwo-62, of which there are only a few examples in public or private collections; all are extremely close in style.[53] The characteristics of Nòwo-62 are: an overall form of a high cone (the head) on a wide cylinder (the neck); high neck rings with a grilled viewing panel in front; the whole face in a diamond shape overlapping the front grill; the facial features located in the lower triangular half of the diamond, indented

below the brow; a striated indication of eyebrows (in most examples); small slit eyes; a comparatively long but delicate triangular nose; three vertical scarification marks under each eye; a tiny, slit mouth; a high-peaked triple chevron indicating the hairline above the forehead; and a braided hair pattern on the sides of the head, usually with a series of low sagittal crests on top. Siegmann, in his Collection Notes, questioned whether this was a women's Sande mask on the basis of its resemblance to a male Humoi association mask that is pictured in performance in the ethnographer and linguist Frederick Migeod's 1927 publication, "A View of Sierra Leone."[54]

In 2008 a mask almost identical to this one was donated to the Yale University Art Gallery. After weeks spent examining every square centimeter of it, we came to the indubitable conclusion that it is the very mask photographed in situ and in full costume first published about 1901–3 and then in Harry Hamilton Johnston's 1906 book, *Liberia*. The photographer, Cecil H. Firmin, was an engineer working with the Sierra Leone Government Railway, which began extending the line from Bo to Baiima, near the Liberian border, in 1902. This means Firmin was in Sierra Leone by at least that date, if not before.[55] In the photograph, the figure wearing this mask stands with another Sande masker, clearly participating in a Sande ceremony, with the female initiates in the background (fig. 4.12). Unquestionably, then, both the Yale and Siegmann masks are Sande masks.

The mask is probably from the Southern Bullom (Sherbro), where other high-necked Sande masks are found. The

9

4.13

Probably Southern
Bullom (Sherbro)

Sierra Leone

**BONDO
HELMET
MASK**, late 19th
century

Wood

H. 17 ¹¹⁄₁₆ in.
(45 cm)

This mask was
collected by
the missionaries
Sanford and Esther
Sage in Sierra
Leone sometime
between 1883
and 1890. It is
now in the Udvari
Collection.

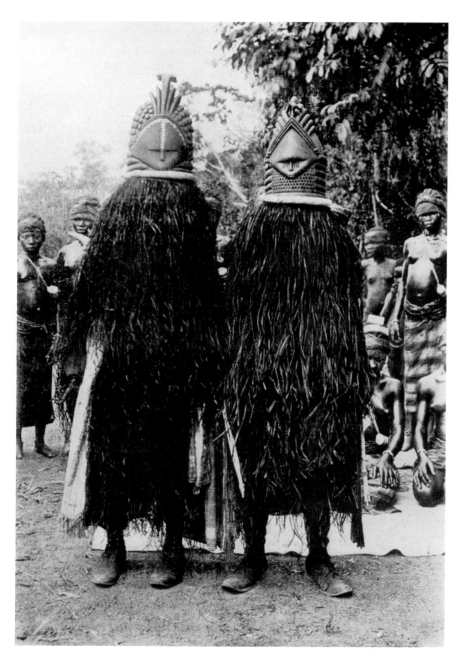

4.12

Two Bondo maskers, probably Southern Bullom (Sherbro), are seen in this Cecil H.
Firmin photograph taken in Sierra Leone around 1900. The mask on the right (from
Workshop Nòwo-62) is now in the Yale University Art Gallery, Gift of Charles D.
Miller III, acc. no. 2008.200.2.

photograph may have been taken among the Vai, as Johnston's 1906 text suggests, or among the Southern Bullom, which I think is more likely. Several data support this: First, the fact that the photograph is labeled "Bundu Devils" in this early publication suggests the Southern Bullom (Sherbro) or their linguistic relatives, who call their women's association Bondo, rather than the Vai of the Sierra Leone-Liberia borderland, where the term Bondo/Bundu is less commonly known. Second, Firmin in his commentary about the photograph describes the masqueraders as feminine, as they are identified (in every aspect: the spirit represented, the mask and masquerade, and the wearer) by all groups in Sierra Leone except the Vai, who, with their neighbors the Gola are said to regard the mask and masquerade as masculine (although usually danced by the women of Sande, but occasionally by men for Sande events).[56] Third, this mask is clearly by the same hand as one collected by Sanford and Esther Sage in Sierra Leone sometime between 1883 and 1890 (fig. 4.13). The Sages were missionaries stationed at Rotifunk, which is at the juncture of the Southern Bullom (Sherbro), Temne, and Mende areas, and other objects collected by missionaries also at Rotifunk are almost certainly Bullom.[57] So this Siegmann mask and the Yale and Sage masks by the same hand are most likely Southern Bullom (Sherbro). The fact that the Sages acquired the mask during their missionary tours in the 1880s pushes the date when this carver would have been active to the late nineteenth century.

MALE NON-SANDE HELMET MASKS

One object that Siegmann classed as a "Bundu mask" (cat. no. 21) is instead almost certainly a men's mask from a tradition that has not yet been studied. Unlike the helmet-shaped women's Sande/Bondo masks of Sierra Leone and Liberia, which are numerous, similar helmet masks that appear to be male are extremely rare. Nothing has been published regarding their use or the ritual association to which they might belong. Siegmann mentioned this himself, reporting that in the Moyamba District, in west-central Sierra Leone, a male initiation association exists that has been "inappropriately called 'Male Bundu,'" possibly originating with the Temne. He offered this is as one of many possible contexts, believing that this particular mask was linked with one of numerous male associations in the Poro association region.[58]

The common diagnostic of these male masks is the representation of a beard, carved as a prominent cowl below the chin in this case but often more stylized. Although this mask is delicate and thin-walled like the female Sande masks, male masks tend to be bulkier and heavier, with some aggressive natural features. Some female masks have horns, but those tend to be curved and either roughly horizontal or downward-pointing, like cow horns. But on male masks the heavy horns project upward, as on this one. An allusion to medical expertise and the manipulation of spiritual forces is evidenced in the special flaps that shield the face. These probably are related to the four decorated leather flaps usually wrapped around the neck of

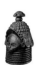
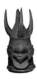

10 21

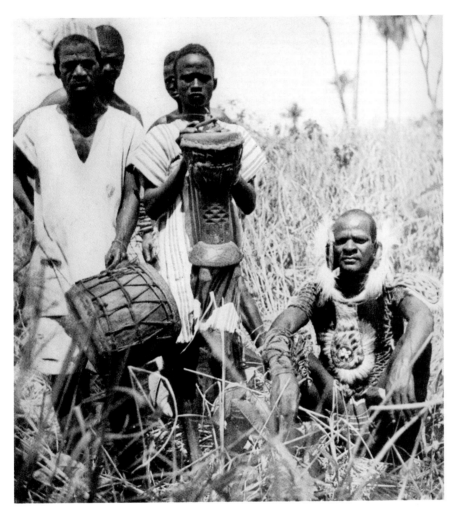

4.14

A Mende healer of the Ngufoi association, Sierra Leone, is seen in this photograph, which is figure 151 in the ethnographer Rudolf Eberl's 1936 report on his 1935 tour of that country.

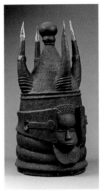

4.15

Probably Mende

Moyamba District, Sierra Leone

MALE HELMET MASK, late 19th or early 20th century

Wood, metal

H. 18 ⅞ in. (47.9 cm)

The Metropolitan Museum of Art, New York, NY, U.S.A.: Gift of Robert and Nancy Nooter, 1982 (1982.489)

a traditional male healer (fig. **4.14**; see also the flaps on the costumes in figs. **4.21** and **4.22**). Such flaps occasionally appear on Sande masks in a range of configurations—for example, the vertical flaps attached to the hairdo of the Sande mask in the Brooklyn Museum collection (cat. no. **10**). On the Siegmann male helmet mask, the two flaps serve as blinders, suggesting the secrecy in which this mask and its exclusive ceremonial membership function. Four other, almost identical masks are known—one in the Metropolitan Museum of Art (fig. **4.15**) and three others in private collections.

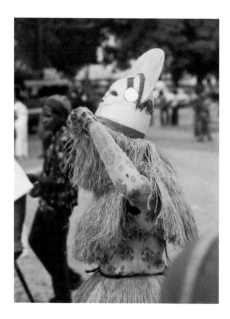

4.16

A male Mende mask is shown in use, Moyamba, Moyamba District, Southern Province, Sierra Leone, 1980. *Photograph by Frederick John Lamp.*

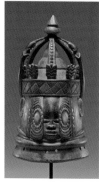

4.17

Probably Sogande the father or an earlier member of Workshop Nòwo-9

Mende

Sierra Leone

MALE HELMET MASK, early–mid-20th century

Wood, paint

H. 17 ½ in. (44.4 cm)

Yale University Art Gallery: Leonard C. Hanna, Jr., Class of 1913, Fund 2011.133.2

William Siegmann collected this mask.

Other male masks have some sort of representation of a beard, aggressive symbols such as bull horns and snakes, larger overall portions, and, often, no neck rings or modified neck rings.[59] Male masks tend to be more adventuresome in their physical characteristics than their female counterparts. For example, a Mende male mask I photographed in a 1980 performance in Moyamba District, in west-central Sierra Leone, was painted bright yellow and red (fig. 4.16). A mask in the Yale University Art Gallery, collected by Siegmann and probably carved by the elder Sogande (fig. 4.17; compare this with the Siegmann Sande mask cat. no. 2), bears some red and blue paint. It also has a twined cord below the chin, which would seem to represent a beard—similar to the braided beards worn exclusively by chiefs in Sierra Leone. Three male masks by the same hand in the collection of the Wereldmuseum, Rotterdam (formerly the Museum voor Land- en Volkenkunde) (fig. 4.18), the Peabody Museum of Archaeology and Ethnology at Harvard University, and the Royal Albert Memorial Museum, Exeter, England, also take the form of the Sande mask but have a striated beardlike band around the chin, stretching from ear to ear. Two other male helmet masks—in the collection of the Samuel P. Harn Museum of Art, University of Florida, Gainesville (fig. 4.19), and the former collection of Joseph Mueller, Solothurn,

Switzerland—also resemble Sande masks but have a chin band formed of a beaded row that presumably represents a beard.

The Mende are well known for their prolific use of masks of all sorts and in media that include wood, cloth, and fiber, among others. They have quite a few men's ceremonial associations that employ masks, while there are a number of masks that seem to be independent of any ritual institution. The powerful Poro, the universal male initiation association in Mende society, has many masks, including the great *goboi* and *gbini* fiber masks. Yet because of the reign of secrecy within Poro, their masks have been little studied.

Three other possible contexts for a male wooden helmet mask are suggested in the literature. One is Humoi, a healing association that is dominated by women but also admits men. A Humoi masked dancer, identified as male, is pictured in Migeod's "A View of Sierra Leone" wearing a similar helmet mask (fig. **4.20**). The wooden mask does not seem to fit over the wearer's head, as a Sande mask would, but rather to perch atop the head.[60]

Njaye is another healing association that is led by women but has male and female members. It is known to employ a Sande-type helmet mask as well, although one of the few

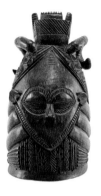

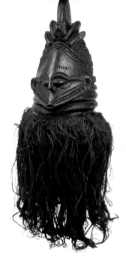

4.18

Mende

Sierra Leone

MALE HELMET MASK, late 19th century

Wood

H. 16 in. (40.6 cm)

Collection Wereldmuseum, Rotterdam 14292, ex-J. J. Korndorffer

4.19

Vai

Liberia or Sierra Leone

MALE HELMET MASK, 20th century

Wood, vegetable fiber

H. 32 ½ in. (82.6 cm)

Samuel P. Harn Museum of Art, University of Florida, Gainesville: Gift of Rod McGalliard 1990.14.98

4.20
A Humoi
association dancer
in Bandajuma,
Sowa Chiefdom,
Pujehun District,
Southern Province,
Sierra Leone, is
shown in this
photograph,
which is plate VI
in Frederick
Migeod's "A View
of Sierra Leone"
(1927).

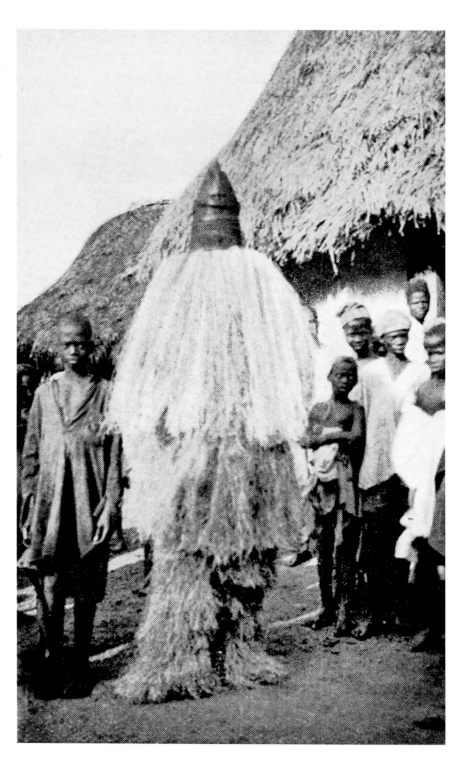

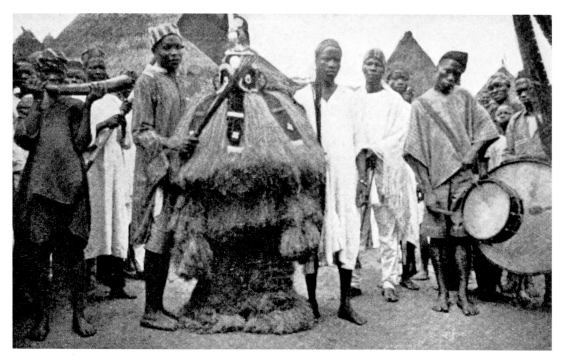

4.21
A Kpolo-Mia-Ngundu association dancer in Nyandehun, Sierra Leone, is seen in this photograph, which is plate VI in Migeod's "A View of Sierra Leone."

known examples, documented by Ruth Phillips, seems quite aberrant—as a plain helmet with perforations for the eyes, with a woman's head and neck on top.[61] In some cases, the Njaye mask is simply a more rudimentary carving of the Sande mask, painted with spots.

Finally, Kpolo-Mia-Ngundu is an association in which a performer wears a big fiber costume. But Migeod's photograph seems to show a helmet mask topped by the head of a female figure, with the four leather flaps of the male healer mentioned above, which seem to have rosettes at each end (fig. 4.21). Phillips illustrated a similar men's mask called *Jobai*, made around 1966—a four-faced helmet mask surmounted by a female head and neck, decorated with four flaps made of cloth (fig. 4.22)—greatly enlarged

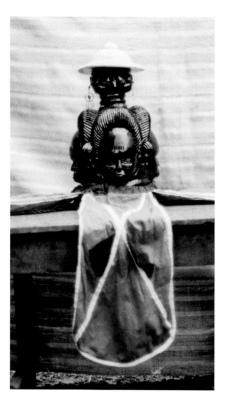

4.22
Momoh Lamin carved this mask, called *Jobai*, around 1966. Kponima, Jaiama-Bongor, Bo District, Southern Province, Sierra Leone. The photograph is figure 3.16c in Ruth Phillips's book *Representing Woman*.

from the earlier customary leather-and-fur flaps that Eberl had photographed (fig. 4.14).

Each of these male masks, like all Mende male masks, is costumed with white-bleached raffia rather than with the black raffia that accompanies the blackened Sande female mask. None of the apparently male masks in collections, mentioned above, retains any of its original costume; so that diagnostic is not available to us. The Siegmann mask under consideration is probably from one of the male societies—Poro, Humoi, Njaye, or Kpolo-Mia-Ngundu—and poses many interesting questions for future research.

.

Let us be clear that the search for names and personalities in the arts is our obsession, not that of the Africans under discussion here. During the last couple of decades, Africanist art historians have been dedicated to erasing the identifier "anonymous." We believe that individual artists deserve credit and praise, to the point of adoration and even worship. Although the cult of personality is pervasive in the United States and, to a lesser extent, in Europe, it is not, in my experience, a cult that has interested Africans for the most part. Elsewhere, I have cited examples of some

Africans' nearly complete indifference about the identity of artists—even practitioners of those arts about which they are passionate and in which they are deeply engaged.[62] This was so even in cases where the artist in question was still active in the community; it was a fact that emerged rarely in the course of my inquiries, and often late in the research tour—a result of my constant prodding.

The fact is that artists in the Sande/Bondo region, working on sacred forms, often do so in severe secrecy, imposed to ward off prying eyes. So the production of art is often not open to observation even by the indigenous users of that art. Furthermore, many sacred masks, such as those of the *Nòwo*, are said to be "found" or "discovered" in nature, not made by human hands; so it would be a violation to attribute a mask to a particular carver.[63] One might even argue that we are abusing the trust of those we study by revealing the artistic source of the mask. The artworks do not bear signatures of any kind. Carvers themselves are known to deny the existence of other carvers, even of their own mentors (who in some instances are their fathers), claiming

that their artistry is self-taught.[64] Although the identity of an artist himself, independent of his specific works, is not secret, and he may be admired, he (and, in the case of these masks, it is always "he") is not set on a pedestal, and his name does not live on in perpetuity.

In the present study, I have engaged in a particularly Western occupation: the examination of personality. But it is a useful occupation, in that it helps sharpen our powers of observation and our understanding of human agency in the arts. Sande officials and Mende carvers do not write books and articles on the Sande, nor do they even like to discuss it with outsiders. This is what we, as scholars, do.

We have little written legacy from the artists whose work I have examined in this essay, only the intriguing forms and shapes they produced—their fruits—which suggest tantalizing interpretations. In the Sande/Bondo region, the range of formal ideas held by these disparate artists is enormous, so much so that we can only speak of personal styles, not of cultural or ethnic styles, as it is a region of little formal centralization or even consensus. Given a body of works available in images with multiple views—especially with twenty or thirty examples—one begins to get a sense

of individual choices made from one time to another, and also of the larger parameters within which the carver chose to work.

What is missing, and cannot be obtained, is the exegesis of the carvers themselves about the impetus for and significance of their choices. Nor can we solicit expressions of affect, interpretation, or criticism from the carver's constituency—the local people who observed the masks, feared them or celebrated them, reveled in their beauty and their kinesthetic efficacy, held them and felt their shapes, and experienced, perhaps, an effervescence, a spiritual possession, or a transporting to other states of consciousness while wearing them. That opportunity is now closed in regard to the masks under consideration here. But it remains open for the current state of art, whatever that may be, however disjunctive from the past, and however more or less embedded it may be in the type of codified cultural structure, with cultural consensus, that produced the Sande masks and their use in performance.

DANIEL B. REED

Spirits from the Forest:
Dan Masks in Performance and Everyday Life

For many of the Dan, a southern Mande group whose homeland straddles the border between Côte d'Ivoire and Liberia, masks are one part of a multifaceted, complex phenomenon called *Ge*.[1] Although *Ge* (or *Gle*, as among the western and southern Dan) has generally been translated in the scholarly literature as "mask," some Dan argue that it is more accurate to characterize a Dan mask as but one aspect of the visual manifestation of a *ge* spirit in performance. (Here I capitalize *Ge* when referring to the institution and philosophical concept, and lowercase *ge* when referring to specific forest spirits.[2])

Ge performances were commonplace in the postcolonial setting of 1990s western Côte d'Ivoire, where longstanding traditions were mixed with social practices and institutions introduced earlier in the twentieth century.[3] Historically farmers, many of the Dan continued their agricultural practices. For some, agriculture was a business—growing coffee, cacao, rice, and other crops for sale. Subsistence farming also remained common. Many Dan in the late twentieth century, however, lived in Dan-region cities such as Man and Danane and worked in the service economy, selling goods in urban markets or working in local businesses. A large Dan population also inhabited southern Côte d'Ivoire, working on plantations or adapting to urban life in Abidjan. Many of the Dan were Christian or Muslim, while some

interwove world religious traditions with indigenous practices such as *Ge*. Although not every Dan person continued to value *ge*, many found creative ways to keep what some called "The Tradition" or "the tradition of our ancestors" relevant in their lives.[4]

Many of the Dan say that *Ge* originated during the time of their ancestors. Individual *ge* spirits spend most of their time residing in a spiritual realm called *gebo*, alongside ancestors and other spirits who serve as intermediaries between people and *Zlan* (God). When the Dan have need of one of these spirits, they summon it—usually through music—across the boundary between the spiritual and the corporeal realms, where it manifests itself among humans in performance. Each *ge* assumes a particular form, often as a masked figure dancing to a drum ensemble. When a *ge* performs, all elements of its presentation—song, drums, rhythm, dance steps, gestures, verbal utterances such as proverbs or divinations, and costume (including raffia skirt, conical leather hat, fly whisk, and mask)—are transformed into manifestations of a *ge* spirit. The masks in this book, therefore, comprise only one element in a multifaceted, multimedia enactment of belief and social ideals.

There are dozens of types of *ge*, each with a particular purpose in Dan life. A *deangle*, for example, oversees the initiation of young boys into adulthood (fig. **5.1**, right); a *sakpe* inspects family compounds to ensure that no one starts a cooking fire during the windy times of day in the dry

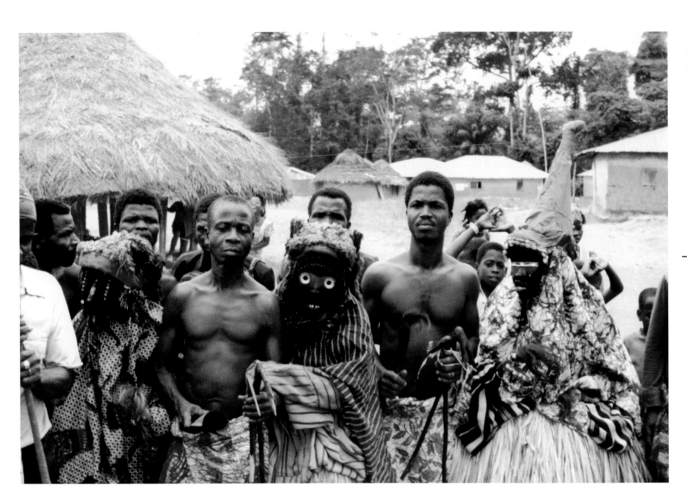

5.1
Dancers in (left to
right) *kagle*, *bagle*,
and *deangle*
masks. Nyor
Diaple, Liberia,
1983. *Photograph by
William Siegmann.*

season; a *zuge* heals, offers divinations, and solves sorcery crimes; a *tankoe ge* (or *tanke gle*) expresses community joy at celebratory occasions such as funerals, harvest festivals, and political public-relations events. As the elder Gueu Gbe Alphonse once told me, "For every function that exists in Dan society, there is a mask . . . that ensures that function."[5]

In the following narrative example, a *gegbleen* (literally, a long/tall *ge*; a *ge* who dances on stilts) was called upon to perform at an event celebrating the first-ever visit to the village of Biélé by the newly installed prefect (equivalent to a U.S. governor) of the Région des 18 Montagnes (Region of the 18 Mountains, a "region" here being a political entity roughly equivalent to a U.S. state). In Dan country, the presence of a *ge* validates an important occasion. As the ultimate authority in Dan communities, a *ge* is a spirit upon whom the power of local politicians rests. A prefect visiting a Dan village and not being greeted by a *ge* could be insulted.

February 1997. A warm morning in the dry season, and I waited, along with hundreds of Dan people, along the main dirt road leading into the village of Biélé, in western Côte d'Ivoire. Dust was kicked up as people wandered about making the rounds, greeting neighbors and looking in on various musical groups that had gathered in this village of roughly a thousand people to receive an introductory visit by the new prefect of the Région des 18 Montagnes. At long last, we heard a stir from down the road, and excited villagers leaned forward to catch a glimpse of two cars rolling into the village. The new prefect, dressed in his beige uniform, waved to the crowd from the backseat of the second car. As the cars drove in, a figure on stilts exited a sacred hut, leaning low to clear the hanging raffia marking the human-sized door as a sacred passageway.

Promenading toward the cars to greet the new prefect was a gegbleen—a stilt-walking masked forest spirit. While the human dignitaries waited, seated in the shade of a shelter, the gegbleen walked toward the prefect's car, followed by several male drummers and a chorus of women and men singing songs in call-and-response as they stepped forward to the beat. The car slowed as the towering figure approached, leaned down, shook the hand of the prefect, and released a commanding falsetto scream before whirling about, with one six-foot-long leg extended above the heads of the crowd. The instant the leg was replanted on the ground, the figure began to dance. "Mèngban waa wondo gewon ye dhoe" (Not everyone knows that the system of Ge exists), called a middle-aged female lead singer, a companion harmonizing in parallel fourths below the melody. "Gewon ye dhoe" (The system of Ge exists), responded the chorus. Still dancing, the ge again screamed in falsetto, then pointed to the drummers with his two fly whisks

32 33

in a gesture meaning "stop." The music trailed off as the ge
leaned his long frame against a thatched-roof hut, taking a
rest while the prefect and his entourage turned to walk toward
the shelter to greet the village chief.

The stilt *ge* is exceptional among Dan masks in that it features a distinctive, nonrepresentational facial covering constructed from fiber. Most Dan masks are made of wood, and some can be readily identified simply by their formal features. The *gunyege*'s facial structure, including its round, "male" eyes, identifies it as the face of a racing *ge* (cat. no. 32). The object William Siegmann identified as a "family mask" (cat. no. 33) bears the characteristic features, such as a straight line running through the center of the forehead, of a *deangle*—the circumcision/initiation *ge*. In most cases, however, it is problematic to categorize Dan masks. One reason is that the Dan classify *ge* not only by form but also by function. For example, in my 2003 book, *Dan Ge Performance: Masks and Music in Contemporary Côte d'Ivoire*, I wrote about a sorcery-catching *ge* whose mask featured a beak protruding from its oval face. Because of the beak, the Dan would classify this *ge*'s form as a *gegon* (male mask). Functionally, however, this is a *zuge*, a *ge* whose role is to heal, offer divinations, and solve sorcery crimes. Adding further complication is the fact that a *ge*'s function can change over time. For example, in the city of Man in the 1990s, I encountered a *gegon* that formerly had served as an enforcer of social norms through proverbs and the recollection of local family histories but had transformed into a rejoicing, dance *ge*. For these and other reasons, the Dan sociologist Daouda Gba claims, "the problem [of classification of Dan masks] is deeper than one can imagine."[6]

Notwithstanding their generic ambiguity, *genu* (plural of *ge*) are pervasive in the Dan region, and especially commonplace is the image of the mask. In the Ivorian west (in the mountains at the borderland between Liberia, Guinea, and Côte d'Ivoire), masks are ubiquitous. The city of Man boasts a *gegbleen* statue at the center of a prominent traffic roundabout. Also, images of masks are painted on sides of buildings and printed on local business cards. Nothing is more symbolic of this region than the image of the Dan mask, and for good reason. Walking down the street, one might pass a *trukoe ge*—a comedian who goes door to door telling jokes and stories and singing songs accompanied by the complex cross-rhythms of his gourd rattle and by the ankle bells above his dancing feet. One might walk by a family compound where a man sits before a dancing *gegon*, waiting for him to deliver a cure from the spirit world for his perplexing illness. At a village funeral, a *tankoe ge* celebrates an elder's life by joyously matching a master

drummer's rapid solo pattern beat for beat with jangling ankle bells on his dancing feet. In the village or urban-neighborhood commons, or at a local soccer field, the crowd cheers as a racing *ge* speeds off in pursuit of a human runner. Truly, *genu* are everywhere.

April 1997. "Dho n ka-o" *(Send me-oh), sang a young man. "Dho n ka, dho n ka" (Send me, send me), a chorus of young men responded. They sang in urgent, strident tones, the short, percussive melody punctuating the rapidly drummed rhythms of* giantan, *or war song/dance. The cryptic lyrics metaphori-cally suggested the brash confidence of youth asking to be sent into battle. In the context of the Léon Robert Stadium in downtown Man, Côte d'Ivoire, however, the young men sang this song to raise the spiritual energy for the* gebian, *or ge race, a traditional sporting event in which humans try to outpace a* gunyege, *or racing ge.*[7] *In an interview five months later, Monsieur Lou, leader of a musical group that is regularly hired to perform at* gebian *events, explained this event to me:*

> Music is very important for a race mask. If there is no music, [the *ge*] is in the dark, not inspired. Even if there is music, but the music is not good, he is not encouraged. . . . His *yinan* [a type of spirit] are not there without the music. . . . The most powerful force of the *ge* is the music. . . . The *yinan* come with the sound of the drum.[8]

The energy became frenetic, building as the young men smiled, danced, sweated, gestured, and kept singing. Like marching bands at sporting events in the United States, music of a mili-tary origin was employed to inspire athletes to realize their greatest potential. This group played to inspire both ge *and human racers for their team, representing the Man neighbor-hood of Petit Gbapleu. A comparable group performed at the other end of the soccer field in support of the competing team from the nearby village of Bigouin. Each team's ge had selected two racers from the other team to pursue. In front of the soccer goalpost, the first of Petit Gbapleu's human racers assumed position, with the Bigouin* gunyege—*his round eyes outlined in white, wearing lavender sweatpants, a green-and-blue patterned cloth hood and a black T-shirt that read (in English) "Way Cool!"—starting two meters behind to allow a handicap for the human who tries to outpace the spirit. Just behind the goalpost, a third, neutral group of drummers and singers began playing yet another* giantan *intended to "heat up the place."*[9] *An official fired a gun with blanks and they were off, the* ge *in hot pursuit of the human, who had to run the length of the soccer field, around the far goalpost and back to the starting line without being caught by the* ge. *The*

human runner, barefoot and wearing only shorts, sprinted madly, occasionally looking over his shoulder as the gun-yege gained ground. The crowd of hundreds cheered from the grandstand, their volume increasing as the ge closed in, reached out, and grabbed the human by the shoulders, winning round one.

Preparations continued in the Petit Gbapleu huddle, as a mystical, spiritual specialist called a zumi arrived, his face painted white with kaolin. He held, on the end of a stick, a sacrificed lizard—a type known for its quickness and speed, properties that had been augmented by herbal medicines sewn into its stomach. Petit Gbapleu's gunyege, whose face featured yellow stripes just above and below his eyes and who wore a matching yellow shawl draped over his head and shoulders, placed first his right and then his left foot on top of the lizard, drawing in its power. A sakpe, a kind of police ge, with protruding round eyes and hair made of freshly cut green leaves, arrived to oversee the event and to ensure that everything was being done in accordance with Dan custom. The group's leader grabbed a piercingly loud clappered bell and jogged confidently around the field, raising more energy and trying to intimidate the group's opponents. Sufficiently prepared, his yinan animated, Petit Gbapleu's ge jogged to the starting line as the crowd roared.

Theoretically, a racing ge should be the fastest runner around, since the spirit of Ge manifests and symbolizes Dan social ideals. "Idealized realism," the term that the Belgian art historian P. J. Vandenhoute coined to describe the visual form of Dan masks, also captures something of the meaning of Ge for many Dan.[10] A ge that solves sorcery crimes? No human could do it better. A dance ge? The best dancer around. Ge embodies idealized behavior, and in that sense it represents Dan cultural identity in idealized form. Oddly enough, though, a human sometimes does triumph over a racing ge, demonstrating that the omniscience and omnipotence generally attributed to ge spirits do not necessarily obtain for "lighter" spirits such as the racing ge. The racing ge is by far the exception in this regard, however. Generally speaking, Ge represents, indeed manifests, ultimate authority and ideal behavior. Some Dan assert that the spiritual basis for the education taught in initiation—when young Dan individuals learn how to become adults—is itself Ge. Both identity as a Dan person and the notion of ideal behavior for Dan adults are inextricably tied to Ge. Performing ge spirits manifest these same notions by being exemplary at whatever function is theirs to fulfill, whether it be healing or inspiring warriors headed into battle.

5.2
Dancer in *kagle*
mask. Nyor
Diaple, Liberia,
1983. *Photograph by*
William Siegmann.

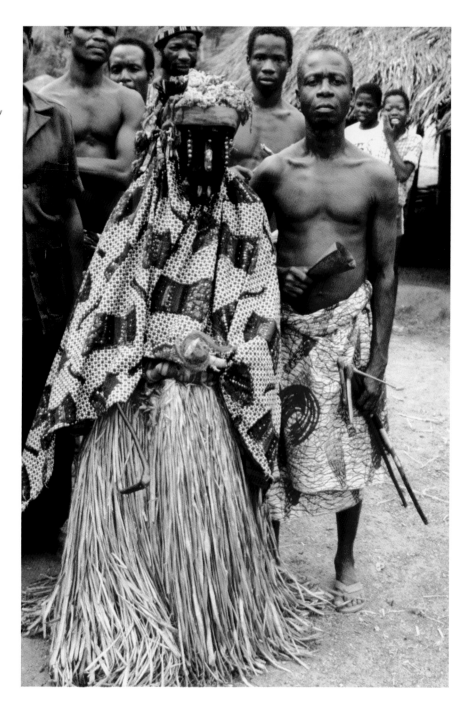

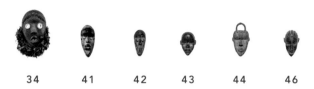

34　41　42　43　44　46

One type of *ge*—the *kao gle*—reinforces proper behavior through ritual inversion, that is, as the art historian Robert Farris Thompson wrote, "by doing the wrong thing dramatically."[11] Representing a chimpanzee, the *kao gle* makes trouble: chasing women and children, harassing goats or chickens, or swatting people with his hooked stick, called a *ka* (hence the term *ka gle, or kagle*—the generic category for all *genu* who appear with a hooked stick) (fig. 5.2). By exhibiting wild, erratic behavior, the *kao gle* inversely promotes appropriate behavior and social ideals.[12]

Also included in this book are several examples of miniature masks, sometimes called "passport masks" (cat. nos. 41–44 and 46). In a 2011 interview with Amyas Naegele, William Siegmann described the role of miniature masks in Dan life:

> [T]hese masks are actually used, basically, as protective devices and are carried by individuals. You basically have to have permission from the elders to recognize that you have status in the community, number one, but that you also have a special spiritual relationship with the protective spirit. The masks, as I say in Dan, are called *ma go*. When there are meetings for certain purposes, and a group of individuals will gather together, elders in the community and such, they may display these. They may take out their own personal masks to essentially identify that they have the right to be there.[13]

The anthropologists Eberhard Fischer and Hans Himmelheber, among others, confirm what Siegmann said, writing that the miniatures are a kind of portable extension of the power of a *ge* based in the home community of a "mask family."[14] Family members carry the miniature when away from home so as to remain protected from malevolent spiritual forces. The literature on Dan masks also describes the use of these small objects as identity cards, rather like passports, when traveling away from one's village, in order to prove one's familial status to strangers. Siegmann took issue with this notion, however:

> It's not about traveling. . . . These things are not shown to other people, they are often kept in bags or you keep them in your pocket and such. They acquire different patinas. Sometimes they're sewn into a cloth bag, and in many other cases they're kept in your pocket where you can feel it in your hand.[15]

Also included in *Visions from the Forests* is a mask collected in the late twentieth century from Dan people in Nyor Diaple, Liberia (cat. no. 34). In the same interview with Naegele, Siegmann described this object:

> SIEGMANN: That particular mask was called Eagle. The owner of the mask sold a mask that belonged to somebody else in his family, but he didn't have the rights to do it. . . . Eagle was essentially banished from

the town, but on the other hand they created a new mask that imitated Eagle, and that was called Hawk, *Slu* [in Dan], and that mask, in effect, took on all the musicians, other attendants and such, and was very, very similar to Eagle. I think there was a certain amount of copyright infringement here. In the end . . . there was a reconciliation between the owner of Eagle and the townspeople. Both masks ended up getting sold, and a third mask was created. I have the second mask. I have *Slu*.

NAEGELE: You have Hawk.

SIEGMANN: I have Hawk.

NAEGELE: And Eagle?

SIEGMANN: Eagle went to, I think, Hans Himmelheber.

NAEGELE: And the third one?

SIEGMANN: The third one was still performing, presumably, up to the [Liberian] Civil War. [16]

Siegmann and Naegele then broached the sensitive topic of the identity of the person dancing a mask:

NAEGELE: The mask had a personality, but the people knew who was dancing it.

SIEGMANN: Yes. . . . It's kind of suspended disbelief because I knew who was dancing *Slu*, and he used to torment me with that, because of course I couldn't tell anyone. Everybody in town knew who it was, I mean. . . . If you're in a small town and somebody is consistently missing whenever the mask is performing, [it] doesn't take too many brains to figure it out. . . . It was an interesting kind of dynamic. . . . There's still a belief that there's a spirit force behind it.

Siegmann's remarks convey the ambiguous nature of Dan mask culture. The fact that nearly everyone knows there is a person behind the mask and that many people know who it is in no way diminishes the belief that everything in the performance, including the human being, is transformed into a spirit. A reasonable analogy

is the idea of transubstantiation in the Catholic Church. Everyone knows the wine or juice and crackers or wafers were purchased at a store and brought to the church for Mass. But knowing this does not render less real the belief that those foodstuffs are, in the moment of communion, transformed into the blood and body of Christ.

Although the masks in the Siegmann collection unquestionably are tied to belief, ultimately *Ge*, like most West African religious practice, is more about behavior than belief. *Ge* is action oriented; it gets things done. And yet in the 1990s, not all Dan believed in or continued to engage in performances of *ge*. In a postcolonial world, *genu* sometimes faced competition with other entities for peoples' belief and loyalty. For example, an intractable conflict between neighbors could be resolved by a *ge*, or could be brought before the judiciary and solved in an Ivorian court of law. A medical problem could send someone either to the hospital or to a *zuge*. A psychological or personal crisis could lead a person to a priest, a marabout, a sacred mountain, or a *ge*.

Yet despite the dramatic social and infrastructural changes wrought by colonialism, many Dan had found ways to maintain the relevance of *ge* in their lives. Increasingly, they recognized, and continued to embrace, the tradition as an expression of Dan ethnic identity in the context of growing cultural diversity. The colonial and postcolonial contexts also provided increased opportunities for entertainment, dance, and/or rejoicing *genu*, who performed not only at life-cycle and harvest rituals but also at events such as staged presentations at tourist hotels and the ceremonial openings of new schools. In addition, *ge* rituals have been enacted on stages around the world by the Ballet National de Côte d'Ivoire and at such political public-relations events as the prefect's visit to Biélé mentioned earlier. The federal judiciary even hired certain *genu* whose job description included solving sorcery conflicts to help enforce anti-sorcery laws in the Ivorian penal code. Far from fading into oblivion in the face of contemporary social upheavals, masks like those in this book continued being used in various ways in the pluralistic setting of late-twentieth-century Côte d'Ivoire.

BARBARA C. JOHNSON

Brass Casting in Liberia

For a brief period early in the twentieth century, a few Liberian sculptors pursued figurative brass casting. The Viennese anthropologist and philologist Etta Becker-Donner, who in 1934 began studying the culture and languages of the people in northeastern Liberia, wrote that she knew of only two brass sculptors, but she didn't record their names.[1] Although well known in their own communities, these brass casters remained largely anonymous until the late twentieth century, when field researchers identified the two who are represented in this book: Ldamie, of Gaple (cat. no. 48) and John Leh, of Gbabobli (cat. nos. 49 and 50).

Historically, copper and its alloys of brass and bronze were precious metals in the African system of values.[2] For many centuries before maritime trade flourished on the west coast of Africa, voluminous quantities of brass crossed the Sahara in camel caravans to various parts of the continent. The brass forms were largely rods, bowls, and basins, and they came from the greater Mediterranean world (which included western Asia and the Indian Ocean regions) in exchange for gold and ivory, as well as such lesser commodities as gum, dye wood, and pepper. In the fifteenth century, the first European traders to reach West Africa introduced brass into the forest region of Liberia and Sierra Leone.[3] For several centuries thereafter, Portuguese, Dutch, French, and British maritime traders supplied this area with tons of brass bars, *manillas* (bracelets used for currency), basins, and jugs.[4]

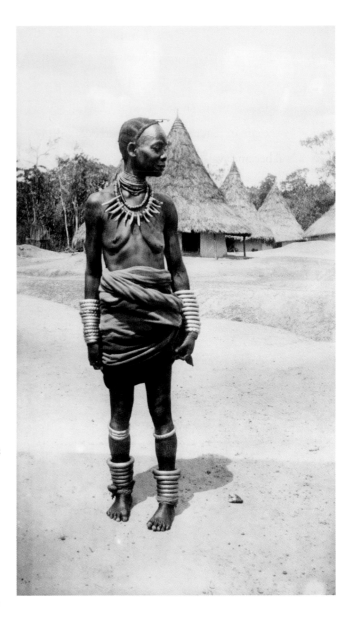

6.1

Woman covered in brass and beaded ornamentation, jewelry, 1929. *Photograph by George Schwab. Peabody Museum of Archaeology and Ethnology, Harvard University, 2004.24.8649 135040053*

48 49 50 52 53

Although little is known about the antiquity of brass casting among the Dan and their neighbors, evidence exists that the art of casting brass jewelry and other objects had been developed by the nineteenth century, and possibly earlier. By the end of that century, new sources of the precious metal became available in Liberia. The imposition of colonial rule in neighboring Côte d'Ivoire and Guinea prompted a brisk trade in brass basins and other brass objects, including old European cannon barrels.[5] Moreover, the so-called pacification of the Liberian interior in the early twentieth century was in fact a time during which the central government in Monrovia gained control over the interior and defended Liberia's borders from neighboring colonial powers—one result of which was the leaving behind of a rich source of brass in the form of spent cartridge shells.[6] After peace was established, it was easier to trade brass into the Dan area, and for a time, artisans produced an abundance of brass jewelry using the lost-wax (or cire perdue) method. (For a description of this method, see page 97.)

It was believed that some brass jewelry magically protected the wearer, but most people wore it simply for prestige or as adornment (fig. **6.1**).[7] Variations included necklaces of brass leopard teeth with brass and glass beads (cat. nos. **52** and **53**), finger rings, bracelets, and rings, sometimes sized to be worn just below the knee or around the ankle. The jewelry was decorated with geometric designs created by adding twisted, spiraled, or braided wax threads to the model before it was cast. Small brass bells were often incorporated into the jewelry design; their tinkling sound, along with the clanging of the brass, added a musical dimension to the overall aesthetic effect.[8] Both men and women wore brass jewelry, although women tended to be more heavily laden. In 1928 George Schwab, a Harvard anthropologist, described the Gio (as the Dan of Liberia were often called) as being

> aglitter from head to foot. Theirs seems to be an exuberant spirit, bursting forth in tinkling bells and clanging brass. With neck, arms, legs, fingers, toes so loaded with massive brass and iron ornaments that they can hardly walk with the weight of them, a grand head woman in Gio presents a dazzling spectacle.[9]

In the past, men had worn *floku* (anklets) of brass, but by the 1930s, Becker-Donner wrote, women wore them almost exclusively and in pairs that might weigh eight or more pounds apiece.[10] Anklets were attached at the time a first or best-loved wife was married, and they were never removed until her death. The weight and richness of these anklets and other brass jewelry reflected a husband's wealth, and they implied that the woman, nearly immobilized by the mass of the metal, could live a life of leisure, while her husband's other wives or retainers did the necessary agricultural work and daily chores.

By the late 1930s, as the republic of Liberia was being developed, male labor was aimed at building roads, not cultivating crops. Women, therefore, worked in the fields and could not be hindered by heavy brass jewelry. In fact, the Hungarian

physician Rudolf Fuszek, minister of health in the new republic, outlawed brass jewelry, claiming it caused chafing infections and orthopedic problems. A result of the diminished use of brass jewelry was an increased availability of brass that could be melted down and recast into new forms.

One new form was the *ma go,* or "small head," a cast-brass miniature mask that the Bassa, neighbors of the Dan in Liberia, probably made. A harmonious tattoo pattern extends from the forehead to the chin of the object, which also has protruding open lips and flared nostrils. Its pierced slit eyes, like those of a *deangle* mask, likely originated with the Dan. The brass miniature mask in the Siegmann collection is a symmetrical work of gentle femininity (cat. no. **44**).

A *ma go* is sometimes seen as a much smaller version of a larger mask, as the present object may be. Sometimes called a passport mask, the *ma go* conferred protection on an individual who carried it—the special spiritual protection of the larger mask. This example, made of prestigious brass, was attached, and gave power, to a medicine packet by its loop. The loop was also the sprue, or funneled opening, through which the molten brass was poured.

The *nitien* (or *tien*), a sacred ring with four knobs, is an older brass object of unknown origins (cat. no. **54**). The Grebo believe a *nitien* embodies a water spirit that dwells in small brooks and creeks in the deepest recesses of the forest. If the spirit can be captured and brought into town, it will roam around at night and apprehend thieves and other miscreants. Furthermore, as an object of divination that can be questioned at times of uncertainty, a *nitien* is a valued and powerful ritual item (fig. **6.2**).[11]

During the brief period in the early twentieth century when brass casting was practiced in some West African countries, sculptors typically produced figures that stand about eight inches (twenty centimeters) tall. Most show objects of cultural importance, such as the clitoridectomy knife that is part of catalogue number **48**, or are genre figures that depict various activities in village life, such as women pounding rice or tending children. Animals such as tortoises (cat. no. **50**), elephants, and dogs are also depicted.

These prestigious figures were often carefully wrapped in cloth and stored in baskets, to be brought out and displayed for honored visitors. Initially, only chiefs and wealthy men could afford this nonessential novelty, this "something different."[12] Commissioning a brass figure was an expensive proposition, as all the brass and other necessary materials had to be supplied by the wealthy man who sought to own one. When the piece was finished, it had to be presented to the village for approval, and a feast had to be provided. Eventually, such brass figures were sold to foreigners, who appreciated their novelty and could better afford them.

Brass casters, respected members of their communities, usually were blacksmiths who possessed the necessary tools and skills to work with metal. The blacksmith in a Dan village

44 48 50 54

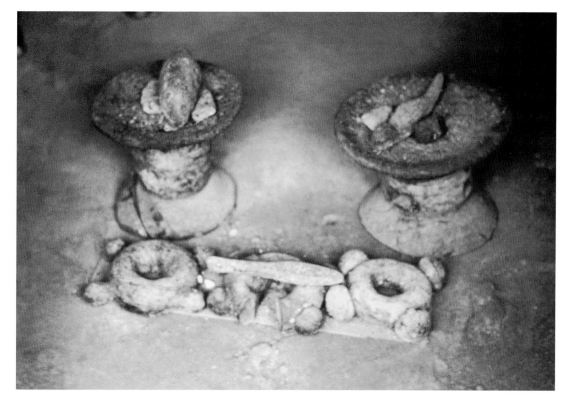

6.2
Shrine with altar that includes *nitien*, stools, and other objects. Grebo culture, Liberia, undated. *Photograph by William Siegmann.*

was always held in high regard and treated well because the community depended on him for its metal agricultural tools and weapons. Traditionally, a blacksmith captured in war was released if he could prove his metal-forging talent.

Unlike in other parts of West Africa, where blacksmiths were physically and socially isolated from the rest of the village, the Dan blacksmith played a central role in the village's political and ritual life. Because his skill was needed for making objects used by the men's initiation society, he was kept informed of political happenings, often performed certain ritual practices such as circumcision, and in many cases was a high-ranking member of the men's society.[13] The

blacksmith shop, a favorite gathering place for village men, was considered sacred because ritual objects were often kept there. Women were forbidden to enter, as were those men who had not been initiated. In addition to their smithing skills, many Dan blacksmiths were also adept wood-carvers. Fashioning wooden handles to fit iron tools often prepared them to master more complex carving. Frequently, those who learned the specialized techniques of brass casting already were blacksmiths and wood-carvers, performing essential functions in the village.

Brass casting took place at night, and very few people were allowed to watch because it was feared that onlookers

6.3
Brass caster John
Leh kneading
beeswax. Gbabobli,
Liberia, 1986.
*Photograph by
William Siegmann.*

6.4
Brass caster John
Leh applying
clay mixture to a
beeswax model.
Gbabobli, Liberia,
1986. *Photograph by
William Siegmann.*

might steal the caster's secrets and spoil his magic. The caster had to observe certain rules and taboos before and during the creative process. He needed to purify his heart and mind by banishing any evil thoughts and feelings, take care not to break anything, abstain from sexual intercourse for the week or so required to produce a brass figure, and avoid women in general because of their perceived tendency toward witchcraft.[14]

THE LOST-WAX (CIRE PERDUE) METHOD

The first step in the lost-wax method involved softening a lump of beeswax in the sun. After pieces of wax were kneaded, some were rolled into threads and wound into spirals, while others were formed as parts of a human or animal figure (fig. 6.3). Once these pieces were assembled, details were impressed into the wax or applied with warm threads of wax. Sprues, the conduits for eventually pouring out the wax and then pouring in the molten brass, were added in the form of thin wax funnels, frequently to the soles of the figures' feet.

The finished wax model was oiled and then covered with a very fine soft clay made from an appropriate soil, such as that of a termite mound or the loamy soil of an old house mixed with the juice of palm leaves (fig. 6.4). It was important to mix sufficient carboniferous matter with the clay in order to absorb heated gasses.[15] Each brass caster was cautiously secretive about which of these ingredients was the most effective. This first layer of clay was thin enough that the shape of the wax model was recognizable. A funnel opening was made to cover the wax sprues, and the clay was allowed to dry slowly in the shade for several days. When this layer was completely dry, thicker, coarser layers of clay were applied and then allowed to dry. These outer layers often had animal hairs or pieces of bark added to strengthen the mold.[16]

Small pieces of brass were melted in a crucible that was placed in a hole in the ground. Bellows brought the burning coals surrounding the hole to a high temperature. The mold also was heated, and the wax was either poured out and saved or burned and vaporized. The molten brass was poured into the funnel opening, filling the shape that the wax had formed in the clay.

The mold was then put in cold water, which immediately hardened the brass. In a few minutes, it was broken open and the brass piece removed. The object was soaked in a concoction made of cola leaves boiled in water, followed by further cleaning with citrus juice to remove any copper residue brought to the surface by reaction to the heat. The sprues were filed off, as were any irregularities, and sometimes the surface was hammered. Finally, the brass sculpture was burnished.

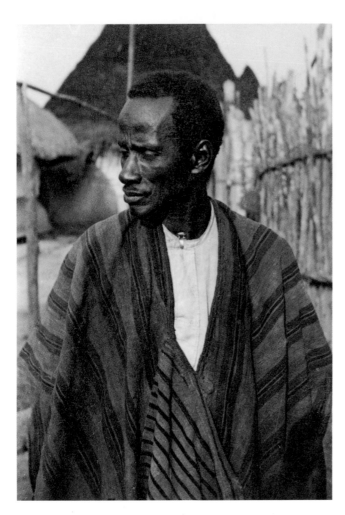

6.5

"Gelbgießer aus Ga-Plei."

Photograph by Etta Becker-Donner.

The Dan artist Ldamie in the 1930s.

LDAMIE (c. 1890–1958?)

In the 1930s, as noted above, Etta Becker-Donner spent time in northeastern Liberia studying the art and handwork of the Dan. When she wrote about brass casting, she mentioned a man from the town of Gaple who was one of only two in that region who cast figures from brass. She included a photograph of him but did not name him (fig. 6.5).

In 1983, nearly fifty years later, I traveled to Gaple with Bill Siegmann, taking a copy of that photograph with me. Ldamie's son Yanemie said the man in the picture was indeed his late father, and a group of old people who saw it concurred. Gbangor Gweh, an oral historian in the neighboring town of Beple, also said it was a picture of Ldamie. In 1986 I met Chief Blazua, son of Chief Toway, in Towaytown. Blauza was another Dan who remembered Ldamie and the many brass objects he had cast (fig. 6.6).

Born in Zonleh, in northeastern Liberia, Ldamie was descended from a long line of brass casters dating back, in memory, to his great-grandfathers. As a boy, he spent hours watching an older male relative named Munmie, who was a master brass caster. From Munmie, Ldamie learned the skills of blacksmithing. He also tried his hand at wood carving, and eventually learned the technique of brass casting. But according to Dan belief and the people who remembered Ldamie, dreams were the true source of his artistic ability.

"Dreams tell you what God has already made you," a woodcarver named Dro explained to me.[17] The Dan believe that

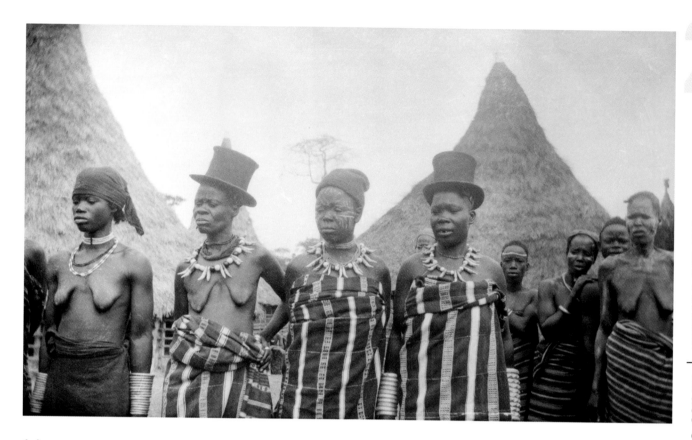

6.6

"Sesengge and Two Wives." Chief Toway's wives, bedecked with jewelry, 1929. *Photograph by George Schwab. Peabody Museum of Archaeology and Ethnology, Harvard University, 2004.24.8651 135040055*

dreaming is the mechanism through which *du*, the spiritual power essential to becoming great in any area, communicates with individuals. As a force that is present in all aspects of the universe, *du* can be harnessed by man for either good or evil. It may take any form, natural or man-made, and it announces its presence in a dream. Besides communicating its earthly form, *du* also conveys specific power and ability through dreams. Since one who has excelled in any area is presumed to have acquired *du* by this means, Dan woodcarvers naturally attribute their artistry to dreams.[18] When Gbangor Gweh, of Beple, was interviewed and asked how Ldamie had become famous, he replied that he did not know what kind of special power Ldamie had used, nor did he know about Ldamie's dreams. Nevertheless, as he

acknowledged to me in March 1983, "there were and are people who can dream and make their pursuit famous."[19]

As a child, Ldamie migrated with his family to the nearby town of Gaple, where he lived the rest of his life. He married and, with his wives, cultivated rice and other foods. Unable to earn a living from their art alone, artists of this area have almost always had to be farmers, frequently growing the cash crops of coffee and cocoa.

According to his son, Ldamie's big break came when a government official with a broken typewriter visited Gaple. Although Ldamie could neither read nor write, he proved his metalworking skill to the official by repairing the machine. After that, he began casting brass figures for

officials to take back to the national capital, Monrovia. His name spread, and so did his fame. Eventually, the government had a workshop built for Ldamie, who became, his son said, "so rich and famous that he was carried everywhere in a hammock and never again had to walk."[20]

Besides casting brass swords, sword handles and sheaths, gun handles, jewelry, bells, and animals, Ldamie also was one of the few figurative brass casters in the region. He observed life around him and captured, in genre figures, villagers performing daily activities. These were often cast as status objects for a chief or a wealthy man.

Almost all known pieces by Ldamie were collected in Liberia in the 1920s and 1930s. One exception was an outstanding object Bill Siegmann found in Dan country in 1986 (cat. no. **48**). This female figure wears a necklace, with brass leopard teeth in back, a band of beads around her waist, and a pair of brass knee rings worn, in traditional fashion, between knee and calf. She carries a large knife in her right hand. Typically, Ldamie hammered the brass figure after casting it, a technique that produces an attractive faceted surface. Becker-Donner described Ldamie as a "genuine craftsman who obstinately sticks to old complicated subjects and carefully hammers the metal smooth after it has cooled."[21] Other stylistic characteristics of his work include similar facial features and body shapes; he usually depicted hands and feet as flat and rigid, and he indicated fingers and toes with incised lines, including the details of fingernails and toenails. Another mark of Ldamie's work was the creation of pouring sprues cut into the soles of the feet.

6.7

John Leh demonstrating brass casting. Gbabobli, Liberia, 1986. *Photograph by William Siegmann.*

JOHN LEH (c. 1900–1987)

In 1986, when Bill Siegmann met John Leh, a Kran brass caster from Gbabobli, the Liberian was too old to cast anymore, but he was willing to demonstrate much of his technique (fig. **6.7**). Taking some beeswax that had been softened in the sun, he rolled it and formed part of it into wax threads. The result was a small crocodile figure.

Leh was a prolific caster who worked mostly in the 1920s and 1930s and primarily for missionaries and government

47 48 49 51

officials, who paid him well for his figures. His favorite subjects were soldiers in the Frontier Force of the Liberian army, organized in 1908 to defend the country's borders. He usually portrayed them carrying a gun or a knife and wearing a uniform of short striped pants, a fezlike hat, and no shoes (see cat. no. 49). The many figures he made are easily recognizable by his subject matter as well as by the soldiers' rounded arms and shoulders and bowed legs.[22]

OTHER SPECIAL BRASS PIECES

Another, probably much older, object in this exhibition and book, catalogue number 47, is a tour de force of casting, distinguished by its unusually large size, its weight and solidity, and its coppery patina. Given its surface and the fact that it oxidized in a particular way, Siegmann, who collected it in Liberia, believed it was cast in the nineteenth century. He also surmised that the figure had been used in a ritual context, unlike later brass figures, which were prestige items. This standing nude female figure wears a belt of blue beads on string and has rings around her neck, signifying beauty. Typical of earlier times, she is covered with elaborate scarification—a sign of being respected in the community; these raised marks were not only beautiful but also pleasingly tactile. Both her hairdo, which would have taken a woman relative or friend at least a day to complete, and the scarification reflect the subject's prestige and the affection she elicited from her Mano community.

Another older brass casting, probably dating from the nineteenth century, is the staff finial from the Bassa people (cat. no. 51). It represents a woman's head, with five rows of hair running from front to back and an encircling herringbone pattern. The brass was cast over an iron rod, now mostly broken, that served as a walking stick. According to legend, it belonged to Sma Vlen, a mythical ancestor who migrated from the interior to the coast in the sixteenth century.

We are fortunate to view the charm and beauty of the brass castings featured in this exhibition and book. But we also must note that the era of casting for ritual or prestige has passed. As Siegmann summarized brass casting in Liberia and Sierra Leone in his 1977 book, *Rock of the Ancestors*:

> Cast brass figures are found among the Kran, Dan and Bassa. Some have ritual significance, but most were purely decorative. The tradition of making figures for aesthetic purposes in both wood and brass seems to be a twentieth-century phenomenon. It may be that it developed as an outgrowth of the increased supply of brass available from European sources during the late nineteenth century. If so, it would parallel an increase in the size and quantity of brass jewelry used as a means of conspicuously demonstrating wealth and prestige in northeastern Liberia during the late nineteenth and early twentieth centuries. Whatever the origin of the brass figures, they went out of style by the time of World War II, and today the brass caster's art is virtually dead.[23]

Ritual Recycling: Modern Uses of Ancient Stone Sculptures in the Upper Guinea Forest Region

Although the Upper Guinea Forest is one of Africa's richest stone-carving regions, the ancient stone figures unearthed over time in parts of present-day Sierra Leone and adjacent areas of Guinea and Liberia remain shrouded in mystery.[1] More than forty years ago, the archaeologists John Atherton and Milan Kalous summarized the questions surrounding these sculptures: "Who made these figures? Why? When? and How have their functions changed, if at all, from those for which they were originally intended?"[2] These questions are still relevant today, and in this essay I will review some of the answers posited in the past. I will also address issues beyond the specifics of the Upper Guinea Forest region stone sculptures but prompted by the study of them—for example, the ethnic attribution of objects, historical continuity in African art, and the practice of ritual recycling.

7.1

This drawing, originally published by the missionary George Thompson in 1852, appears to be the first representation of a *nomoli* stone figure.

STONES, STYLES, AND NAMES

May 21st [1850].

This evening I found a nest of old, broken, *graven images*—the first I have seen in Africa. There were five of them, lying at the foot of a small tree, where a town once stood, which was destroyed by war. . . . They were made of *stone*, intended as [an] imitation of something, perhaps of human beings—if so, very *comical*.[3]

Thus reads the first explicit published mention of Sierra Leonean stone figures, written by the British missionary

George Thompson in an American missionary tract published in 1852. A drawing of one of the figures accompanied the description (fig. 7.1).

Since the early twentieth century, numerous stone carvings in several styles representing complete human figures and large heads have been found throughout an area of some twenty-three thousand square miles (about sixty

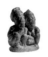 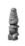

55 57 60

thousand square kilometers). Two groups of styles can be distinguished in this vast area. The "coastal styles" are found in Sierra Leone, less than a hundred miles (about one hundred sixty kilometers) from the Atlantic Ocean, in territories currently inhabited by the Mende and Southern Bullom (Sherbro). The "inland styles" appear farther north, in the border region of Sierra Leone, Guinea, and Liberia, primarily home to the Kissi.

Modern-day inhabitants of the coastal regions are unaware of the cultural origin of the stone carvings. "We don't know," a local Mende chief told Thompson when asked where the figures came from, "but suppose they *grew*—nobody among us *now* can make such things."[4] While the Mende usually consider the figures to be the work of spirits or past owners of the land, the inland Kissi see them more as manifestations of their ancestors. All the finders consider these carvings endowed with special, spiritual powers and use them in various ritual contexts.

None of the carvings has been discovered in archeological excavations; indeed, most of them have been found accidentally by farmers, well diggers, and diamond miners. Precise dating is, therefore, problematic, but they are tentatively dated to a period ranging from the thirteenth century to the twentieth century. They have been written about since the early twentieth century, yet racial prejudice prompted some of the first scholars to attribute the stone carvings to foreign artists—specifically, ancient Egyptians or Carthaginians or the inevitable Phoenicians.[5] Even examples crafted within a small geographic area show

striking stylistic variety, ranging from columnar shapes with schematic heads to complex, multifigure ensembles. The most compelling sculptures display a creative play with volumes and a sophisticated treatment of detail, including hairstyle, scarification, and ornament.

The vast majority of the Upper Guinea Forest region sculptures are small, standing from three to seven inches tall (7.6 to 17.8 centimeters; cat. nos. **57** and **60**). Some quite detailed examples are between eight and twelve inches tall (20.3 and 30.5 centimeters), while a few are considerably larger, ranging from twenty-three to twenty-six inches tall (60 to 66 centimeters). Some figures have no obvious sexual characteristics. Among the gendered ones, most are male and represent either the penis or a beard. Female figures are very rare, as are hermaphroditic or bi-gendered Janus figures. The sizable seated male-and-female couple included in this book (cat. no. **55**) is unique in that it depicts a male figure beside a female figure, his left hand resting on her shoulder—an uncommon gesture in West African figural sculpture. Both are richly adorned, with necklaces, bracelets, belts, and anklets; the female figure also wears an earring. The representation of a hand on the head of each of the two figures adds a note of intrigue to this object. Both hands are broken off, but their scale suggests that they once were attached to a smaller figure located between and above the couple. It is of course also possible that a larger figure originally stood behind the couple.[6]

Animal stone sculptures have also been found, perhaps representing dogs, while other figures show a man sitting on

an elephant or a leopard. Finally, a very few stone carvings feature zoomorphic hybrids, displaying oversized mouths, feet with six toes, and other deliberately "monstrous" characteristics.[7]

Most sculptures are carved from steatite or soapstone, a magnesium silicate composed mostly of talc. Soapstone can assume various colors and hues, from light beige to green to almost black. The patinas of the carved stones also differ, from dry and rough to polished by time and usage; some are encrusted, the result of offerings made long after the objects were carved. Other materials include sandstone, granite, and basalt.[8] Some terra-cotta figures are made in the style of the stone carvings. Those collected after 1970 were recently fabricated and were meant to deceive the buyer; others, however, apparently were used in a ritual context. The American-born British sculptor Jacob Epstein owned an unusual terra-cotta head from Sierra Leone; acquired in the second quarter of the twentieth century, it is undoubtedly authentic (fig. 7.2). Bronze specimens also have appeared on the market in recent decades, and apparently they, too, were newly made.[9]

Because soapstone is relatively soft, it can be carved with tools and techniques similar to those used in woodcarving.[10] Rare wooden figures, mostly discovered in the 1980s and first described by the art historian Frederick Lamp, indicate that the same artists or workshops may indeed have worked in both media. With their bulging eyes, fanned beards, and detailed hairdos, they markedly resemble the Kissi stone carvings. Some wooden figures have been radiocarbon dated. One male figure, currently in the collection of the Baltimore Museum of Art, was found six yards below ground in the Eastern Province of Sierra Leone and appears to be approximately datable to 1200–1400, a stunning age for an African wood sculpture (fig. 7.3). Another male figure, in a private collection, was dated to about 1450–1650, while a large female figure with a detachable head, at the British Museum, may have been made in 1800 or earlier.[11] The existence of these objects reflects an ancient and enduring inland tradition of carving in stone and wood, at least among the Kissi people.

Early on, carvers living along the Sierra Leone coast also sculpted objects out of ivory. In 1959, a few decades before the wooden figures were discovered, the art historian William Fagg compared stone carvings from the coastal Upper Guinea Forest region with Luso-African ivories (often called Sapi-Portuguese ivories). These are the ivory horns, saltcellars, spoons, and other objects that African artists carved between roughly 1490 and 1650, mainly for Portuguese patrons.[12] More than a hundred of them have

survived, but most likely ten to twenty times that number were carved and traded. Fagg found enough stylistic and iconographic similarities between the ivories and the stone figures from near the coast—including the treatment of the eyes, nose, lips, and shoulder blades and the scarifications—to consider the two genres contemporaneous and attribute them to the same artists or workshops.[13] In some cases, a link can be established between an ivory carving, a stone figure, and a contemporary practice or object. For instance, a three-legged reclining chair is depicted on the lid of a saltcellar and in several stone figures. In many areas of Sierra Leone and Liberia, such a tripod is still used today as part of the chief's regalia, suggesting a striking cultural continuity between past and present.[14]

Stone sculptures are usually categorized according to stylistic distinctions and/or geographical origin; because these categories lack distinct boundaries, there are over-laps and singularities. The literature distinguishes among *nomoli*, *mahen yafe*, and *pomdo*: the first two are round, smooth figures found mainly in the coastal region of Sierra Leone, especially where the Mende and Southern Bullom (Sherbro) people live today, while the latter are ribbed and come from the interior regions, from Kissi-inhabited and neighboring areas.

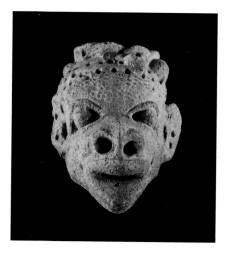

7.2

Sapi peoples or Kissi

Sierra Leone or Guinea

HEAD, possibly 15th–17th century

Terra-cotta

H. 6 ½ in. (16.5 cm)

Formerly in the Jacob Epstein Collection; currently in the collection of Charles Ratton-Guy Ladrière, Paris

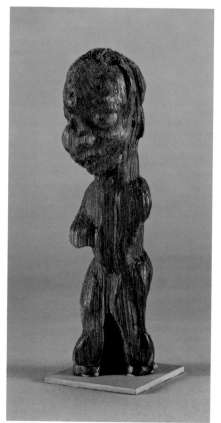

7.3

Kissi style

Near Sefadu, Sierra Leone

FIGURE, possibly 1200–1400 (based on radiocarbon dating)

Wood

H. 7 ⅝ in. (19.4 cm)

The Baltimore Museum of Art: Gift of Elliott and Marcia Harris, Pikesville, Maryland BMA 1991.85

56 59

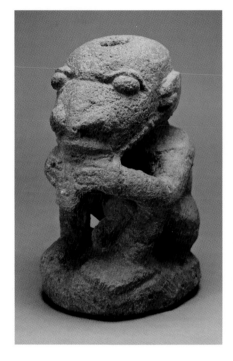

7.4

Sapi peoples

Sierra Leone

NOMOLI FIGURE, possibly 13th–16th century

Stone

H. 12 in. (30.5 cm)

The New Orleans Museum of Art: Gift of Helen and Dr. Robert Kuhn 91.652

Nomoli is the most common Mende name for the stone figures found in the ground (fig. 7.4). It is also a Mende term for the African bowstring hemp (*Sansevieria sene-gambica liberica*), which in Sierra Leone was planted in a field to enhance crop yields by propitiating the spirits. According to Frederick Lamp, it is still being planted on graves and used in powerful medicines—hence, the more general use of the word for any object believed to have medicinal or spiritually efficacious properties.[15] A different Mende term, less often employed, is *mali yafa*, which means "discovered spirit." This alludes to the Mende claim that they found the figures, already extant, when they first moved into the region, in the sixteenth century. Yet another Mende term, used for a particular style of carving, is *mahen yafe*. Meaning "spirit belonging to the chief," it is

interpreted as a portrait of a deceased ruler.[16] These stones consist of a large head, usually tilted backward, resting on a tubular neck. The face typically has large, heavy-lidded and downcast eyes, a broad nose, and slightly parted lips. They often display detailed coiffures, marked by complex cross-hatched patterns. The example in Bill Siegmann's collection has an unusually long neck and erect head (cat. no. **59**).

Pomdo, a Kissi word meaning "the dead" or "image of the dead," refers to stone figures found northeast of Mende country, in Guinea and the adjacent corners of Liberia and Sierra Leone.[17] This region is inhabited by the Kissi and small neighboring groups. The styles of these carvings differ from the above-mentioned stone figures: *pomdo* tend to be smaller and less rounded than *nomoli*, with a head that is usually smaller in relation to the body, and they are often truncated (cat. no. **56**) or in a kneeling position. There is a wide variety of *pomdo* carvings, ranging from the fairly abstract to the detailed and naturalistic; sometimes, a sizable figure is surrounded by smaller ones, and many figures have large mouths with filed teeth (the so-called grinning *pomdo*). Overall, there are fewer *pomdo* carvings than *nomoli*, while *mahen yafe* carvings are even less numerous.[18]

In some cases, various styles appear within a small region. At the same time, figures from sites separated by a hundred miles or more may share similarities, such as a specific treatment of the head and the hair or an unusual scarification pattern on the belly and the back. Some sets of *pomdo*

106

seem to come from a single school of stone carving, yet it is also possible that "artists may have been itinerant or that an extensive network had been established for the marketing of their work."[19] Furthermore, some stone carvings are atypical, showing "foreign" influences. The art historian Annemieke Van Damme, for one, analyzed five small stone figures found in the domain of the Loma people, north and south of the border between Liberia and Guinea. Their styles differ, with some being close to *pomdo* figures, one resembling the *mahen yafe* carvings, and another being more like the typical wooden Loma sculptures.[20] Such a variety would indicate the occurrence, in the past, of ritual and artistic exchanges over a large portion of the Upper Guinea Forest region. It is hard to determine how long ago these exchanges would have occurred, even though historical sources may offer some clues.

HISTORICAL SOURCES

In 1461 the first expedition from Portugal, led by Pedro de Sintra, reached the coast of what is now Sierra Leone. The explorers encountered peoples of the now-vanished Sapi society, a multiethnic amalgam of the related forbears of many of the region's present-day populations—including the Temne, Northern Bullom, and Southern Bullom (Sherbro). The Sapi peoples did not include the Mende nor the Vai, Mande-speaking populations whose roots are in the Mali empire farther to the north. Sometime before 1500, a group of Mande-speaking people from this empire, the so-called Mani, migrated south to the Cape Mount

region of present-day Liberia. From there, by the 1540s, splinters of the Mani moved deep into the Sierra Leone interior and its coastal regions. By far the largest single group to emerge from this move was the Mende.[21]

In the past, scholars have invoked the Mande migration and its demographic, social, and political consequences, referred to in the literature as the Mani invasion, to explain the stylistic "divide" in Sierra Leonean art—between early stone and ivory carving, on the one hand, and wood sculpting after the mid-nineteenth century, on the other.[22] According to this view, the artistic tradition in stone and ivory came to a catastrophic halt in the mid-sixteenth century, when Mani invaders destroyed the original Sapi culture. The historians Paul Hair and Adam Jones, however, cite research conducted over several decades indicating that this catastrophe thesis is not supported by linguistic data. They also contend that the Mande takeover was dynastic rather than demographic. Hair's painstaking editing and translation of early European sources further reveals the continuation of Sapi cultural institutions and art forms beyond the mid-sixteenth century; and a case can be made for the view that the arts of Sierra Leone present more continuity than discontinuity.[23]

Evidence about when and by whom the stone figures were carved is circumstantial, and there was much scholarly speculation throughout the twentieth century about their origins and ages. Obviously, it is difficult to draw

conclusions based merely on similarities between the stone figures and the aforementioned Luso-African ivories. The latter are clearly post-contact, but nothing indicates that the stone figures are. In the 1950s, it was suggested that some details of clothing on the carvings could be identified as Portuguese armor and garments worn in the sixteenth century. But in the mid-1990s, the philosopher William Hart advanced new interpretations that refute this view.[24] The emerging consensus is to date the earliest coastal and inland stone carvings to the fourteenth, or perhaps the thirteenth, century. The main production of coastal *nomoli* and *mahen yafe* ceased by 1650 or 1700, while that of inland *pomdo* continued into the late nineteenth and early twentieth century.[25]

If most stone carvings do predate the initial contact between West Africans and Europeans, it seems likely that the first explorers would have mentioned them in their writings. Yet we have no unequivocal testimonies from early European travelers that describe the creation, appearance, or use of stone figures. What is thought to be the earliest Portuguese reference to stone sculpture is dated 1506, before the Mani invasion, but it is rather vague. Valentim Fernandes, a German-born geographer living in Portugal during the first two decades of the sixteenth century, collected and published anonymous texts, among which one can read, for example, that "all [Sapi people] are idolaters and they believe in whatever they wish and love to make idols of wood and stone."[26] The same collection of texts describes the burial of a Sapi dignitary who held weapons and a shield in his hands, an arrangement also evident on some of the stone figures.

Later European sources, from the sixteenth and seventeenth centuries, contain other clues that can be linked to the stone sculptures. André Thevet, a Frenchman traveling in Sierra Leone, wrote in 1575— after the Mani invasion—about a stone carved in "the likeness of a great toad or frog."[27] Some Mende *nomoli* sculptures, with their rounded heads, protuberant eyes, and flaring nostrils, do indeed look like amphibians (see fig. 7.4). Thevet may have been writing about them, which would make his the earliest published testimony, predating that of the British missionary George Thompson by just over two hundred seventy-five years.

In 1594 the Portuguese nobleman André Alvares de Almada described courtly symbols and rites among the Sapi peoples, specifically mentioning a warrior chief surrounded by heads of vanquished enemies. He also witnessed the installation ceremony of a new king whose hands had been bound.[28] Interestingly, some stone sculptures found among the Mende and Kissi represent precisely these kinds of scenes— a chief portrayed as a prisoner with his hands bound and a warrior holding a shield with heads carved around him. One complex *pomdo* in the "grinning style," collected by Siegmann, shows a main figure holding a small round shield and making a fist with his other hand; he is surrounded by four diminutive figures, all bearded and with similar hairstyles. It may well represent a leader with his followers (cat. no. 58).

58 62

The iconography of the sculptures also reveals a few clues that may somewhat clarify their meaning. Ornaments are ubiquitous, either carved on the objects, around the neck, arms, or legs, or attached as rings in the nose or ears. They clearly indicate status. The stone carvers also often represented hair in great detail on the *nomoli, mahen yafe*, and *pomdo*. Late-twentieth-century fieldwork among the Temne people has revealed that the plaiting of hair, practiced by men as well as women, is associated with refinement and cultivation, while beards have a special significance in relation to communal protection, fecundity, and lineage. As can be seen on their nineteenth- and twentieth-century Sande Society masks, the Mende and their neighbors, too, pay great attention to elaborate hairstyles; they view a delicate coiffure as a reflection of human refinement. Finally, a few rare stone figures show men mounted on animals, including elephants and leopards. Throughout the region, these creatures are still regarded as symbols of royal power and chieftaincy. For example, the chief's hammock, in which he is carried in procession, is associated with the elephant (see cat. no. 62).[29]

All available evidence suggests that many of the carvings represent kings, chiefs, and dignitaries. Because they are found under the ground, it is also often assumed that these objects had been buried by the original makers, who would have used them in a funeral context dedicated to such leaders. The funerary use appears plausible in light of a late-nineteenth-century source, the Swiss industrialist and trader H. Ryff. Local informants in Sierra Leone, probably

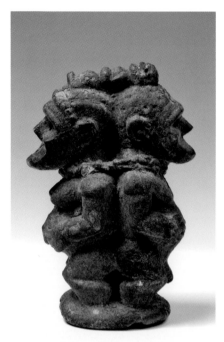

7.5

Kissi (?)

Guinea or Sierra Leone

MALE AND FEMALE FIGURE, possibly 16th–19th century

Stone

H. 9 ½ in. (23.5 cm)

The Gary Schulze Collection, New York

This sculpture represents two porters bearing a corpse.

Southern Bullom (Sherbro), told him that the *nomoli* were primarily found in tomblike tumulus hills that could contain up to fifty of them.[30]

One genre of stone figure does not seem to fit the chief-related, commemorative category, however. It includes stones, carved in *nomoli* as well as *pomdo* styles, that represent a dead person—either as a single figure lying on a flat panel with legs crossed or as a reclining figure supported by two standing figures (fig. 7.5).[31] These sculptures are thought to stem from a divination ceremony performed in the seventeenth century (and maybe earlier) with a human corpse; more recently, an ancient stone carving has been substituted for the corpse in such ceremonies.[32]

RITUAL RECYCLING

Although Portuguese sources are, as noted, fairly vague about stone sculpture, it was a Portuguese explorer—André Donelha, visiting Sierra Leone and Guinea in the 1570s—who made an interesting observation about "wooden idols." They were, he wrote in 1625, offered food and sometimes thrown down and whipped.[33] Until the middle of the twentieth century, this is precisely what Mende and Southern Bullom farmers did with stone carvings found on their land. They placed *nomoli* figures in temporary shelters near their fields, "fed" them small portions of cooked rice, kept them as protectors of rice crops, and prayed to them for a good harvest. If the yield turned out to be insufficient, the owners would flog them with a small whip.[34]

Nomoli carvings often have a large hole drilled in the crown of the head or in the abdomen, sometimes even in the hands (see fig. 7.4). These are likely containers for "power material," mixtures of medicinal and beneficial substances. It is not known, however, if such openings were original or inserted later by the finders, or whether this power material would have played a role in the agricultural importance of the stone figures.[35] Surprisingly, a CT scan of the *mahen yafe*-style seated couple (cat. no. 55) revealed four relatively small and perfectly round holes drilled into the man's forehead, upper lip, necklace, and chest (fig. 7.6). They are not visible to the naked eye, having been plugged at some point in the past—perhaps by a dealer—with waxy material; their meaning is unknown.[36]

Neither *mahen yafe* heads nor *pomdo* carvings found in the twentieth century have been reused for farming-related purposes. The former usually were thought to represent an ancient king or chief, and so were turned over to the contemporary local leader. Such a head may then have served as a "swearing stone" during court procedures supervised by the chief. In 1906 a British resident in Sierra Leone named Greensmith noted that *mahen yafe* heads were used "to swear the natives on in their native courts, and [it] is regarded as a powerful oath."[37] *Pomdo* figures also appear to have been used for oath-taking. Yet the most widespread understanding of *pomdo*, by the Kissi and their neighbors, is that they form physical containers for ancestors. Through them, the ancestors can communicate with their descendants.

In 1913 H. Néel, a French military doctor, recorded two ritual uses for the ancient stone figures in Guinean Kissi country. One was incorporated in a ritual practiced after the death of a chief. It was believed that the deceased would rise up from the earth in the form of a stone figure, and that a dream would reveal to a relative where the stone could be found. Once unearthed, the *pomdo* was placed on the grave of the deceased or in a shrine dedicated to the ancestors, where it served as an intermediary between the living and the dead and received supplications in the form of sacrifices of food, animal blood, and kola nuts.[38] The French anthropologist Denise Paulme photographed such complex ancestral stone shrines in Kissi villages in the late 1940s. A circle of granite slabs was erected at the center of the village, each

stone evoking the memory of a specific ancestor. Kept in a nearby thatched place were the polished stones that represented ancestors whose names one no longer remembered. Figural *pomdo* stones also could be found there.[39]

Frederick Lamp observed a similar arrangement among the neighboring Temne in Sierra Leone in the 1970s. In the center of a Temne village was the "house of stones," where (uncarved) stones from the gravesites of important people were kept and prayed to for the prosperity and health of the village. According to Lamp: "The *am-boro ma-sar* [house of stones] is more than simply a memorial to the dead. It is the place where the benevolent power of the dead is transmitted back to the living."[40] He also learned that, in the eastern Temne area, ancient figures—some in *pomdo* style—were placed in the "house of stones" and used ritually, the same way the plain ancestral stones were. Stone "worshipping," as it was called by an early nineteenth-century British observer, Thomas Winterbottom, also occurred among the neighboring Northern Bullom, where uncarved stones were preserved "in memory of the dead" and were offered rice.[41] Apparently, coastal and inland peoples of this region alike believed there was a link between stones and ancestors.

The second use for the stone carvings that Néel documented among the Kissi was in the context of divination. A figure was designated as an intermediary with the spirit world and was consulted for public or private reasons. The figure was placed on a board, which one or two initiated men put atop their heads. Questions were asked, and depending on the perceived motion of the statue, the reply was considered either negative or positive.[42] One Portuguese missionary in Sierra Leone in the early seventeenth century described how the body of a deceased person would thus be used, and would respond to the investigator through its movements on the bier. Early twentieth-century colonial judicial records in Guinea also allude to this practice. It is unclear, however, when the actual corpse was replaced by a carved stone figure. Some *pomdo* figures appear to have been slightly recarved to fit between

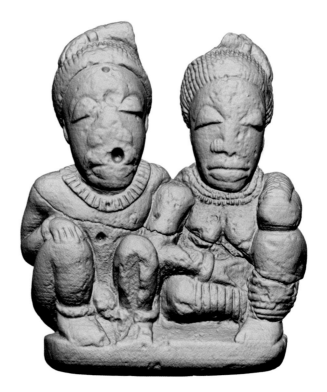

7.6

This CT scan of the *mahen yafe*-style seated couple (cat. no. 55) reveals an oblique break through the right shoulder of the male figure and left leg of the female figure as well as small holes drilled into the male.

61

7.7

Kissi

Guinea

DIVINATION BOWL ("DRESSED POMDO"), early 20th century

Wood, stone, cotton, metal, glass, cowrie shells, feathers, undetermined materials

H. 13 in. (33 cm)

Musée du Quai Branly, Paris, France

The ring, beads, and cowrie shells seem to have been laid out to form a human face, thereby anthropomorphizing the object.

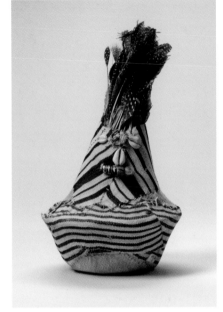

the shafts of the litter carried during divination ceremonies. But more often, the stone was placed inside a larger structure that was attached to the litter.[43]

Paulme described two such containers among the Kissi, both called *pom'kandya* ("dressed *pomdo*") or *pom'wama* ("divining *pomdo*"). The first type of container consists of a bowl for the stone, wrapped in cloth and decorated with cowrie shells, beads, and feathers (fig. **7.7**). The second type of divining *pomdo* is shaped like a bottle, with the top carved into a human head and the base wrapped in cloth. A cavity in the base accommodates the stone sculpture and other powerful objects, usually in metal.[44] Siegmann photographed a *pom'wama* in action in 1968 or 1969, probably in a Loma village, near the neighboring Kissi (fig. **7.8**).[45] He also collected two of these figural oracles (cat. no. **61** and fig. **7.9**). Siegmann's divination figures are clad in plain cloth; except for the antelope horn and feline tooth attached to a lace that goes through a small hole toward the rear of the crest of one of them (fig. **7.9**), they lack ornaments. Usually, however, these figures wear a (miniature) paramount-chief robe, and they are adorned with beaded necklaces, coins, mirrors, cowrie shells, leather amulets, and brass bells.[46]

In November 2012, the radiologist Dr. Marc Ghysels performed CT scans of both these divination figures. The application of radiography in analyzing African artifacts is not new. In one of the first general publications on the

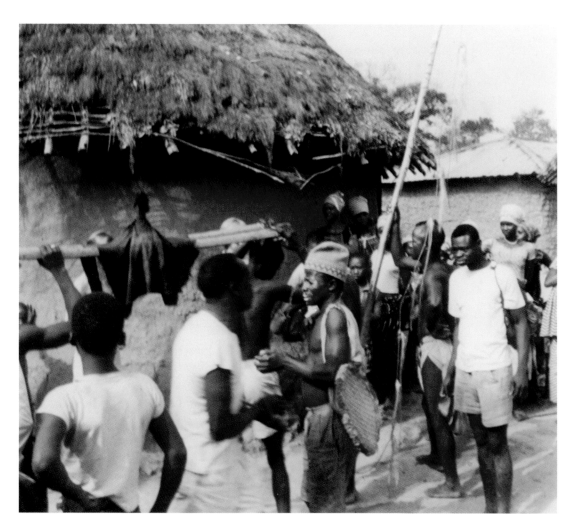

7.8

In this divination ceremony in an unidentified Loma village in Liberia, two men carry a bier on which a human-shaped "dressed *pomdo*" has been placed. Siegmann took this photograph in the late 1960s.

subject, a 1977 article by the art historians Roy Sieber and Theodore Celenko in the now-defunct journal *Arts d'Afrique Noire*, the authors examined about a dozen objects, chiefly from West Africa. Among them is one such divination figure, attributed to the Bassa but probably of Kissi origin. The X-ray photograph is not very clear, but it reveals a cavity in the figure's belly that contains "stone and metal bits." An X-ray of another Kissi divination figure, in the collection of Gary Schulze and published in 2005, reveals an undetermined mass and two so-called Kissi pennies.[47] This forged-iron currency, originally made by the Loma people, was circulated by the Kissi starting around 1850 and commercialized in great quantities in

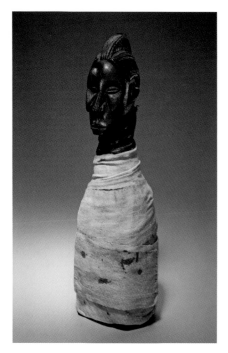

7.9

Kissi

Guinea or Liberia

DIVINATION FIGURE ("DRESSED POMDO"), mid-20th century

Wood, cloth, metal, stone, horn, ivory, undetermined materials

H. 16 in. (40.6 cm)

The Estate of William Siegmann, Brooklyn

7.10

Loma

Liberia

BUNDLE OF CURRENCY (KISSI PENNIES), early 20th century

Metal

L. (appx.) 17 in. (43.2 cm)

Minneapolis Institute of Arts, Gift of William Siegmann 2011.70.28a–p

Guinea, Sierra Leone, and Liberia. It is a T-shaped thin and square rod, twisted from top to bottom, with a leaf-shaped appendage attached to one of its ends (fig. 7.10).

Contrary to classical X-ray radiography, CT scanning (X-ray-computed tomography) creates three-dimensional images that can display both the surfaces of objects and their interior structures. These 3-D images are the result of digitally processing numerous two-dimensional cross sections of the given object, taken by rotating the X-ray source around it. CT scanning is becoming increasingly important in the field of art history, both for conservation purposes and to resolve questions of authentication.[48] Siegmann's divination figure wrapped in layers of white cloth (fig. 7.9) has an ample cavity hidden underneath. The space contains a large ball of loose fabric, what look like two thin iron blades, and four Kissi pennies (fig. 7.11). The red-clothed figure (cat. no. 61) conceals a cavity that is open at the base. It contains pieces of metal, including half a dozen bent and broken Kissi pennies plus three blocks of stone. One of these is a carved *pomdo* figure, placed upside down and consisting of a headless trunk with bent arms, shoulders, buttocks, and strips of scarification (fig. 7.12).

The common element in all the wooden divination figures appears to be the presence of both stones (carved and uncarved) and Kissi pennies. The latter ceased to be regular currency around 1950, but their use continued in ritual contexts, such as tokens on the completion of initiation in the Sande and Poro societies, gifts placed on tombs, and accoutrements in divination ceremonies. It has been noted that

"Kissi iron money . . . seems related to both stones and the ancestors," which would account for its presence in these divination figures.[49]

It is unclear how long the Kissi had been using their stone figures for these rituals by the time of Néel's observations, a century ago. Because the carving of *pomdo* figures appears to have lasted much longer than that of the coastal *nomoli* and *mahen yafe*—maybe even into the twentieth century—they must have been continuously used for centuries. While the link between stone figures, ancestors, and chieftainship seems well established among inland peoples and goes back to a distant past, I would argue that the use of *pomdo* in divination is of a more recent date (although it is not known exactly *how* recent). This supposition is based on the fact that the Kissi stopped using corpses in their divination practices and replaced them with ancient stone figures.[50]

The ritual recycling of the *nomoli*, *mahen yafe*, and *pomdo* should be placed in the wider context of the local use of stones believed to be imbued with supernatural powers. Siegmann referred to this tradition in the title of the 1977 book he co-authored with the ethnomusicologist Cynthia E. Schmidt about Cuttington University College's collection of Liberian art, *Rock of the Ancestors*; the title refers to the Kpelle belief that any object formerly belonging to a dead person can become a "stone," and serve to contact and call upon the spirit of the deceased (see fig. 1.3).[51] Denise Paulme had observed that the Kissi gave the name *pomdo* to stone figures as well as to Neolithic axes

7.11
This CT scan of one of Siegmann's divination figures (fig. **7.9**) shows the contents of the internal cavity, including four bent iron rods (Kissi pennies). Also visible are the antelope horn and feline tooth attached to the back of the head.

7.12
This CT scan of Siegmann's other divination figure (cat. no. **61**) zooms in on the internal cavity. Visible are half a dozen bent Kissi pennies, a metal block, and three stones, the longest of which is a fragment of a carved *pomdo* figure.

7.13
This 1979
Thomas Seligman
photograph
shows a Gbandi
blacksmith making
a silver ring in
Bolahun, Liberia.
He is hammering
the ingot formed
by pouring melted
U.S. silver coins
into a hollowed-
out palm-leaf rib.

and stone balls found in the soil, all of which were placed on domestic altars dedicated to ancestors. It is clear that stones were also powerful objects for the Mende, Southern Bullom (Sherbro), Temne, and Kono, who viewed them with awe. Even the sight of them was potentially danger-ous—"expectant mothers are forbidden even to look at [*nomoli* figures]"—while touching them would, it was believed, make a woman sterile.[52]

An early twentieth-century source further noted that, among the Temne, *nomoli* figures "are placed in the black-smith's forge, and are supposed to assist in making the iron smelt easily."[53] A photograph taken by the art historian Thomas Seligman in 1979 shows an unnamed Gbandi blacksmith from neighboring Liberia with a stone carv-ing lying on the ground (fig. 7.13); presumably, it was there for a reason. Another indication of these figures' perceived potency is the existence of a *mahen yafe* head covered in part by sacrificial animal blood. There are also examples of *nomoli* figures adorned with beads around the neck or the waist, most likely given as past offerings in honor of efficacious interventions (fig. 7.14).[54] Here, too, a link exists with ancient practices as recorded in 1619 by the Frenchman Augustin de Beaulieu. Near a Mende or Southern Bullom village, he wrote, "can be seen little figu-rines grotesquely shaped, made to look like devils, to which they make offerings, giving them the fruits and *the beads* which are their form of wealth."[55] Although de Beaulieu did not mention in what medium these "grotesquely shaped" figures were sculpted, it is reasonable to speculate that he was describing *nomoli* stone carvings.

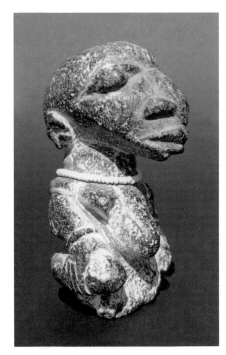

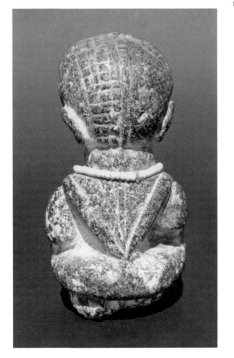

7.14

Sapi peoples

Sierra Leone

NOMOLI FIGURE, possibly 13th–16th century

Stone

H. 3 ⅜ in. (8.5 cm)

Formerly in the collection of Mario Meneghini; whereabouts unknown

The figure is coated in rice powder and wears a white-bead necklace.

• • • • •

In terms of ritual utilization, the differences between *nomoli* and *pomdo* figures depend to some extent on how the finders—primarily the Mende and the Kissi, respectively—regard these stones that are buried in the ground. The Kissi view them as manifestations of the dead, incorporating the spirits of deceased ancestors, and they place them in ancestral shrines or use them for divination. The Mende, on the other hand, see them as products of previous inhabitants or spirits, and implore these so-called rice gods to protect and increase their harvests. The Mende are most certainly not the original makers of the stone figures found in their soil: prior to their arrival in the coastal regions of Sierra Leone in the sixteenth century, the so-called Sapi people lived in this area. Mende use of the figures is, therefore, an instance of genuine ritual recycling. In Kissi country, on the other hand, the forebears of the current inhabitants most likely carved the stone figures that have been unearthed inland. Yet even though there very probably is a degree of continuity in the use of these figures, the Kissi, too, seem to have repurposed them to some extent.

Beyond their aesthetic appeal, the stone sculptures from Sierra Leone, Liberia, and Guinea are intriguing. To begin with, little is known about their origin, which makes the notion of ethnic attribution, so common and important for African art, problematic. Because no archaeological excavations have been done to shed light on the past makers, it is assumed that the ancient Kissi people produced the stone figures found inland. The no-longer-extant Sapi peoples, mentioned in the Portuguese sources, are thought to have made the figures found along the coast. Some authors prefer to avoid ethnic names altogether, using instead

geographical distribution (coastal and inland) or stylistic designations (*nomoli*, *mahen yafe*, and *pomdo*).

Unfortunately, African art is too often regarded as ahistorical—that is, as if at some undetermined point, it became frozen in time. This bias is due in part to the dearth or superficiality of available historical knowledge. Yet the *nomoli*, *pomdo*, and related stone sculptures offer a means to help overcome this handicap. The age of the pieces, possible comparisons with dated ivories and wooden figures, historical records (however scant), and contemporary field data all make a more diachronic approach to this particular sculpture possible.

Finally, the practice of ritual recycling illustrates the complex "biographies" of objects that do not adhere to a single and predetermined function or context of use. Ritual recycling is timeless and occurs in many cultures. In some instances, the original function was retained but converted by practitioners of a different religion. Many examples can be found in the domain of architecture. The Roman Forum alone offers half a dozen examples of classical temples that were made over into Christian churches. The Great Mosque of Kairouan, Tunisia, was rebuilt in the ninth century using countless columns with ornamental capitals from early North African Christian basilicas.[56] In other instances, the original function changed. For example, a luxurious chasuble (the outer garment a priest wears to celebrate the Eucharist) in the treasury of the cathedral of Fermo, Italy, was reshaped for Christian use in the twelfth century from a Spanish Muslim canopy or tent that had been seized in war.[57] The modest stone carvings unearthed in the Upper Guinea Forest region belong to the same centuries-old tradition of continuous reinvention.

CHRISTINE MULLEN KREAMER

William Siegmann, Advocate for Connoisseurship

William Siegmann—Bill, as scholars and collectors internationally knew him—was a rare individual whose deep-seated enthusiasm for the arts of Africa and exceptional eye for quality distinguished him as a true connoisseur. During many years of research and curatorial work, Siegmann developed a large personal collection of tradition-based African art, primarily from Sierra Leone, Liberia, and Côte d'Ivoire, which reflected his extensive fieldwork and study and the passion he had for the peoples and cultures of this region of West Africa.

I first met Bill in the mid-1970s at Indiana University, where we were enrolled as graduate students. I was a first-year student with a work-study job at the university's art museum. Bill had recently returned to Bloomington after years in Liberia that included field research toward an advanced degree in history. On our first encounter, he was wearing a light blue tie-dye shirt and a stunning silver ring—both made in Liberia—that I associate with him to this day.[1] To this newly arrived grad student with no field experience in Africa, Bill was the epitome of worldly sophistication.

Several months before Bill died, we visited at his home in Brooklyn and had a good laugh over my first impressions of him. It came as no surprise that what he remembered about our initial meeting in the museum's storage area was the Loma feather tunic in a metal trunk that we had inspected together that day. At the time, Bill shared with me everything he knew about the object, which he had collected in the field: how it was made; the significance of the feathers and other constituent materials; and the visually impressive statement the tunic made about power. He indicated that the other contents of the storage trunk—including a fly whisk, an iron bell, two iron percussive instruments, and a basketry container holding four small animal horns—likely formed part of a collection of objects associated with the Poro male initiation society. I still remember the excitement we shared when Bill removed a worn textile pouch at the bottom of the trunk. Knowing it contained something special, he carefully opened the pouch and removed a Loma miniature mask with a superb patina (fig. 8.1), further evidence of the power—both hidden and revealed—wielded by the high-status individual, possibly a hunter or warrior, who had carried the auspicious accessory.[2] Thus began my fascination with the stories and the aesthetic power that objects convey in their contexts of use and display, including the museum context, and with the intersection of intellectual knowledge and visual acuity that demonstrates a connoisseur's expertise.

8.1

Loma

Liberia

MINIATURE MASK AND ITS POUCH, mid-20th century

Wood, encrustation, leather (mask), textile (pouch)

Mask: H. 6 ⅝ in. (16.8 cm)
Pouch: H. 10 ½ in. (26.7 cm)

Indiana University Art Museum, Gift of Rita and John Grunwald 74.71.3a,b

BEGIN AND END WITH THE OBJECT

My years in the doctoral art history program at Indiana University, beginning in 1975, offered unparalleled opportunities for training and intellectual growth that have sustained me throughout my career in the museum profession. Bill Siegmann also benefited, as we both worked closely with Roy Sieber, the world-renowned Africanist art historian who was the first American PhD in this field. Sieber's firsthand, object-centered approach to Africa's arts honed our appreciation for the object as the starting and ending point for art-historical enquiry. Along with other graduate students studying with Sieber, I was able to witness and participate in deliberations about the quality and authenticity of African works of art.[3] These encounters with objects occurred in Bloomington hotel rooms and in Sieber's own living room, where African art dealers displayed their wares for his inspection and interrogation. They also took place in the object-storage room and galleries of the Indiana University Art Museum, where scholars with particular field experience would visit and comment on items within their areas of expertise.

Like Sieber, Siegmann manifested what the scholar Janet Tassel called a "reverence for the object"—stemming from decades of closely observing, handling, and researching African art.[4] These attributes marked them both as true connoisseurs. As a field of study, connoisseurship is often said to have originated with the legendary Paul J. Sachs. In the early 1920s, this associate director of Harvard's Fogg Museum created a graduate course, Museum Work and Museum Problems, that was designed "to implant scholarly standards in future museum workers; to educate their eyes so that they might be helped to see."[5] The art historian Jakob Rosenberg joined Sachs at Harvard in the late 1930s, and his work on criteria of excellence in old master drawings and paintings served as a guide to principles of connoisseurship—including formal clarity and balance, spatial coherence, a feeling for the medium, artistic economy, and originality—that remain relevant up to the present and apply to a wide range of art forms.[6] Both Sachs and Rosenberg advocated a close investigation of individual works of art within their historical contexts, an approach that, decades later, Roy Sieber embraced and taught to his own students at Indiana University.

To many, connoisseurs seem to "possess the somewhat mysterious ability to render aesthetic judgments."[7] And though there is something to be said about the apparently visceral response that influences their assessments, connoisseurship, as Sieber defined it, requires scholarly rigor, for it "involves understanding the subtleties of a given object type and recognizing the difference in style and form which may occur within the category. It means knowing that more

than one kind of style or form may be represented, but that all genuine examples conform to the general requirements of the object."[8] Such knowledge informs the assessment of an object's quality, authenticity, and history. For example, a connoisseur worthy of the title would recognize that the surfaces of certain objects bearing residues from libations, offerings, and applications of oils and pigments were culturally significant and reflected different processes of care, use, and deterioration in the African communities where they were made and used, as opposed to how African objects in European and American art galleries and private collections were treated with varnish or wax. Connoisseurship involves value judgments that are objective and intellectual as well as subjective and intuitive. These approaches to aesthetic evaluation complement one another and are the "accumulation of experience with objects, the careful and comparative study of as many aspects of them as possible, to the point where one's response is no longer reasoned but somehow felt, thus intuitive."[9]

AN EYE FOR QUALITY

Bill Siegmann brought his eye for quality and his knowledge of Africa's arts to the collections he formed at the Brooklyn Museum, where he was a curator from 1987 to 2007. During that time, he reinstalled the African art galleries twice. The 1989 reinstallation was done with a "focus

on aesthetics and connoisseurship" through the use of freestanding cases and a preference for neutral settings that served "to highlight the artworks while de-emphasizing the setting in which they were displayed."[10] However, a popular and well-received exhibition in 2000 that juxtaposed African works from the museum's collection with large-scale contextual photographs by the noted photographers Carol Beckwith and Angela Fisher prompted a reconsideration of presentation strategies for Brooklyn's permanent collections, one that aimed to attract new audiences and increase attendance. As Siegmann characterized the exhibition, "Gone was the idea of contemplative, serene galleries and connoisseurship," replaced by "a stimulating, dynamic atmosphere" enlivened with new technologies, including "music, video performance, and audio tours."[11] No wonder, then, that the museum's resulting reinstallation of the African galleries, which were designed with photo murals and with blocks of color and geometric patterns, created a "visual cacophony" that reportedly challenged Siegmann's aesthetic preference and his contention that gallery designs should complement the objects rather than compete with them.[12]

Interestingly, a series of photographs Siegmann took in 1987 of the objects he and his Liberian colleagues reinstalled at the National Museum of Liberia in Monrovia suggest that, to some degree, his curatorial approach remained fairly

8.2

Installation view,
National Museum
of Liberia,
Monrovia, 1987.
Photograph by
William Siegmann.

consistent throughout his career (fig. **8.2**). The crowded cases and platforms exhibited a mix of artifacts, natural history specimens, and contextual images consistent with nineteenth-century ethnographic display techniques that persisted in museums worldwide through much of the twentieth century. By contrast, the clean lines of white walls and casework suggest what might be considered an art museum approach, which is designed to promote an aesthetic encounter by keeping the visual focus on the objects. The limited use of enclosed cases and vitrines

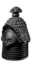

facilitated more direct inspection of the objects, but this was likely the result of budgetary constraints rather than design decisions. The distinctions between art, artifact, scientific specimen, and contextual material, which seem to dominate Western museum practice, may not have concerned those who installed the collection; after all, the museum was designed to be relevant to local Liberian audiences, who doubtless had a more holistic understanding of the relationships between and among the items on view.

While he was in Brooklyn, Siegmann sought to fill gaps in the museum's collection, noting that "over 1,600 objects have been added to the collection in the past twenty years, largely by solicited donation."[13] Pursuing that goal, he added ceramics, textiles, East African beadwork, and Ethiopian Orthodox religious objects to the institution's African holdings. An example of his initiative to enhance the museum's limited collections from eastern Nigeria and Cameroon was the acquisition, in 1987, of an Igbo beautiful-maiden mask (*agbogho mmwo*, or *mmuo*) with a complex coiffure.[14] Siegmann's longstanding friendship with the U.S. Foreign Service officer Blake Robinson resulted in the acquisition of a large group of Dan and Mende artworks, which, in Siegmann's estimation, made "Brooklyn's collection from Liberia and Sierra Leone among the largest and most significant in North America."[15] Outstanding objects from the Robinson collection include a Sherbro Sande Society mask (cat. no. 10) and a beautifully realized Sherbro or Mende fragment of a female figure (fig. 8.3).

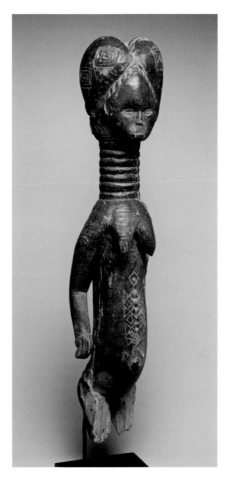

8.3

Southern Bullom (Sherbro) or Mende

Sierra Leone

FRAGMENT OF A FEMALE FIGURE, 19th century

Wood

H. 17 5/16 in. (44 cm)

Brooklyn Museum, Gift of Blake Robinson 2002.31.3

Like most connoisseurs, Siegmann acquired works for his private collection, which concentrated on the arts of Liberia and Sierra Leone and provided him with visual pleasure and the opportunity to examine and appreciate a decorative motif, the treatment of facial features, the thickness of a mask's flared edge, and so on.[16] By surrounding himself with objects of varying quality, not just with the finest examples from a given region, he gained valuable comparative perspectives on the extent of artistic production from particular areas and art-producing groups. His

31 34 39 44 66 69 70 72

collection of miniature personal masks, for example, suggests that he sought a range of mask types, surfaces, and materials—from highly polished to encrusted wooden examples to those made of brass (cat. no. 44) and stone.

Siegmann also built a significant collection of pendants, including a selection made of ivory and horn and embellished with carved elements and decorative silver overlay (cat. no. 72). Significantly, many of these pendants are embellished with inscriptions—some in Vai, an indigenous syllabic script developed in Liberia in the early nineteenth century (cat. no. 69); others are in Arabic, which was used to transliterate the Mende language (cat. no. 70). Siegmann recognized that the general public and even some scholars were unaware that African artists creatively incorporate script—indigenous and imported—into works of art as a way to emphasize ideas about history, ethnicity, and power (cat. no. 66).[17]

Over the years, Siegmann developed considerable expertise in recognizing how an object's changing form, surface, or material might reflect alterations in the meaning or function of that object. He noted, for example, that a Kono mask's surface of accumulated sacrificial materials, including clay, suggested it had been deactivated as a dance mask (cat. no. 39).[18] Selected masks in Siegmann's collection include full or partial costumes that are valuable for communicating a fuller understanding of the masquerade in its performative context (cat. no. 31).

Siegmann attributed certain works in his personal collection to particular towns or to the hands of known artists or workshops, reflecting his field research and his interest in countering the anonymity that frequently characterizes collections of traditional works of African art. For example, he photographed a *bagle* entertainment mask in a 1983 performance (fig. 8.4) that was identified as bearing the local name of *Slu* (Hawk) and originating in the town of Nyor Diaple (cat. no. 34).[19] In an August 2011 interview conducted for the Minneapolis Institute of Arts by the New York gallery owner and dealer Amyas Naegele, Siegmann noted that a mask called "Eagle" from that area had been sold by its owner, who apparently did not have the right to sell it. As a result, the Eagle mask was "essentially banished from the town," and "a new mask that imitated Eagle, and that was called Hawk, *Slu*" [in Dan], was created as a replacement. Siegmann recalled: "In the end . . . there was a reconciliation between the owner of Eagle and the townspeople. Both masks ended up getting sold, and a third mask was created. I have the second mask. I have *Slu*."[20]

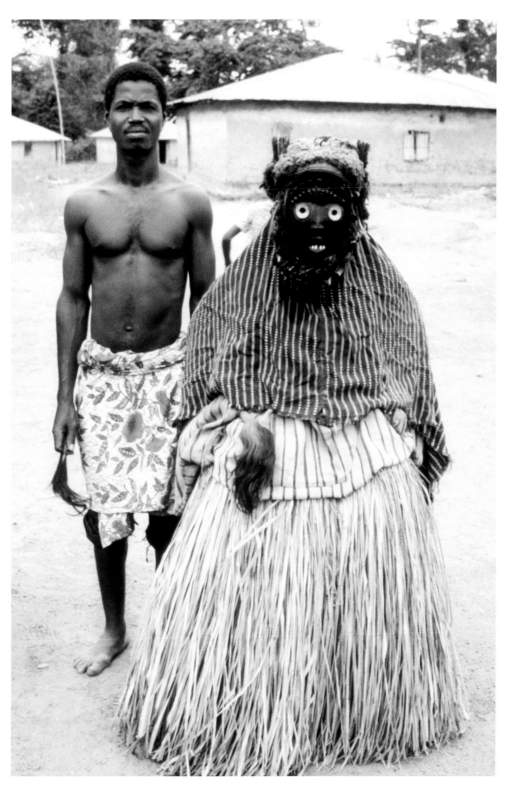

8.4
Dancer perform-
ing with a *bagle*
entertainment
mask called *Slu*
(Hawk), Nyor
Diaple, Liberia,
1983. *Photograph by
William Siegmann.*

Visions from the Forests | William Siegmann, Advocate for Connoisseurship

1 2

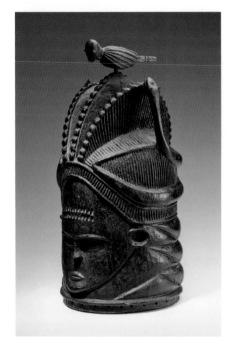

8.5

Kaiwa

Southern Bullom
(Sherbro)

Jong Chiefdom,
Bonthe District,
Southern Province,
Sierra Leone

**HELMET
MASK**, c. 1935

Wood, pigment,
abrus seeds

H. 18 ¼ in
(46 cm).

*National Museum
of African Art,
Smithsonian
Institution, Bequest
of William Siegmann
in memory of Sylvia
Williams 2012-11-1*

A particular strength of the Siegmann collection is its group of Sande Society masks, reflecting his interest in acquiring works representing diverse forms, styles, and motifs characteristic of this female masking tradition. During my own museum career, Bill Siegmann was my "go-to guy" for quality assessments and expertise regarding Sande masks. His extensive research of published sources bolstered his expertise and provided him with clues about a mask's origin and its maker. As a passionate collector, he acquired Sande Society masks that exemplified the formal and aesthetic qualities of works attributed to the known masters, including one Bill called the "Master of the Raccoon Eyes" (cat. no. **1**), the Sogande family workshop (cat. no. **2**), and the Sherbro carver Kaiwa (fig. **8.5**).[21] Besides recognizing the importance—to scholarship and to posterity—of researching, preserving, and displaying objects attributed to specific individuals, Siegmann also clearly appreciated the technical virtuosity of the artists who carved Sande Society masks and the criteria of beauty encoded in them. His collection includes an impressive range of Sande masks bearing elaborate, detailed coiffures and distinctive approaches to facial features that communicate Mende concepts of the feminine ideal and reveal the hands of master artists.

CONNOISSEURSHIP CONSIDERED

Nowadays, interest in connoisseurship training in the tradition-based arts of Africa appears to have waned. The discipline requires regular visual, tactile, and intellectual engagement with actual works of art—as many as possible—in order to understand and compare the qualities of style, form, material, surface, and so on that close examination of a particular corpus of objects reveals. This hands-on skill is rarely taught in universities these days—a particular sore point for Bill Siegmann and a problem we discussed periodically over the years, including just a few months before his death. We speculated that fewer recent graduates in African art history had extensive exposure to actual objects, that fewer professors were also serious African art collectors, and that working with museum collections was not well-integrated into art history curricula, even at universities with well-established museums. We also wondered if the academy viewed connoisseurship as an elitist pursuit or as expertise that could readily be acquired on the job by neophyte curators. Recognizing, of course, that the field had greatly expanded over the decades since we had been in graduate school, we realized that connoisseurship had become peripheral to many in our field. Nevertheless, the discipline has been greatly enriched by its embrace of contemporary and popular arts, photography, museum and heritage studies, and diaspora studies, among other topics, all of which confirm the relevance and global reach of African expressive culture.

Having worked in art museums for decades, Bill and I knew that connoisseurship plays a vital role in assessing the strengths of a museum's existing collection—particularly in light of new research—and in recommending new acquisitions. These deliberations, in which curators regularly engage, turn particularly challenging when objects under consideration lack sufficient provenance or have not been vetted through their "circulation" via scholarly exhibitions and publications. In 2003, citing a crisis in connoisseurship, the Africanist art historian Herbert M. Cole wondered:

> [How] many finely wrought but undetected fakes are now in public and museum collections? Will the passage of time make them easier to expose. . . . Who, if anybody, is monitoring these fakes, the techniques for creating patinas, the false dating, the international traffic in them. . . . It is when the stakes get high that people learn to be connoisseurs, and the fact that few African art scholars are avid collectors or are able to buy expensive pieces probably has a lot to do with the fact that most are not especially competent in detecting fakes.[22]

A problem with connoisseurship is that it is a fairly subjective skill, one that relies largely upon personal taste, individual judgment, particular points of view, and specific expertise. It is also informed by scholarly research and by the canon—that is, objects that conform to formal and aesthetic attributes of excellence, often defined by the West—and exercised to recognize variations in quality and to discern the authentic from the fake.[23] Even acknowledged connoisseurs make mistakes, as do other scholars in their interpretations of data. Furthermore, the African art canon emphasizes objects that were made before 1950 and that have circulated through publications and exhibitions, thus offering only a limited corpus of works for comparative quality assessments. Finally, no one individual is cognizant of all forms, styles, surfaces, and motifs that are believed to constitute works of art worthy of museum acquisition. Despite these limitations, there is a place for the connoisseur's informed judgments, recognizing that they will always be open to debate—as with any scholarly endeavor.[24]

Writing in a 1999 issue of the scholarly journal *African Arts*, the art historian Frederick Lamp suggested that there had been a "retreat from research in Africa," particularly with regard to the traditional arts.[25] Several art historians strongly disputed his position, claiming that he had presented traditional and contemporary African art as contending fields of scholarly inquiry, while ignoring significant contributions that theoretical perspectives and diaspora studies have made to the field.[26] Lamp's observations and the responses they provoked did not address the topic of connoisseurship as it related to fieldwork in Africa, but they might as well have. Although field research there may not be essential in order to cultivate and refine a connoisseur's skill, it does provide valuable firsthand insights into the range of artistic output in particular communities as well as into the history and circulation of objects within and outside the areas where they were produced. In addition, fieldwork affords insight into changing aesthetic criteria and contexts—including the emergence of new

traditions and art forms—that guide the ongoing (re)assessment of objects in museum and private collections and expand our understanding of Africa's evolving tradition-based arts.

In a 2013 opinion piece for *African Arts*, published fourteen years after Lamp's essay appeared, the art historian Sidney Littlefield Kasfir raises similar issues about the generational shift in the discipline. Given that increasing numbers of scholars are focusing on the contemporary, Kasfir wonders what impact that development will have on the study and understanding of pre-1950 African art, and how emerging scholars and museum professionals might adopt new strategies that bring relevance to the older genres.[27] Fortunately, the field of African art history is sufficiently robust to produce successive generations of scholars whose research, on and off the continent, enhances our understanding of African expressive culture. So while contemporary art-historical research may not address the "connoisseurship gap" in a scholar's set of skills, it does provide ample opportunities for working with objects and creating exhibitions that portray the peoples, cultures, and art forms of Africa and its diasporas in dynamic and relevant ways.

Roy Sieber encouraged students, colleagues, and collectors to "begin and end with the object." This succinct expression underscored Sieber's firm conviction that focusing on the object is what distinguishes art history from other disciplines and that art historians must use that methodology to explain the object.[28] Reflecting upon Bill Siegmann's exceptional eye and scholarly expertise, particularly regarding the arts of Liberia and Sierra Leone, prompts thoughts about his indelible imprint on the field and speculation about the future of connoisseurship as it pertains to the arts of Africa. For those of us working in museums and teaching African art history, it seems shortsighted to neglect training new generations in the intellectual and aesthetic pleasures that arise from a rapport with objects, one that is achieved through close, critical, and informed observation.

Catalogue

of Objects

ALEXANDER BORTOLOT

Sande Society Masks

1

Culture unknown

Liberia or Sierra
Leone

NDOLI JOWEI
MASK, late 19th
century

Wood

H. 15 ⅛ in.
(38.4 cm)

*Minneapolis Institute
of Arts, Gift of
William Siegmann*
2011.70.8

ASSOCIATIONS ORGANIZED AROUND the discovery, transmission, and application of *hale* (pronounced "ha-lay")—a Mende term for specialized knowledge, or "medicine," gained through spiritual assistance—are widespread in Liberia and Sierra Leone. Among the largest is the Sande Society, an association with which all adult women in the region are connected, and through which they maintain their health and well-being and promote their interests. Girls enter Sande around the start of puberty, following an extensive period of education and conditioning.

The concepts embodied by the Sande Society find public, aesthetic expression in the use of masks in performances throughout the period of Sande training. For example, a woman wearing a mask might appear in town when the girls are sequestered in the forest to undergo clitoridectomy; this is done to indicate the presence of women's beneficial expertise at a moment of great physical danger.

Although carved by men, the black wooden Sande masks are among a limited number of masks in Africa made specifically for women's performances. The Sande mask—also called the *ndoli jowei*, *nòwo*, or "*sowei* mask" in the literature—depicts a woman in her physical prime, with smooth, glistening skin, neck creases, and an elaborate coiffure. When worn, the wooden headpiece covers much of the performer's head, while the blackened palm-fiber ruff obscures her neck, shoulders, and torso. Additional palm-fiber capes are tied to the performer's shoulders and waist; the overall form is bulky yet surprisingly responsive to the dancer's movements.

Perhaps because Sande mask aesthetics are quite narrowly defined, sculptors have embraced the form as a vehicle for artistic exploration and invention. Numerous individual artists and artistic workshops are recognizable among masks Westerners have collected since the nineteenth century. Both William Siegmann and Frederick Lamp sought to identify individual carvers, workshops, and likely date ranges for known Sande masks; research on those is summarized in Lamp's essay in this book.

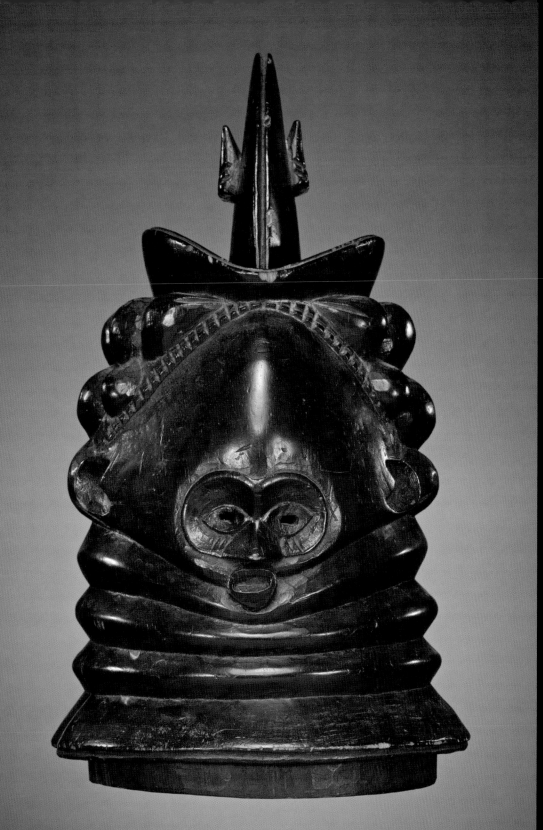

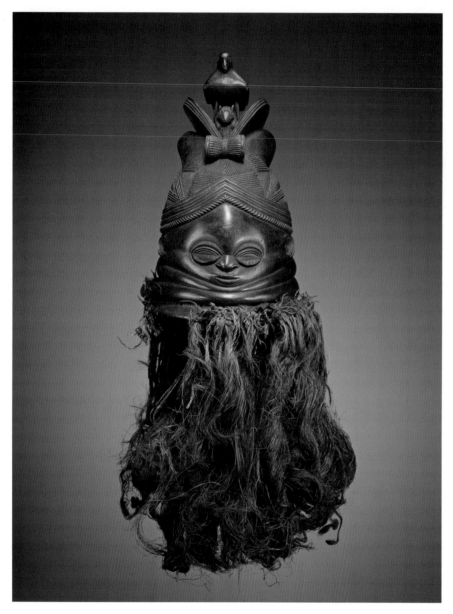

2

Sogande family
workshop

Mende

Sierra Leone

NDOLI JOWEI
MASK, first half
of 20th century

Wood, raffia

H. 16 in.
(40.6 cm) (mask)

*The Estate of William
Siegmann, Brooklyn*

3

Mende

Sierra Leone

NDOLI JOWEI
MASK, mid-20th
century

Wood

H. 15 ½ in.
(39.4 cm)

*The Estate of William
Siegmann, Brooklyn*

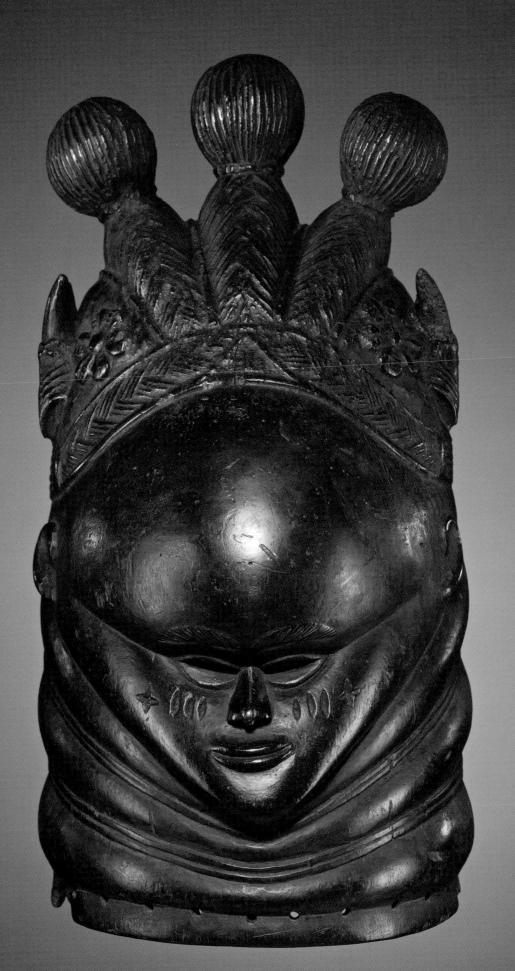

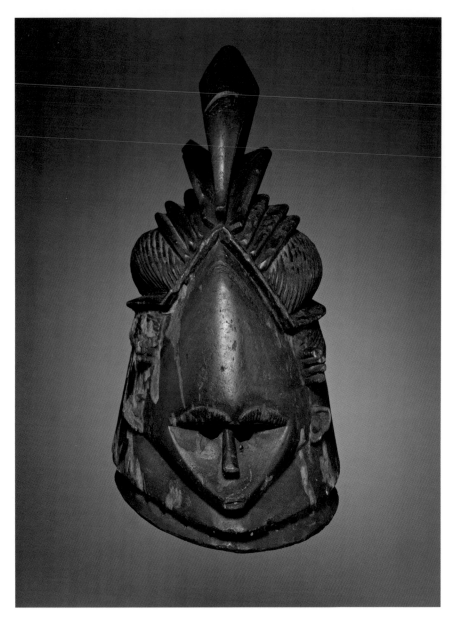

4

Vai

Liberia

NDOLI JOWEI
MASK, late 19th
century

Wood

H. 18 ½ in.
(47 cm)

*The Estate of William
Siegmann, Brooklyn*

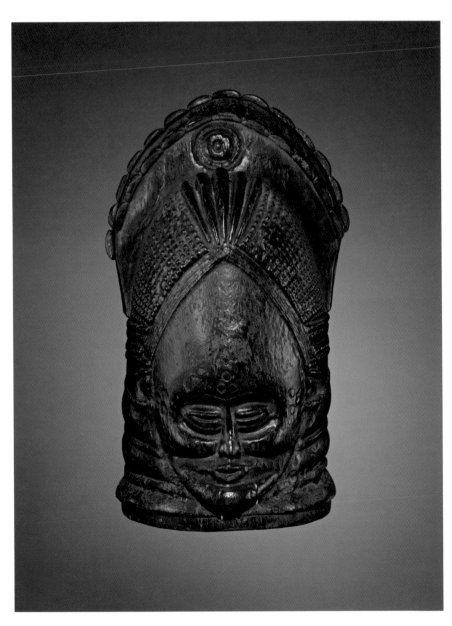

5

Southern Bullom
(Sherbro)

Sierra Leone

NDOLI JOWEI
MASK, early 20th
century

Wood

H. 15 in.
(38 cm)

*The Estate of William
Siegmann, Brooklyn*

Mende Female Figure

BILL SIEGMANN ACQUIRED a wooden female figure (cat. no. **7**) together with a Sande Society mask (cat. no. **6**) in 1986; he believed the same person had made both of them. Based on the art historian Loretta Reinhardt's fieldwork in Sierra Leone in 1970 and on his own research, Frederick Lamp, in his essay for this book, identifies the maker as Pa Jobo, a talented and prolific Mende wood sculptor who carved from the 1920s until his death in 1970. While at least twenty masks by Pa Jobo are known, only four of his figures, including this one, have been identified to date.[1]

Scholars and collectors usually associate Mende figures with divination and healing associations led by women. In the absence of specific collection data, however, it is impossible to identify the function of a particular figure. In his notes about this object, Siegmann wrote: "Not all figurative carvings are used in the context of curing societies. Some figures are kept by chiefs or prominent female elders simply as symbols of their roles in 'protecting' the women's societies such as Sande."[2]

Regardless of its function, the sculpture exemplifies Mende aesthetic ideals, many of which are also expressed in Sande Society masks. The hairdo shows stylized braids, the face is small, the neck is long and has three bulges, and the chest, abdomen, and lower back display various patterns of scarification. The swellings of the neck have often been interpreted as rings of fat, supposedly a sign of health and beauty. But research done in Sierra Leone in the 1970s and 1980s suggests that they depict grooves, which used to be made by tying and constricting the neck to enhance a young woman's appearance. The rings also refer to the abdominal segments of the chrysalis. This insect pupa, which is associated with metamorphosis and the life cycle, forms a fitting metaphor for the transformation of young girls during the Sande Society initiation process.[3]

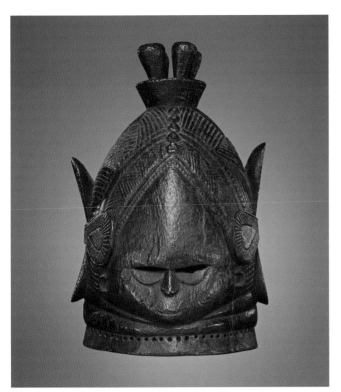

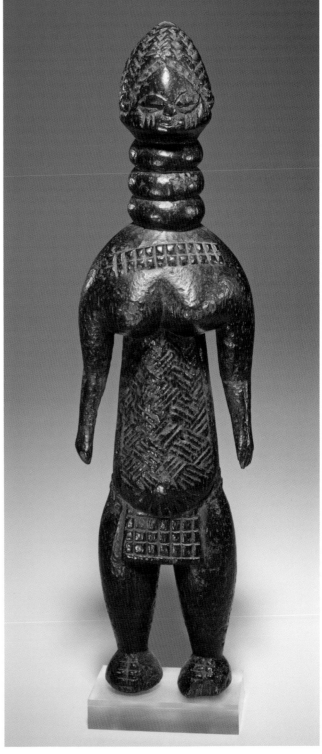

6 *(above)*

Amara, a.k.a.
Pa Jobo
(c. 1900–1970)

Mende

Sierra Leone
(Mano-Penubo,
Bo District)

NDOLI JOWEI
MASK, first half
of 20th century

Wood

H. 14 ³/₁₆ in.
(36 cm)

*Minneapolis Institute
of Arts, Gift of
William Siegmann
2011.70.5*

7 *(right)*

Amara, a.k.a.
Pa Jobo
(c. 1900–1970)

Mende

Sierra Leone
(Mano-Penubo,
Bo District)

**FEMALE
FIGURE**, mid-
20th century

Wood

H. 17 ½ in.
(44.5 cm)

*Minneapolis Institute
of Arts, Gift of
William Siegmann
2011.70.47*

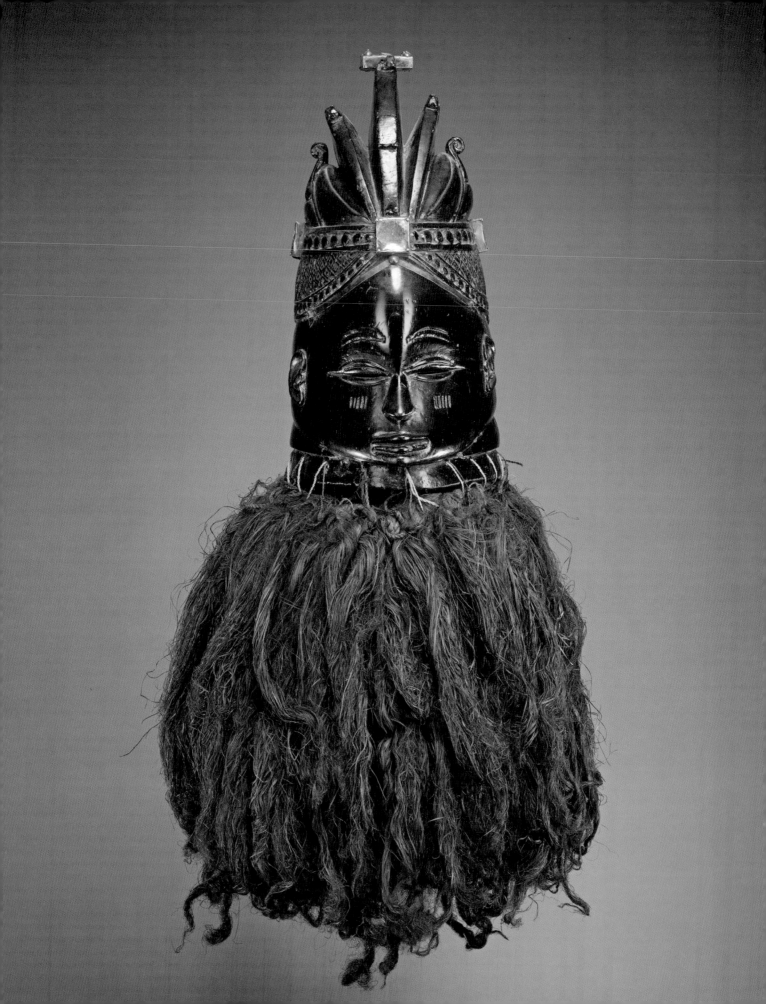

8

Ansumana Sona
(b. 1931)

Mende

Sierra Leone

***NDOLI JOWEI*
MASK AND
COSTUME**,
c. 1960

Wood, plant
fibers, silver,
cotton

H. 15 ¼ in.
(38.7 cm) (mask)

*Minneapolis Institute
of Arts, Gift of
William Siegmann
2011.70.3.1-2*

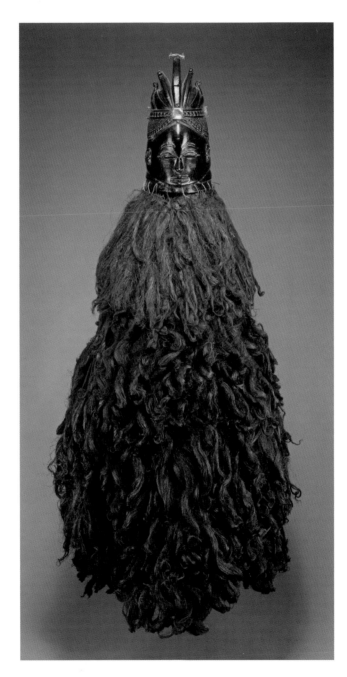

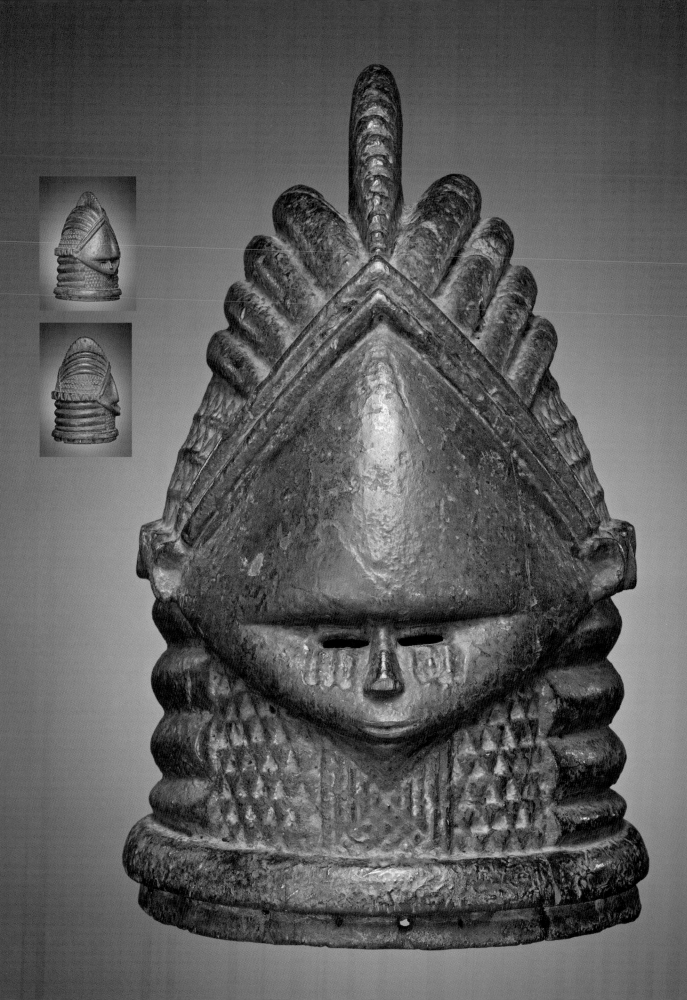

9 *(left)*

Probably Southern
Bullom (Sherbro)

Sierra Leone

***NDOLI JOWEI
MASK***, late 19th
century

Wood

H. 15 ¾ in.
(40 cm)

*Minneapolis Institute
of Arts, Gift of
William Siegmann
2011.70.4*

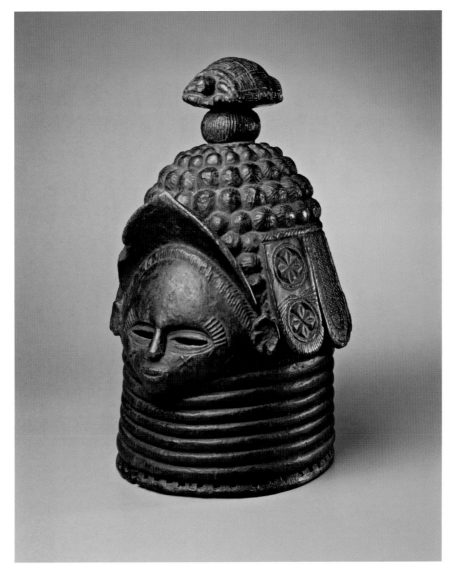

10

Southern Bullom
(Sherbro)

Sierra Leone

NDOLI JOWEI
MASK, late 19th
century

Wood

H. 14 ¾ in.
(37.5 cm)

*Brooklyn Museum,
Gift of Blake Robinson
1998.127.1*

JAN-LODEWIJK GROOTAERS

Sande Society Pendants and Necklace

11

Mende

Sierra Leone

**SQUARE
PENDANT**, early
20th century

Silver

H. 4 in.
(10.2 cm)

*The Estate of William
Siegmann, Brooklyn*

WHEN THE BRITISH PHYSICIAN and abolitionist Thomas Winterbottom visited Sierra Leone in the late eighteenth century, he observed that blacksmiths "made a variety of elegant, fancy ornaments for the women out of pieces of gold and silver dollars."[1] Foreign currency constituted a source of precious metals in many parts of Africa. Along the Guinea Upper Coast, where silver jewelry was especially popular, adornments were made from the Austrian Maria Theresa thaler, a silver-bullion coin that began being used in world trade during the 1750s and remained in circulation in parts of Africa until the mid-twentieth century. In the mid-nineteenth century, smiths started using French Napoleon five-franc coins, traded mainly through Guinea. From 1900 on, American silver dollars came into vogue as a currency and a source of silver, both in Liberia and Sierra Leone. The supply of silver pieces diminished throughout the twentieth century. In 1979, however, the art historian Thomas Seligman photographed an old Gbandi blacksmith in northwestern Liberia melting silver coins for jewelry (see fig. 7.13, p. 116).

Bill Siegmann collected a handful of silver pendants in various shapes as well as ivory pendants with silver fittings, which Sierra Leonean women of the Sande Society wore as status symbols (see fig. 3.2, p. 44). It is unclear whether these pendants are containers. The barrel-shaped pendant included here (cat. no. 15) is hollow and originally may have held Qur'anic scripts as a protective device. The large square pendant (cat. no. 11) closely resembles pendants with Islamic verses or magic numbers found elsewhere in West Africa.[2] And the smaller square pendant (cat. no. 12) is open on one side and shows a small wood block—possibly a reference to Muslim talismans. Some of the pendants display intricate filigree motifs of silver wire, a technique developed by the Mende in the nineteenth century.[3] In recent decades, Sande Society initiates have worn dense necklaces made of yellow beads, such as the one included here (cat. no. 18).

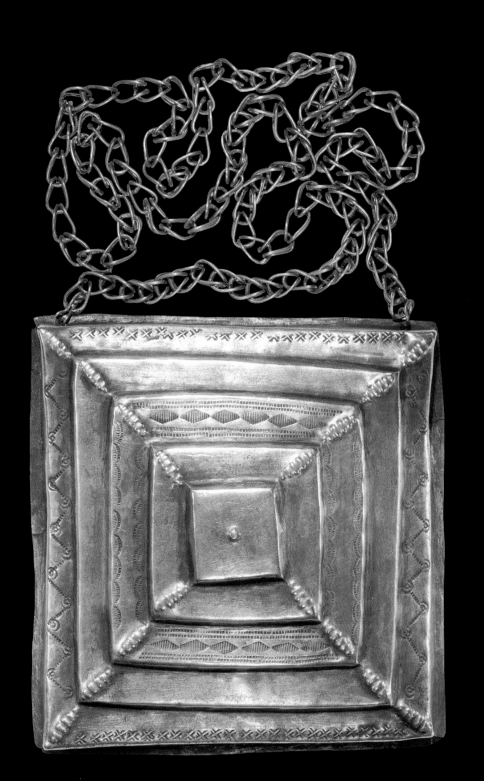

12

Mende

Sierra Leone

SQUARE PENDANT, early 20th century

Silver, wood

H. 2 in. (5.1 cm)

Minneapolis Institute of Arts, Gift of William Siegmann 2011.70.42a,b

13

Mende

Sierra Leone

CRESCENT-SHAPED PENDANT, early 20th century

Silver

H. 2 ¼ in. (5.7 cm)

Minneapolis Institute of Arts, Gift of William Siegmann 2011.70.44a,b

14

Mende

Sierra Leone

HEART-SHAPED PENDANT, early 20th century

Silver

H. 1 ¾ in. (4.5 cm)

Minneapolis Institute of Arts, Gift of William Siegmann 2011.70.43

15

Mende

Sierra Leone

BARREL-SHAPED PENDANT, early 20th century

Metal

W. 3 ½ in. (8.9 cm)

The Estate of William Siegmann, Brooklyn

16

Mende

Sierra Leone

**HORN-
SHAPED
PENDANT**,
early 20th century

Ivory (tusk of
the giant forest
hog, *Hylochoerus
meinertzhageni*),
silver

W. 4 ³/₁₆ in.
(10.6 cm)

*Minneapolis Institute
of Arts, Gift of
William Siegmann
2011.70.41*

17

Mende

Sierra Leone

**HORN-
SHAPED
PENDANT**,
early 20th century

Ivory, silver

W. 6 ¾ in.
(17.2 cm)

*The Estate of William
Siegmann, Brooklyn*

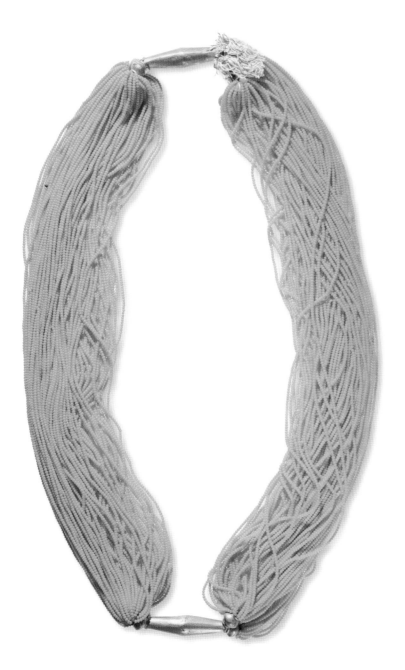

18

Mende

Sierra Leone

NECKLACE,
mid-20th century

Glass beads, metal

Diam. 15 in.
(38.1 cm)

*The Estate of William
Siegmann, Brooklyn*

ALEXANDER BORTOLOT

Masks of the Poro, Thoma, and Other Societies

19

Mende

Sierra Leone

PORO *GBINI*
MASK, mid-20th
century

Wood, leopard
skin, sheepskin,
antelope skin,
raffia, cotton,
cowrie shells

H. 17 in.
(43.2 cm) (mask)

Brooklyn Museum,
Gift of William C.
Siegmann
2004.77.1

AMONG THE MENDE and Mende-related peoples are numerous associations concerned with the acquisition and manipulation of *hale* ("hah-lay"), a Mende term meaning specialized knowledge or "medicine" gained through spiritual assistance.[1]

The Poro Society is often characterized as the male counterpart of the Sande Society; all young men of a given population are expected to enter it following a formative period of initiation. For both participants and onlookers, masks play a key role in shaping the initiation experience. The Mende consider the *gbini* mask to be the most powerful of all those related to the Poro Society (cat. no. 19). The *gbini* mask and costume are particularly imposing, composed of layer upon layer of palm-fiber skirts and a flat-topped cylindrical headpiece made from leopard skin and suggestive of a chiefly crown. *Bowu*, which means "long neck," characterizes feminine beauty, so it is not surprising that the mask included here, catalogue number 20, closely resembles women's Sande masks.[2] In contrast to the stately *gbini*, the *bowu* mask entertains the crowd through the performer's acrobatic, energetic feats.

In his essay for this book, Frederick Lamp suggests that the horned and bearded helmet mask shown here was created for an as-yet-unidentified association (cat. no. 21).[3] The beard reveals the mask's subject as male, while the blinders associate the object with secret knowledge.

Both men and women are members of the Thoma Society, which is found in Southern Bullom (Sherbro) communities and is primarily concerned with matters of fertility and gender relations. A set of four masks representing a human and an animal couple are associated with the Thoma Society. The animal masks indicate the "wildness" of members prior to initiation, while the human masks represent the male and female ancestral spirits that are present when they enter the society. The mask included here may represent the female half of the couple, although more research is required to confirm this (cat. no. 22).[4]

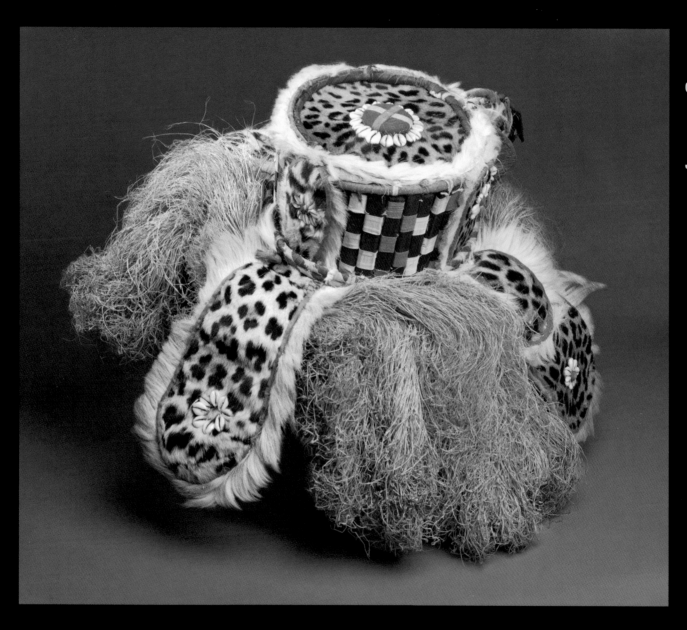

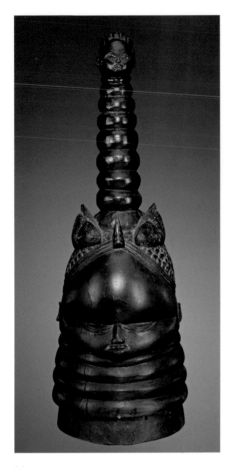

20

Vai

Liberia

**PORO *BOWU*
MASK**, mid-20th
century

Wood

H. 26 in.
(66 cm)

*The Estate of William
Siegmann, Brooklyn*

21

Mende or
Southern Bullom
(Sherbro)

Sierra Leone

**UNIDENTIFIED
HELMET MASK**,
first half of 20th
century

Wood

H. 19 ½ in.
(49.5 cm)

*The Estate of William
Siegmann, Brooklyn*

22 *(right)*

Southern Bullom
(Sherbro)

Sierra Leone

THOMA MASK,
first half of 20th
century

Wood

H. 15 in.
(38.1 cm)

*Minneapolis Institute
of Arts, Gift of
William Siegmann
2011.70.6*

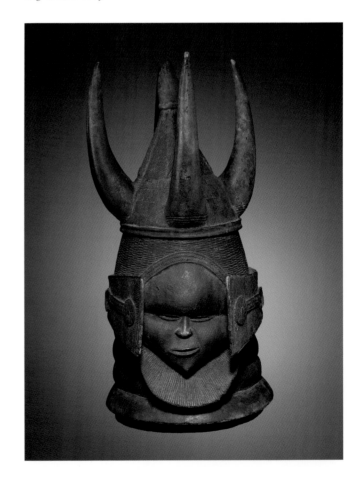

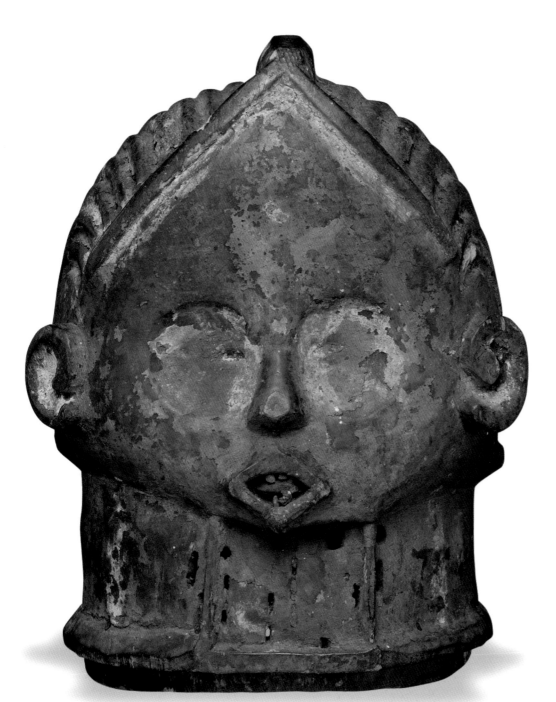

ALEXANDER BORTOLOT

Gongoli Masks

23

Mende

Sierra Leone

GONGOLI MASK, second half of 20th century

Wood

H. 21 in. (53.3 cm)

The Estate of William Siegmann, Brooklyn

24

Mende

Sierra Leone

GONGOLI MASK, second half of 20th century

Wood, raffia

H. 23 in. (58.4 cm) (mask)

The Estate of William Siegmann, Brooklyn

THE MENDE MASK known as *gongoli* is used in performances for satirical purposes. Its typically grotesque features and the comic choreographies with which it is associated render it a humorous figure, beloved by audiences. It is also employed on visits to grieving families after funerals.[1] As the levity of its persona suggests, the *gongoli* is distinct from the types of masks associated with initiatory societies such as Poro and Sande; nor is it related to medicinal knowledge or spiritual authority. This lower status is also denoted by its costume, which is meager and revealing, and the fact that it is not accompanied by attendants during performances. By contrast, masks embodying powerful forces must be contained, controlled, and checked by human interlocutors when presented in public.[2] A mask related to *gongoli*, known as *kökpö*, is found in Vai and Gola communities. Older examples of these masks are flatter in form than *gongoli* masks, and performers wear them on their backs.[3]

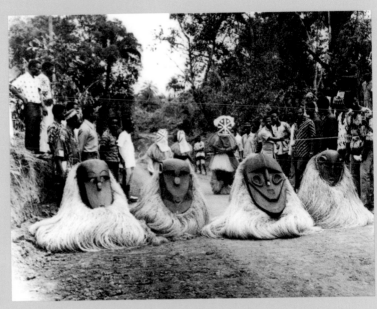

9.1

This undated William Siegmann photograph shows dancers with *gongoli* masks. *Nafali* mask performers appear in the background.

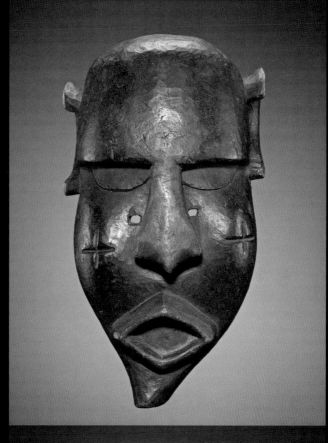

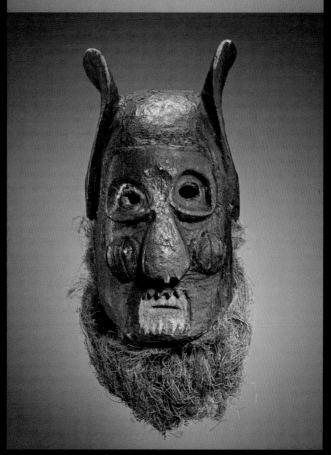

ALEXANDER BORTOLOT

Masks and Figures of the Loma People

25

Loma

Liberia

ANGBAÏ (or ***NYANGBAÏ***) **MASK**, mid-20th century

Wood

H. 18 5/16 in. (46.5 cm)

Minneapolis Institute of Arts, Gift of William Siegmann 2011.70.12

LOMA COMMUNITIES IN northwestern Liberia and adjacent areas of Guinea use a great variety of masks and objects in conjunction with associations concerned with *sale* (pronounced "sah-lay"), a Loma word equivalent to the Mende term *hale* ("hah-lay"), meaning specialized knowledge or "medicine" gained through spiritual assistance.

The masks are characterized by their horizontal orientation and combination of animal and human forms that reflect *sale*'s forest origins. *Angbaï* (or *nyangbaï*)(cat. no. 25) and *gazelégi* (cat. no. 27) masks are identified by sets of three and two horns, respectively, while the curling horns of the ram characterize the *okobuzogui* mask (cat no. 26).[1] Appearing at Poro Society-related events, these masks typically serve to protect participants through the manipulation and manifestation of *sale*.[2] *Angbaï* maintains a unique status among Loma masks, because it is summoned to broker disagreements among masking societies.[3]

As is the case with the Dan, Loma mask owners often commission miniaturized versions of their masks that are kept private and worn on the body for protective purposes (cat. no. 28).[4] Miniaturized masklike forms, such as those adorning the Janus-faced staff included here (cat. no. 29), are probably replicas of larger mask types and link the object with *sale* forces. Mysterious objects, such as the medicine figure with mortar and pestle shown here (cat. no. 30), require more context in order to be fully understood, but they generally express *sale* knowledge for personal concerns such as healing and problem solving. William Siegmann said he was unclear about the use of this particular object but believed it protected the owner from magical substances blown at him or her by an enemy.[5]

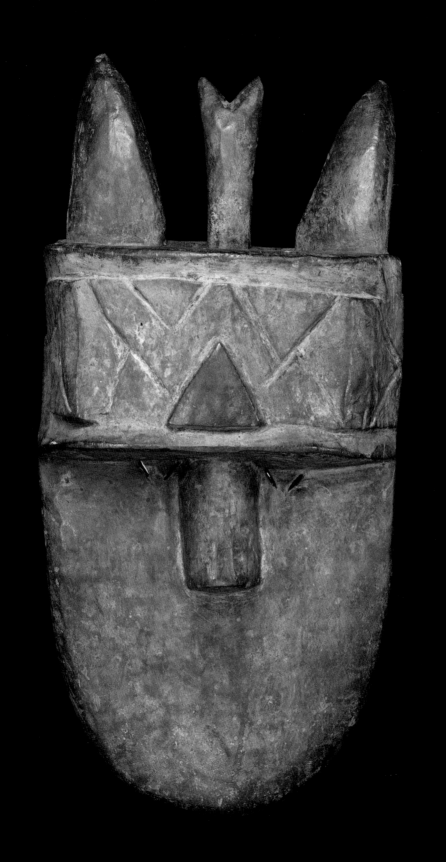

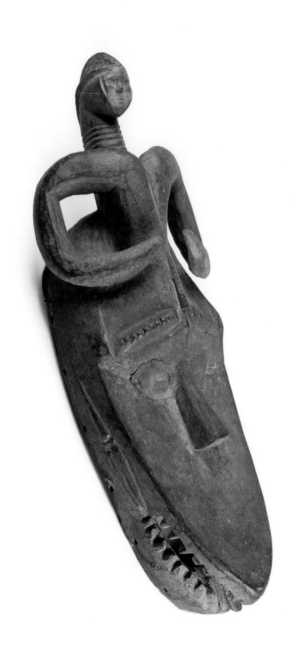

26

Loma

Liberia

OKOBUZOGUI
MASK, mid-20th
century

Wood, clay,
copper alloy

H. 40 in.
(101.6 cm)

Brooklyn Museum,
A. Augustus Healy
Fund and Designated
Purchase Fund 2004.1

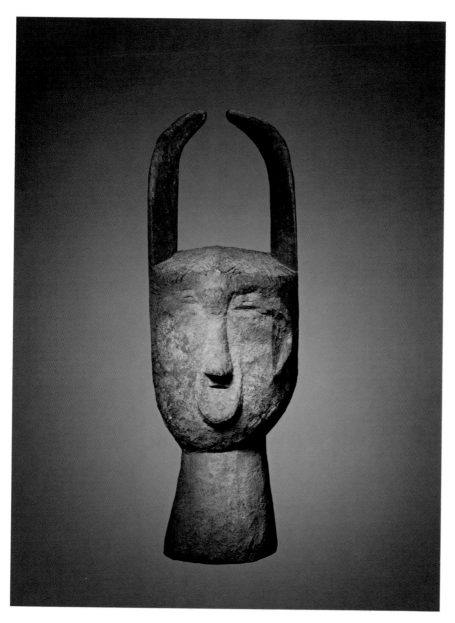

27

Loma

Liberia or Guinea

GAZELÉGI MASK, mid-20th century

Wood

H. 20 ½ in. (52 cm)

Private collection, New York

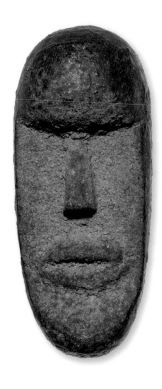

28

Loma

Liberia

MINIATURE MASK, mid-20th century

Wood

H. 4 in. (10.2 cm)

The Estate of William Siegmann, Brooklyn

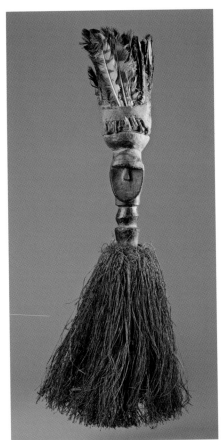

29

Loma

Liberia

JANUS-FACED STAFF, first half of 20th century

Wood, feathers, palm fiber

H. 30 ½ in. (77.5 cm)

Brooklyn Museum, Gift of Blake Robinson 1992.196.2

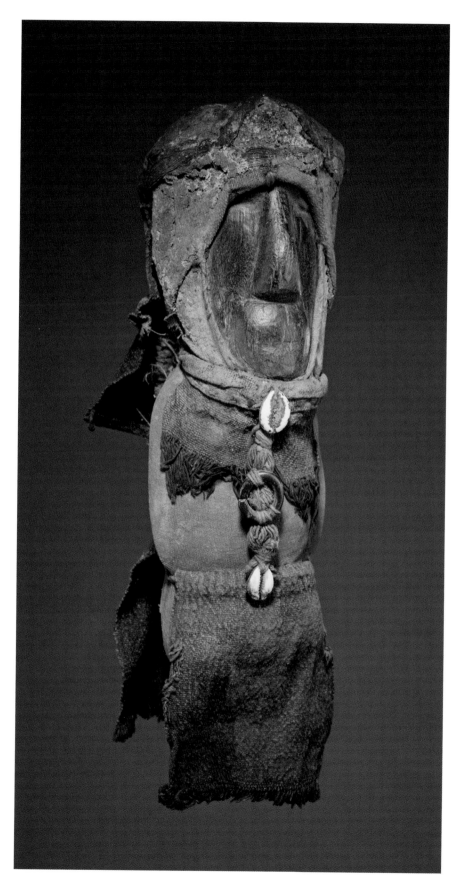

30

Loma

Liberia

MEDICINE FIGURE, first half of 20th century

Wood, cotton, metal, shell, plant fibers

H. 26 ½ in. (67.3 cm)

Minneapolis Institute of Arts, Gift of William Siegmann 2011.70.46.1-2a,b

JAN-LODEWIJK GROOTAERS

Masks of the Dan, Mano, Kono, and Bassa Peoples

31

Dan or Mano

Liberia

MASK WITH SHOULDER CLOTH, first half of 20th century

Wood, animal fur, feathers (of the great blue turaco, *Corythaeola cristata*), cotton, beads

H. 9 in. (22.9 cm) (mask)

Minneapolis Institute of Arts, Gift of William Siegmann 2011.70.1

MASKS ARE THE MOST important art form of the Dan, the approximately five hundred thousand people inhabiting the interior of Liberia and Côte d'Ivoire. Their mask societies perform at initiations and funerals and on other religious and secular social occasions. It is sometimes difficult to distinguish between masks from the Dan and their less numerous Mano neighbors (cat. no. 31). Each mask, with its headdress and costume, embodies a particular forest spirit or the spirit of a particular household, and some are given individual names (cat. nos. 34 and 36). The distinctive shape of a given mask communicates its type and its role in performance. An example is the *kagle* mask, which, with its deep-set eyes and triangular cheekbones, often takes the form of a chimpanzee's face (cat. no. 35). The *kagle* wearer throws sticks at the audience to "warm up" the dancing area for subsequent performers.[1] Other Dan masks may change their outlook, meaning, and function over time. Bill Siegmann collected a thin-walled example from Côte d'Ivoire that originally must have had slit eyes and served as an entertainment mask; later, the eyes were enlarged to convert the mask for another purpose (cat. no. 32).

Artistry is highly valued in Dan society, and a number of sculptors from the past are still known by name today. Based on his fieldwork in the 1980s, Siegmann was able to identify the maker of a pair of ceremonial hoes (cat. nos. 37 and 38) as Feia Tomekpa, a sculptor who also had carved masks.[2] A ceremonial hoe is a status symbol given to a woman in recognition of her leadership in collective-farming activities. The heads on the handles of this particular pair of objects may have been carved as portraits of the owners.

Masks of the Kono, like Mano masks, resemble those of the Dan. The layers of material built up on the surface of the mask included here indicate that it had been retired as a dance mask before being used as an altar for offerings to its associated spirit (cat. no. 39).[3]

The masks of the Bassa—among whom Siegmann conducted his first fieldwork, in 1966—are characterized by their angular faces (cat. no. 40).[4] The dancer would have worn the mask, fastened to a braided bonnet, at an angle on his forehead and looked out through openings in the costume.

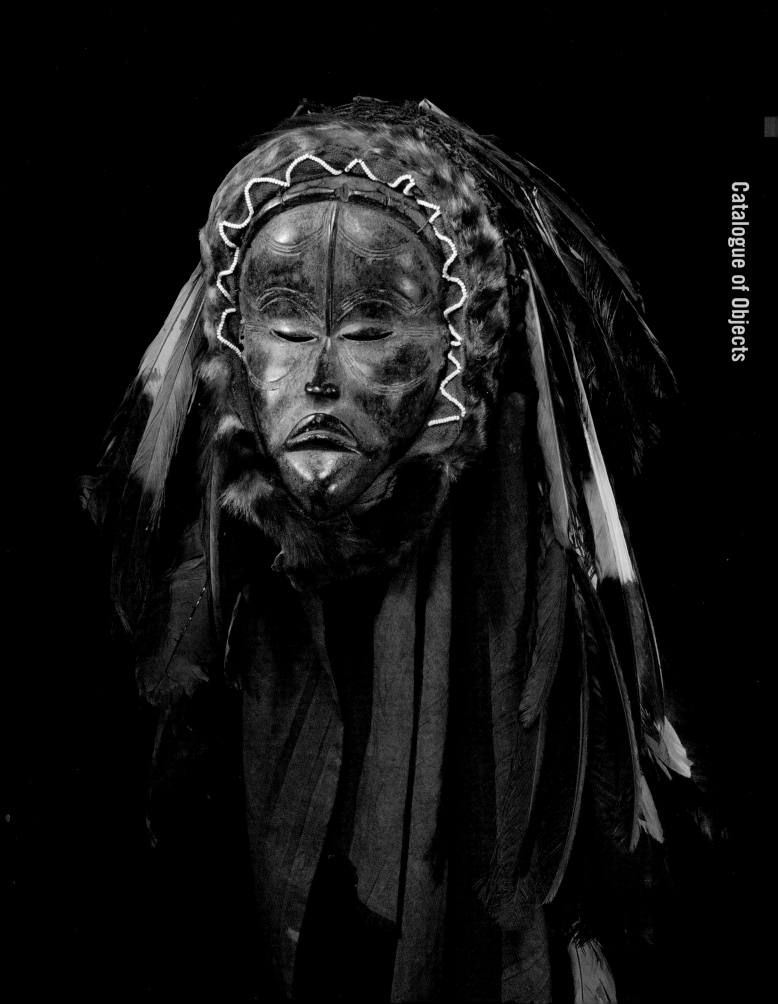

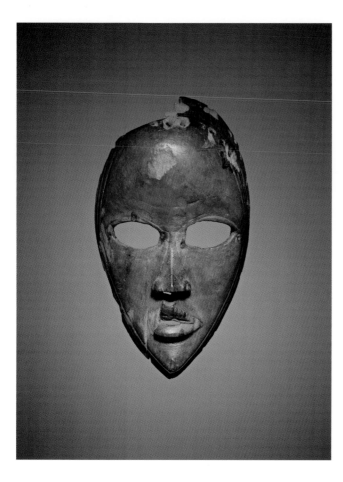

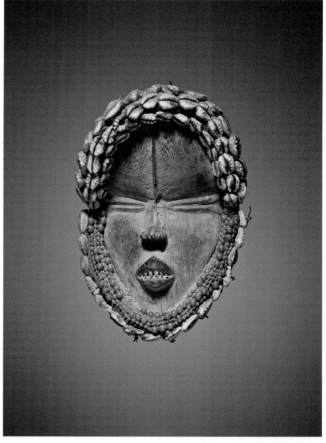

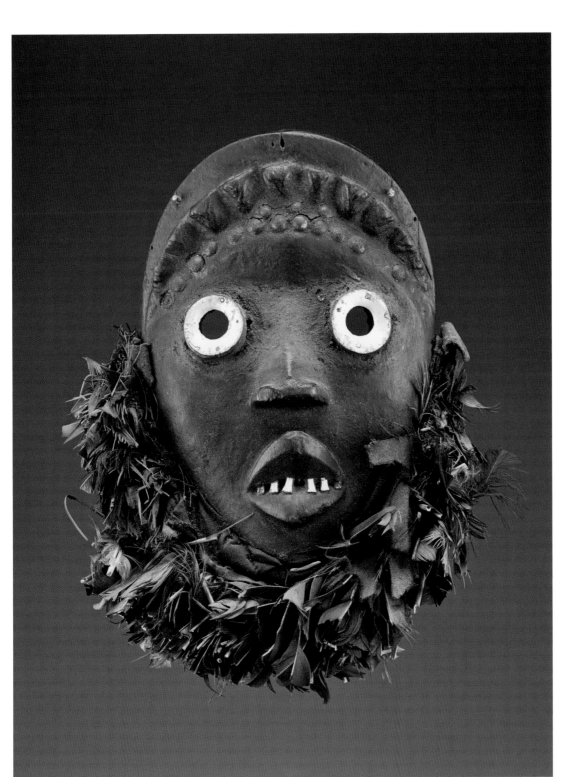

34

Tompieme
(active 1960–80)

Dan

Liberia (Nyor
Diaple)

***BAGLE* MASK,
CALLED *SLU*
("HAWK"),**
c. 1965

Wood, pigment,
metal, feathers

H. 11 ⁷⁄₁₆ in.
(29 cm)

*National Museum
of African Art,
Smithsonian
Institution, Bequest
of William Siegmann
in memory of Philip
Ravenhill 2012-11-2*

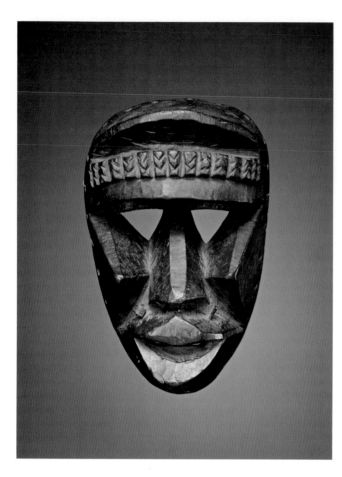

36

Dan

Liberia (Tanwie)

MASK, CALLED *DA* ("BIG OLD MAN"), mid-20th century

Wood

H. 9 in. (22.9 cm)

The Estate of William Siegmann, Brooklyn

35

Dan

Liberia

***KAGLE* MASK**, mid-20th century

Wood, metal

H. 8 ¼ in. (21 cm)

Minneapolis Institute of Arts, Gift of William Siegmann 2011.70.2

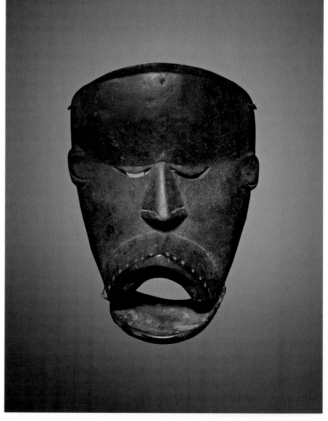

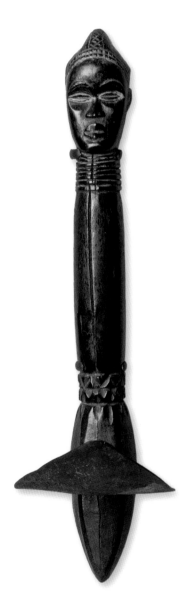
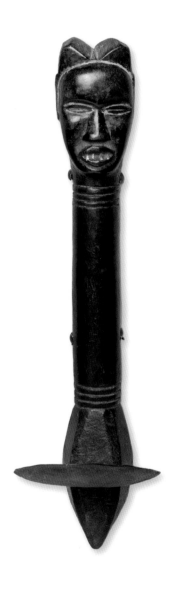

37 AND **38**

Feia Tomekpa
(active 1940s–early
1950s)

Dan

Liberia (Gaple)

**CEREMONIAL
HOES**, mid-20th
century

Wood, iron

Right: H. 14 ⅛ in.
(35.9 cm)

Left: H. 15 in.
(38.1 cm)

*Brooklyn Museum,
Gift of Mr. and Mrs.
Brian S. Leyden
87.216.1 and
87.216.2*

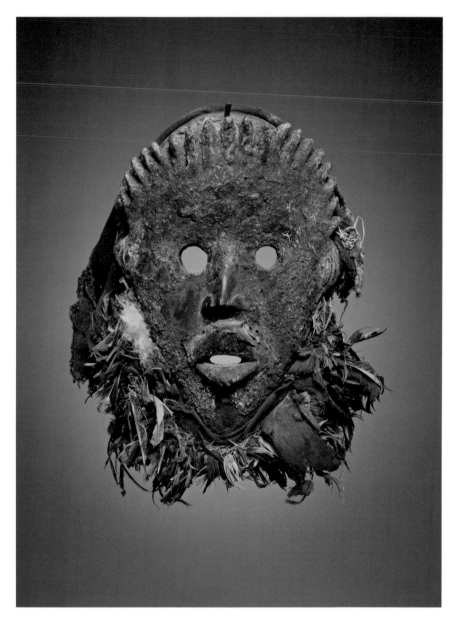

39

Kono

Sierra Leone

MASK, first half
of 20th century

Wood, cotton,
plant fibers,
feathers

H. 9 in.
(22.9 cm) (mask)

*Minneapolis Institute
of Arts, Gift of
William Siegmann
2011.70.10*

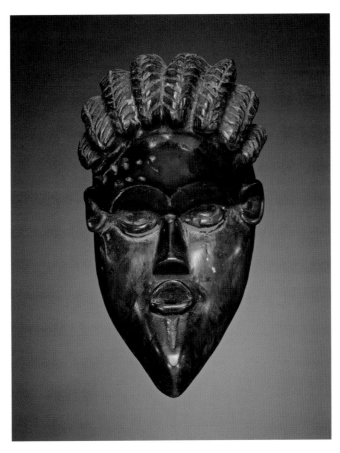

40

Bassa

Liberia (Gibi
District, Margibi
County)

***GEH-NAW
MASK***, first half
of 20th century

Wood

H. 7 9/16 in.
(19.2 cm)

*Minneapolis Institute
of Arts, Gift of
William Siegmann
2011.70.11*

ALEXANDER BORTOLOT

Miniature Masks

41

Mano

Liberia

MINIATURE MASK, mid-20th century

Wood

H. 5 in. (12.7 cm)

Private collection, New York

THE DAN AND OTHER culturally related inhabitants of Liberia and Côte d'Ivoire use masks for various purposes. Typically, a mask is created following an encounter between a forest spirit and a human being in a dream; the spirit initiates contact, and the human is compelled to reciprocate and accommodate the spirit in his or her life. A mask, commissioned from an artist and consecrated through performances and offerings, is the most tangible marker of this spirit-human relationship.

Miniature masks constitute a distinctive category of objects (cat. nos. 41–44 and 46). Much like their full-size counterparts, they take many forms, serve a number of functions, and are created for a range of reasons. Some are indeed smaller-scale replicas of larger masks that people own and use in performances. These smaller masks may serve as altars—focal points for human-spirit interaction. They also may be displayed in certain settings to indicate an owner's rank.

In some cases, a diviner advises an individual to commission a miniature mask for preventative, protective, or curative purposes. Objects in this category are generally oval in form, with delicate features. Usually, they are wrapped up and kept on the owner's body or among his or her possessions following the application of offerings such as oil or food.

Miniature masks are almost always carved from wood. Some examples made from cast metal or sculpted stone are also known, although their rarity has led some to believe they were made for sale to foreigners (cat. no. 44). Except for those masks that serve as smaller replicas of larger originals—whose design and construction are likely dictated by actual masks—the power of miniature masks most likely depends upon the iconic qualities of the mask form itself. Given this, the choice of material would have little apparent bearing on the efficacy of the object.

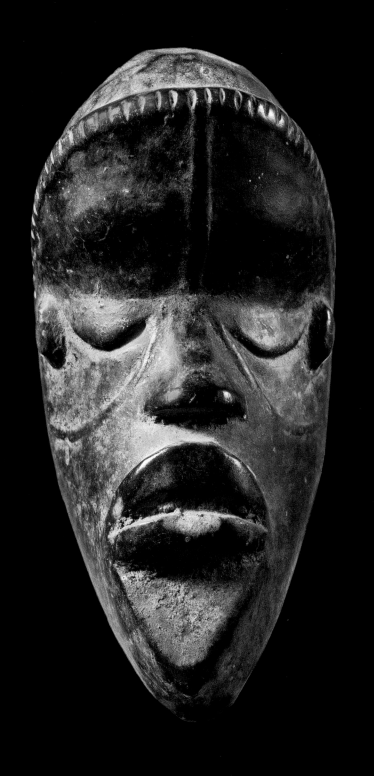

42

Dan

Liberia

MINIATURE MASK (*MA GO*), mid-20th century

Wood

H. 3 ⁷⁄₁₆ in. (8.7 cm)

Minneapolis Institute of Arts, Gift of William Siegmann 2011.70.17

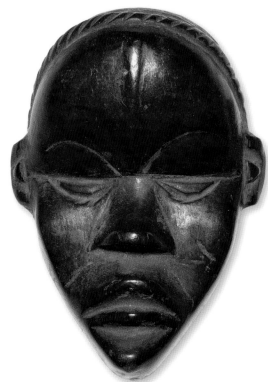

43

Dan

Liberia

MINIATURE MASK (*MA GO*), mid-20th century

Wood

H. 3 ¼ in. (8.3 cm)

Minneapolis Institute of Arts, Gift of William Siegmann 2011.70.16

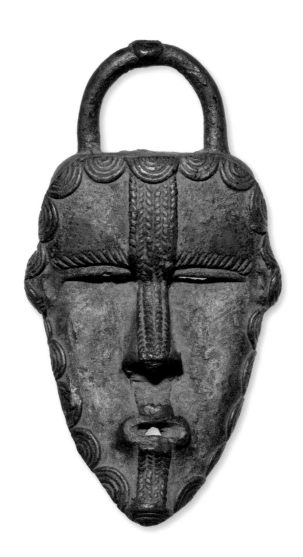

44

Bassa

Liberia

**MINIATURE
MASK
(*MA GO*),**
mid-20th century

Brass

H. 4 ½ in.
(11.4 cm.)

*The Estate of William
Siegmann, Brooklyn*

ALEXANDER BORTOLOT

Game Board and Miniature Mask

THE DAN ARTIST ZON created the game board and miniature mask shown here (cat. nos. **45** and **46**). Active from about 1948 to 1985, when he died in his eighties, Zon was among the most prominent and prolific Dan carvers of the twentieth century. A descendent of blacksmiths, he became a wood-carver under the tutelage of the well-known artist Zlan. Over time, Zon developed a signature style characterized by angular features and hair depicted in a herringbone pattern. The game board and miniature mask are two forms for which he is especially known, although he also produced full-size masks, guardian heads, feast ladles, and human and animal figures.[1]

The African game widely known in the West as *mankala* (or *wari*) is played throughout the continent and is popular among the Dan, who call it *ma kpon*. Well-sculpted game boards are expensive and cherished possessions. *Ma kpon* is played by two individuals using seeds or bits of metal as game pieces. Each player begins with a set number of pieces on either side of the game board and takes turns distributing and redistributing them in the twelve depressions around the board. If a player sees a hole with only one piece inside, he claims that piece for himself. The game ends when one side of the board has been emptied; the player with the most pieces wins.[2]

45

Zon (c. 1900–1985)

Dan

Liberia (Nuopie)

GAME BOARD (*MA KPON*), second half of 20th century

Wood

L. 27 ½ in. (69.9 cm)

The Estate of William Siegmann, Brooklyn

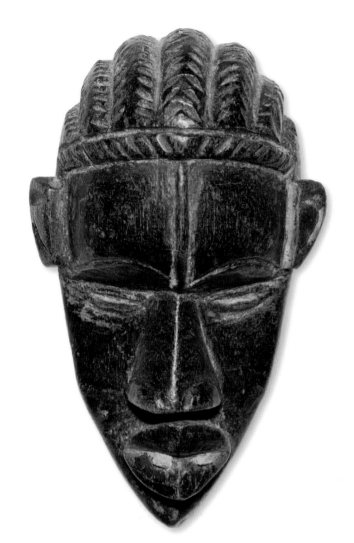

46

Zon (c. 1900–1985)

Dan

Liberia (Nuopie)

MINIATURE MASK (*MA GO*), second half of 20th century

Wood

H. 3 ⁵⁄₁₆ in. (8.4 cm)

Minneapolis Institute of Arts, Gift of William Siegmann 2011.70.14

NATASHA THORESON

Brass from Liberia

47

Mano

Liberia

FEMALE FIGURE, end of 19th or early 20th century

Brass, beads, string

H. 11 ¹⁵/₁₆ in. (28.7 cm)

Minneapolis Institute of Arts, Gift of William Siegmann 2011.70.23

THE STRIKING FIGURE by the Dan sculptor Ldamie depicts fashionable feminine adornments of a bygone era (cat. no. 48). The massive brass jewelry encircling the figure's neck, waist, and legs were distinct reflections of prestige and wealth in early twentieth-century Liberia. The development of the Liberian republic in the late 1930s prompted several changes in the workforce, including a need for female laborers. Participation in manual labor meant that Liberian women had to abandon their heavy, immobilizing jewelry.[1] Resourceful smiths melted this discarded material, along with scrap metal such as cartridge casings and auto parts, and recast it into new forms. Adopted as contemporary symbols of prestige, decorative figures such as those cast by Ldamie and John Leh (cat. nos. 49 and 50) were commissioned for display or were sold to visiting foreigners. This dramatic shift also prompted the creation of a new style of jewelry, comprised of colorful glass beads and tinkling metal bells. Leopard teeth, important and longstanding Dan symbols of prestige, were used to embellish the necklaces, both as stylized brass pendants and as molded plastic baubles (cat. nos. 52 and 53).

In contrast to these decorative prestige objects, the heavily patinated female figure included here testifies to a much older metalworking tradition (cat. no. 47). Believed to have been a ritual object used in divination, it was likely cast in the late nineteenth or early twentieth century. This imposing, impressively constructed figure belies a delicate touch. Intricate details—an elaborate hairstyle, elongated and ringed neck, embossed scarification pattern, protruding belly button, and beaded girdle—emphasize the figure's idealized feminine beauty.

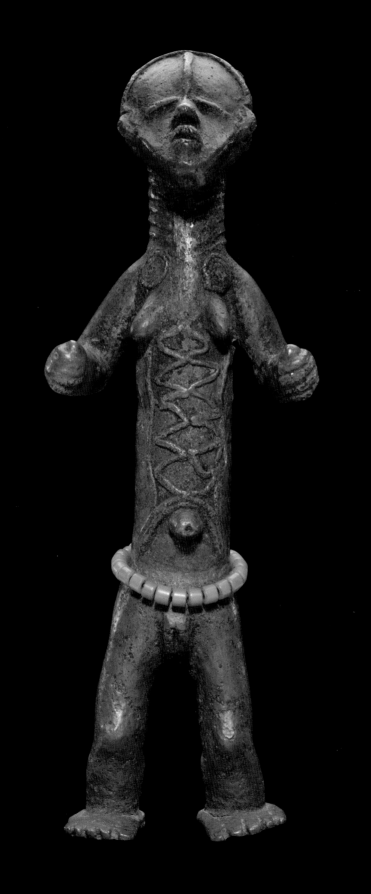

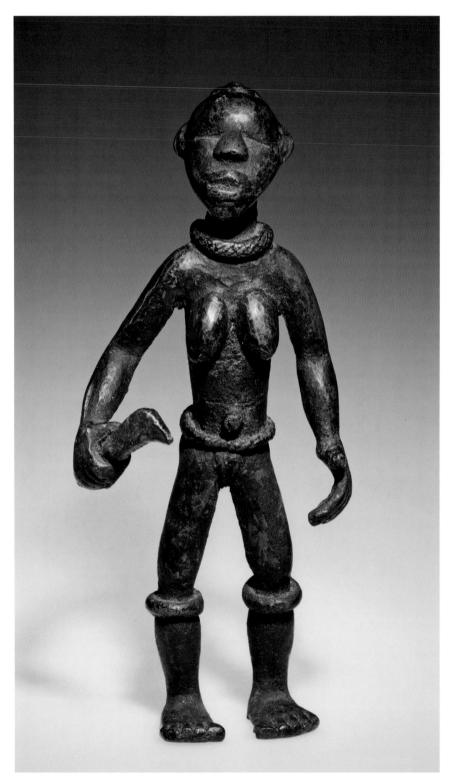

48

Ldamie
(c. 1890–1958?)

Dan

Liberia (Gaple)

**FEMALE
FIGURE
HOLDING A
KNIFE**, first half
of 20th century

Brass

H. 7 ⅞ in.
(20 cm)

*The Estate of William
Siegmann, Brooklyn*

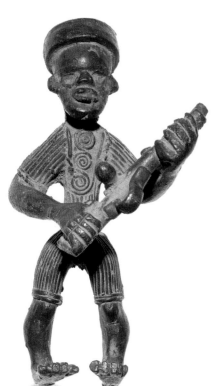

49

John Leh
(c. 1900–1987)

Kran

Liberia (Gbabobli)

SOLDIER,
mid-20th century

Brass

H. 5 ¾ in.
(14.6 cm)

*Minneapolis Institute
of Arts, Gift of
William Siegmann
2011.70.24*

50

John Leh
(c. 1900–1987)

Kran

Liberia (Gbabobli)

TORTOISE,
mid-20th century

Brass

L. 5 ¾ in.
(14.6 cm)

*The Estate of William
Siegmann, Brooklyn*

51

Bassa

Liberia

STAFF FINIAL,
probably 19th
century

Brass

H. 5 in.
(12.7 cm)

*The Estate of William
Siegmann, Brooklyn*

52

Dan

Liberia

NECKLACE,
mid-20th century

Brass, glass

Diam. 7 ¾ in.
(19.7 cm)

*The Estate of William
Siegmann, Brooklyn*

53

Dan

Liberia

NECKLACE,
mid-20th century

Brass, glass,
plastic

Diam. 5 ¼ in.
(13.3 cm)

*The Estate of William
Siegmann, Brooklyn*

JAN-LODEWIJK GROOTAERS

Grebo or Kru Ring

54

Grebo or Kru

Liberia

RING WITH KNOBS (*NITIEN*), age undetermined

Brass

Diam. 7 $\frac{1}{16}$ in. (18 cm)

Minneapolis Institute of Arts, Gift of William Siegmann 2011.70.25a,b

THIS RING IS ONE OF numerous mysterious objects that have intrigued Western explorers and scholars ever since they were first encountered in southeastern Liberia, during the nineteenth century. Such rings are made of brass, either solid or with a core of sand. They have four squat knobs and come in the shape of a bracelet with an opening on one side, a complete circle in one piece, or, as is the case here, a circle in two parts held together by pegs. This example weighs sixteen pounds, but some are known to weigh more than twenty-five pounds.

The rings have been variously understood as indigenous currency ("Kru money") and as sacred objects called *nitien* ("god of water" or "spirit of water"). The missionary George Schwab wrote of how the Kru people considered the rings to be animated, possessing the powers to heal, protect, divine, and capture.[1] When a *nitien* was found in a creek or river, it was brought to a ritual priest, who kept it to guard and protect the village.[2]

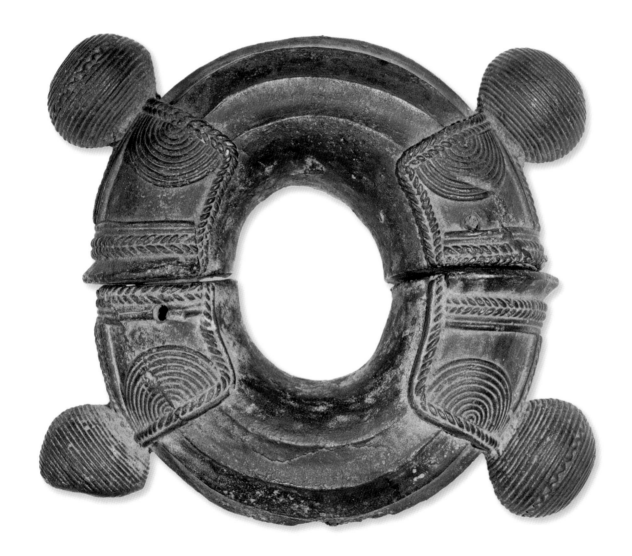

JAN-LODEWIJK GROOTAERS

Stone Sculpture of the Sapi and Kissi Peoples

55

Sapi peoples

Sierra Leone

COUPLE (*MAHEN YAFE* STYLE), probably 14th–17th century

Stone

H. 10 in. (25.4 cm)

Private collection

ALTHOUGH STONE SCULPTURE does not constitute a major African art form, works in stone—some even prehistoric—are found in most regions of the continent. The oldest examples, often stylized zoomorphic representations, date from about 6000 BCE, during the Neolithic era, and come from the Saharan Desert.[1] Ancient Egypt and Nubia, the North African Maghreb, the Ethiopian highlands, the mouth of the Congo River, and the Zimbabwean veld are homes to historic traditions of stone sculpture, while prominent and enduring expressions of this art form are also found in Nigeria and the Upper Guinea Forest region.[2]

The stone figures shown here, called *pomdo*, *nomoli*, and *mahen yafe*, are from the latter region—parts of Sierra Leone and adjacent areas of Guinea and Liberia. They are centuries old, but as they have not been subject to archaeological digs, little is known about when and why they were made, or even who made them. Broadly attributed to the forefathers of the present-day Kissi people (cat. nos. 56–58) and to the no-longer-extant Sapi peoples (cat. nos. 55, 59, and 60), these figures provide examples of ritual recycling, as they are being repurposed today by those who find them in the ground. Some are utilized in agrarian rituals aimed at increasing the harvest, while others play a role in divination rituals. The wooden figure wrapped in red cloth, called a *pom'kandya* ("dressed *pomdo* figure") or *pom'wama* ("divining *pomdo* figure"), is used in divination (cat. no. 61). Its power derives from the inclusion, in a cavity hidden behind the cloth, of a found stone *pomdo* figure, other stones, and metal pieces that the Kissi and many of their neighbors believe are related to their ancestors.[3]

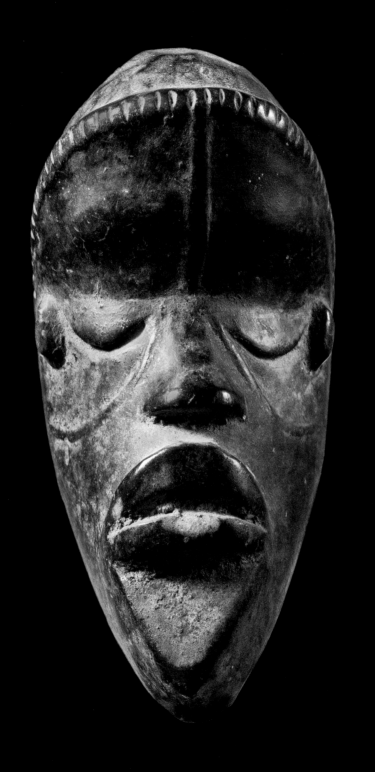

42

Dan

Liberia

MINIATURE MASK (*MA GO*), mid-20th century

Wood

H. 3 7/16 in. (8.7 cm)

Minneapolis Institute of Arts, Gift of William Siegmann 2011.70.17

43

Dan

Liberia

MINIATURE MASK (*MA GO*), mid-20th century

Wood

H. 3 ¼ in. (8.3 cm)

Minneapolis Institute of Arts, Gift of William Siegmann 2011.70.16

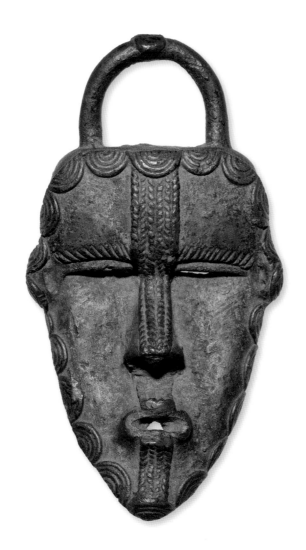

44

Bassa

Liberia

**MINIATURE
MASK
(*MA GO*),**
mid-20th century

Brass

H. 4 ½ in.
(11.4 cm.)

*The Estate of William
Siegmann, Brooklyn*

ALEXANDER BORTOLOT

Game Board and Miniature Mask

9.2

William Siegmann took this picture of the Dan artist Zon of Nuopie, Liberia, in 1983.

THE DAN ARTIST ZON created the game board and miniature mask shown here (cat. nos. **45** and **46**). Active from about 1948 to 1985, when he died in his eighties, Zon was among the most prominent and prolific Dan carvers of the twentieth century. A descendent of blacksmiths, he became a wood-carver under the tutelage of the well-known artist Zlan. Over time, Zon developed a signature style characterized by angular features and hair depicted in a herringbone pattern. The game board and miniature mask are two forms for which he is especially known, although he also produced full-size masks, guardian heads, feast ladles, and human and animal figures.[1]

The African game widely known in the West as *mankala* (or *wari*) is played throughout the continent and is popular among the Dan, who call it *ma kpon*. Well-sculpted game boards are expensive and cherished possessions. *Ma kpon* is played by two individuals using seeds or bits of metal as game pieces. Each player begins with a set number of pieces on either side of the game board and takes turns distributing and redistributing them in the twelve depressions around the board. If a player sees a hole with only one piece inside, he claims that piece for himself. The game ends when one side of the board has been emptied; the player with the most pieces wins.[2]

45

Zon (c. 1900–1985)

Dan

Liberia (Nuopie)

GAME BOARD (*MA KPON*), second half of 20th century

Wood

L. 27 ½ in. (69.9 cm)

The Estate of William Siegmann, Brooklyn

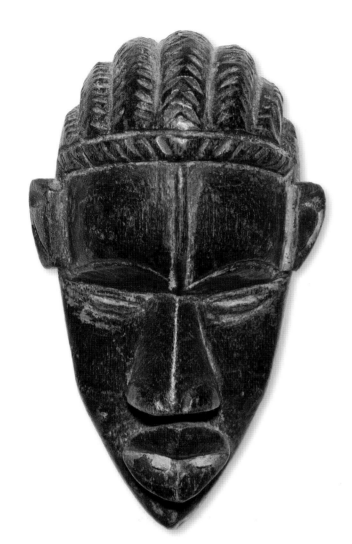

46

Zon (c. 1900–1985)

Dan

Liberia (Nuopie)

MINIATURE MASK (*MA GO*), second half of 20th century

Wood

H. 3 ⁵⁄₁₆ in. (8.4 cm)

Minneapolis Institute of Arts, Gift of William Siegmann 2011.70.14

NATASHA THORESON

Brass from Liberia

47

Mano

Liberia

FEMALE FIGURE, end of 19th or early 20th century

Brass, beads, string

H. 11 ¹⁵/₁₆ in. (28.7 cm)

Minneapolis Institute of Arts, Gift of William Siegmann 2011.70.23

THE STRIKING FIGURE by the Dan sculptor Ldamie depicts fashionable feminine adornments of a bygone era (cat. no. 48). The massive brass jewelry encircling the figure's neck, waist, and legs were distinct reflections of prestige and wealth in early twentieth-century Liberia. The development of the Liberian republic in the late 1930s prompted several changes in the workforce, including a need for female laborers. Participation in manual labor meant that Liberian women had to abandon their heavy, immobilizing jewelry.[1] Resourceful smiths melted this discarded material, along with scrap metal such as cartridge casings and auto parts, and recast it into new forms. Adopted as contemporary symbols of prestige, decorative figures such as those cast by Ldamie and John Leh (cat. nos. 49 and 50) were commissioned for display or were sold to visiting foreigners. This dramatic shift also prompted the creation of a new style of jewelry, comprised of colorful glass beads and tinkling metal bells. Leopard teeth, important and longstanding Dan symbols of prestige, were used to embellish the necklaces, both as stylized brass pendants and as molded plastic baubles (cat. nos. 52 and 53).

In contrast to these decorative prestige objects, the heavily patinated female figure included here testifies to a much older metalworking tradition (cat. no. 47). Believed to have been a ritual object used in divination, it was likely cast in the late nineteenth or early twentieth century. This imposing, impressively constructed figure belies a delicate touch. Intricate details—an elaborate hairstyle, elongated and ringed neck, embossed scarification pattern, protruding belly button, and beaded girdle—emphasize the figure's idealized feminine beauty.

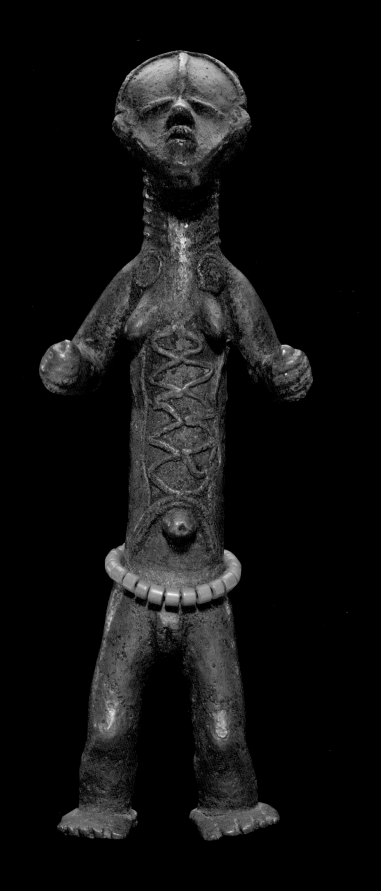

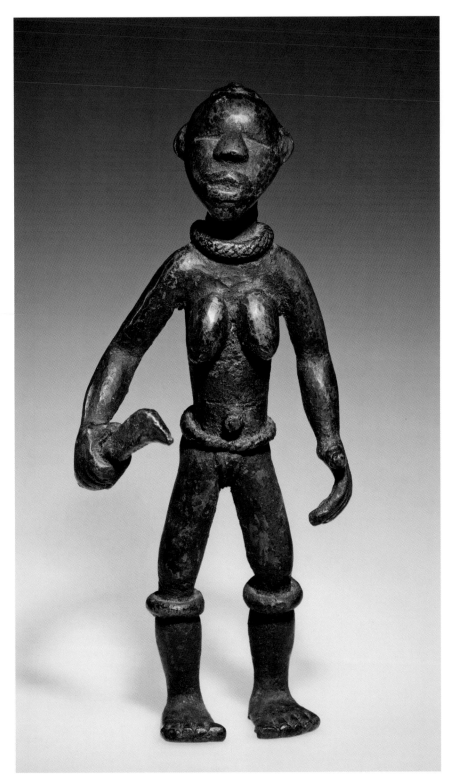

48

Ldamie
(c. 1890–1958?)

Dan

Liberia (Gaple)

FEMALE FIGURE HOLDING A KNIFE, first half of 20th century

Brass

H. 7 ⅞ in.
(20 cm)

The Estate of William Siegmann, Brooklyn

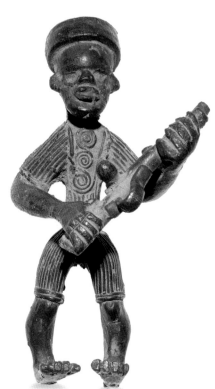

49

John Leh
(c. 1900–1987)

Kran

Liberia (Gbabobli)

SOLDIER,
mid-20th century

Brass

H. 5 ¾ in.
(14.6 cm)

*Minneapolis Institute
of Arts, Gift of
William Siegmann
2011.70.24*

50

John Leh
(c. 1900–1987)

Kran

Liberia (Gbabobli)

TORTOISE,
mid-20th century

Brass

L. 5 ¾ in.
(14.6 cm)

*The Estate of William
Siegmann, Brooklyn*

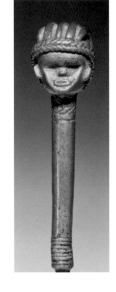

51

Bassa

Liberia

STAFF FINIAL,
probably 19th
century

Brass

H. 5 in.
(12.7 cm)

*The Estate of William
Siegmann, Brooklyn*

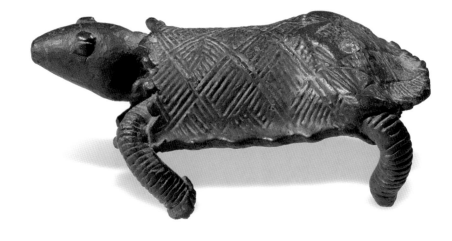

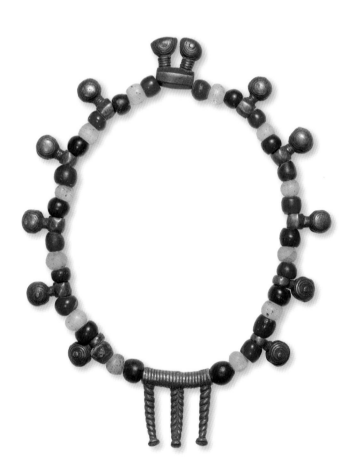

52

Dan

Liberia

NECKLACE, mid-20th century

Brass, glass

Diam. 7 ¾ in. (19.7 cm)

The Estate of William Siegmann, Brooklyn

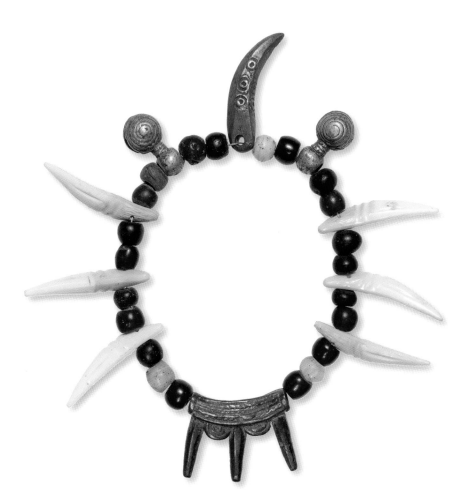

53

Dan

Liberia

NECKLACE,
mid-20th century

Brass, glass,
plastic

Diam. 5 ¼ in.
(13.3 cm)

*The Estate of William
Siegmann, Brooklyn*

JAN-LODEWIJK GROOTAERS

Grebo or Kru Ring

54

Grebo or Kru

Liberia

RING WITH KNOBS (*NITIEN*), age undetermined

Brass

Diam. 7 ¹⁄₁₆ in. (18 cm)

Minneapolis Institute of Arts, Gift of William Siegmann 2011.70.25a,b

THIS RING IS ONE OF numerous mysterious objects that have intrigued Western explorers and scholars ever since they were first encountered in southeastern Liberia, during the nineteenth century. Such rings are made of brass, either solid or with a core of sand. They have four squat knobs and come in the shape of a bracelet with an opening on one side, a complete circle in one piece, or, as is the case here, a circle in two parts held together by pegs. This example weighs sixteen pounds, but some are known to weigh more than twenty-five pounds.

The rings have been variously understood as indigenous currency ("Kru money") and as sacred objects called *nitien* ("god of water" or "spirit of water"). The missionary George Schwab wrote of how the Kru people considered the rings to be animated, possessing the powers to heal, protect, divine, and capture.[1] When a *nitien* was found in a creek or river, it was brought to a ritual priest, who kept it to guard and protect the village.[2]

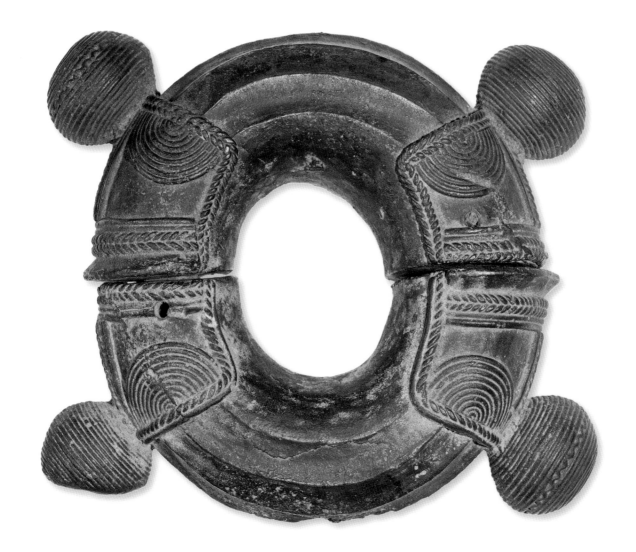

JAN-LODEWIJK GROOTAERS

Stone Sculpture of the Sapi and Kissi Peoples

55

Sapi peoples

Sierra Leone

**COUPLE
(*MAHEN
YAFE* STYLE)**,
probably 14th–
17th century

Stone

H. 10 in.
(25.4 cm)

Private collection

ALTHOUGH STONE SCULPTURE does not constitute a major African art form, works in stone—some even prehistoric—are found in most regions of the continent. The oldest examples, often stylized zoomorphic representations, date from about 6000 BCE, during the Neolithic era, and come from the Saharan Desert.[1] Ancient Egypt and Nubia, the North African Maghreb, the Ethiopian highlands, the mouth of the Congo River, and the Zimbabwean veld are homes to historic traditions of stone sculpture, while prominent and enduring expressions of this art form are also found in Nigeria and the Upper Guinea Forest region.[2]

The stone figures shown here, called *pomdo*, *nomoli*, and *mahen yafe*, are from the latter region—parts of Sierra Leone and adjacent areas of Guinea and Liberia. They are centuries old, but as they have not been subject to archaeological digs, little is known about when and why they were made, or even who made them. Broadly attributed to the forefathers of the present-day Kissi people (cat. nos. 56–58) and to the no-longer-extant Sapi peoples (cat. nos. 55, 59, and 60), these figures provide examples of ritual recycling, as they are being repurposed today by those who find them in the ground. Some are utilized in agrarian rituals aimed at increasing the harvest, while others play a role in divination rituals. The wooden figure wrapped in red cloth, called a *pom'kandya* ("dressed *pomdo* figure") or *pom'wama* ("divining *pomdo* figure"), is used in divination (cat. no. 61). Its power derives from the inclusion, in a cavity hidden behind the cloth, of a found stone *pomdo* figure, other stones, and metal pieces that the Kissi and many of their neighbors believe are related to their ancestors.[3]

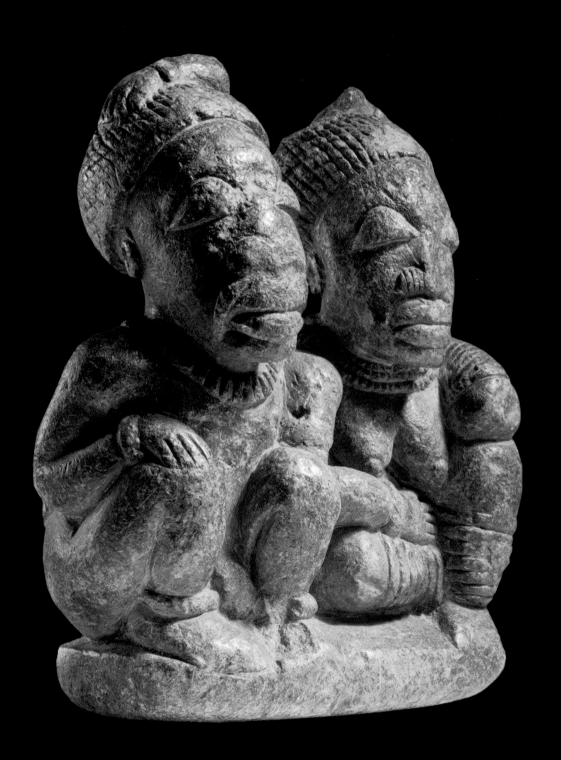

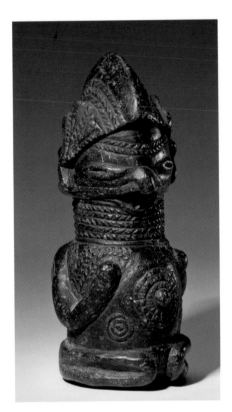

56

Kissi

Guinea or Liberia

***POMDO
FIGURE***,
probably 17th–
20th century

Stone

H. 4 ⁵⁄₁₆ in.
(11 cm)

*Minneapolis Institute
of Arts, Gift of
William Siegmann
2011.70.56*

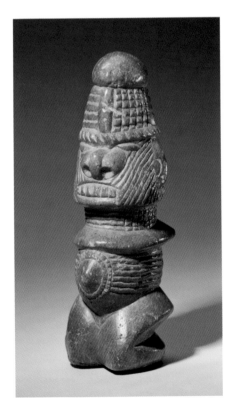

57

Kissi

Guinea or Liberia

***POMDO
FIGURE***,
probably 17th–
20th century

Stone

H. 4 ½ in.
(11.4 cm)

*Minneapolis Institute
of Arts, Gift of
William Siegmann
2011.70.55*

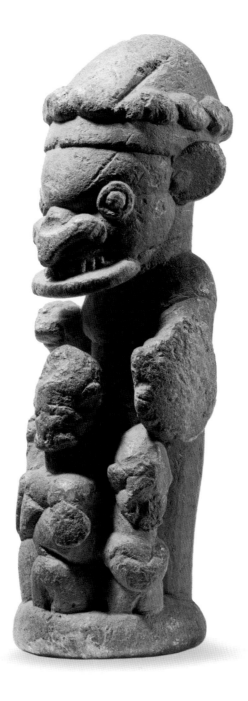

58

Kissi

Guinea or Liberia

POMDO FIGURE,
probably 14th–
17th century

Stone

H. 6 in.
(15.2 cm)

*Private collection,
New York*

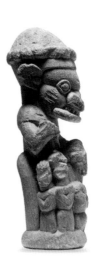

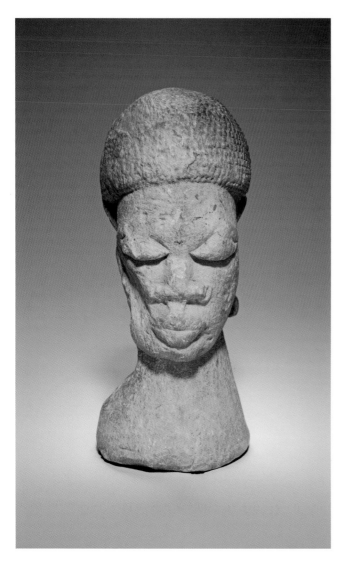

59

Sapi peoples

Sierra Leone

*MAHEN YAFE
HEAD*, probably
14th–17th century

Stone

H. 12 ½ in.
(31.8 cm)

*The Estate of William
Siegmann, Brooklyn*

60

Sapi peoples

Sierra Leone

*NOMOLI
HEAD*, probably
14th–17th century

Stone

H. 3 ⁷⁄₁₆ in.
(8.7 cm)

*Minneapolis Institute
of Arts, Gift of
William Siegmann
2011.70.54*

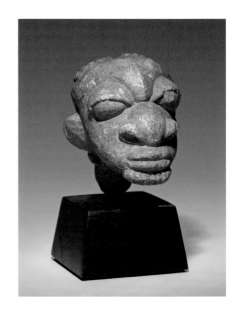

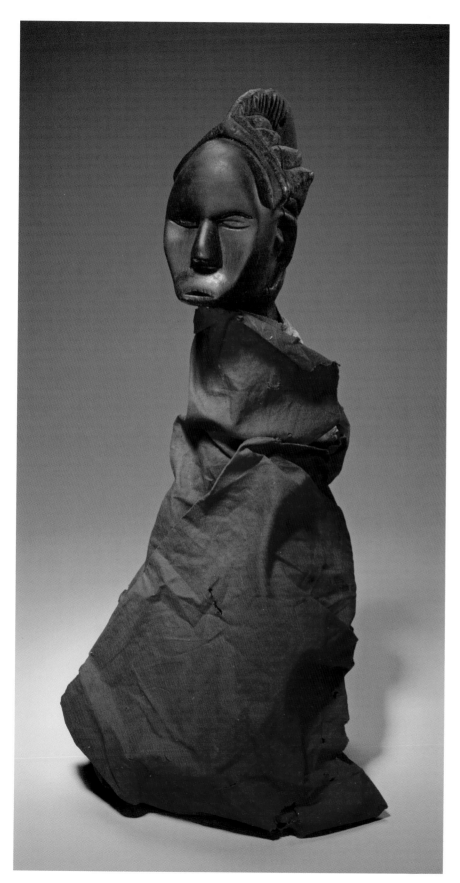

61

Kissi

Guinea or Liberia

DIVINATION FIGURE ("DRESSED *POMDO*"), mid-20th century

Wood, cloth, metal, stone, undetermined materials

H. 21 in. (53.3 cm)

The Estate of William Siegmann, Brooklyn

NATASHA THORESON

Textiles

62

Mende

Sierra Leone

HAMMOCK WITH FLAPS, 1984

Cotton

L. 74 x W. 45 in. (188 x 114.3 cm)

Saint Louis Art Museum, Gift of William C. Siegmann 1144:2010

THESE FOUR OBJECTS, each representing a distinct creative tradition, showcase the diversity of the textile arts practiced in Sierra Leone and Liberia. The Mende's mastery of the portable triangle loom gave itinerant weavers the freedom to travel among local communities, crafting regional reputations along the way (fig. 9.3). Intricately strip-woven cloth was used as a hammock upon which a chief or other noble person reclined, carried aloft by a team of porters (cat. no. 62). Often associated with the elephant, the chief's hammock was a prestigious "vehicle," both a physical conveyance and a symbolic means of communicating power. Made from similar woven strips, the rare Kuranko hunter's shirt also served a dual purpose (cat. no. 63). Designed to protect and to empower, the shirt is notable for its printed motif. The fabric was painted and stamped with a star-shaped block, carved from raffia palm to create a design meant to invoke a successful hunt.[1]

Though most often recognized for their woven textiles, artists in this West African region are also well known for their innovative use of natural dyes. Of particular note is the tradition of tie-dyeing, which provides a continuum between old and new artistry. Islamic influences are echoed in the form, color, and pattern of the man's tunic, or *boubou* (cat. no. 64). Such tie-dyed fabrics are known as *gara* cloths (*gara* refers to the leaves of the indigo plant) in Sierra Leone. Although traditional indigo dyes are still popular, contemporary *gara* artists experiment with kola nut and commercial dyes. Serving a cultural and ceremonial function, these colorful cloths also constitute an important source of revenue for local artists. Bill Siegmann purchased the wrapper included here at a Monrovian marketplace in 1985 from an artist he identified only as Christiana Tombe (cat. no. 65).

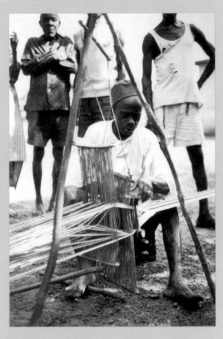

9.3

A weaver works on a two-harness, two-treadle triangle loom. Treadles control each harness's height; the order in which the harnesses are raised or lowered creates a pattern. This weaver's right foot presses the first treadle, lowering the first harness and corresponding yarn (the warp). *Photograph by William Siegmann.*

63

Kuranko

Sierra Leone or
Guinea

**HUNTER'S
SHIRT**, mid-20th
century

Cotton

H. 38 x W. 50 in.
(96.5 x 127 cm)

*Saint Louis Art
Museum, Gift of
William C. Siegmann
1174:2010*

64

Kissi

Liberia

TUNIC (*BOUBOU*), c. 1970

Cotton, indigo

H. 55 ¼ x W. 60 ¾ in. (140.3 x 154.3 cm)

High Museum of Art, Atlanta, Gift of William Siegmann, Emeritus Curator of African Art, Brooklyn Museum 2011.374

65

Christiana Tombe (active last quarter of 20th century)

Sierra Leone

WRAPPER, late 20th century

Cotton

L. 70 ½ x W. 50 ½ in. (179.1 x 128.3 cm)

Saint Louis Art Museum, Gift of William C. Siegmann 1182:2010

JAN-LODEWIJK GROOTAERS

Prestige Arts of the Mende, Vai, Kim, and Temne Peoples

66

Mende

Sierra Leone

SIDE-BLOWN HORN, early 20th century

Ivory, wood

L. 26 ¾ in. (68 cm)

Minneapolis Institute of Arts, Gift of William Siegmann 2011.70.45

As EARLY AS 1500, Europeans commissioned artists along the Sierra Leone coast to produce ivory horns for export—a genre known as Luso-African ivories.[1] Although that practice ended in the seventeenth century, many peoples in Sierra Leone and Liberia still carve side-blown ivory horns for local use; the Mende call them *ndolo maha bului*, meaning "paramount chief horn." Bill Siegmann collected two such symbols of high office. The oldest one, richly embellished with figurative representations in low relief, has a red-brown color that results from prolonged rubbing with palm oil (cat. no. 67). The more recent side-blown horn, of lighter color, is inscribed with the name of the original owner, Musa Abdi Wajif, in Arabic (cat. no. 66). The human figure carved at one end possibly represents a European woman; her hair is in a ponytail, and she wears a man's top hat and boots.[2]

Ivory was also used for prestigious snuff containers adorned with silver decorations. The same type of decoration is found on snuff containers made of animal horns. Although mainly owned by male notables, some of these horns were worn by women of the Sande Society as status symbols.[3] One of the snuff horns Siegmann collected bears an inscription in the local Vai syllabary reading, "This [horn] belonging to Yassa Kwe, wife of Sama Ba, was obtained from the water side," a reference to the spirit world that is connected with rivers (cat. no. 69).[4] A Mende snuff horn is inscribed in Arabic with the name of its original male owner, Musa Konate of Sembehun (cat. no. 70). Among the Mende, and throughout West Africa, Arabic script signifies the power of Islam and of the written word.

Another status emblem influenced by the presence of Islam in the Upper Guinea Forest region is a Temne chief's hat in silver in the shape of a fez, a headdress of Moroccan origin and typically worn by Muslims (cat. no. 74).[5] Its floral decoration—chili peppers on vines—is highly unusual in African art, which generally represents animal imagery.

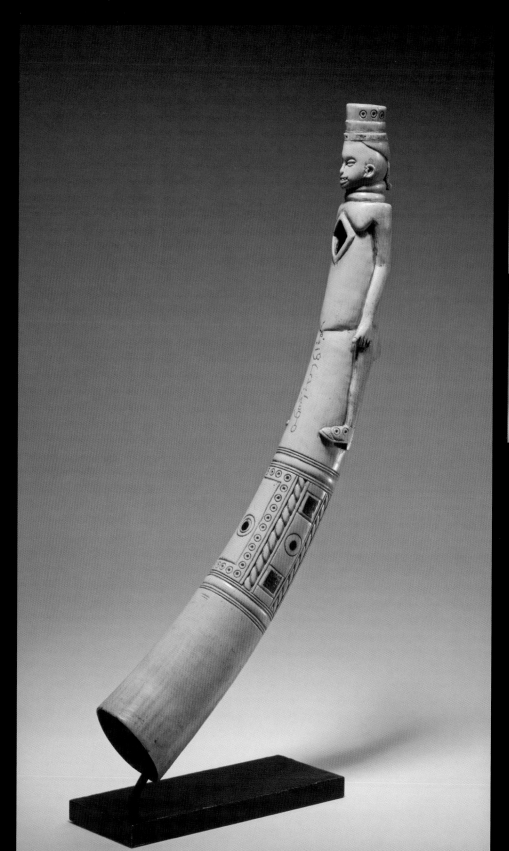

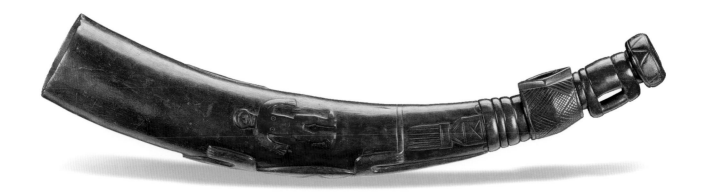

67

Vai or Kim

Liberia or Sierra Leone

SIDE-BLOWN HORN, late 18th or early 19th century

Ivory

L. 29 in. (73.7 cm)

Indiana University Art Museum, Gift of Bill Siegmann in honor of Roy and Sophie Sieber 2008–222

Detail views of low-relief carving are shown at left.

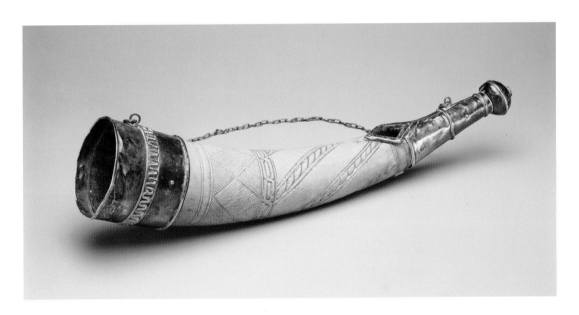

68

Mende

Sierra Leone

**SIDE-BLOWN
HORN**, early 20th
century

Elephant ivory,
silver

L. 20 in.
(50.8 cm)

*Brooklyn Museum,
Gift of Blake Robinson
2004.76.4*

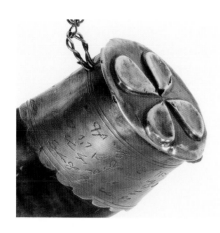

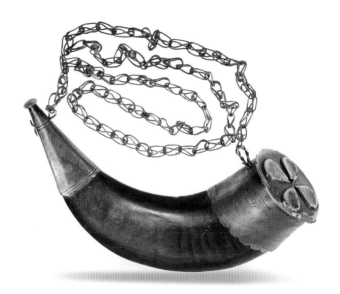

69

Vai

Liberia

SNUFF HORN, early 20th century

Horn, silver

W. 7 ⅜ in. (18.7 cm)

Minneapolis Institute of Arts, Gift of William Siegmann 2011.70.36

A detail of the Vai inscription is shown at left.

70

Mende

Sierra Leone

SNUFF HORN, early 20th century

Ram's horn, silver, silver alloy

W. 6 ¹¹⁄₁₆ in. (17 cm)

National Museum of African Art, Smithsonian Institution, Bequest of William Siegmann in memory of Roy Sieber 2012-11-3

A detail of the Arabic inscription is shown at left, above.

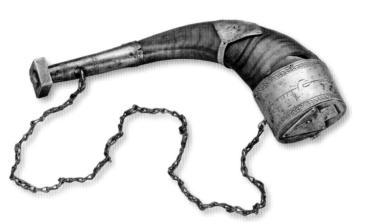

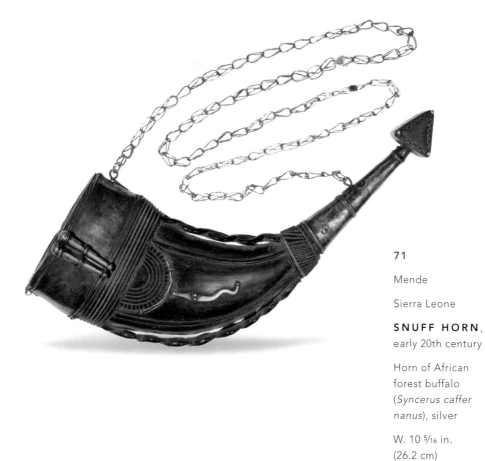

71

Mende

Sierra Leone

SNUFF HORN, early 20th century

Horn of African forest buffalo (*Syncerus caffer nanus*), silver

W. 10 5/16 in. (26.2 cm)

Minneapolis Institute of Arts, Gift of William Siegmann 2011.70.38

72

Mende

Sierra Leone

SNUFF HORN,
early 20th century

Ivory, silver

W. 8 ⅝ in.
(22 cm)

*Minneapolis Institute
of Arts, Gift of
William Siegmann
2011.70.40*

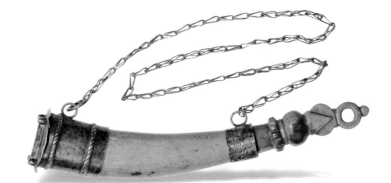

74 *(right)*

Temne

Sierra Leone

**HAT WITH
TASSEL**, early
20th century

Silver

W. 7 ⁹⁄₁₆ in.
(19.2 cm)

*Minneapolis Institute
of Arts, Gift of
William Siegmann
2011.70.29*

73 *(below)*

Mende

Sierra Leone

SNUFF HORN,
early 20th century

Elephant ivory,
silver

W. 16 ¾ in.
(42.6 cm)

*Brooklyn Museum,
Gift of Blake Robinson
2004.76.2*

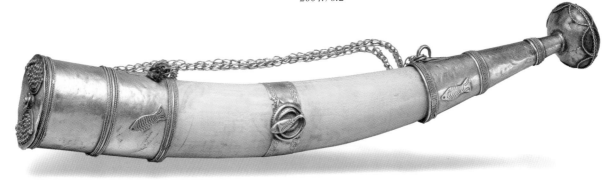

Appendix: A Historiography of the Term *Nòwo*

Variations on the term *nòwo* appear in numerous early sources on the Mende and Vai peoples, beginning in the mid-nineteenth century with the earliest European (predominantly German) forays into the interior to compile word lists. Sigismund Koelle's *Outlines of a Grammar of the Vei Language* (1854) lists the term as *nòu* (spelled "nou," with a dot under the "o"), defining it as "a masked woman in the *sande* ceremony, intended to represent a demon or the devil."[1] James Frederick Schön's *Vocabulary of the Mende Language* (1884) gives three definitions for the same word in the same orthography, *nòwo* (spelled "nowo," underlining the first "o"), the first of which is "Bondo or Sande devil."[2]

Referring to the Mende in his book *The Sherbro and Its Hinterland* (1901), Thomas Alldridge listed the degrees of Sande officials as the Sowehs, the Normehs ("or Bundu devils"), and the Digbas, in order from highest to lowest rank, confirming the datum recorded by later writers that it is not the highest official, Sowo, who wears the mask.[3] I am convinced that Alldridge's word for the middle rank is a typographical error and that it should have been Norweh, which would correspond to every other early report, employing the common British orthography "or" to stand for the international phonetic character "ò." But he mentioned the word nowhere else in any publication, and I have not been able to locate his original manuscript or his notes in order to settle the question.[4] It should be noted that the ending "ei" or "o" in Mende signifies simply the definite or the indefinite (thus Alldridge's ending "eh," Schön's "o," and Koelle's "u," and, later, "Sowo" in Boone and "Sowei" in Phillips).[5] In *The Advance of Our West African Empire* (1903), Charles Wallis, clearly plagiarizing from Alldridge, further corrupted the word as "normah."[6]

In the mid-twentieth century, much more extensive field research was conducted among the Mende and Southern Bullom (commonly called Sherbro, after the name of an

island). Rudolf Eberl, in his extensive 1936 ethnographic report on his tour throughout Sierra Leone the previous year, wrote of the Sande official Sandé-Jowo (a common Mende transformation of Sowo) with other Sande leaders at a funeral, behind whom "emerged the black head mask of a Sande-demon, a Nowi."[7] He extensively documented her role at the funeral and her movements and gestures, as well as her costume. Henry Usher Hall's unpublished "Field Notes on the Sherbro Expedition" (1937) designated the Bondo masked spirit among the Southern Bullom as *nòwo* (Bullom) or *nòwe* (Mende).[8] Hall claimed that it is the third-ranking Bondo leader, the Digba (Ligba in Mende), who wears the mask, and this has been suggested by others, including Eberl and Loretta Reinhardt. George Schwab's *Tribes of the Liberian Hinterland* (1947) described Sande among the Gbandi (or Gbundé), listing *nowi* among the degrees of Sande hierarchy, apparently ranking third—though the sequence of the ranking is unclear.[9]

The term persisted in dictionaries up to the end of the twentieth century but, curiously, not in ethnographies. Walter J. Pichl's *Sherbro-English Dictionary* (1967) defines *bol* [mask] *nòw* to mean "Bondo helmet mask."[10] Gordon Innes's *A Mende-English Dictionary* (1969) defines *nòwo* as "a Bundu devil"; and Reinhardt cited this in her 1975 dissertation.[11] The only field documentation of the use of *nòwo* (*a-nòwo*, employing the Temne prefix "the") since 1969 is in my publications on Temne art and culture from 1978 to the present. I believe that if the question were asked, ethnologists and art historians conducting research among the Mende, Vai, and Gola would find that the term *nòwo* is known there as well as among the western and northern Sierra Leone groups—even if it is esoteric.

Notes

PART 1
Remembering Bill Siegmann

1. On August 21 and September 24, 2011, Siegmann's friend the New York–based art dealer Amyas Naegele digitally recorded two extended interviews with Bill at his home, where he was bedridden. Sarah Muenster-Blakley transcribed the recordings at the Minneapolis Institute of Arts (MIA) in early 2012. The transcriptions were reviewed by Naegele, who added some clarifications; Lou Wells, a friend of Bill and a specialist in Liberian art and collecting, also reviewed them. We thank these three individuals for their valuable efforts in getting the interviews recorded and put on paper. A 115-page type-script of the transcriptions is in the library of the Department of the Arts of Africa and the Americas at the MIA; it is referenced in this book's chapter notes and bibliography as "Siegmann-Naegele interviews."

PART 2
Visions from the Forests

FORESTS IN THE IMAGINATION OF THE UPPER GUINEA COAST

1. Raymond Schnell, "Sur Quelques Plantes à Usage Religieux de la Région Forestière d'Afrique Occidentale," *Journal de la Société des Africanistes* 16 (1946): 29–38.

2. Jeremy A. Lindsell, Erik Klop, and Alhaji M. Siaka, "The Impact of Civil War on Forest Wildlife in West Africa: Mammals in the Gola Forest, Sierra Leone," *Oryx* 45, no. 1 (January 2011): 69–77.

3. Mariane C. Ferme, *The Underneath of Things: Violence, History, and the Everyday in Sierra Leone* (Berkeley: University of California Press, 2001): 194–95.

4. Frederick John Lamp, "House of Stones: Memorial Art of Fifteenth-Century Sierra Leone," *Art Bulletin* 65, no. 2 (1983): 220.

5. Frank B. Livingstone, "Anthropological Implications of Sickle Cell Gene Distribution in West Africa," *American Anthropologist* 60, no. 3 (June 1958): 533–62.

6. Paul Richards, "Natural Symbols and Natural History: Chimpanzees, Elephants, and Experiments in Mende Thought," in *Environmentalism: The View from Anthropology*, edited by Kay Milton (London: Routledge, 1993), 151–54.

7. There are other initiation societies, such as the Humoi, whose ritual objects and masks are also included in this collection. Membership in them, however, cannot substitute for membership in the Poro or the Sande but only supplements it.

8. Monni Adams, "Introduction," *Ethnologische Zeitschrift Zürich*, special issue, 1 (1980): 9–12. Adams and other contributors to this special journal issue on arts of the region follow the argument for this area's cultural and historical distinctiveness advanced in Warren L. d'Azevedo, "Some Historical Problems in the Delineation of a Central West Atlantic Region," *Annals of the New York Academy of Sciences* 96, no. 2 (January 1962): 512–38.

9. An instance of this practice is reported in M. C. Jedrej, "Dan and Mende Masks: A Structural Comparison," *Africa* 56, no. 1 (1986): 71–80.

10. *Sowei* (or *jowei*) is the title conferred on the Sande Society's highest-ranking officials.

11. We use the present tense here, but in some areas cotton production is reported as a casualty of the 1991–2002 civil war in Sierra Leone. That is because the cotton harvest (and the knowledge of how to spin cotton) resided mainly with a generation of older women now departed.

12. See, for example, William C. Siegmann and Judith Perani, "Men's Masquerades of Sierra Leone and Liberia," *African Arts* 9, no. 3 (April 1976): 42–47, 92.

EXTENDING THE STAGE: PHOTOGRAPHY AND SANDE INITIATES IN THE EARLY TWENTIETH CENTURY

I thank Christraud Geary, William Hart, Frederick Lamp, Ruth Phillips, and Gary Schulze for the helpful comments they offered as I was preparing this essay. I am also grateful to the editors of this book. Any errors or omissions are, of course, my responsibility.

1. The Sande Society, as well as its male counterpart, the Poro Society, was also found among the Vai, Gola, Temne, and Bullom peoples of Sierra Leone and Liberia. Sande is called Bondo by the latter two peoples.

2. Christraud M. Geary, *In and Out of Focus: Images from Central Africa, 1885–1960* (London: Philip Wilson, 2002), 7.

3. For detailed accounts of the early history of photography along the West African coast, see Jürg Schneider, "The Topography of Early History of African Photography," *History of Photography* 34, no. 2 (2010): 134–46; and Erin Haney, *Photography and Africa* (London: Reaktion Books, 2010).

4. For an overview of African postcard producers, see Christraud M. Geary, "Different Visions?," in *Delivering Views: Distant Cultures in Early Postcards*, edited by Christraud M. Geary and Virginia-Lee Webb (Washington, D.C., and London: Smithsonian Institution Press, 1998), 147–77.

5. Christraud M. Geary, "Through the Lenses of African Photographers: Depicting Foreigners and New Ways of Life, 1870–1950," in *Through African Eyes: The European in African Art, 1500 to Present,* edited by Nii O. Quarcoopome (Detroit: Detroit Institute of Arts, 2009), 94.

6. Haney, *Photography and Africa,* 59–60. For photographic portraits of initiates, see also Martha G. Anderson and Lisa L. Aronson, "Jonathan A. Green: An African Photographer Hiding in Plain Sight," *African Arts* 44, no. 3 (Autumn 2011): 43.

7. M. C. Jedrej, "Structural Aspects of a West African Secret Society," *Ethnologische Zeitschrift Zürich,* special issue, 1 (1980): 136.

8. Ruth B. Phillips, *Representing Woman: Sande Masquerades of the Mende of Sierra Leone* (Los Angeles: UCLA Fowler Museum of Cultural History, 1995), 78. The information given in this paragraph is based on her findings.

9. William Vivian, "The Mendi Country, and Some of the Customs and Characteristics of Its People." *Journal of the Manchester Geographical Society* 7, no. 1 (January 1896): 32.

10. Thomas Joshua Alldridge, *A Transformed Colony: Sierra Leone as It Was, and as It Is; Its Progress, Peoples, Native Customs, and Undeveloped Wealth* (London: Seeley, 1910), 220.

11. To my knowledge, this image exists only in postcard format today.

12. Phillips, *Representing Woman,* 82.

13. Jedrej, "Structural Aspects": 136.

14. Alldridge, *A Transformed Colony,* 221–22. To the Sande, a chief's request is not considered compulsory. In fact, the Sande Society is powerful enough to depose a chief if he attempts to interfere in its affairs. See Carol MacCormack, "Sande: The Public Face of a Secret Society," in *The New Religions of Africa,* edited by Bennetta Jules-Rosette (Norwood, N.J.: Ablex, 1979), 36.

15. Alldridge, *A Transformed Colony,* 222–23.

16. Jedrej, "Structural Aspects": 133.

17. Daniel Kumler Flickinger, *Ethiopia; or, Thirty Years of Missionary Life in Western Africa* (Dayton, Ohio: United Brethren Publishing House, 1885), 172.

18. William Vivian, *Mendiland Memories: Reflections and Anticipations* (London: Henry Hooks, 1926), 79.

19. Thomas Joshua Alldridge, *The Sherbro and Its Hinterland* (London: Macmillan, 1901), 191.

20. Alldridge, *A Transformed Colony,* 75.

21. Jedrej, "Structural Aspects": 136.

22. Alldridge, *The Sherbro and Its Hinterland,* 138–39.

23. Alldridge, *A Transformed Colony,* 228; Phillips, *Representing Woman,* 122.

24. Charles Braithwaite Wallis, *The Advance of Our West African Empire* (London: T. Fisher Unwin, 1903), 248.

25. In my archival research, I have come across seven different images derived from this particular photographic session.

26. Phillips, *Representing Woman,* 115.

27. Vera Viditz-Ward, "Alphonso Lisk-Carew: Creole Photographer," *African Arts* 19, no. 1 (November 1985): 49.

28. Edward Ayearst Reeves, ed. *Hints to Travellers: Scientific and General* (London: Royal Geographical Society, 1906), 2: 60.

29. Alldridge, *The Sherbro and Its Hinterland,* 204.

30. Phillips, *Representing Woman,* 131.

31. Frederick Lamp, "An Opera of the West African Bondo: The Act, Ideas, and the Word." *TDR* [The Drama Review] 32, no. 2 (Summer 1988): 98.

32. See the images of a Sande graduate carried in a hammock in Alldridge, *A Transformed Colony,* 226, and of Sande graduates reclining on deck chairs in Phillips, *Representing Woman,* 84.

33. Allister MacMillan, *The Red Book of West Africa: Historical and Descriptive, Commercial and Industrial Facts, Figures, and Resources* (London: W. H. and L. Collingridge, 1920), 267.

34. Further research is needed to determine whether Lisk-Carew or the European printing company supplied the captions.

35. Geary, "Different Visions?," 151, 154.

"BY THEIR FRUITS YOU WILL KNOW THEM": SANDE MASK CARVERS IDENTIFIED

1. This assertion has a long history, although the claim that it is the only type of mask worn by women in Africa has in recent years been repeatedly challenged, including in the journal *African Arts,* which devoted its full summer 1998 issue to the correction. Nevertheless, there is still no evidence of another type of carved wooden mask (of either male or female identity) that women traditionally wore in premodern Africa. Other masks documented as being worn by women are made of other materials, and most known usage is of the occasional, rather than the institutional, kind.

2. The principal books are: Sylvia Ardyn Boone, *Radiance from the Waters: Ideals of Feminine Beauty in Mende Art* (New Haven, Conn.: Yale University Press, 1986); Daniel Mato and Charles Miller III, *Sande: Masks and Statues from Liberia and Sierra-Leone* (Amsterdam: Galerie Balolu, 1990), Burkhard Gottschalk, *Bundu: Buschteufel im Land der Mende* (Düsseldorf: U. Gottschalk, 1990); Ruth B. Phillips, *Representing Woman: Sande Masquerades of the Mende of Sierra Leone* (Los Angeles: UCLA Fowler Museum of Cultural History, 1995); and Gavin H. Imperato and Pascal James Imperato, *Bundu: Sowei Headpieces of the Sande Society of West Africa; The Imperato Family Collection* (Bayside, N.Y.: Queensborough Community College; Manhasset, N.Y.: Kilima House, 2012).

3. The spelling *Bundu* is used in much of the older literature. Here, I spell the word *Bondo,* causing some confusion for the general reader. Bundu, however, is incorrect, no matter which Sierra Leonean culture is referenced. It is a term that was used by colonial administrators, casual observers, and other non-specialists, who were neither linguists nor keen listeners to the local language. However it is spelled, the term is generally not used by the Mende, who consistently refer to the women's association as Sande, except when they are simply repeating the word Bundu/Bondo as they have heard it elsewhere. All scholars who have worked among the Bullom (Sherbro), Temne, or Limba (such as myself, Henry Usher Hall, Carol MacCormack, and Simon Ottenberg)—peoples who use the term Bondo—are unanimous on the Bondo spelling. Scholars who have worked among the Mende, Vai, or Gola are not accustomed to hearing the word Bondo among the people with whom they work, so they have often used the spelling found in the available literature. The discrepancy is between specialists who have worked with Sierra Leoneans on language and non-specialists who draw from the literature, most of which is inaccurate.

For the reader unfamiliar with the International Phonetic Alphabet (IPA), pronouncing the word *Bondo* is somewhat difficult. The spelling Bondo uses the IPA, in which "o" is pronounced as in the English "oh," or the French *bon*; this is where the problem begins: American English speakers seeing the word Bondo will pronounce "bon" as "ban" (phonetically), rendering it as "Bando." As I note in this essay, Bondo is pronounced "bone-doe" in English, requiring the lips to be protruded and pursed, as the French would pronounce *bon*. To the untrained ears of colonial administrators, missionaries, and tourists, Bondo could easily sound like "Bundu"; this is what has been perpetuated in the literature. It is not easy to correct a pronunciation error that has been steadily made over the course of a century. For example, Gavin and Pascal James Imperato, who are new to the field of study, acknowledged in their 2012 book on Sowei headpieces of the Sande association that *Bondo* is correct. Nonetheless, they used *Bundu* simply because that is the term everybody knows.

4. On Bondo/Sande spirits, see Frederick John Lamp, "An Opera of the West African Bondo: The Act, Ideas, and the Word," *TDR* [The Drama Review] 32, no. 2 (Summer 1988): 83–101.

5. For the Temne, see Frederick John Lamp, "Cosmos, Cosmetics, and the Spirit of Bondo," *African Arts* 18, no. 3 (May 1985): 28. For the Southern Bullom (Sherbro), see Henry Usher Hall, "Field Notes on the Sherbro Expedition" (unpublished ms., 1937; University of Pennsylvania Museum of Archaeology and Anthropology), A133. For the Vai, see Svend E. Holsoe, "The Cassava-Leaf People: An Ethnohistorical Study of the Vai People with Particular Emphasis on the Tewo Chiefdom" (PhD diss., Boston University, 1967), 97. For the Gola, see Mario Meneghgni, "The Gola Masks" (unpublished ms., 1982), 1–2.

6. Temne is a prefix language in which all nouns are accompanied by their articles, whether definite or indefinite ("the" or "a/an")." Thus the Temne pronounce the Bondo masked spirit "*a-Nòwo*" (the *Nòwo*).

7. Lamp, "Cosmos, Cosmetics, and the Spirit of Bondo," "An Opera of the West African Bondo," and "Transcendent Womanhood and the Scavenger: A Mende Mask (*Ndoli Jowei*)," in Lamp, ed., *See the Music, Hear the Dance: Rethinking African Art at the Baltimore Museum of Art* (Munich and New York: Prestel, 2004), 174–77.

8. During my professional career, I have had the opportunity to see hundreds of private collections of African art and have made it a mission to photograph voraciously the art from my two countries of interest, Sierra Leone and Guinea. In 1976 and 1978, I received travel grants enabling me to visit North American public collections. In 1980 and 1986, I spent four months visiting European collections (most of them public), again making as full a photographic record as possible. All the while, I scoured (and photocopied from) every auction and collection catalogue that came my way. (As it turned out, Bill Siegmann was doing the same thing, concentrating on Liberia and Sierra Leone; so our efforts overlapped.) At this writing, my image bank comprises some thirty thousand photographs of objects from the Baga (and related groups), Susu, Fulbe, and Kissi of Guinea; the Temne, Limba, Loko, Bullom (and related groups), Mende, Kono, Kuranko, and ancient Sapi of Sierra Leone; and the Vai and Gola of the Sierra Leone-Liberia borderland. My image bank, like Siegmann's, now belongs to the Yale University Art Gallery.

I pay tribute to the Yale University Art Gallery–van Rijn Archive of African Art (hereafter cited as YVRA) and particularly to Guy van Rijn, its founder, and Bruno Claessens, its recent archivist, for providing me with additional images and updated collection data for use in this essay. Yale's Ross Archive of African Art Images, 1600–1920, has also been a valuable resource. It contains illustrations of figurative African art published before 1921, compiled by the art collector and Yale governing board member James J. Ross, with texts and captions as well as scholars' comments. By focusing on the early literature and amassing a formidable library, Ross was able to find images that had escaped me. At present, the Yale-van Rijn Archive is accessible only at the Yale University Art Gallery's Department of African Art, or via password granted to contributing consultants—African art scholars, collectors, and dealers—upon application to yalegvr@yale.edu. We hope the archive will in time be publicly accessible, pending the resolution of funding and legal issues. The Ross Archive is freely accessible on the Yale libraries' central system at http://raai.library.yale.edu.

9. I thank my student staff at Yale University for their years of work on this continuing project and for lending their perceptive eyes to help me sort out stylistic characteristics. Students who have contributed to this project, and have my gratitude, include: Kristopher Driggers, Richard Espinosa, Marlon Forrester, Dominique Jefferson, Sean Leatherbury, Stephen Lloyd, Laura Merriman, Nontsikelelo Kudzai Mutiti, Cristian Oncescu, Aneetha Ramadas, Sarah Shellaby, Elaine Sullivan, Matthew Tedeschi, and J. Neel Williams. Their supervisors were senior museum assistants Amanda Maples and, since 2010, Elizabeth Solak.

10. Loretta R. Reinhardt, "Mende Carvers" (PhD diss., Southern Illinois University, 1975), 87–92.

11. Ibid., 87.

12. See Phillips, *Representing Woman*, and Reinhardt, "Mende Carvers."

13. For more regarding the attribution to the Kim, see Phillips, *Representing Woman*, 169.

14. William C. Siegmann, Collection Notes, 2011, n.p.

15. William C. Siegmann with Cynthia E. Schmidt, *Rock of the Ancestors: ɲamôa koni* (Suakoko, Liberia: Cuttington University College, 1977), 10.

Notes (continued)

16. See Harry Hamilton Johnston, *Liberia*, 2 vols. (London: Hutchinson, 1906), 2:1033, fig. 411. The image is very small, of poor quality, and heavily retouched; so it is difficult to discern the details. The facial features look not only blurred but also defaced, with two black cylinders to indicate the eyes. There is no explanation for why the eyes appear this way—unlike any other example from this workshop—except as the result of an attempt to manipulate the photograph in order to make it sharper. Otherwise, every detail matches the d'Azevedo mask in the Smithsonian, particularly the asymmetrical hairstyle, with a large round tuft of hair on the proper left side at the forehead but not on the proper right. The detailed, checkered strip of carved hair at the hairline is also obscured in the Johnston image. An argument against the identification of the two images would be that the d'Azevedo/Smithsonian mask seems too fresh to be dated earlier than 1906, though that appearance could be due to careful conservation in situ. Given their identical volumes and details, and their identical peculiarities, I believe the two images represent the same mask.

17. A. R. Wright, "Secret Societies and Fetishism in Sierra Leone," *Folklore* 18, no. 4 (December 1907): pl. 8.

18. Ibid., 423–24.

19. See William Ockelford Oldman, *Illustrated Catalogue of Ethnographic Specimens*, sale cat., 74 (1909), fig. 10; and Osvaldo Svanascini, *Arte Africano* (Buenos Aires: Asociación Amigos del Museo Nacional de Bellas Artes, 1964).

20. The author, conversation with a private collector, Leonard Kahan Gallery, New York, 1979.

21. In addition to the Siegmann mask, eight masks from Workshop Nòwo-42 are identifiable in the following collections:
- British Museum, London, accession no. Af1954,+23.3652 (Reinhardt, "Mende Carvers," fig. 11).
- British Museum, London, acc. no. Af1954,+23.3483. Provenance: Bought from a dealer, 1926 (Phillips, *Representing Woman*, fig. 8.17).
- Museo Etnográfico, Buenos Aires (Svanascini, *Arte Africano*, 72; Oldman, *Illustrated Catalogue of Ethnographic Specimens*, fig. 10).
- National Museum of Natural History, Smithsonian Institution, Washington, D.C., acc. no. E385719-0. Provenance: Warren d'Azevedo (Johnston, *Liberia*, 2:103, fig. 411).
- Private collection, New York (author sketched this mask at Leonard Kahan Gallery, New York, 1979; no photo in file). Provenance: collector obtained the mask from Mrs. Ada Thomas, "Yandegui" (Sande leader), Gelehun, Badjia Chiefdom, Bo.
- Unknown collection. Formerly in the Africana Museum, Cuttington University College, Suakoko, Liberia (destroyed during the Liberian civil wars) (Siegmann, *Rock of the Ancestors*, 10).
- Unknown collection (Wright, "Secret Societies and Fetishism": pl. 8).
- Unknown collection. Provenance: Pace Primitive, New York, February 2004, lot 53-1282; Woods Davy, Los Angeles; Michael Sorafine, Los Angeles, late 1980s (Roy Sieber and Frank Herreman, *Hair in African Art and Culture* [New York: Museum for African Art; Munich: Prestel, 2000], 75, cat. no. 91).

22. In addition to the Siegmann mask, eleven masks from Workshop Nòwo-9 featuring a bird on top are identifiable in the following collections:
- Afrika Museum, Berg en Dal, Netherlands, acc. no. 3082.
- Baltimore Museum of Art, acc. no. 1984.50.
- Indianapolis Museum of Art. Provenance: Harrison Eiteljorg; William Brill (William Brill, *Selections from the William W. Brill Collection of African Art* [Milwaukee: Milwaukee Public Museum, 1969], fig. 8).
- Charles D. Miller III, St. James, N.Y. (Mato and Miller, *Sande*, 54–55).
- Musée d'Arts Africains, Océaniens, Amérindiens, Marseille. Provenance: Leonce and Pierre Guerre (Danièle Giraudy, *Le Musée d'Arts Africains, Océaniens, Amérindiens de Marseille* [Paris: Fondation BNP Paribas, Réunion des Musées Nationaux; Marseille: Réunion des Musées de Marseille, 2002]; *Art Africain: Donation L.-Pierre Guerre* [Marseille: Musée des Beaux-Arts, 1980], 22, fig. 2; Pierre Guerre, *Arts Africains* [Marseille: Musée Cantini, 1970], 8).
- Museum of Anthropology, University of British Columbia, Vancouver.
- National Museum of African Art, Smithsonian Institution, Washington, D.C. Provenance: Michael Oliver.
- National Museums Scotland (formerly Royal Scottish Museum), Edinburgh, acc. no. 1953.343. Provenance: Wellcome Historical Medical Museum (Royal Scottish Museum, *Traditional African Sculpture* [Edinburgh:

Howie and Seath, 1981], fig. 3; Robert Brain, *Art and Society in Africa* [London: Longman, 1980], 163).

- Museum Rietberg, Zurich, acc. no. Raf 130. Provenance: Han Coray, acquired 1940.

- Völkerkunde Museum der Universität Zürich, acc. no. 10370. Provenance: Volksbank, Han Coray, acquired 1941 (Miklós Szalay, *Die Kunst Schwarzafrikas: Werke aus der Sammlung des Völkerkundemuseums der Universität Zürich*, vol. 1: *Kunst und Gesellschaft* [Munich: Trickster, 1994], 34; idem, *Schön Hässlich: Gegensätze; Afrikanische Kunst aus der Sammlung des Völkerkundemuseums der Universität Zürich* [Zurich: Offizin, 2001], 92–94).

- Unknown collection (*African Art from the Collection of the Late Joseph Mueller of Solothurn, Switzerland*, sale cat., Christie's, London, June 13, 1978, lot 46).

23. Rudolf Eberl [Ralph Eberl-Elber, pseud.], *Westafrikas letztes Rätsel: Erlebnisbericht über die Forschungsreise 1935 durch Sierra Leone* (Salzburg: Verlag das Berglandbuch, 1936), fig. 157; idem, *Sierra Leone: Allein Durch Westafrikas Tropen* (Berlin: Verlag die Heimbücherei, 1943), pl. nn.

24. William Hommel, *Art of the Mende* (College Park, Md.: University of Maryland, 1974).

25. Reinhardt, "Mende Carvers," fig. 41.

26. Ibid., 77, 83, 93, 97, 272–74.

27. It should be noted that Phillips attributes a mask in a very different style to Sowo Gande of Foindu, Kenema District, carved about 1930 (see *Representing Woman*, 174, fig. 8.28). *Sowo* and *so* are the variant forms of honorific terms of Sande and Poro leadership, which Phillips translates as "expert." Sogande and Sowo Gande are alternate pronunciations of the same name. This suggests either a third Sogande (besides the father and son already described in this essay), possibly from the same town (Foindu/Fuinda) north of Kenema; or it refers to the same Sogande (the elder, described here), carving in a different style.

28. Reinhardt, "Mende Carvers," 84. Furthermore, there exists another body of work that Reinhardt attributed to a "Sogande" in a style not dissimilar but distinct enough to suggest a separate workshop ("Mende Carvers," 84 and fig. 43). Designated as Workshop 16, it is characterized by a simple cornrow coiffure with a single topknot, a crotal-shaped eye (sometimes with eyeglasses), a small nose with articulated nostrils, and a high nose bridge. This carver may be unrelated to Bokarie Sogande or his father. For the other sculptures she attributes to Sogande, see Reinhardt, "Mende Carvers," figs. 10, 18, 41, 42.

29. Phillips, *Representing Woman*, 258, n. 20.

30. Reinhardt, "Mende Carvers," 272–73.

31. Ibid.

32. Siegmann, Collection Notes.

33. See Ruth B. Phillips, "The Iconography of the Mende Sowei Mask," *Ethnologische Zeitschrift Zürich*, special issue, 1 (1980): 128; and idem, *Representing Woman* 15, 89, respectively.

34. For the two objects whose whereabouts are unknown, see *Important Tribal Art*, sale cat., Christie's, New York, November 4, 1994, lot 106; and Mato and Miller, *Sande*, 32–33.

35. In addition to the Siegmann mask, thirteen masks from Workshop Nòwo-47 are identifiable in the following collections:

- Baltimore Museum of Art, acc. no. 1984.251. Provenance: Dr. Robert Cumming, Ousman Berete, New York.

- British Museum, acc. no. 1938.10.4.12. Provenance: Bromholt.

- Dr. and Mrs. Hanus Grosz, Indianapolis (Jane Graham, ed., *African, South Pacific, and Precolumbian Art from Private Indianapolis Collections* [Indianapolis: Indianapolis Museum of Art, 1992], fig. 33).

- John and Monica Haley, Richmond, Va. (James Byrnes, *The Artist as Collector: Selections from Four California Collections of the Arts of Africa, Oceania, the Amerindians, and the Santeros of New Mexico* [Newport Harbor, Calif.: Newport Harbor Art Museum, 1975], fig. 15).

- Karob Collection, Boston (Warren M. Robbins and Nancy Ingram Nooter, *African Art in American Collections: Survey 1989* [Washington, D.C.: Smithsonian Institution Press, 1989], fig. 270).

- Kreeger Museum, Washington, D.C. Provenance: Dr. Nicolas Zervas, Milton, Mass. (Margy P. Sharpe, ed., *The Collection of Mr. and Mrs. David Lloyd Kreeger* [Richmond, Va.: Brown, 1976], 271).

- Charles D. Miller III, St. James, N.Y. (Mato and Miller, *Sande*, 32–33).

- Gary Schulze, New York (Donna Page, *Artists and Patrons in Traditional African Cultures: African Sculpture from the Gary Schulze Collection* [Bayside, N.Y.: Queensborough Community College Art Gallery, 2005], 17).

- Unknown collection (William A. Fagaly, "The Traditional Arts of Liberia," *African Arts* 18, no. 2 [February 1985]: 81). Exhibited in *The Traditional Arts of Liberia*, curated by William Siegmann, Louisiana World's Fair, New Orleans, 1984.

- Unknown collection (*Arts Primitifs, Art Pre-Columbian*, sale cat., Hôtel Drouot, Paris, November 8, 1996, lot 46; Raymond Mauny, "Masques Mende de la Société Bundu," *Notes Africaines* 81 [1959]: 8–13, fig. 2).

- Unknown collection. Provenance: Helmut Zake, Heidelberg, Germany (*Tribal Art Auktion*, sale cat., Kunstauktionshaus Zemanek-Münster, Würzburg, Germany, November 27, 2004, lot 105).

- Unknown collection (sale cat., J. Loiseau, A. Schmitz, M. Digard, St. Germain-en-Laye, France, February 23, 1997, lot 26; photographed in situ, Mattru, Tikonko, Bo District, in Phillips, *Representing Woman*, figs. 1.3, 4.19a; Boone, *Radiance from the Waters*, 59, 71).

- Mask photographed in situ, Mofindor, Banta Chiefdom, Moyamba District (Phillips, "Iconography of the Mende Sowei Mask," fig. 3).

36. In addition to the Siegmann mask, nine masks from Workshop Nòwo-72 are identifiable in the following collections:

- Bernisches Historisches Museum, Bern, Switzerland, acc. no. Lib. 266. (Gottschalk, *Bundu*, 309).

- Birmingham Museum of Art, Birmingham, Ala.

- Robert Jacobs (Roy Sieber and Roslyn A. Walker, *African Art in the Cycle of Life* [Washington, D.C.: National Museum of African Art, 1987], fig. 18).

- Private collection. Provenance: Gerbrand Luttik, Amsterdam, 1991 (Alfred Scheinberg and Kristin Jefferson, *SHE: Images of the Woman in Black African Art* [New York: Germans Van Eck Gallery, 1983], fig. 14).

- Unknown collection. Provenance: Charles D. Miller III, St. James, N.Y. (*African Arts* 26, no. 1 [January 1993]: 23).

- Unknown collection. Provenance: Robertson African Arts, New York. (*African Arts* 23, no. 4 (October 1990): 13).

- Unknown collection. Provenance: Kahan Gallery, New York (*African Art from New Jersey Collections* [Montclair, N.J.: Montclair Art Museum, 1983], fig. 77).

- Unknown collection. Provenance: Charles Jones, Wilmington, N.C. (*African Arts*, 27, no. 4 [Autumn 1994]: 19).

- Unknown collection, Brussels, Belgium. Provenance: Vittorio Mangio, Monza, Italy (Hélène Joubert, *Image de la Femme dans l'Art Africain* [Paris: Ville de Tours, 2000], no. 4; Burkhard Gottschalk, *L'Art du Continent Noir: Du Guimballa aux Rives du Congo* [Düsseldorf: U. Gottschalk, 2005], 109).

37. Johann Büttikofer, *Reisebilder aus Liberia: Resultate Geographischer, Naturwissenschaftlicher und Ethnographischer Untersuchungen während der Jahre 1879–1882 und 1886–1887* (Leiden, Netherlands: E. J. Brill, 1890), 309. According to William Hart, the Bernisches Historisches Museum's records indicate that although Büttikofer saw the masquerade in the town of Tosso, he collected the mask in the nearby village of Tala (e-mail to author, January 9, 2013). For more about Koelle and Schön, see Appendix, p. 204.

38. Warren L. d'Azevedo, Review of *African Art of the West Atlantic Coast: Transition in Form and Content*, by Frederick John Lamp, *African Arts* 14, no. 1 (November 1980): 81–88.

39. The figure is in the collection of the Museum of Anthropology, University of British Columbia, Vancouver. In addition to the Siegmann mask, three examples from Workshop Nòwo-27 are identifiable in the following collections:

- Baltimore Museum of Art. Provenance: Steven Ludwig, Baltimore.

- National Museum and Galleries on Merseyside, England, accession no. 25.11.1910.27.

- University of Pennsylvania Museum of Archaeology and Anthropology, acc. no. um. 37–33.206. Provenance: collected by Henry Usher Hall during the museum's expedition to Sierra Leone in 1936 and 1937; Paramount Chief Banu of Bendu, Bendu Chiefdom, Sherbro Island, Bonthe District (Alan Wardwell, *African Sculpture from the University Museum, University of Pennsylvania* [Philadelphia: Philadelphia Museum of Art, 1986], 42).

40. Reinhardt, "Mende Carvers," 51–54, figs. 35 and 36.

41. Siegmann, Collection Notes.

42. Three additional examples are: in the Baltimore Museum of Art, acc. no. 1985.278; 2; a figure published in *African Arts* 17, no. 4 (August 1984): 18 (now in a private collection, Baltimore); and in Reinhardt, "Mende Carvers," fig. 29.

43. Reinhardt, "Mende Carvers," 77.

44. Ibid., 76, 88, 93, 338, 342–48, 358–61, 377, 388.

45. Phillips, *Representing Woman*, figs. 4.7, 6.25.

46. In addition to the Siegmann mask, nineteen masks from Workshop Nòwo-39 are identifiable in the following collections:

• Samuel P. Harn Museum of Art, University of Florida, Gainesville (three masks).

• Indianapolis Museum of Art, acc. no. E72.19. Provenance: Harrison Eiteljorg.

• Private collection, Baltimore. Provenance: Robert Cumming, Baltimore.

• Private collection, Washington, D.C. Provenance: Mr. and Mrs. Albert Votaw, Mr. and Mrs. MacKenzie Gordon (Warren M. Robbins, "How to Approach the Traditional African Sculpture," *Smithsonian* 3, no. 6 [September 1976]).

• Douglas Yaney Gallery (douglasyaney.com).

• Unknown collection. Formerly in the Africana Museum, Cuttington University College, Suakoko, Liberia (destroyed during Liberia's civil wars), acc. no. 71.12.

• Unknown collection (photographed in situ, Navo, Small Bo Chiefdom, Kenema District, in Phillips, *Representing Woman*, 1.2, 6.26).

• Unknown collection (*Antiquities and Tribal Art*, sale cat., Christie's, New York, April 25–26, 1984, lot 658).

• Unknown collection (YVRA 0068537).

• Mask photographed in situ, Badjia Chiefdom, Bo District (Reinhardt, "Mende Carvers," fig. 53, left).

• Mask photographed in situ, Badjia Chiefdom, Bo District (Reinhardt, "Mende Carvers," fig. 53, right).

• Mask photographed in situ, Bagbwe Chiefdom, Bo District (Reinhardt, "Mende Carvers," fig. 51).

• Mask photographed in situ, Komboya Chiefdom, Bo District (Reinhardt, "Mende Carvers," fig. 35).

• Mask photographed in situ, Bagbwe Chiefdom, Bo District (Reinhardt, "Mende Carvers," fig. 52).

• Mask photographed in situ, Kori Chiefdom, Moyamba District (Reinhardt, "Mende Carvers," fig. 54, right).

• Mask photographed in situ, Bagbwe Chiefdom, Bo District (Reinhardt, "Mende Carvers," fig. 36).

• Mask photographed in situ, Bandajuma Kovegbuami, Small Bo Chiefdom, Kenema District (Phillips, *Representing Woman*, fig. 4.7).

47. Pa Jobo, as quoted in Reinhardt, "Mende Carvers," 346.

48. In addition to the Siegmann mask, five masks that are probably by Ansumana Sona (son of Vandi Sona), Workshop Nòwo-25b, are identifiable in the following collections:

• David Attenborough (Attenborough, *Tribal Encounters: An Exhibition of Ethnic Objects Collected by David Attenborough* [Leicester, U.K.: Leicestershire Museums, Art Galleries, and Record Services, 1981], 28).

• Charles D. Miller III, St. James, N.Y. (Mato and Miller, *Sande*, 48–49).

• Unknown collection. Provenance: Alain Schoffel, Paris; Jacques Marchais, Paris, until 2007; Charles-Wesley Hourdé, Paris, 2008 (sale cat., Fraysse et Associés, Paris, December 3, 2007, lot 17; YVRA 0084501).

• Mask photographed in situ, Telu, Jaiama-Bongor Chiefdom, Bo District (Phillips, *Representing Woman*, fig. 8.26).

• Mask photographed in situ, Juhun, Jaiama-Bongo Chiefdom, Bo District (Sowei Safula Jiogba, custodian) (Phillips, *Representing Woman*, fig. 55).

49. In addition to the Siegmann mask, eighteen masks that are probably by Vandi Sona (Ansumana Sona's father), Workshop Nòwo-25a, are identifiable in the following collections:

• Brooklyn Museum, acc. no. 69.39.2 (Siegmann, *Rock of the Ancestors*, fig. 11).

• Cesaré DeCredico, Providence, R.I. Provenance: Alfred DeCredico, Providence, R.I., until December 26, 2009; Koranko village, near Blama, Kandu-Leppiama Chiefdom, Kenema District (Nancy Barr Archive, Department of African Art, Yale University Art Gallery).

• DeYoung Museum, San Francisco, acc. no. 1981.21.9.

• Musée Royal de l'Afrique Centrale, Tervuren, Belgium, acc. no. 74.62.11.

• Trelet. Provenance: collected by George Schwab in 1905 from Sefadu (now known

as Koidu–New Sembehun), Kono District. (Author saw image in Goldwater Library, Metropolitan Museum of Art, in the 1970s, but it could not be located in 2012; no photo in file.)

- Unknown collection. Provenance: Jeremiah Cole, Los Angeles, 2008.
- Unknown collection (Gottschalk, *Bundu*, 120).
- Unknown collection (sale cat., Sotheby's, London, July 26, 1976, lot 117).
- Unknown collection. Provenance: Amadu Sillah, Monrovia, Liberia, 1986.
- Unknown collection. Provenance: Paolo Morigi, collected in situ c. 1960 (Gottschalk, *Bundu*, 148; *Collection Paulo Morigi (2e partie): Art Africain et Oceanien*, sale cat., Sotheby's, Paris, December 6, 2005, lot 38).
- Unknown collection. Provenance: René Rasmussen, Paris, 1950s (YVRA 0019874~01).
- Unknown collection (sale cat., Loudmer, Paris, December 5, 1987, lot 291; YVRA 0023277).
- Unknown collection (sale cat., Sotheby's, London, July 26, 1976. lot 117, pl. 2; YVRA 0040529).
- Unknown collection (YVRA 0084356).
- Unknown collection. Provenance: Antoine and Antoinise Ferrari de la Salle; Alexandra Martin-Blasselle-Galerie Kilangui, Cannes, France, 2008. Exhibited in *Parcours des Mondes*, Paris, September 10–14, 2008 (YVRA 0098396).
- Mask photographed in situ, Njombohun, Jaiama-Bongor Chiefdom, Bo District

(Sowei Sambo Kadi, custodian) (Phillips, *Representing Woman*, fig. 8.24).
- Mask photographed in situ, Bandajuma Kovegbuami, Small Bo Chiefdom, Kenema District (Phillips, *Representing Woman*, fig. 7.11).
- Sowei Gbujahun, custodian (Phillips, *Representing Woman*, fig. 8.24; and idem, "Iconography of the Mende Sowei Mask," 113–32). Photographed in performance by the author, Telu, Jaiama-Bongor Chiefdom, Bo District, 1979.

50. Phillips, *Representing Woman*, 173–74.

51. Siegmann, Collection Notes.

52. For more on Ansumana Sona, see Phillips, *Representing Woman*, 149–51; and Reinhardt, "Mende Carvers," 77.

53. In addition to the Siegmann mask, six masks from Workshop Nòwo-62 are identifiable in the following collections:
- Gerald and Lila Dannenberg, 1987 (Jerry Dannenberg, "The Dannenberg Collection," *Arts d'Afrique Noire* 64 [Winter 1987]: 39, top left; Frank Herreman, ed., *Material Differences: Art and Identity in Africa* [New York: Museum for African Art; Ghent: Snoeck-Ducaju and Zoon, 2003], 23; sale cat., Christie's, London, July 7, 1982, lot 9; YVRA 0027586~01).
- Private collection, Honolulu. Provenance: collected by Kris Konarski in Sierra Leone, 1970s.
- Yale University Art Gallery. Provenance: Gift of Charles D. Miller III, St. James, N.Y. (Shown in situ, Augustus Henry Keane,

"Africa: Social, Religious, and Political Institutions," in *The Living Races of Mankind: A Popular Illustrated Account of the Customs, Habits, Pursuits, Feasts, and Ceremonies of the Races of Mankind Throughout the World*, 2 vols., edited by Harry Hamilton Johnston [London: Hutchinson, 1901–3], 2:488; Johnston, *Liberia*, 2:410; and Thomas Joshua Alldridge, "Sierra Leone," in *Customs of the World: A Popular Account of the Manners, Rites, and Ceremonies of Men and Women in All Countries*, 2 vols., edited by Walter Hutchinson [London: Hutchinson, 1913], 2:771.)
- Udvari Collection. Provenance: collected by Sanford and Esther Sage, 1883–90 (William Hart, "Trophies of Grace?: The 'Art' Collecting Activities of United Brethren in Christ Missionaries in Nineteenth Century Sierra Leone," *African Arts* 39, no. 2 [Summer 2006]: 24).
- Unknown collection (sale cat., Christie's, New York, October 16, 1979, lot 62).
- Unknown collection (*Art Africain, Oceanién et d'Asie du Sud-Est: Divers Amateurs*, sale cat., Christie's, Paris, December 7, 2006, lot 35; YVRA 0074060~01).

54. Siegmann, Collection Notes.

55. For more on the mask now at the Yale University Art Gallery, see Keane, "Social, Religious, and Political Institutions," 2:488; Johnston, *Liberia*, 2:1031; and Alldridge, "Sierra Leone," 2:771. The exact date of the Keane publication is unclear. The copy at Yale is listed in the catalogue as 1901, but the book itself indicates no date. William Hart questions

the 1901 date: "Firmin was an engineer working with the Sierra Leone Government Railway. I don't know when he arrived in Sierra Leone, but I suspect he was involved in extending the line from Bo to Baiima, near the Liberian border, and work on that extension only began in 1902. I would have put his photographs between then and his departure from Sierra Leone in September 1904 (when incidentally Harry Johnston, coming from Liberia, was also a passenger on the ship)." E-mail to author, January 9, 2013.

56. D'Azevedo, Review of *African Art of the West Atlantic Coast*, 81–88.

57. Hart, "Trophies of Grace?": 14–25, 86.

58. Siegmann, as quoted in *African, Oceanic, and Pre-Columbian Art*, sale cat. (New York: Sotheby's, May 16, 2013), 132 (lot 121).

59. Neck rings are not diagnostic of female figures, however; male figures also have them.

60. Based on internal measurements, cat. no. 21, an unidentified Southern Bullom (Sherbro) helmet mask, was made to fit over the head of its wearer.

61. Phillips, *Representing Woman*, fig. 3.9.

62. Frederick John Lamp, "Dancing the Hare: Appropriation of the Imagery of Mande Power among the Baga," in *The Younger Brother in Mande: Kinship and Politics in West Africa; Selected Papers from the Third International Conference on Mande Studies, Leiden, March 20–24, 1995*, edited by Jan Jansen and Clemens Zobel (Leiden, Netherlands: Leiden University, 1996), 105–15.

63. For more on the terms *found* and *discovered*, see Reinhardt, "Mende Carvers," 71; Lamp, "Cosmos, Cosmetics, and the Spirit of Bondo," 28–43, 98–99; and Boone, *Radiance from the Waters*, respectively.

64. Reinhardt, "Mende Carvers," 82.

SPIRITS FROM THE FOREST: DAN MASKS IN PERFORMANCE AND EVERYDAY LIFE

I consider it a great honor to contribute to the book accompanying this exhibition of William Siegmann's collection. A mentor, a staunch supporter of my work, a caring colleague, and a kind friend, Bill lives on in my heart and in this essay, which I dedicate to his memory.

1. In Côte d'Ivoire, the Dan are known as Yacouba and, in Liberia, as Gio. I conducted the research upon which this essay is based in the 1990s in western Côte d'Ivoire, near the Liberian border. Siegmann's fieldwork, done some twenty years earlier, was based on the Liberian side of the Dan region that is split in two by the international border. Given the changes likely due to the passage of time—particularly the periods of war in both countries—and to normal regional variation, I cannot claim here to be representing the ethnographic reality that Siegmann encountered when he procured the masks in this collection.

2. This is analogous to the distinction between *Church* (institution, the Vatican) and *church* (individual buildings/congregations) in Catholicism.

3. The Ivorian civil war that began in 2002 had a tremendous negative impact on the Dan people and western Côte d'Ivoire. The conflict also has prevented me from returning to the country. As a result, this essay is historical; I do not claim to portray life in the present day.

4. A considerable amount of scholarly literature exists on *Ge*, most of it written by art historians and anthropologists. See, for example, Eberhard Fischer, "Dan Forest Spirits: Masks in Dan Villages," *African Arts* 11, no. 2 (January 1978): 16–23, 94; Eberhard Fischer and Hans Himmelheber, *The Arts of the Dan in West Africa* (Zurich: Museum Rietberg, 1984); Daouda Gba, "Les Masques chez les Dan: 'Fonctions Éducatives.'" Mémoire de Diplôme d'Études Approfondies (master's thesis) (Université Nationale de Côte d'Ivoire, 1982); George W. Harley, *Masks as Agents of Social Control in Northeast Liberia* (Cambridge, Mass: Peabody Museum of American Archaeology and Ethnology, 1950); Hans Himmelheber, "Le Système de la Religion des Dan," *Rencontres Internationales de Bouaké: Les Religions Africaines Traditionnelles* (Paris: Éditions du Seuil, 1965), 75–96; Ichiro Majima, "Voix de masque sans visage: 'Maania' chez les Dan du Danané-Sud (Côte d'Ivoire)," in *Cultures Sonores d'Afrique* (Tokyo: Institut de Recherches sur les Langues et Cultures d'Asie et d'Afrique, 1997); George W. W. Tabmen, "Gor and Gle: Ancient Structure of Government in the Dan (Gio) Tribe" (Monrovia, Liberia: mimeograph, 1971; hardcover copy, Herman B. Wells Library, Indiana University, Bloomington); P. J. Vandenhoute, *Poro and Mask: A Few Comments on* Masks as Agents of Social

Notes (continued)

Control *by Dr. G. W. Harley* (1952; repr. Ghent, Belgium: Department of Ethnic Art, State University of Ghent, 1989); Hugo Zemp, *Musique Dan: La Musique dans la Pensée et la Vie Sociale d'une Société Africaine* (Paris and the Hague: Mouton, 1971); and idem, liner notes, *Masques Dan* (Paris: Ocora ocr, 52, 1993; recorded in 1969).

5. Alphonse, as quoted in Daniel B. Reed, *Dan Ge Performance: Masks and Music in Contemporary Côte d'Ivoire* (Bloomington: Indiana University Press, 2003), 77.

6. Daouda Gba, "Les Masques chez les Dan: 'Fonctions Éducatives,'" 57.

7. In the northern Dan region, where I did my research, the racing *ge* is called *biansoege*. I use *gunyege* here because that is the name for this *ge* in Liberia, where Siegmann collected the racing mask included in this book.

8. M. Lou, author interview, Man, Côte d'Ivoire, September 25, 1997.

9. Ibid.

10. Vandenhoute, *Poro and Mask*, 8.

11. Robert Farris Thompson, *African Art in Motion: Icon and Act in the Collection of Katherine Coryton White* (Berkeley and Los Angeles: University of California Press, 1974), 163.

12. With its deep-set, triangular eyes, pyramidal cheekbones, and protruding mouth, the *ka gle* in this collection is likely the monkey mask, or *kao gle*. See Fischer and Himmelheber, *Arts of the Dan,* 67.

13. Siegmann-Naegele interviews, August 21, 2011: 2–3.

14. Fischer and Himmelheber, *Arts of the Dan*, 107.

15. Siegmann-Naegele interviews, August 21, 2011: 2–3.

16. Ibid.: 34–35.

BRASS CASTING IN LIBERIA

1. In 1955 Becker-Donner became director of the Museum für Völkerkunde, Vienna, and remained in that position for twenty years.

2. Eugenia W. Herbert, *Red Gold of Africa: Copper in Precolonial History and Culture* (Madison: University of Wisconsin Press, 1984), 296.

3. Ibid., 120.

4. Harry Hamilton Johnston, *Liberia*, 2 vols. (London: Hutchinson, 1906), 1: 74–75.

5. Hans Himmelheber, "Gelbgussringe der Guere (Elfenbeinküste)," *Tribus*, n.s., 13 (1964): 1–88.

6. Siegmann, phone call with author, 1984.

7. Etta Becker-Donner, "Kunst und Handwerk in NO [Northeastern] Liberia." *Baessler-Archiv* 23, nos. 2–3 (1940): 45–110; and George Schwab, *Tribes of the Liberian Hinterland, Papers of the Peabody Museum of American Archaeology and Ethnology, Harvard University*, vol. 31, edited by George Way Harley (Cambridge, Mass.: Peabody Museum of American Archaeology and Ethnology, 1947), 111–12.

8. Barbara C. Johnson, "Ldamie: Figurative Brass Caster of the Dan," in *Iowa Studies in African Art: The Stanley Conferences at the University of Iowa* 2 (1987): 50.

9. Schwab, *Tribes of the Liberian Hinterland*, 112.

10. Becker-Donner, "Kunst und Handwerk in NO Liberia": 55.

11. Schwab, *Tribes of the Liberian Hinterland*, 363; and William C. Siegmann with Cynthia E. Schmidt, *Rock of the Ancestors: ɲamôa koni* (Suakoko, Liberia: Cuttington University College, 1977), 48.

12. Yanemie Ldamie, author interview, Gaple, Liberia, March 19, 1983.

13. Schwab, *Tribes of the Liberian Hinterland,* 145. See also Bohumil Holas, *Craft and Culture in the Ivory Coast* (Abidjan: Republic of the Ivory Coast Ministry of National Education Centre for Human Studies, 1968), 68; and Eberhard Fischer and Hans Himmelheber, *The Arts of the Dan in West Africa* (Zurich: Museum Rietberg, 1984), 104.

14. Fischer and Himmelheber, *Arts of the Dan*, 144. This is based on the authors' observations of two old brass casters in the 1950s.

15. Gbangor Gweh, author interview, Beple, Liberia, March 23, 1983; and Himmelheber, "Gelbgussringe der Guere": 84

16. Becker-Donner, "Kunst und Handwerk": 48.

17. Dro, author interview, Tapita, Liberia, January 1986.

18. Becker-Donner, "Kunst und Handwerk": 90; and Hans Himmelheber, *Negerkunst und Negerkünstler* (Braunschweig, Germany: Klinkhardt and Biermann, 1960), 243.

19. Gbangor Gweh interview.

20. Yanemie Ldamie interview.

21. Etta Becker-Donner, *Hinterland Liberia*, trans. Winifred M. Deans (London: Blackie and Sons, 1939), 149.

22. Other figures by Leh are in the collections of the American Museum of Natural History, New York; Cuttington University, Suakoko, Liberia; the Museum of Art, Fort Lauderdale, Florida; and various private collections.

23. Siegmann, *Rock of the Ancestors*, 49.

RITUAL RECYCLING: MODERN USES OF ANCIENT STONE SCULPTURES IN THE UPPER GUINEA FOREST REGION

1. The Upper Guinea Forest region extends from Guinea and Sierra Leone in the west through Liberia, Côte d'Ivoire, and Ghana to Togo in the east, and a few hundred miles inland from the Atlantic coast. The present book deals only with Sierra Leone, Liberia, and a small portion of Guinea—technically speaking, the western part of the Upper Guinea Forest region. I will, however, use the shorter terminology here. In writing this essay, I greatly profited from the help of Frederick Lamp, Gary Schulze, and Natasha Thoreson.

2. John H. Atherton and Milan Kalous, "Nomoli," *Journal of African History* 11, no. 3 (1970): 305.

3. George Thompson, *Thompson in Africa: Or, an Account of the Missionary Labors, Sufferings, Travels, and Observations of George Thompson in Western Africa, at the Mendi Mission* (Cleveland: D. M. Ide, 1852), as quoted in Douglas Fraser, "Note on the Stone *Nomoli* Figures of Sierra Leone," *Art Bulletin* 53, no. 3 (September 1971): 393.

4. Ibid.

5. The publications devoted to this subject have been written in English, German, French, and Italian. The early authors include the British colonial official Thomas Joshua Alldridge, the Swiss medical doctor Leopold Rütimeyer, the British museum keeper Thomas Athol Joyce, the French military doctor H. Néel, and the French ethnographer Maurice Delafosse. For a critical review of most of this literature, see William A. Hart and Christopher Fyfe, "The Stone Sculptures of the Upper Guinea Coast," *History in Africa* 20 (1993): 71–87.

6. The iconography of this group can be distantly related to a stone bas-relief in the British Museum, London, and a composite group of three figures in the Pitt Rivers Museum, Oxford—both from Sierra Leone. See William A. Hart, "Sculpted Tablet," in *Africa: The Art of a Continent,* edited by Tom Phillips (New York: Prestel, 1995): 468 and 470, respectively. The former shows two squatting figures on whose shoulders a third, much smaller figure stands. The latter

represents a central figure resting his hands on the heads of two smaller figures in front of him. Neither scene is fully understood.

7. For very tall stone carvings, see Aldo Tagliaferri, *Pomdo, Mahen Yafe et Nomoli* (Paris: Johann Levy, Art Primitif, 2003), no. 17; Donna Page, *Artists and Patrons in Traditional African Cultures: African Sculpture from the Gary Schulze Collection* (Bayside, N.Y.: Queensborough Community College Art Gallery, 2005), 53; and Mario Meneghini, *Collecting African Art in Liberia and Neighboring Countries, 1963–1989* (Gavirate, Italy: Nicolini Editore, 2006), 131. For a bi-gender Janus figure, see Meneghini, *Collecting African Art,* 146–47. For animals, see Aldo Tagliaferri and Arno Hammacher, *Fabulous Ancestors: Stone Carvings from Sierra Leone and Guinea* (New York: Africana Publishing, 1974), no. 40; and Tagliaferri, *Pomdo, Mahen Yafe et Nomoli,* no. 22. For zoomorphic hybrids, see Meneghini, *Collecting African Art,* 153–55. For an explanation of the occurrence of "monsters" as representations of ancestor spirits with malformations, see Atherton and Kalous, "Nomoli": 315.

8. For a general overview of the materials used for the stone carvings, see Elizabeth Jérémine, "Étude des Statuettes Kissiennes au Point de Vue Minéralogique et Pétrographique," *Journal de la Société des Africanistes* 15 (1945): 3–14 and pl. 1. See also Leopold Rütimeyer, "Über Westafrikanische Steinidole," *Archives Internationales d'Ethnographie* 14 (1901): 198; H. Néel, "Statuettes en Pierre et en Argile de l'Afrique Occidentale," *L'Anthropologie* 24 (1913): 430; and Page, *Artists and Patrons,* 53.

Notes (continued)

9. A striking but most probably fake 5 ¾ in. (14.5 cm)-tall brass figure in the style of a stone figure was advertised in *African Arts* 14, no. 2 (February 1981): 7. Stone carvings themselves, once their market value had been recognized, began to be counterfeited. Louis T. Wells, "Art and Expatriates in Liberia," *Tribal Art* 14, no. 2 (Spring 2010): 102, discusses the appearance on the market of "a flood of copies" in the 1960s and 1970s, and Mario Meneghini (*Collecting African Art,* 123) mentions a Sierra Leonean forger nicknamed Moussa Nomoli—after the *nomoli* figures (see below). *Fabulous Ancestors,* the first book focused on stone carvings from this area of West Africa, includes a brief section dedicated to "Imitations and Fakes," which featured two examples of the latter (Tagliaferri and Hammacher, 8–9, nos. 79 and 80).

10. Yves Person, "Les Kissi et Leurs Statuettes de Pierre dans le Cadre de l'Histoire Ouest-Africaine," *Bulletin de l'Institut Fondamental d'Afrique Noire* 23, nos. 1–2 (1961): 2. It is interesting to note, in light of the fakes discussed above, that a famous Mende carver of wooden masks, Kondeh Bundu, of Waiama, Bo District, Sierra Leone, declared in a 1962 interview with the Peace Corps Volunteer Gary Schulze: "If I had known you wanted one, I would have made one from the stone. I can imitate what the devils [spirits] used to make. It would take a month for this" (as quoted in Page, *Artists and Patrons,* 76).

11. Frederick John Lamp, "Ancient Wood Figures from Sierra Leone: Implications for Historical Reconstruction," *African Arts* 23,

no. 2 (April 1990): 48–59, 103. William A. Hart identified two Sierra Leonean, possibly Temne, wooden figures in Scottish public collections that probably date from around 1790 and the early nineteenth century, respectively. Hart, "Continuity and Discontinuity in the Art History of Sierra Leone," *Quaderni Poro,* special issue, 9 (1995): 63, figs. 5 and 6. Yet contrary to the examples from the Baltimore Museum of Art, the British Museum, and the private collection, the style of these two figures differs greatly from that of the stone carvings.

12. For the classic reference, see Ezio Bassani and William Fagg, *Africa and the Renaissance: Art in Ivory* (New York: Center for African Art; Munich: Prestel-Verlag, 1988). For a recent reassessment of the dating and geographical origins of these ivories, see Peter Mark, "Towards a Reassessment of the Dating and the Geographical Origins of the Luso-African Ivories, Fifteenth to Seventeenth Centuries," *History in Africa* 34 (2007): 189–211.

13. William Fagg, *Afro-Portuguese Ivories* (London: Batchworth Press, 1959). See also Bassani and Fagg, *Africa and the Renaissance,* 48–49, 61–63, 75–77, 80–81, 88, 96. As Kunz Dittmer notes in "Bedeutung, Datierung und Kulturhistorische Zusammenhänge der 'Prähistorischen' Steinfiguren aus Sierra Leone und Guinée," *Baessler-Archiv* 25 (1967): 194, Fagg used the similarities between ivory and stone carvings to locate the geographical origin of the former, whereas subsequent authors were interested in historically dating the latter thanks to the documented ivories.

14. For representations of the reclining chair, see Bassani and Fagg, *Africa and the Renaissance,* 62–63; and Meneghini, *Collecting African Art,* 144–45.

15. Frederick John Lamp, "House of Stones: Memorial Art of Fifteenth-Century Sierra Leone," *Art Bulletin* 65, no. 2 (1983): 220, n. 8. For an earlier source on Mende agricultural beliefs, see Frank Musa, "Farming and Superstition in Sierra Leone," *Sierra Leone Studies* 21 (1939): 104, as quoted in Atherton and Kalous, "Nomoli": 311.

16. Lamp, "House of Stones": 220; Meneghini, *Collecting African Art,* 128. It should be noted that the term *mahen yafe* is also applied to metallic rings that are sometimes attached to stone carvings; they, too, are considered to be powerful objects and also receive offerings. Leopold Rütimeyer, "Weitere Mitteilungen über Westafrikanische Steinidole," *Archives Internationales d'Ethnographie* 18 (1908): 170–71; Thomas A. Joyce, "Steatite Figures from Sierra Leone," *Man* 9 (1909): 66–67.

17. Denise Paulme, *Les Gens du Riz: Kissi de Haute-Guinée Française* (Paris: Plon, 1954), 144–49. Depending on the particular Kissi subgroup, the terms *pombo* and *piamdo* are also used. See Julien Volper, "Pomdo and Nomoli: The Jean Houzeau de Lehaie Archives," *Tribal Art* 10, no. 4 (2006): 100.

18. Lamp pointed out that the terms *nomoli, mahen yafe,* and *pomdo* are somewhat misleading: the former two are Mende words, and the Mende were not the makers of these figures, while the latter is a Kissi term and a substantial percentage of such figures were found outside

Kissi country. I will nonetheless continue to use these terms in this essay. Lamp, "Ancient Wood Figures": 48.

19. Lamp, "House of Stones": 222.

20. Annemieke Van Damme, "À Propos de Huit Sculptures en Pierre Découvertes en Territoire Loma," *Arts d'Afrique Noire*, no. 79 (Autumn 1991): 19–29. Interestingly, a wooden Loma figure discovered in the late 1920s, representing an ancestor and buried in the ground, was called *piumdo* by the Loma, clearly a cognate of the Kissi term *pomdo/piamdo*. Paul Germann, *Die Völkerstämme im Norden von Liberia: Ergebnisse einer Forschungsreise im Auftrage des Staatlich-Sächsischen Forschungs-institutes für Völkerkunde in Leipzig in den Jahren 1928/29* (Leipzig: R. Voigtländer, 1933), 93, as quoted in Van Damme, "À Propos de Huit Sculptures": 23. See also Tagliaferri, *Pomdo, Mahen Yafe et Nomoli*, no. 1, for a Loma-looking stone carving.

21. It is generally accepted that the Mende are a product of Mani influence on a Gola and Kissi substratum. See Cecil Magbaily Fyle, *Historical Dictionary of Sierra Leone* (1977; rev. ed., Lanham, Md.: Scarecrow Press, 2006), 118. For an opposing view, see Hart, "Continuity and Discontinuity": 21. For an important contribution to this complicated and only partly understood history, see Adam Jones, "Who Were the Vai?," *Journal of African History* 22, no. 2 (1981).

22. Walter Rodney, "A Reconsideration of the Mane Invasions of Sierra Leone," *Journal of African History* 8, no. 2 (1967): 219–46;

J. D. Fage, "Upper and Lower Guinea," in *The Cambridge History of Africa*, vol. 3: *From c. 1050 to c. 1600*, edited by Roland Oliver (Cambridge: Cambridge University Press, 1977), 508–9.

23. For Hair's writings, see especially Paul E. H. Hair, "An Ethnolinguistic Inventory of the Upper Guinea Coast before 1700," *African Language Review* 6 (1967): 32–70; "Ethnolinguistic Continuity on the Guinea Coast," *Journal of African History* 8, no. 2 (1967): 247–68; and *Africa Encountered: European Contacts and Evidence, 1450–1700* (Aldershot, U.K.: Variorum, 1997). See also the bibliographies in Frederick John Lamp, *La Guinée et ses Héritages Culturels* (Conakry, Guinea: Service d'Information et de Relations Culturelles, Ambassade des Etats-Unis, 1992); and Hart, "Continuity and Discontinuity." Arguing for the continuity thesis are Jones, "Who Were the Vai?"; Hart, "Continuity and Discontinuity"; and Mark, "Towards a Reassessment." In Lamp's opinion, however, Hair "underestimated the magnitude and consequences of the Mande takeover." Note to author, March 2013.

24. For the identification of supposedly Portuguese armor, see Paulme, *Les Gens du Riz*, 9, 144; and Dittmer, "Bedeutung, Datierung und Kulturhistorische Zusammenhänge," 193–94. For a refutation of this, see Hart, "Continuity and Discontinuity": 26, 86.

25. There is some debate about the existence, at least among the Kissi, of a stone-carving tradition that lasted into the early twentieth

century. See Maurice Delafosse, "Au Sujet des Statuettes en Pierre du Kissi (Guinée Française)," *Revue d'Ethnographie et de Sociologie* 5 (1914): 143–44; Paulme, *Les Gens du Riz*, 145; and Person, "Les Kissi et Leurs Statuettes": 32–40.

26. Fernandes cited in Lamp, "House of Stones": 229, 234. According to Hart ("Continuity and Discontinuity": 32), the silence of the Portuguese sources suggests that stone carving ceased "some time before the Europeans arrived." Most authors on the subject, however, think that production continued at least into the seventeenth century. (See Mark, "Towards a Reassessment," and the preceding endnote.)

27. Thevet cited in Lamp, "House of Stones": 230.

28. Almada cited in ibid.: 227.

29. For a *mahen yafe* with metal rings, see Lamp, "House of Stones,": 221, fig. 2. Early authors noted that the rings themselves were also called *mahen yafe*: Rütimeyer, "Weitere Mitteilungen," 170; Joyce, "Steatite Figures from Sierra Leone": 66. For the relevance of hair to the Temne, see Lamp, "House of Stones": 224; and to the Mende, see Sylvia Ardyn Boone, *Radiance from the Waters: Ideals of Feminine Beauty in Mende Art* (New Haven, Conn.: Yale University Press, 1986), 184–99. For animal imagery, see Lamp, "House of Stones": 237; and idem, ed., *See the Music, Hear the Dance: Rethinking African Art at the Baltimore Museum of Art* (Munich and New York: Prestel, 2004), 194. An exceptionally

Notes (continued)

large figure seated on an elephant, carved of hard rock rather than steatite, is illustrated in Page, *Artists and Patrons*, 53.

30. Leopold Rütimeyer, "Über Westafrikanische Steinidole," *Archives Internationales d'Ethnographie* 14 (1901): 197. It should nevertheless be acknowledged that most stone carvings, whether *nomoli* or *pomdo*, are found singly.

31. Rare examples of lying or reclining figures are found in the British Museum, London (see Philip Allison, *African Stone Sculpture* [New York and Washington, D.C.: Frederick A. Praeger, 1968], fig. 64; and Lamp, "House of Stones": 226, figs. 19, 20); in the Musée du Quai Branly, Paris (see Paulme, *Les Gens du Riz*, 145; and Lamp, "House of Stones": 230, fig. 29); and in private collections (see Tagliaferri, *Pomdo, Mahen Yafe et Nomoli*, no. 36; and Page, *Artists and Patrons*, 50).

32. Paulme, *Les Gens du Riz*, 145. Lamp ("House of Stones": 229) mentions that the Portuguese Jesuit Father Barreira witnessed such a divination ritual in Sierra Leone in 1606.

33. Donelha cited in Hart, "Continuity and Discontinuity": 47–48.

34. For the ritual use of *nomoli*, see Joyce, "Steatite Figures from Sierra Leone": 99; Walter L. Edwin, "Notes on the Nomolis of Sherbroland," *Journal of Negro History* 2, no. 2 (April 1917): 160–63; and Stanley Brown, "The Nomoli of Mende Country," *Africa* 18, no. 1 (1948): 18–19.

35. Page, *Artists and Patrons*, 49.

36. See Dr. Marc Ghysels's unpublished report "Tomodensitometric Analysis by X-ray Scanner," November 15, 2008. Ghysels also noted that "the scanner provides no explanation for the hands resting on both heads."

37. Greensmith, as quoted in Rütimeyer, "Weitere Mitteilungen": 171; see also Brown, "The Nomoli of Mende Country": 19. For the use of *pomdo* in oath-taking, see Tagliaferri and Hammacher, *Fabulous Ancestors*, nos. 75 and 76.

38. Néel, "Statuettes en Pierre et en Argile de l'Afrique Occidentale": 435.

39. Paulme, *Les Gens du Riz*, plate 3.

40. Lamp, "House of Stones": 235; see also Edwin, "Notes on the Nomolis of Sherbroland": 163.

41. Thomas Winterbottom, *An Account of the Native Africans in the Neighbourhood of Sierra Leone: To Which Is Added an Account of the Present State of Medicine among Them* (London: C. Whittingham, 1803), 1: 241, as quoted in Atherton and Kalous, "Nomoli": 313.

42. Néel, "Statuettes en Pierre et en Argile de l'Afrique Occidentale": 435. For photos of a divination séance with a stone carving, see Paulme, *Les Gens du Riz*, 147 and plate 11.

43. Lamp, "House of Stones": 229 and Paulme, *Les Gens du Riz*, 126; see also note 32 above. On the tradition of interrogating corpses in West Africa, see Denise Paulme, "Deux Statuettes en Pierre de Guinée Française," *Bulletins et*

Mémoires de la Société d'Anthropologie de Paris 3 (1942): 41. For the recarved figure, which is now in the Musée du Quai Branly, Paris, see Tagliaferri and Hammacher, *Fabulous Ancestors*, nos. 30 and 31; and Meneghini, *Collecting African Art*, 196.

44. For the two types of dressed *pomdo*, see Paulme, *Les Gens du Riz*, 146 and plates 11–12. Lamp, "Ancient Wood Figures": 58, illustrates a *pomdo*-containing divination figure from the Museum für Völkerkunde, Berlin. Van Damme ("À Propos de Huit Sculptures": 24) mentions the existence of such a divination figure among the Loma people in Macenta, Guinea.

45. I thank Thomas Seligman for his help in tentatively identifying the date and origin of this photograph.

46. Tagliaferri and Hammacher, *Fabulous Ancestors*, 13 and nos. 72 and 73; Page, *Artists and Patrons*, 67–68.

47. For the first published X-ray of a Kissi divination figure, see Roy Sieber and Theodore Celenko, "Rayons X et Art Africain," *Arts d'Afrique Noire*, no. 21 (1977): 17. For Schulze's divination figure and X-ray, see Page, *Artists and Patrons*, 67.

48. For the use of CT scanning in art analysis, see Marc Ghysels, "CT Scans in Art Work Appraisal," *Art Tribal* 4 (2003): 116–31; and Anne-Marie Bouttiaux and Marc Ghysels, "Probing Art with CT Scans: A New Look at Two Masterpieces from Central Africa," *Arts and Cultures* 9 (2008): 230–49.

49. Page, *Artists and Patrons*, 67.

50. It could be argued, of course, that in the distant past corpses and stone figures were *both* used for divination. New evidence from European sources dating from the fifteenth century to the seventeenth century would be needed to prove either hypothesis.

51. William C. Siegmann with Cynthia E. Schmidt, *Rock of the Ancestors: ŋamôa koni* (Suakoko, Liberia: Cuttington University College, 1977). See Henrique Tokpa's comment about the origin of the title in "Remembering Bill Siegmann," in this book, p. 18.

52. For the Guinean Kissi, see Denise Paulme, "Utilisation Moderne d'Objets Préhistoriques à des Fins Rituelles en Pays Kissi," *Notes Africaines* 44 (1949): 119. The British colonial official Lieutenant William Addison, stationed in Sierra Leone, described how he had to hide his collection of *nomoli* stone figures, lest his indigenous personnel would leave his household. William Addison, "Steatite Figures from Moyamba District, Central Province, Sierra Leone, West Africa," *Man* 23 (November 1923): 177. The quote about pregnant women is in Brown, "The Nomoli of Mende Country": 19.

53. Major D'Arcy Anderson, cited in Thomas Joshua Alldridge, *A Transformed Colony: Sierra Leone as It Was, and as It Is; Its Progress, Peoples, Native Customs, and Undeveloped Wealth* (London: Seeley, 1910), 287.

54. The blood-covered *mahen yafe* is reproduced in Page, *Artists and Patrons*, 50. In the 1930s, Houzeau de Lehaie described the origin of the sticky patina of some Kissi stone figures he collected in Kissidougou, Guinea, as they

had just received libations of "oil, fat, and possibly also blood" (cited in Volper, "Pomdo and Nomoli": 101).

55. De Beaulieu, as quoted in Lamp, "House of Stones": 234. The emphasis is mine.

56. Mourad Rammah, "Kairouan et la Grande Mosquée," in *Tunisie, un Patrimoine Inédit* (Paris: Institut du Monde Arabe, 1995), 75. The author adds: "Thus, paradoxically, this mosque [of Kairouan] forms the largest museum of Roman and Byzantine capitals ever brought together in a Muslim monument" (my translation).

57. Rosamond E. Mack, *Bazaar to Piazza: Islamic Trade and Italian Art, 1300–1600* (Berkeley: University of California Press, 2002), 27. "Moreover, the textile's Arabic inscription invoking Allah's blessing on the owner was turned into an [ornamental band] centered on the back of the vestment, where it would face the congregation during Mass." I owe this example to my colleague Roberta Bartoli, whose encyclopedic knowledge I gratefully acknowledge.

WILLIAM SIEGMANN, ADVOCATE FOR CONNOISSEURSHIP

1. Siegmann told me that an elderly Liberian man gave the ring to him as a Christmas present. Coincidentally, it was the first ring made by the Liberian blacksmith who was Siegmann's "stranger-father" during Bill's years in Liberia.

2. The donor Rita Grunwald confirmed that Siegmann collected the Loma feather tunic, which she and her husband, John, dontated

to the Indiana University Art Museum in 1974. Grunwald, conversation with the author, Bloomington, Ind., June 8, 2013. For discussions of Liberian patchwork tunics, see William C. Siegmann with Cynthia E. Schmidt, *Rock of the Ancestors: ŋamôa koni* (Suakoko, Liberia: Cuttington University College, 1977); and Siegmann, "Patchwork Gowns as State Regalia in Western Liberia," in *Man Does Not Go Naked: Textilien und Handwerk aus Afrikanischen und Anderen Ländern*, edited by Beate Engelbrecht and Bernhard Gardi (Basel: Ethnologisches Seminar der Universität und Museum für Völkerkunde, 1989), 107–16.

3. Sieber's considerations informed acquisition recommendations that expanded the holdings of the Indiana University Art Museum as well as the mutual decisions he and his wife, Sophie, made as they built their personal collection of African art over the years.

4. Janet Tassel, "Reverence for the Object: Art Museums in a Changed World," *Harvard Magazine* 105, no. 1 (September–October 2002): 48–58, 98–99.

5. Ibid.: 49.

6. Jakob Rosenberg, "The Problem of Quality in Old Master Drawings," *Bulletin of the Allen Memorial Art Museum* 8, no. 2 (Winter 1951): 48. Rosenberg elaborated on connoisseurship and the power of discrimination in *On Quality in Art: Criteria of Excellence, Past and Present* (Princeton, N.J.: Princeton University Press, 1967). I am grateful to Tufts University professor Andrew McClellan for bringing these publications to my attention.

7. Monni Adams, "An Evening with William Fagg," *African Arts* 10, no. 4 (July 1977): 38.

8. Roy Sieber, "Fakes, Reproductions, and Restorations in African Art," unpublished lecture, National Museum of African Art, Smithsonian Institution, Washington, D.C., May 16, 1984: 3.

9. Herbert M. Cole, "A Crisis in Connoisseurship?," *African Arts* 36, no. 1 (Spring 2003): 8.

10. William C. Siegmann, "A Collection Grows in Brooklyn," in *Representing Africa in American Art Museums: A Century of Collecting and Display*, edited by Kathleen Bickford Berzock and Christa Clarke (Seattle and London: University of Washington Press, 2011), 75.

11. Siegmann, "A Collection Grows in Brooklyn," 76. The museum's exhibition was titled *Passages: Photographs in Africa by Carol Beckwith and Angela Fisher.*

12. Alex Bortolot, who interned for Siegmann at that time, recalled Siegmann's objections to the design direction the museum was then taking; e-mail to author, January 17, 2013.

13. Siegmann, "A Collection Grows in Brooklyn," 76.

14. The Igbo beautiful-maiden mask is Brooklyn Museum inv. no. 87.215.

15. Siegmann, "A Collection Grows in Brooklyn," 75.

16. In an interview with the New York gallery owner and dealer Amyas Naegele for the Minneapolis Institute of Arts, Siegmann noted that he probably bought his first piece of African art on his third day at Cuttington University College (as it was then called) in Suakoko, Liberia, where he taught as a Peace Corps Volunteer from 1965 to 1969. "[It] was a textile, from the father of one of my students, who had a beautiful blanket he was selling in order to help pay for tuition," he recalled. "I became fascinated by the textiles and the really wonderful handwork. Very quickly, I went on from these to sculpture." Siegmann-Naegele interviews, August 21, 2011: 34.

17. Discussing the use of Arabic to transliterate the Mende language, Siegmann pointed out: "In the 19th century, powerful new forces were entering Sierra Leone. Moslem missionaries entered from the north while Christian missionaries and English colonial officials entered from the Coast. The Mende often incorporated elements from both of these foreign groups to co-opt the power associated with these foreigners and thereby to augment their own traditional powers and symbols." Siegmann, Collection Notes, 2011, n.p.

18. Ibid.

19. Siegmann's Collection Notes indicate that *bagle* masks, especially popular among the western Dan, are characterized by tubular eyes rimmed with metal, a broad nose, a prominent forehead ornamented with two registers of small raised horns and metal tacks, and a large mouth with metal teeth. They were oiled before performances and adorned with a costume and headgear made of fiber, feather, and cloth. The *bagle* masqueraders typically carried a hooked stick and performed in an aggressive manner. For more on *bagle* masks, see Eberhard Fischer and Hans Himmelheber, *The Arts of the Dan in West Africa* (Zurich: Museum Rietberg, 1984), 51–57.

20. Siegmann-Naegele interviews, August 21, 2011: 31. Eberhard Fischer documented this *bagle* mask in the late 1970s, noting that the carver Tompieme had made it. See Fischer, "Dan Forest Spirits: Masks in Dan Villages," *African Arts* 11, no. 2 (January 1978): 20–21.

21. For Sande Society masks and for the formal and aesthetic characteristics that define the work of particular master carvers and workshops, see Frederick John Lamp's essay in this book.

22. Cole, "A Crisis in Connoisseurship?": 5.

23. The Africanist art historian Sidney Littlefield Kasfir has critically examined the issue of authenticity with regard to the arts of Africa, paying particular attention to "cultural appropriation, since in the past it has been reviewed in terms of fakes, forgeries, and imitations—terms that themselves are heavily laden with the weight of earlier ideas about African art and culture, most specifically the primacy of 'traditional society.'" Sidney Littlefield Kasfir, "African Art and Authenticity: A Text with a Shadow," *African Arts* 25, no. 2 (April 1992): 41. See also *African Arts* 9, no. 3 (April 1976); the issue was devoted to questions of authenticity in African art.

24. I am grateful to Alex Bortolot for his insights that inform my discussion of connoisseurship.

25. Frederick John Lamp, "Africa Centered," *African Arts* 32, no. 1 (Spring 1999): 6. This essay was included in part two of a special issue focused on authorship in African art. Lamp suggested that the study of traditional, or "classical," African art was losing ground to studies of contemporary art and arts of the African diaspora.

26. See the responses to Lamp's "Africa Centered" by Suzanne Preston Blier, Chika Okeke, Carol Magee-Curtis, Judith Bettleheim, and Steven Nelson in *African Arts* 32, no. 2 (Summer 1999): 1, 4, 6, 10 (respectively); and Mike McGovern, "More on Lamp's 'First Word,'" *African Arts* 32, no. 3 (Fall 1999): 9, 85.

27. Sidney Littlefield Kasfir, "The Disappearing Study of the Premodern African Past," *African Arts* 46, no. 1 (Spring 2013): 4.

28. Doran H. Ross, "Interview with Roy Sieber," *African Arts* 25, no. 4 (October 1992): 39.

PART 3
Catalogue of Objects

MENDE FEMALE FIGURE

1. Pa Jobo's given name was probably Amara; see Lamp's essay in this book, p. 69.

2. William Siegmann, Collection Notes, 2011, n.p.

3. Frederick John Lamp, "Cosmos, Cosmetics, and the Spirit of Bondo," *African Arts* 18, no. 3 (May 1985): 32–36; Ruth B. Phillips, *Representing Woman: Sande Masquerades of the Mende of Sierra Leone* (Los Angeles: UCLA Fowler Museum of Cultural History, 1995), 116–17.

SANDE SOCIETY PENDANTS AND NECKLACE

1. Thomas Winterbottom, *An Account of the Native Africans in the Neighbourhood of Sierra Leone* (London: C. Whittingham, 1803), 92, as quoted in Patricia Ann O'Connell, "Bandi Silver Jewelry," *African Arts* 12, no. 1 (November 1978): 49.

2. A similar Tuareg *tcherot* silver amulet from Niger is described and illustrated in Thomas K. Seligman and Kristyne Loughran, eds., *Art of Being Tuareg: Sahara Nomads in a Modern World* (Los Angeles: Iris and B. Gerald Cantor Center for Visual Arts, Stanford University/ UCLA Fowler Museum of Cultural History, 2006), 191.

3. This is according to William Siegmann in a personal communication with Patricia Ann O'Connell, 1978, as quoted in O'Connell, "Bandi Silver Jewelry": 50.

MASKS OF THE PORO, THOMA, AND OTHER SOCIETIES

1. Ruth B. Phillips, *Representing Woman: Sande Masquerades of the Mende of Sierra Leone* (Los Angeles: UCLA Fowler Museum of Cultural History, 1995), 22.

2. In his Collection Notes, Siegmann wrote that most *bowu* masks have a non-figural base, making this and similar examples unique.

3. See Frederick Lamp's essay in this book, p. 74.

4. Carol MacCormack, "Proto-Social to Adult: A Sherbro Transformation," in *Nature, Culture, and Gender*, edited by Carol MacCormack and Marilyn Strathern (Cambridge: Cambridge University Press, 1980), 100.

GONGOLI MASKS

1. William C. Siegmann and Judith Perani, "Men's Masquerades of Sierra Leone and Liberia," *African Arts* 9, no. 3 (April 1976): 46.

2. Ruth B. Phillips, *Representing Woman: Sande Masquerades of the Mende of Sierra Leone* (Los Angeles: UCLA Fowler Museum of Cultural History, 1995), 68.

3. Siegmann and Perani, "Men's Masquerades," 46.

MASKS AND FIGURES OF THE LOMA PEOPLE

1. Christian Kordt Højbjerg, "The Ambiguity of Gender," in *See the Music, Hear the Dance: Rethinking African Art at the Baltimore Museum of Art*, edited by Frederick Lamp (Munich and New York: Prestel, 2004), 56–59; and Annemieke Van Damme, *De Maskersculptuur binnen het Poro-Genootschap van de Loma: Getuigenis van een Ecologisch-Culturele Aanpassing?* (Ghent, Belgium: Rijksuniversiteit, Seminarie voor Etnische Kunst, 1987), 30–32.

2. Christian K. Højbjerg, *Resisting State Iconoclasm among the Loma of Guinea* (Durham, N.C.: Carolina Academic Press, 2007), 139.

Notes (continued)

3. Højbjerg, "Ambiguity of Gender," 59

4. Ibid., 56.

5. Siegmann-Naegele interviews, August 21, 2011: 59.

MASKS OF THE DAN, MANO, KONO, AND BASSA PEOPLES

1. For more about *kagle* masks, see Daniel Reed's essay in this book, pp. 87–89.

2. These two hoes, a gift from the New York collectors Brian and Diane Leyden, were the first objects Siegmann acquired for the Brooklyn Museum, a few months after becoming a curator there in 1987.

3. William Siegmann, Collection Notes, 2011, n.p.

4. For informal comments on Siegmann's fieldwork among the Bassa, see "Remembering Bill Siegmann," in this book, p. 20.

GAME BOARD AND MINIATURE MASK

1. Barbara C. Johnson, *Four Dan Sculptors: Continuity and Change* (San Francisco: Fine Arts Museums of San Francisco, 1986), 41–42.

2. Eberhard Fischer and Hans Himmelheber, *The Arts of the Dan in West Africa* (Zurich: Museum Rietberg, 1984), 138–39.

BRASS FROM LIBERIA

1. For more about changes in Liberia's economic and agricultural systems during the 1930s, see Barbara C. Johnson's essay in this book.

GREBO OR KRU RING

1. For "Kru money," see Roberto Ballarini, *The Perfect Form: On the Track of African Tribal Currency* (Milan: Galleria Africa Curio, 2009), 126. For *nitien*, see George Schwab, *Tribes of the Liberian Hinterland*, *Papers of the Peabody Museum of American Archaeology and Ethnology, Harvard University*, vol. 31, edited by George Way Harley (Cambridge, Mass.: Peabody Museum of American Archaeology and Ethnology, 1947), 363–64. For a survey of the literature about these rings, see Scott Shepperd, "Nitien: The Curious Case of Kru Money," *Liberian Studies Journal* 31, no. 2 (2006): 50–85.

2. For a Siegmann photograph of a Grebo shrine with *nitien* rings placed on the ground, see Barbara C. Johnson's essay in this book, p. 95.

STONE SCULPTURE OF THE SAPI AND KISSI PEOPLES

1. C. E. Klenkler, *Sahara: Objets Préhistoriques/ Prähistorische Artefakte*, 2 vols. (Geneva: Dodo Publications, 2003), 1: 109–15 and 2: 123–31.

2. An early book devoted to stone sculpture from the continent's various regions was Philip Allison, *African Stone Sculpture* (New York and Washington, D.C.: Frederick A. Praeger, 1968).

3. CT scans of two such divination figures, revealing their contents, are reproduced as figs. 7.11 and 7.12 in my essay in this book, p. 115.

TEXTILES

1. Simon Ottenberg, "Decorated Hu Ronko Shirts from Northern Sierra Leone: Birth, Life, and Decline," *African Arts* 40, no. 4 (Winter 2007): 18.

PRESTIGE ARTS OF THE MENDE, VAI, KIM, AND TEMNE PEOPLES

1. Ezio Bassani and William Fagg, *Africa and the Renaissance: Art in Ivory* (New York: Center for African Art; Munich: Prestel-Verlag, 1988); William A. Hart, "Early-Nineteenth-Century Chiefs' Horns from Coastal Liberia," *African Arts* 32, no. 3 (Autumn 1999), 62–67, 96; and Peter Mark, "Towards a Reassessment of the Dating and the Geographical Origins of the Luso-African Ivories, Fifteenth to Seventeenth Centuries," *History in Africa* 34 (2007), 209.

2. I thank Dr. Hisham Khalek of the University of Minnesota, Minneapolis, for translating the Arabic inscription. A similar figurative horn, most probably older, is in the collection of the Virginia Museum of Fine Arts, Richmond. That object is reproduced in Joe Henggeler, "Ivory Trumpets of the Mende," *African Arts* 14, no. 2 (February 1981): 60, 62; Bassani and Fagg, *Africa and the Renaissance,* 211

(which has the image flipped); Marie-Thérèse Brincard, ed., *Sounding Forms: African Musical Instruments* (New York: American Federation of Arts, 1989), 154; and Richard Woodward, *African Art: Virginia Museum of Fine Arts* (Richmond: Virginia Museum of Fine Arts, 2000), 33.

3. For an illustration of Sande women wearing horns, see fig. 3.2 in Nanina Guyer's essay in this book, p. 44.

4. The Vai people developed a unique syllabic script in the early nineteenth century that was used especially in commercial contracts and trade inventories. Its 192 characters are phonetic, representing the consonant-and-vowel units of the spoken language. See Saki Mafundikwa, *Afrikan Alphabets: The Story of Writing in Afrika* (West New York, N.J.: Mark Batty, 2004), 65–69.

5. A silver hat, or "crown," of similar shape, also of Temne origin, is in a private collection. See William A. Hart, "*Kololewengoi* and the Myth of the Big Thing," *RES: Anthropology and Aesthetics* 37 (Spring 2000): 78; and Donna Page, *Artists and Patrons in Traditional African Cultures: African Sculpture from the Gary Schulze Collection* (Bayside, N.Y.: Queensborough Community College Art Gallery, 2005), 65, pl. 55.

APPENDIX: A HISTORIOGRAPHY OF THE TERM *NÒWO*

1. Sigismund W. Koelle, *Outlines of a Grammar of the Vei Language: Together with a Vei-English Vocabulary and an Account of the Discovery and Nature of the Vei Mode of Syllabic Writing.* (London: Church Missionary House, 1854), 203.

2. James Frederick Schön, *Vocabulary of the Mende Language* (London: Society for Promoting Christian Knowledge, 1884), 118.

3. Thomas Joshua Alldridge, *The Sherbro and Its Hinterland* (London: Macmillan, 1901), 141–42.

4. This term is also used in A. R. Wright, "Secret Societies and Fetishism in Sierra Leone," *Folklore* 18, no. 4 (December 1907): 423–24.

5. See Sylvia Ardyn Boone, *Radiance from the Waters: Ideals of Feminine Beauty in Mende Art* (New Haven, Conn.: Yale University Press, 1986) and Ruth B. Phillips, *Representing Woman: Sande Masquerades of the Mende of Sierra Leone* (Los Angeles: UCLA Fowler Museum of Cultural History, 1995).

6. Charles Braithwaite Wallis, *The Advance of Our West African Empire* (London: T. Fisher Unwin, 1903), 251.

7. Rudolf Eberl [Ralph Eberl-Elber, pseud.], *Westafrikas letztes Rätsel: Erlebnisbericht über die Forschungsreise 1935 durch Sierra Leone* (Salzburg: Verlag das Berglandbuch, 1936), 325–29.

8. Henry Usher Hall, "Field Notes on the Sherbro Expedition" (unpublished ms., 1937), A133, 137 (University of Pennsylvania Museum of Archaeology and Anthropology).

9. George Schwab, *Tribes of the Liberian Hinterland*, *Papers of the Peabody Museum of American Archaeology and Ethnology, Harvard University*, vol. 31, edited by George Way Harley (Cambridge, Mass.: Peabody Museum of American Archaeology and Ethnology, 1947), 188.

10. Walter J. Pichl, *Sherbro-English Dictionary* (Pittsburgh, Pa.: Duquesne University Press, 1967), 13.

11. Gordon Innes, *A Mende-English Dictionary* (Cambridge: Cambridge University Press, 1969), 117. Unfortunately, Innes did not document the locations and sources of his words. He did extensive cultural research in the field, however, and presumably obtained the word *nòwò* (or *nòwo*, as I have heard it among the Temne) from a Mende speaker. Reinhardt indicated that she did not get specific information on Sande-official grades, and did not find the word *nòwo* in her field research but, rather, in Innes's dictionary. See Loretta R. Reinhardt, "Mende Carvers" (PhD diss., Southern Illinois University, 1975), 48.

225

Bibliography

Adams, Monni. "An Evening with William Fagg." *African Arts* 10, no. 4 (July 1977): 38–43, 88.

_____. "Introduction." *Ethnologische Zeitschrift Zürich*, special issue, 1 (1980): 9–12.

Addison, William. "Steatite Figures from Moyamba District, Central Province, Sierra Leone, West Africa." *Man* 23 (November 1923): 176–77.

African Art from New Jersey Collections. Montclair, N.J.: Montclair Art Museum, 1983.

Alldridge, Thomas Joshua. *The Sherbro and Its Hinterland*. London: Macmillan, 1901.

_____. *A Transformed Colony: Sierra Leone as It Was, and as It Is; Its Progress, Peoples, Native Customs, and Undeveloped Wealth*. London: Seeley, 1910.

_____. "Sierra Leone." In *Customs of the World: A Popular Account of the Manners, Rites, and Ceremonies of Men and Women in All Countries*, 2 vols. Edited by Walter Hutchinson. London: Hutchinson, 1913. 2:768–92.

Allison, Philip. *African Stone Sculpture*. New York and Washington, D.C.: Frederick A. Praeger, 1968.

Anderson, Martha G., and Lisa L. Aronson. "Jonathan A. Green: An African Photographer Hiding in Plain Sight." *African Arts* 44, no. 3 (Autumn 2011): 38–49.

Art Africain: Donation L.-Pierre Guerre. Marseille: Musée des Beaux-Arts, 1980.

Atherton, John H., and Milan Kalous. "Nomoli." *Journal of African History* 11, no. 3 (1970): 303–17.

Attenborough, David. *Tribal Encounters: An Exhibition of Ethnic Objects Collected by David Attenborough*. Leicester, U.K.: Leicestershire Museums, Art Galleries, and Record Services, 1981.

d'Azevedo, Warren L. "Some Historical Problems in the Delineation of a Central West Atlantic Region." *Annals of the New York Academy of Sciences* 96, no. 2 (January 1962): 512–38.

_____. Review of *African Art of the West Atlantic Coast: Transition in Form and Content*, by Frederick Lamp. *African Arts* 14, no. 1 (November 1980): 81–88.

Ballarini, Roberto. *The Perfect Form: On the Track of African Tribal Currency*. Milan: Galleria Africa Curio, 2009.

Bassani, Ezio, and William Fagg. *Africa and the Renaissance: Art in Ivory*. New York: Center for African Art; Munich: Prestel-Verlag, 1988.

Becker-Donner, Etta. *Hinterland Liberia*. Translated by Winifred M. Deans. London: Blackie and Sons, 1939.

_____. "Kunst und Handwerk in NO [Northeastern] Liberia." *Baessler-Archiv* 23, nos. 2–3 (1940): 45–110.

Bettelheim, Judith. "First Fieldwork, Then Theory: Anywhere, But Do It!" *African Arts* 32, no. 2 (Summer 1999): 85–86.

Blier, Suzanne Preston. "The GOGAG's Lament." *African Arts* 32, no. 2 (Summer 1999): 9–10.

Boone, Sylvia Ardyn. *Radiance from the Waters: Ideals of Feminine Beauty in Mende Art*. New Haven, Conn.: Yale University Press, 1986.

Bouttiaux, Anne-Marie, and Marc Ghysels. "Probing Art with CT Scans: A New Look at Two Masterpieces from Central Africa." *Arts and Cultures* 9 (2008): 230–49.

Brain, Robert. *Art and Society in Africa*. London: Longman, 1980.

Brill, William. *Selections from the William W. Brill Collection of African Art*. Milwaukee: Milwaukee Public Museum, 1969.

Brincard, Marie-Thérèse, ed. *Sounding Forms: African Musical Instruments*. New York: American Federation of Arts, 1989.

Brown, Stanley. "The Nomoli of Mende Country." *Africa* 18, no. 1 (1948): 18–20.

Büttikofer, Johann. *Reisebilder aus Liberia: Resultate Geographischer, Naturwissenschaftlicher und Ethnographischer Untersuchungen während der Jahre 1879–1882 und 1886–1887*. Leiden, Netherlands: E. J. Brill, 1890.

Byrnes, James. *The Artist as Collector: Selections from Four California Collections of the Arts of Africa, Oceania, the Amerindians, and the Santeros of New Mexico*. Newport Harbor, Calif.: Newport Harbor Art Museum, 1975.

Cole, Herbert M. "A Crisis in Connoisseurship?" *African Arts* 36, no. 1 (Spring 2003): 1, 4–5, 8, 86, 96.

Dannenberg, Jerry. "The Dannenberg Collection." *Arts d'Afrique Noire* 64 (Winter 1987): 37–42.

Delafosse, Maurice. "Au Sujet des Statuettes en Pierre du Kissi (Guinée Française)." *Revue d'Ethnographie et de Sociologie* 5 (1914): 143–44.

Dittmer, Kunz. "Bedeutung, Datierung und Kulturhistorische Zusammenhänge der 'Prähistorischen' Steinfiguren aus Sierra Leone und Guinée." *Baessler-Archiv* 25 (1967): 183–238.

Eberl, Rudolf [Ralph Eberl-Elber, pseud.]. *Westafrikas letztes Rätsel: Erlebnisbericht über die Forschungsreise 1935 durch Sierra Leone*. Salzburg: Verlag das Berglandbuch, 1936.

_____. *Sierra Leone: Allein durch Westafrikas Tropen*. Berlin: Verlag die Heimbücherei, 1943.

Edwin, Walter L. "Notes on the Nomolis of Sherbroland." *Journal of Negro History* 2, no. 2 (April 1917): 160–63.

Fagaly, William A. "The Traditional Arts of Liberia." *African Arts* 18, no. 2 (February 1985): 80–81.

Fage, J. D. "Upper and Lower Guinea." In *The Cambridge History of Africa*. Vol. 3: *From c. 1050 to c. 1600*. Edited by Roland Oliver. Cambridge: Cambridge University Press, 1977. 463–518.

Fagg, William. *Afro-Portuguese Ivories*. London: Batchworth Press, 1959.

Ferme, Mariane C. *The Underneath of Things: Violence, History, and the Everyday in Sierra Leone*. Berkeley: University of California Press, 2001.

Fischer, Eberhard. "Dan Forest Spirits: Masks in Dan Villages." *African Arts* 11, no. 2 (January 1978): 16–23, 94.

Fischer, Eberhard, and Hans Himmelheber. *The Arts of the Dan in West Africa*. Zurich: Museum Rietberg, 1984.

Flickinger, Daniel Kumler. *Ethiopia; or, Thirty Years of Missionary Life in Western Africa*. Dayton, Ohio: United Brethren Publishing House, 1885.

Fraser, Douglas. "Note on the Stone *Nomoli* Figures of Sierra Leone." *Art Bulletin* 53, no. 3 (September 1971): 393.

Fyle, Cecil Magbaily. *Historical Dictionary of Sierra Leone*. 1977. Revised edition. Lanham, Md.: Scarecrow Press, 2006.

Gba, Daouda. "Les Masques chez les Dan: 'Fonctions Éducatives.'" Mémoire de Diplôme d'Études Approfondies (master's thesis), Université Nationale de Côte d'Ivoire, 1982.

Geary, Christraud M. "Different Visions?" In *Delivering Views: Distant Cultures in Early Postcards*. Edited by Christraud M. Geary and Virginia-Lee Webb. Washington, D.C., and London: Smithsonian Institution Press, 1998. 147–77.

_____. *In and Out of Focus: Images from Central Africa, 1885–1960*. London: Philip Wilson, 2002.

_____. "Through the Lenses of African Photographers: Depicting Foreigners and New Ways of Life, 1870–1950." In *Through African Eyes: The European in African Art, 1500 to Present*. Edited by Nii O. Quarcoopome. Detroit: Detroit Institute of Arts, 2009. 87–99.

Germann, Paul. *Die Völkerstämme im Norden von Liberia: Ergebnisse einer Forschungsreise im Auftrage des Staatlich-Sächsischen Forschungsinstitutes für Völkerkunde in Leipzig in den Jahren 1928/29*. Leipzig: R. Voigtländer, 1933.

Ghysels, Marc. "CT Scans in Art Work Appraisal." *Art Tribal* 4 (2003): 116–31.

_____. "Tomodensitometric Analysis by X-ray Scanner." Unpublished ms., November 15, 2008.

Giraudy, Danièle. *Le Musée d'Arts Africains, Océaniens, Amérindiens de Marseille*. Paris: Fondation BNP Paribas, Réunion des Musées Nationaux; Marseille: Réunion des Musées de Marseille, 2002.

Gottschalk, Burkhard. *Bundu: Buschteufel im Land der Mende*. Düsseldorf: U. Gottschalk, 1990.

_____. *L'Art du Continent Noir: Du Guimballa aux Rives du Congo*. Düsseldorf: U. Gottschalk, 2005.

Bibliography (continued)

Graham, Jane, ed. *African, South Pacific and Precolumbian Art from Private Indianapolis Collections.* Indianapolis: Indianapolis Museum of Art, 1992.

Guerre, Pierre. *Arts Africains.* Marseille: Musée Cantini, 1970.

Hair, Paul E. H. "Ethnolinguistic Continuity on the Guinea Coast." *Journal of African History* 8, no. 2 (1967): 247–68.

_____. "An Ethnolinguistic Inventory of the Upper Guinea Coast before 1700." *African Language Review* 6 (1967): 32–70.

_____. *Africa Encountered: European Contacts and Evidence, 1450–1700.* Aldershot, U.K.: Variorum, 1997.

Hall, Henry Usher. "Field Notes on the Sherbro Expedition." Unpublished ms., 1937. University of Pennsylvania Museum of Archaeology and Anthropology.

Haney, Erin. *Photography and Africa.* London: Reaktion Books, 2010.

Harley, George W. *Masks as Agents of Social Control in Northeast Liberia* (Cambridge, Mass: Peabody Museum of American Archaeology and Ethnology, Harvard University, 1950).

Hart, William A. "Continuity and Discontinuity in the Art History of Sierra Leone." *Quaderni Poro*, special issue, 9 (1995).

_____. "Sculpted Tablet." In *Africa: The Art of a Continent.* Edited by Tom Phillips. New York: Prestel, 1995. 468–69.

_____. "Early-Nineteenth-Century Chiefs' Horns from Coastal Liberia." *African Arts* 32, no. 3 (Autumn 1999): 62–67, 96.

_____. "*Kololewengoi* and the Myth of the Big Thing." *RES: Anthropology and Aesthetics* 37 (Spring 2000): 72–88.

_____. "Trophies of Grace? The 'Art' Collecting Activities of United Brethren in Christ Missionaries in Nineteenth Century Sierra Leone." *African Arts* 39, no. 2 (Summer 2006): 14–25, 86.

Hart, William A., and Christopher Fyfe. "The Stone Sculptures of the Upper Guinea Coast." *History in Africa* 20 (1993): 71–87.

Henggeler, Joe. "Ivory Trumpets of the Mende." *African Arts* 14, no. 2 (February 1981): 59–63.

Herbert, Eugenia W. *Red Gold of Africa: Copper in Precolonial History and Culture.* Madison: University of Wisconsin Press, 1984.

Herreman, Frank, ed. *Material Differences: Art and Identity in Africa.* New York: Museum for African Art; Ghent: Snoeck-Ducaju and Zoon, 2003.

Himmelheber, Hans. *Negerkunst und Negerkünstler.* Braunschweig, Germany: Klinkhardt and Biermann, 1960.

_____. "Gelbgussringe der Guere (Elfenbeinküste)." *Tribus*, n.s., 13 (1964): 1–88.

_____. "Le Système de la Religion des Dan." In *Rencontres Internationales de Bouaké: Les Religions Africaines Traditionnelles.* Paris: Éditions du Seuil, 1965. 75–96.

Højbjerg, Christian Kordt. "The Ambiguity of Gender." In *See the Music, Hear the Dance: Rethinking African Art at the Baltimore Museum of Art.* Edited by Frederick Lamp. Munich and New York: Prestel, 2004. 56–59.

_____. *Resisting State Iconoclasm among the Loma of Guinea.* Durham, N.C.: Carolina Academic Press, 2007.

Holas, Bohumil. *Craft and Culture in the Ivory Coast.* Abidjan: Republic of the Ivory Coast Ministry of National Education Centre for Human Studies, 1968.

Holsoe, Svend E. "The Cassava-Leaf People: An Ethnohistorical Study of the Vai People with Particular Emphasis on the Tewo Chiefdom." PhD diss., Boston University, 1967.

Hommel, William. *Art of the Mende.* College Park, Md.: University of Maryland, 1974.

Imperato, Gavin H., and Pascal James Imperato. *Bundu: Sowei Headpieces of the Sande Society of West Africa; The Imperato Family Collection.* Bayside, N.Y.: Queensborough Community College; Manhasset, N.Y.: Kilima House, 2012.

Innes, Gordon. *A Mende-English Dictionary.* Cambridge: Cambridge University Press, 1969.

Jedrej, M. C. "Structural Aspects of a West African Secret Society." *Ethnologische Zeitschrift Zürich*, special issue, 1 (1980): 133–42.

_____. "Dan and Mende Masks: A Structural Comparison." *Africa* 56, no. 1 (1986): 71–80.

Jérémine, Elisabeth. "Étude des Statuettes Kissiennes au Point de Vue Minéralogique et Pétrographique." *Journal de la Société des Africanistes* 15 (1945): 3–14 and plate.

Johnson, Barbara C. *Four Dan Sculptors: Continuity and Change*. San Francisco: Fine Arts Museums of San Francisco, 1986.

_____. "Ldamie: Figurative Brass Caster of the Dan." *Iowa Studies in African Art: The Stanley Conferences at the University of Iowa* 2 (1987): 49–64.

Johnston, Harry Hamilton. *Liberia*. 2 vols. London: Hutchinson, 1906.

Joubert, Hélène. *Image de la Femme dans l'Art Africain*. Paris: Ville de Tours, 2000.

Joyce, Thomas A. "Steatite Figures from West Africa in the British Museum." *Man* 5 (1905): 97–100.

_____. "Steatite Figures from Sierra Leone." *Man* 9 (1909): 65–68.

Kasfir, Sidney Littlefield. "The Disappearing Study of the Premodern African Past." *African Arts* 46, no. 1 (Spring 2013): 1, 4–5.

Keane, Augustus Henry. "Africa: Social, Religious, and Political Institutions." In *The Living Races of Mankind: A Popular Illustrated Account of the Customs, Habits, Pursuits, Feasts, and Ceremonies of the Races of Mankind Throughout the World*. 2 vols. Edited by Harry Hamilton Johnston. London: Hutchinson 1901–3. 2:481–512.

_____. *Africa*. 2 vols. London: E. Stanford, 1895–1904.

Klenkler, C. E. *Sahara: Objets Préhistoriques/Prähistorische Artefakte*. 2 vols. Geneva: Dodo Publications, 2003.

Koelle, Sigismund W. *Outlines of a Grammar of the Vei Language: Together with a Vei-English Vocabulary and an Account of the Discovery and Nature of the Vei Mode of Syllabic Writing*. London: Church Missionary House, 1854.

Lamp, Frederick John. "House of Stones: Memorial Art of Fifteenth-Century Sierra Leone." *Art Bulletin* 65, no. 2 (1983): 219–37.

_____. "Cosmos, Cosmetics, and the Spirit of Bondo." *African Arts* 18, no. 3 (May 1985), 28–43, 98–99.

_____. "An Opera of the West African Bondo: The Act, Ideas, and the Word." *TDR* [The Drama Review] 32, no. 2 (Summer 1988): 83–101.

_____. "Ancient Wood Figures from Sierra Leone: Implications for Historical Reconstruction." *African Arts* 23, no. 2 (April 1990): 48–59, 103.

_____. *La Guinée et ses Héritages Culturels*. Conakry, Guinea: Service d'Information et de Relations Culturelles, Ambassade des Etats-Unis, 1992.

_____. "Dancing the Hare: Appropriation of the Imagery of Mande Power among the Baga." In *The Younger Brother in Mande: Kinship and Politics in West Africa; Selected Papers from the Third International Conference on Mande Studies, Leiden, March 20–24, 1995*. Edited by Jan Jansen and Clemens Zobel. Leiden, Netherlands: Leiden University, 1996. 105–26.

_____. "Africa Centered." *African Arts* 32, no. 1 (Spring 1999): 1, 4, 6, 8–10.

_____. "It Is the East That Has Power: Sapi Stones and Wood Figures." In *See the Music, Hear the Dance: Rethinking African Art at the Baltimore Museum of Art*. Edited by Frederick John Lamp. Munich and New York: Prestel, 2004. 194–97

Lindsell, Jeremy A., Erik Klop, and Alhaji M. Siaka. "The Impact of Civil War on Forest Wildlife in West Africa: Mammals in the Gola Forest, Sierra Leone." *Oryx* 45, no. 1 (January 2011): 69–77.

Livingstone, Frank B. "Anthropological Implications of Sickle Cell Gene Distribution in West Africa." *American Anthropologist* 60, no. 3 (June 1958): 533–62.

MacCormack, Carol. "Sande: The Public Face of a Secret Society." In *The New Religions of Africa*. Edited by Bennetta Jules-Rosette. Norwood, N.J.: Ablex, 1979. 27–37.

_____. "Proto-Social to Adult: A Sherbro Transformation." In *Nature, Culture, and Gender*. Edited by Carol McCormack and Marilyn Strathern. Cambridge: Cambridge University Press, 1980. 95–118.

Bibliography (continued)

Mack, Rosamond E. *Bazaar to Piazza: Islamic Trade and Italian Art, 1300–1600*. Berkeley: University of California Press, 2002.

MacMillan, Allister. *The Red Book of West Africa: Historical and Descriptive, Commercial and Industrial Facts, Figures, and Resources.* London: W. H. and L. Collingridge, 1920.

Mafundikwa, Saki. *Afrikan Alphabets: The Story of Writing in Afrika.* West New York, N.J.: Mark Batty, 2004.

Magee-Curtis, Carol. "'A White Chick Sittin' Round Thinking'—and She Doesn't Like What She's Read!" *African Arts* 32, no 2 (Summer 1999): 85.

Majima, Ichiro. "Voix de masque sans visage: 'Maania' chez les Dan du Danané-Sud (Côte d'Ivoire)." In *Cultures Sonores d'Afrique.* Tokyo: Institut de Recherches sur les Langues et Cultures d'Asie et d'Afrique, 1997.

Mark, Peter. "Towards a Reassessment of the Dating and the Geographical Origins of the Luso-African Ivories, Fifteenth to Seventeenth Centuries." *History in Africa* 34 (2007): 189–211.

Mato, Daniel, and Charles Miller III. *Sande: Masks and Statues from Liberia and Sierra-Leone.* Amsterdam: Galerie Balolu, 1990.

Mauny, Raymond. "Masques Mende de la Société Bundu." *Notes Africaines* 81 (1959): 8–13.

McGovern, Mike. "More on Lamp's 'First Word.'" *African Arts* 32, no. 3 (Fall 1999): 9, 85.

Meneghini, Mario. "The Gola Masks." Unpublished ms., 1982.

_____. *Collecting African Art in Liberia and Neighboring Countries, 1963–1989.* Gavirate, Italy: Nicolini Editore, 2006.

Musa, Frank. "Farming and Superstition in Sierra Leone." *Sierra Leone Studies* 21 (1939): 104–16.

Néel, H. "Statuettes en Pierre et en Argile de l'Afrique Occidentale." *L'Anthropologie* 24 (1913): 419–43.

Nelson, Steven. "The Holy Book of Africanist Art History: Chapter 20." *African Arts* 32, no. 2 (Summer 1999): 86.

O'Connell, Patricia Ann. "Bandi Silver Jewelry." *African Arts* 12, no. 1 (November 1978): 48–51, 108.

Okeke, Chika. "Africanists and African Art History." *African Arts* 32, no. 2 (Summer 1999): 10, 85.

Oldman, William Ockelford. *Illustrated Catalogue of Ethnographic Specimens.* Sale cat. 74 (1909).

Ottenberg, Simon. "Decorated Hu Ronko Shirts from Northern Sierra Leone: Birth, Life, and Decline." *African Arts* 40, no. 4 (Winter 2007): 14–31.

Page, Donna. *Artists and Patrons in Traditional African Cultures: African Sculpture from the Gary Schulze Collection.* Bayside, N.Y.: Queensborough Community College Art Gallery, 2005.

Paulme, Denise. "Deux Statuettes en Pierre de Guinée Française." *Bulletins et Mémoires de la Société d'Anthropologie de Paris* 3 (1942): 38–43.

_____. "Utilisation Moderne d'Objets Préhistoriques à des Fins Rituelles en Pays Kissi." *Notes Africaines* 44 (1949): 119.

_____. *Les Gens du Riz: Kissi de Haute-Guinée Française.* Paris: Plon, 1954.

Person, Yves. "Les Kissi et Leurs Statuettes de Pierre dans le Cadre de l'Histoire Ouest-Africaine." *Bulletin de l'Institut Fondamental d'Afrique Noire* 23, nos. 1–2 (1961): 1–59.

Phillips, Ruth B. "The Iconography of the Mende Sowei Mask." *Ethnologische Zeitschrift Zürich*, special issue, 1 (1980): 113–32.

_____. *Representing Woman: Sande Masquerades of the Mende of Sierra Leone.* Los Angeles: UCLA Fowler Museum of Cultural History, 1995.

Pichl, Walter J. *Sherbro-English Dictionary.* Pittsburgh, Pa.: Duquesne University Press, 1967.

Rammah, Mourad. "Kairouan et la Grande Mosquée." In *Tunisie, un Patrimoine Inédit,* 74–78. Paris: Institut du Monde Arabe, 1995.

Reed, Daniel B. *Dan Ge Performance: Masks and Music in Contemporary Côte d'Ivoire.* Bloomington: Indiana University Press, 2003.

Reeves, Edward Ayearst, ed. *Hints to Travellers: Scientific and General.* London: Royal Geographical Society, 1906.

Reinhardt, Loretta R. "Mende Carvers." PhD diss., Southern Illinois University, 1975.

Richards, Paul. "Natural Symbols and Natural History: Chimpanzees, Elephants, and Experiments in Mende Thought." In *Environmentalism: The View from Anthropology.* Edited by Kay Milton. London: Routledge, 1993. 151–54.

Robbins, Warren M. "How to Approach the Traditional African Sculpture." *Smithsonian* 3, no. 6 (September 1976): 44–51.

Robbins, Warren M., and Nancy Ingram Nooter. *African Art in American Collections: Survey 1989.* Washington, D.C.: Smithsonian Institution Press, 1989.

Rodney, Walter. "A Reconsideration of the Mane Invasions of Sierra Leone." *Journal of African History* 8, no. 2 (1967): 219–46.

Rosenberg, Jakob. "The Problem of Quality in Old Master Drawings." *Bulletin of the Allen Memorial Art Museum* 8, no. 2 (Winter 1951): 48.

_____. *On Quality in Art: Criteria of Excellence, Past and Present.* Princeton, N.J.: Princeton University Press, 1967.

Ross, Doran H. "Interview with Roy Sieber." *African Arts* 25, no. 4 (October 1992): 36–51.

Royal Scottish Museum. *Traditional African Sculpture.* Edinburgh: Howie and Seath, 1981.

Rütimeyer, Leopold. "Über Westafrikanische Steinidole." *Archives Internationales d'Ethnographie* 14 (1901): 195–204 and plates.

_____. "Weitere Mitteilungen über Westafrikanische Steinidole." *Archives Internationales d'Ethnographie* 18 (1908): 167–78 and plates.

Scheinberg, Alfred, and Kristin Jefferson. *SHE: Images of the Woman in Black African Art.* New York: Germans Van Eck Gallery, 1983.

Schneider, Jürg. "The Topography of Early History of African Photography." *History of Photography* 34, no. 2 (2010): 134–46.

Schnell, Raymond. "Sur Quelques Plantes à Usage Religieux de la Région Forestière d'Afrique Occidentale." *Journal de la Société des Africanistes* 16 (1946): 29–38.

Schön, James Frederick. *Vocabulary of the Mende Language.* London: Society for Promoting Christian Knowledge, 1884.

Schwab, George. *Tribes of the Liberian Hinterland. Papers of the Peabody Museum of American Archaeology and Ethnology, Harvard University,* vol. 31. Edited by George Way Harley. Cambridge, Mass.: Peabody Museum of American Archaeology and Ethnology, 1947.

Seligman, Thomas K., and Kristyne Loughran, eds. *Art of Being Tuareg: Sahara Nomads in a Modern World.* Los Angeles: Iris and B. Gerald Cantor Center for Visual Arts, Stanford University/UCLA Fowler Museum of Cultural History, 2006.

Sharpe, Margy P., ed. *The Collection of Mr. and Mrs. David Lloyd Kreeger.* Richmond, Va.: Brown, 1976.

Shepperd, Scott. "Nitien: The Curious Case of Kru Money." *Liberian Studies Journal* 31, no. 2 (2006): 50–85.

Sieber, Roy. "Fakes, Reproductions, and Restorations in African Art," unpublished lecture. National Museum of African Art, Smithsonian Institution, Washington, D.C., May 16, 1984, 3.

Sieber, Roy, and Theodore Celenko. "Rayons X et Art Africain." *Arts d'Afrique Noire,* no. 21 (1977): 16–28.

Sieber, Roy, and Frank Herreman. *Hair in African Art and Culture.* New York: Museum for African Art; Munich: Prestel, 2000.

Sieber, Roy, and Roslyn A. Walker. *African Art in the Cycle of Life.* Washington, D.C.: National Museum of African Art, 1987.

Siegmann, William C. With Cynthia E. Schmidt. *Rock of the Ancestors: ŋamôa koni.* Suakoko, Liberia: Cuttington University College, 1977.

_____. "Patchwork Gowns as State Regalia in Western Liberia." In *Man Does Not Go Naked: Textilien und Handwerk aus Afrikanischen und Anderen Ländern.* Edited by Beate Engelbrecht and Bernhard Gardi. Basel: Ethnologisches Seminar der Universität und Museum für Völkerkunde, 1989. 107–16.

_____. "A Collection Grows in Brooklyn." In *Representing Africa in American Art Museums: A Century of Collecting and Display.* Edited by

Bibliography (continued)

Kathleen Bickford Berzock and Christa Clarke. Seattle and London: University of Washington Press, 2011. 62–80.

Siegmann, William C., and Judith Perani. "Men's Masquerades of Sierra Leone and Liberia." *African Arts* 9, no. 3 (April 1976): 42–47, 92.

Svanascini, Osvaldo. *Arte Africano*. Buenos Aires: Asociación Amigos del Museo Nacional de Bellas Artes, 1964.

Szalay, Miklós. *Die Kunst Schwarzafrikas: Werke aus der Sammlung des Völkerkundemuseums der Universität Zürich*. Vol. 1: *Kunst und Gesellschaft*. Munich: Trickster, 1994.

———. *Schön Hässlich: Gegensätze; Afrikanische Kunst aus der Sammlung des Völkerkundemuseums der Universität Zürich*. Zurich: Offizin Verlag, 2001.

Tabmen, George W. W. "Gor and Gle: Ancient Structure of Government in the Dan (Gio) Tribe." Monrovia, Liberia: 1971, mimeograph (hardcover copy, Herman B. Wells Library, Indiana University, Bloomington).

Tagliaferri, Aldo. *Pomdo, Mahen Yafe et Nomoli*. Paris: Johann Levy, Art Primitif, 2003.

Tagliaferri, Aldo, and Arno Hammacher. *Fabulous Ancestors: Stone Carvings from Sierra Leone and Guinea*. New York: Africana Publishing, 1974.

Tassel, Janet. "Reverence for the Object: Art Museums in a Changed World." *Harvard Magazine* 105, no. 1 (September–October 2002): 48–58, 98–99.

Thompson, George. *Thompson in Africa: Or, an Account of the Missionary Labors, Sufferings, Travels, and Observations of George Thompson in Western Africa, at the Mendi Mission*. Cleveland: D. M. Ide, 1852.

Thompson, Robert Farris. *African Art in Motion: Icon and Act in the Collection of Katherine Coryton White*. Berkeley and Los Angeles: University of California Press, 1974.

Van Damme, Annemieke. *De Maskersculptuur binnen het Poro-Genootschap van de Loma: Getuigenis van een Ecologisch-Culturele Aanpassing?* Ghent, Belgium: Rijksuniversiteit, Seminarie voor Etnische Kunst, 1987.

———. "À Propos de Huit Sculptures en Pierre Découvertes en Territoire Loma." *Arts d'Afrique Noire*, no. 79 (Autumn 1991): 19–29.

Vandenhoute, P. J. *Poro and Mask: A Few Comments on Masks as Agents of Social Control by Dr. G. W. Harley*. 1952. Reprint, Ghent, Belgium: Department of Ethnic Art, State University of Ghent, 1989.

Viditz-Ward, Vera. "Alphonso Lisk-Carew: Creole Photographer." *African Arts* 19, no. 1 (November 1985): 46–51, 88.

Vivian, William. "The Mendi Country, and Some of the Customs and Characteristics of Its People." *Journal of the Manchester Geographical Society* 7, no. 1 (January 1896): 1–34.

———. *Mendiland Memories: Reflections and Anticipations*. London: Henry Hooks, 1926.

Volper, Julien. "Pomdo and Nomoli: The Jean Houzeau de Lehaie Archives." *Tribal Art* 10, no. 4 (2006): 96–105.

Wallis, Charles Braithwaite. *The Advance of Our West African Empire*. London: T. Fisher Unwin, 1903.

Wardwell, Alan. *African Sculpture from the University Museum, University of Pennsylvania*. Philadelphia: Philadelphia Museum of Art, 1986.

Wells, Louis T. "Art and Expatriates in Liberia." *Tribal Art* 14, no. 2 (Spring 2010): 96–111.

Winterbottom, Thomas. *An Account of the Native Africans in the Neighbourhood of Sierra Leone: To Which Is Added an Account of the Present State of Medicine among Them*. London: C. Whittingham, 1803.

Woodward, Richard. *African Art: Virginia Museum of Fine Arts*. Richmond: Virginia Museum of Fine Arts, 2000.

Wright, A. R. "Secret Societies and Fetishism in Sierra Leone." *Folklore* 18, no. 4 (December 1907): 423–27.

Zemp, Hugo. *Musique Dan: La Musique dans la Pensée et la Vie Sociale d'une Société Africaine*. Paris and the Hague: Mouton, 1971.

About the Authors

ALEXANDER BORTOLOT, a specialist in the arts of East Africa, is Content Strategist in the Curatorial Division of the Minneapolis Institute of Arts. He organized the 2007 exhibition *Revolutions: A Century of Makonde Masquerade in Mozambique* at Columbia University's Miriam and Ira D. Wallach Art Gallery and has published several essays and articles on the arts of Mozambique and Tanzania.

MARIANE C. FERME is Associate Professor of Sociocultural Anthropology at the University of California, Berkeley. A specialist on Sierra Leone, she is the author of *The Underneath of Things: Violence, History, and the Everyday in Sierra Leone* (2001) as well as many articles.

JAN-LODEWIJK GROOTAERS is Curator of African Art and Head of the Arts of Africa and the Americas Department at the Minneapolis Institute of Arts. He organized the 2007 exhibition *Ubangi: Art and Cultures from the African Heartland* at the Afrika Museum, Berg-en-Dal, the Netherlands. Grootaers specializes in the arts and cultures of north-central Africa.

NANINA GUYER is a PhD student at the Center of African Studies, University of Basel. Her doctoral research focuses on early photographs of West Africa's so-called secret initiation societies.

BARBARA C. JOHNSON, the author of *Four Dan Sculptors: Continuity and Change* (1986), is an expert on the cast-brass arts of the Dan and related peoples of Liberia and Côte d'Ivoire.

CHRISTINE MULLEN KREAMER is Deputy Director and Chief Curator of the National Museum of African Art, Washington, D.C. Among the exhibitions she has organized there are *Inscribing Meaning: Writing and Graphic Systems in African Art* (2007) and *African Cosmos: Stellar Arts* (2012).

FREDERICK JOHN LAMP is Frances and Benjamin Benenson Foundation Curator of African Art at the Yale University Art Gallery. He specializes in the arts of Sierra Leone and Guinea. His books include *See the Music, Hear the Dance: Rethinking Africa at the Baltimore Museum of Art* (2004) and *Art of the Baga: A Drama of Cultural Reinvention* (1996).

DANIEL B. REED is Associate Professor of Folklore and Ethnomusicology at Indiana University, Bloomington. He has researched and published extensively on contemporary Dan masked performance and on popular culture in Côte d'Ivoire. Reed is the author of *Dan Ge Performance: Masks and Music in Contemporary Côte d'Ivoire* (2003).

PAUL RICHARDS is Emeritus Professor of Technology and Agrarian Development, Wageningen University, the Netherlands. A specialist in agricultural technology and African farming systems, he has written extensively on warfare, resources, and land use in Sierra Leone.

NATASHA THORESON is a PhD student in the Apparel Studies program at the University of Minnesota's School of Design. Her focus is on the history of textiles and costume in the nineteenth and twentieth centuries.

Index

Index (continued)

Credits

BOOK CREDITS

EDITOR AND PROOFREADER:
Phil Freshman, St. Louis Park, MN

CREATIVE DIRECTOR AND GRAPHIC DESIGNER:
Deb Miner, debminer designer LLC, Minneapolis
creativethatconnects.com

MINNEAPOLIS INSTITUTE OF ARTS VISUAL RESOURCES
SENIOR PHOTOGRAPHER: Dan Dennehy
DIGITAL-IMAGE PRODUCTION: Joshua Lynn

MAPMAKER:
Matt Kania, Map Hero, Inc., Duluth, MN
maphero.com

INDEXER:
Enid L. Zafran, Indexing Partners LLC, Rehoboth Beach, DE
indexingpartners.com

PUBLISHING AND PRODUCTION MANAGER:
Jim Bindas, Books and Projects LLC, Minnetonka, MN
booksandprojects.com

PRINTER: Tien Wah Press, Singapore

This book was typeset in Garamond Premier Pro, Avenir, and Trade Gothic.

Library of Congress Control Number: 2013949912
ISBN: 9780989371810

Distributed by
the University of Washington Press
P.O. Box 50096
Seattle, WA 98145-5096
washington.edu/uwpress

Printed in Singapore.

This book was published in conjunction with the exhibition *Visions from the Forests: The Art of Liberia and Sierra Leone*, organized by the Minneapolis Institute of Arts.

EXHIBITION TOUR:

NATIONAL MUSEUM OF AFRICAN ART
Smithsonian Institution, Washington, D.C.
April 9–August 17, 2014

MINNEAPOLIS INSTITUTE OF ARTS
September 20, 2014–January 18, 2015

INDIANA UNIVERSITY ART MUSEUM
Bloomington
March–May 2015

HIGH MUSEUM OF ART
Atlanta
July–October 2015

FRONT AND BACK MATTER PHOTOGRAPHS:
Facing table of contents; facing Upper Guinea Forest Region map; parts 1, 2, and 3 opening pages; and back cover: An aerial view of the Guinean rainforest

Title pages:
A Kpolo-Mia-Ngundu Society dancer, Nyandehun, Sierra Leone, mid-1920s

Endsheets: This mid-20th-century cotton blanket (now in a private collection) was the first Liberian object William Siegmann acquired when he began teaching at Cuttington University College, Suakoko, Liberia, in 1965. It was part of his bedding near the end of his life, in 2011.